Border Country

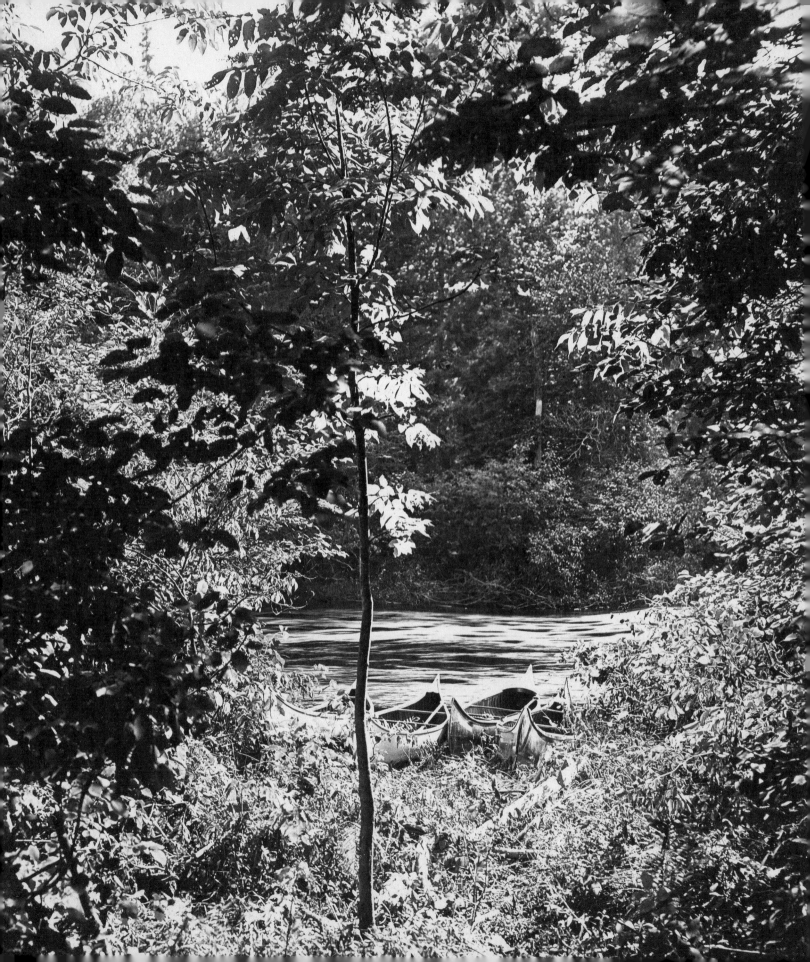

Border Country

The Northwoods Canoe Journals
of Howard Greene

1906–1916

Martha Greene Phillips

Foreword by Peter Geye

University of Minnesota Press

MINNEAPOLIS · LONDON

MINNESOTA HISTORICAL
& CULTURAL GRANTS

CLEAN
WATER
LAND &
LEGACY
AMENDMENT

This publication was made possible in part by the people of Minnesota through a grant funded by an appropriation to the Minnesota Historical Society from the Minnesota Arts and Cultural Heritage Fund. Any views, findings, opinions, conclusions, or recommendations expressed in this publication are those of the authors and do not necessarily represent those of the State of Minnesota, the Minnesota Historical Society, or the Minnesota Historic Resources Advisory Committee.

The publication of this book was assisted by a bequest from Josiah H. Chase to honor his parents, Ellen Rankin Chase and Josiah Hook Chase, Minnesota territorial pioneers.

Published by the University of Minnesota Press
111 Third Avenue South, Suite 290
Minneapolis, MN 55401-2520
http://www.upress.umn.edu

ISBN 978-1-5179-0107-3

A Cataloging-in-Publication record for this book is available from the Library of Congress.

Printed in Canada on acid-free paper

The University of Minnesota is an equal-opportunity educator and employer.

22 21 20 19 18 17 10 9 8 7 6 5 4 3 2 1

To my father, who created these journals, and to my mother, who appreciated their worth and cared for them, ensuring their survival. From my parents I learned to value my roots, to live a full and curious life, and to say "yes" to new experiences, such as writing a book at this point in my life.

To my adventurous daughter, Cora, and her husband, Allen: her grandfather would have appreciated their spirit and travels, as he would have loved to introduce his great-grandsons, Desmond and Nash, to paddling in the North Woods.

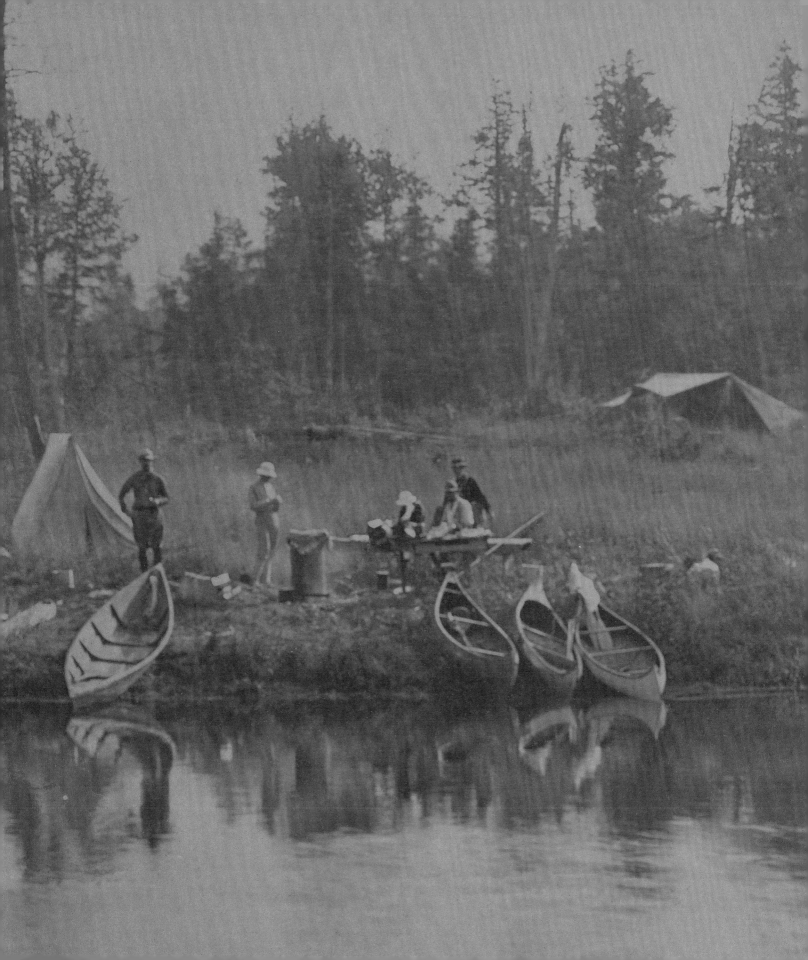

CONTENTS

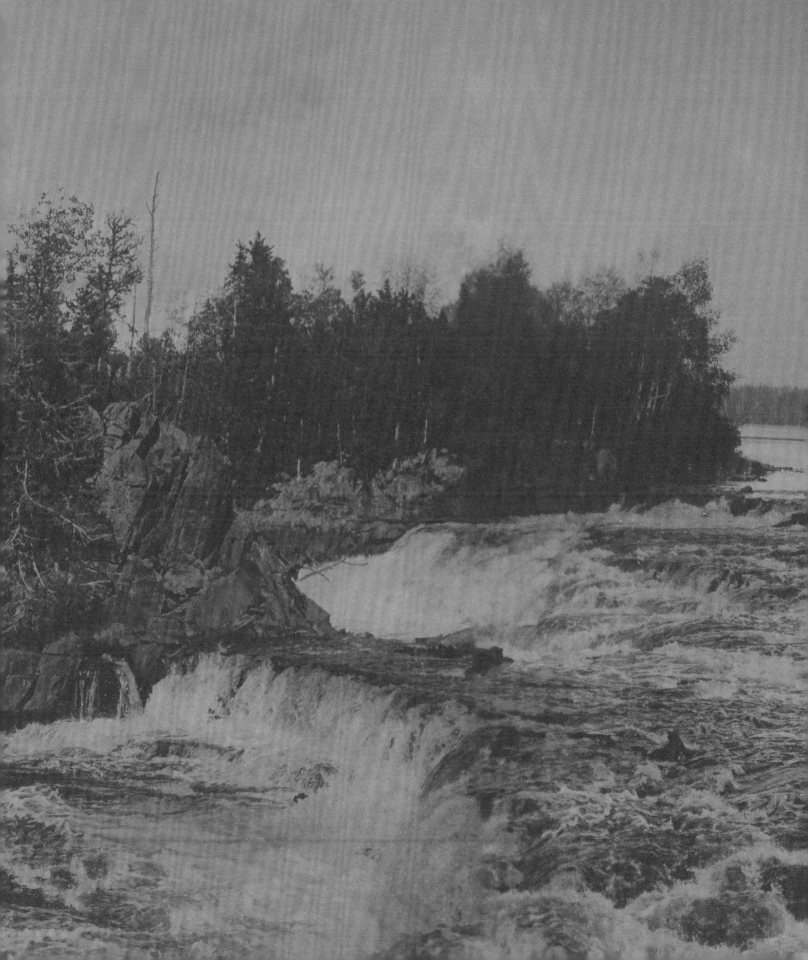

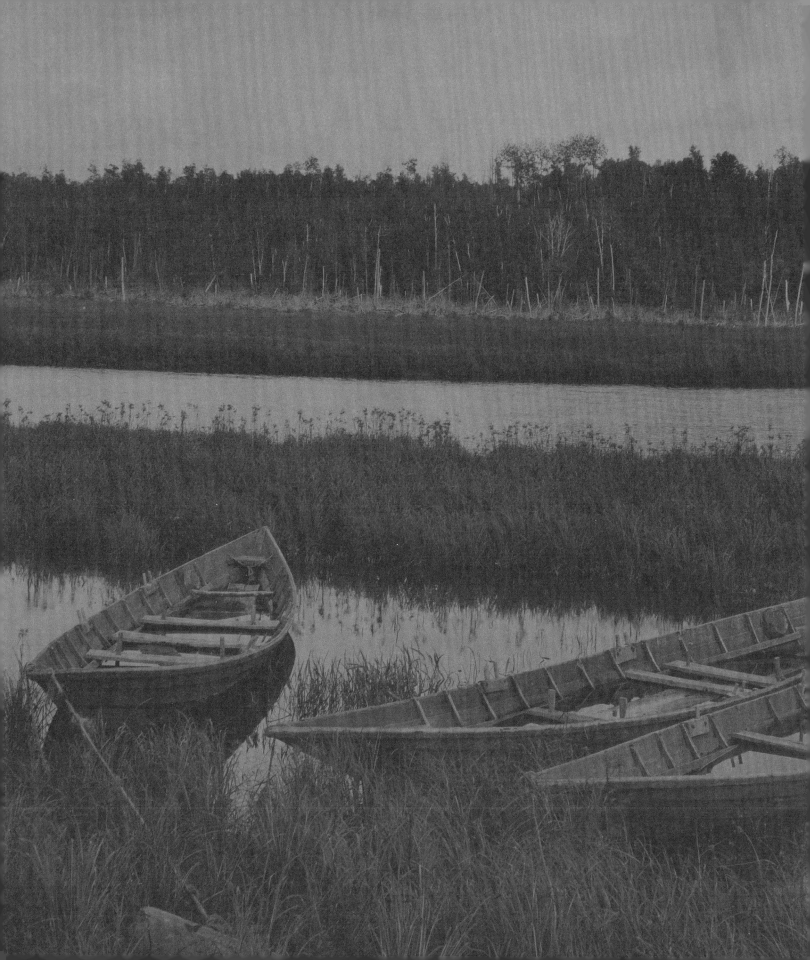

FOREWORD

Peter Geye

The first time I saw these journals and photographs, I was standing in a downtown Minneapolis office building. Marti Phillips had told me about their existence and emphasized their uniqueness. I had been intrigued, of course, but was in no way prepared for the power these pages would eventually have over me.

After Marti explained the path the journals had taken to arrive on that conference room table, she confided that she did not have a single photograph of her and her father together. I wondered how strong such an absence would be in a life, and how, given this fact, she was able to give these journals to the world. It seemed to me an act of utter grace. When she admitted that she was sad to turn them over (the actual physical journals will become exhibits at the Wisconsin Historical Society), I began immediately to ponder my own relationships with my father and my children, to say nothing of the wilderness where we have spent so much time.

I was eleven years old the first time my father took me to the Boundary Waters. I had learned, as have many Minnesota kids, to revere that wilderness and to consider it a place of promise as well as a birthright. To say I was excited would be a grand understatement. Even now, some thirty-five years later, I recall my delight and exuberance in the anticipation of our going.

If I had no context for that wilderness, at least I had my imagination, and in the weeks and months leading up to our departure I studied the Fisher map my father had bought and on which he had outlined our route. We would put in on Round Lake at the end of the Gunflint Trail and make a circle tour that would include about a dozen lakes and portages—Tuscarora, Bologna, Frost, and Rib Lakes among them. With that map as my storybook, I began our trip long before we ever reached the shore of Round Lake. On those afternoons and evenings I spent wondering what would come, I caught enormous fish and whittled toy canoes

from birch sticks and swam naked as the day I was born in pristine waters.

I had been promised such a trip for years, had been told I would get to paddle those hallowed northern lakes as soon as I could carry my own pack on the portages between them. I had also been promised all that would come with such a journey: the long and stumpy portages, the scant larder, the wicked thunderstorms and howling winds, the bear and moose and mosquitoes and blackflies, all of which sounded just fine to me, even if these beasts and battering weather were offered as cautions. But I had also been promised the finer things: the fish that would practically jump into our canoe, the night sky that would rain light on our campsite like the chandelier above the dining room table, the lakes so clear and cold we would only need dip our cup to drink, and of course the laughter and camaraderie, which would follow us everywhere.

I can still recall my excitement and hankering for adventure, the pull of nature, in those weeks and months before our trip. But more than anything I recall my desire to spend time alone with my dad. In our family of five kids, an hour alone with him was cause for celebration. But a week? In the Boundary Waters? It would be the definition of a dream come true.

By that time in my childhood I was already an able canoeist, thanks to family trips down the relatively tame Namekagon, St. Croix, Kettle, and Cannon Rivers in our trusty seventeen-foot (seventy-two pound!) Grumman. I can still recall the J- and C-stroke lessons my father imparted on those Saturday afternoons, can still recall, too, the fun of shooting the relatively tame rapids and lazing on sandbars with my brother and sisters. On those trips we fished and swam and ate bacon and eggs for breakfast. They are fond memories, to be sure, but I knew, even as a young boy, that those weekends on the rivers of my childhood were a mere prelude and that

the real adventures would start at the end of the Sawbill or Gunflint Trails.

That trip in my eleventh year was the first of countless others, each of which bolstered a belief I was already (if unconsciously) forming, which said: *These are the days of your life. And this is the place you will find that thing they call God.* I know this because my memories prove it. My faith in the wilderness also proves it. Whenever I look at the grainy snapshots that were part of those trips—an occurrence that happens more often the older I get—I find myself assigning to the memories a kind of religious awe. There I am, under the burden of a Duluth pack at a portage's end, the tumpline straining against my smiling face. Or sitting in the canoe's stern, a glistening northern pike hanging from my fingertips as though I had just scooped it from the water. Or jumping from ledge rock into a crystalline lake. I recall so many of those memories as if they were only days, and not years, old. It was my childhood, yes and of course. But those were also the days I became *me.* And I couldn't have done it anywhere but in those photographs and the memories that attend them and the things that I learned in that wilderness. And certainly I couldn't have done it without my father's company.

And what did I learn? The obvious woodsmen's skills, for one: how to build a fire and hang a food pack from a tree and pitch a tent and clean a fish and steer a canoe through white water. Lessons that I still practice as often as I can. But there were other things learned in that wilderness. How to listen to the wind, for example, and mark the lowering clouds. How to measure the hour against the coming dark. How to marvel at the aurora borealis pouring from the midnight sky, which taught me how to revere nature and measure my own insignificance against a forty-mile vista.

These things have also been instructive in the ways of love. They have taught me how to be patient and re-

spectful and humble before the unknowable. They have taught me that of all the things in life, those that are beautiful are most worth preserving. And they have taught me why it is important my own children know that a fifty-mile view over Lake Superior is enough to feed their hungry youth for an entire afternoon, and why that youth is going to be the lodestar for the rest of their lives. Of all my responsibilities as a father, few seem as important as giving my children that view and helping them see its majesty. There will be times in their lives when the sanctity of that vista is all that will stand between their happiness and the inevitable difficulties life is sure to offer them. I know this is true because that view and my reverence for it are sometimes my only defense against my own troubles.

Of course there are limits to a father's imparting wisdom. There is only so much I can tell them that will prove useful. It is the view and the awe that will serve them, which is why I have made it my work to expose them to the mysterious and enigmatic wilderness of northern Minnesota. Of course we have our fun—hiking the trails, swimming the lakes, skiing through the woods—but our visits north are so much more than this. They are exercises in faith. And in family. The stories we make there are the stories of our lives.

•

There is little doubt that the journals and photographs in *Border Country: The Northwoods Canoe Journals of Howard Greene, 1906–1916* are a paean to some of these same notions. What is more, and certainly what is urgent, is that they are evidence of the long sway wild places have had over our lives and imaginations. The pages you are about to read are a testament: to both past and future wildernesses and to the ways we inhabit them. And are inhabited by them.

But they are more intimate than that. Through this blending of the historically minded journals and an astonishing collection of photographs, the reader is sure to confront the confluence of her own history and the stories it keeps. And because there *is* a difference between the history we know and the stories we keep, the experience of this book is magical.

The careful and thoughtful reader will recognize in the journals evidence of the way the world was once traveled—the train rides from Milwaukee to the outposts that served as trailheads, the old canvas canoes that floated on the chosen waters. But if she grew up on the same or similar waterways, she will likely also begin to remember, through reading these pages, the blueberry pancakes she ate for breakfast or the fish she caught on some midwestern river or the mosquitoes that plagued her on a summer night. Those bits of history will incite her memories, which likely will have more to do with how fondly she recalls her now departed mother, who was her steward on those waterways, or her anticipation of bringing her own young daughter on a future trip down the Kawishiwi—or some other—River. *That* is life, and the true power of this book.

I lately stood on the shore of Rainy River on the Minnesota–Ontario border. I had only recently finished reading this book, and I reflected almost bitterly on what I saw. There was the paper mill in Fort Frances, just across the water, steam blowing from the myriad stacks and into the heavy autumn mist. One hundred years ago, what might I have seen standing on that same shore? I imagined considerable differences. In fact, I had *seen* considerable differences, right in Howard Greene's photographs. I was troubled and decided I would get back in my car and drive to Ranier, a town just a couple miles east of International Falls, Minnesota, and have a look at Rainy Lake. For all of my travels in the Minnesota wilderness, I had never set foot on the shore of this lake, and my only context for it were the photographs I had recently considered in these journals.

It was properly raining by the time I reached the public beach in Ranier, raining and foggy and impossible to see past the gently lapping water. I stood there for some minutes, waiting for the fog to lift or pass. When it finally did, I saw the shoreline bedecked with houses. I saw docks jutting into the lake. I saw not a wilderness but a small town and its environs, which bore little resemblance to the place I had come to know through these photographs.

I can already hear the complaints. *What right does this visitor have to complain about the progress we've made? The lives that we've supported? Who is he to call into question our right to build our homes on the shore of this lake?* Believe me, I know the answer to these questions. I have *no* right to question the livelihood of the people who live here. I consider what has been done to the wildernesses described by Howard Greene in these journals to be water under the bridge, if you will pardon the pun. But I believe the years ahead are crucial, and I will call for the preservation of wild places with all my breath. There is a balance to be struck, and only by fighting for that balance will these places remain. We have enough. We don't need more.

This is true of our civilization and our society, but it is hardly true of our children's imaginations, of their right to build a faith based on the goodness of the earth and a long view over Lake Superior or any of a hundred vistas in the Boundary Waters. We cannot reclaim those shores of Rainy Lake any sooner than we can reclaim our own memories. But without places to make those memories, where will we be?

•

During my initial meeting with Marti Phillips in that Minneapolis office building, she said something else that impressed me mightily. "I've lived with these men for a long time," she said, pointing to the many photographs spread across the table. "They've given me what I need."

I believe they will give you something, too. Maybe even something you didn't know you needed. A portal to your own childhood, perhaps. Or the promise of the memories you will make someday with your own children on the shores of a sacred northern lake or river.

FACING
*Cascades on the
Presque Isle River*

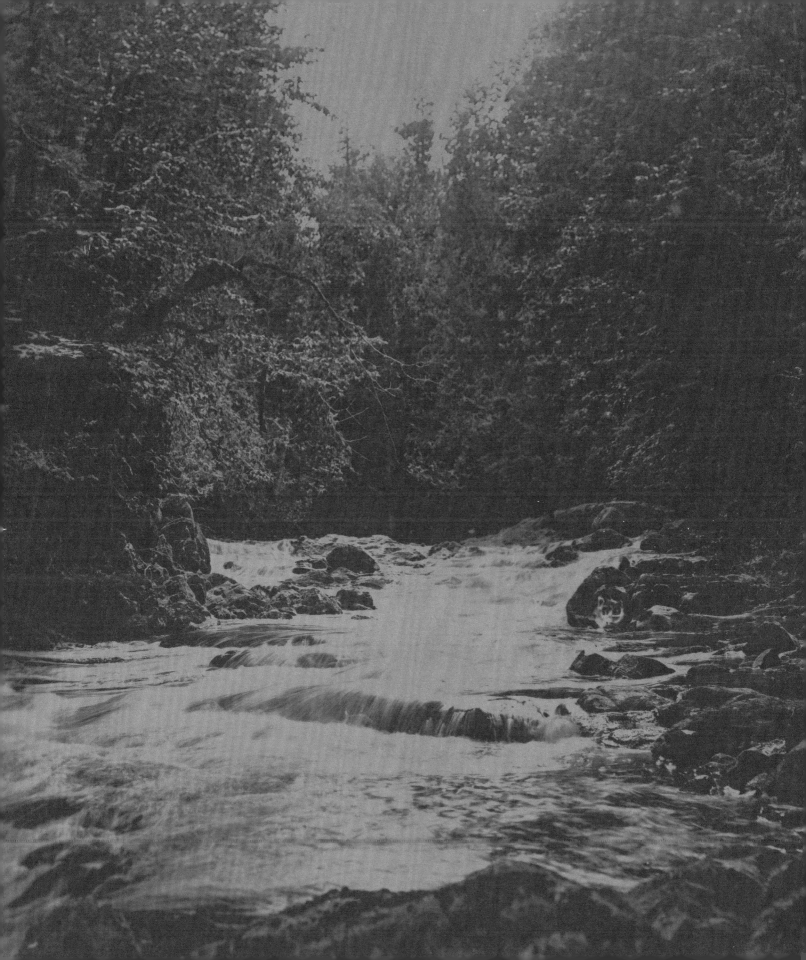

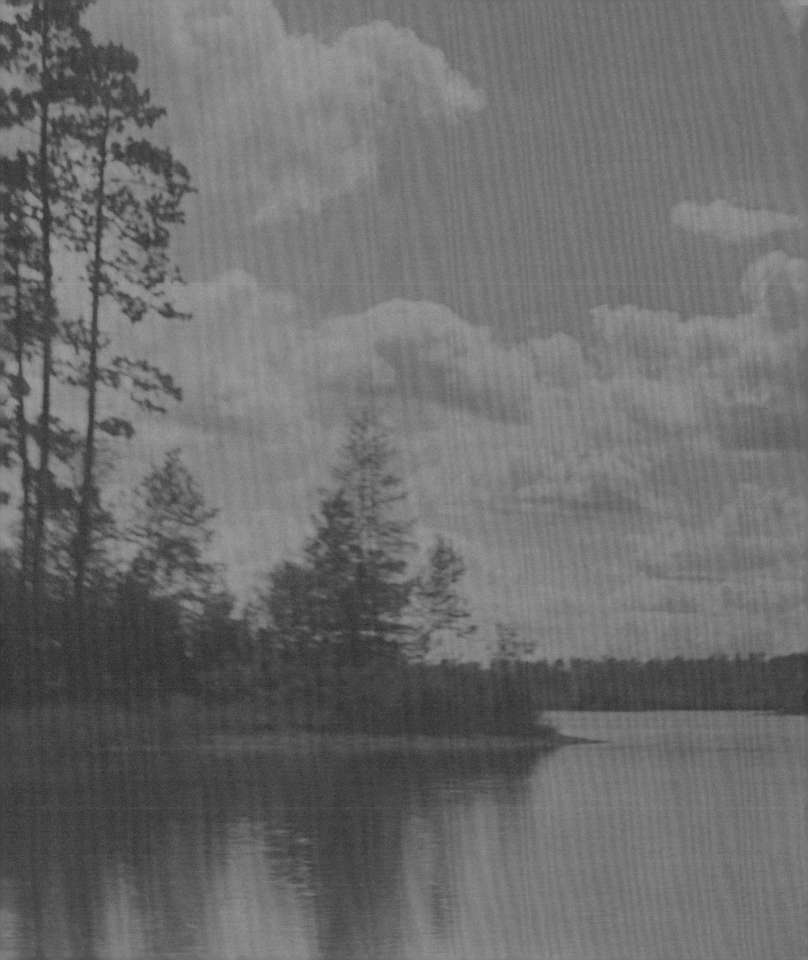

PROLOGUE

When I was a child, I often meandered into my father's library to visit with him, first walking past several rows of ceiling-high bookshelves before going through a paneled archway into his study. It was a sort of peninsula jutting out from the house into the orchard, a large, light-filled room with windows on three sides and a fireplace on the fourth. From his desk in the far corner he would look up with a welcoming smile, cap his pen, and lay aside his work.

The walls of Dad's study were nearly shingled with framed pictures. One wall held family pictures. The wall over his desk held photographs of the North Woods that he had taken on summer journeys: black-and-white studies of old Ojibwe women, amazon tents, York boats, river rapids, logjams, bateaux, lakes, Norway pines on rocky islands, and canoes with paddles flashing in the sun. A massive mahogany case behind his desk chair held various reference books, a framed Mathew Brady photograph of Abraham Lincoln, a scrimshaw walrus tusk inherited from his grandfather's seafaring days, Dad's manuscript for a book about those voyages, the Britannica, and a tin of chocolate for snacks.

Also in this mahogany case was a shelf of handsome, black, leather-bound journals. They were camping journals—a bound journal for each year's trip—written by my father and full of stories about canoe trips beginning at the turn of the twentieth century, trips he made when his sons were school-age, beginning in 1906 and continuing through 1916. Each journal, one copy for each member of the camping party, was meticulously handmade, individually typed, and bound in leather or fine cloth, often with elaborate title pages. They were full of dozens of remarkable photographs, which my father had taken with a Graflex camera, tripod, and hood that he had carried on these trips. In each journal, he had pasted black-and-white prints of these

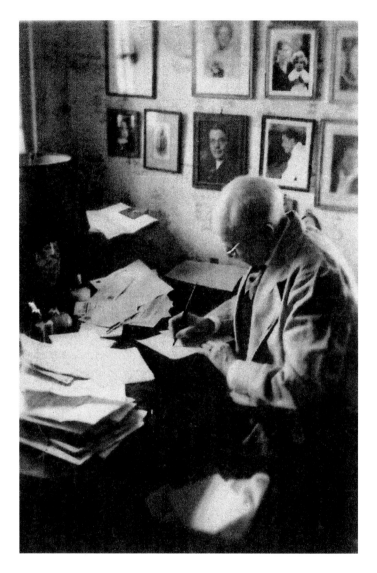

photographs alongside the typed narrative. Those pictures and his camping journals were very dear to him, and they gradually became part of the fiber of my life.

My father, as was customary for a man of his era, recited or quoted poetry at the drop of a hat, often Longfellow. I grew up on "By the shores of Gitche Gumee" and the parody verses about Hiawatha's mittens, all in Longfellow's flowing meter. Paul Bunyan stories were part of our family folklore; I still smile when I imagine Cook's helpers greasing the giant pancake griddle by skating over it on pieces of bacon used for skates. Those poems and stories introduced me, a small child, to the North Woods. Naturally, as I grew, my sense of Dad's canoe trips as well as his attraction to the area and his experiences there increased in significance. His canoe-camping trips were magical. His experiences of the natural world had happened in a bygone era, and yet they were living history in our home.

As I became older, I learned that not everyone's household was filled with the mystique of that northern wilderness and that family dinnertime conversations were not always embroidered with spontaneous bits of Longfellow, Babe the Blue Ox, or firsthand tales of exploring and adventuring in the wilderness with family and friends. By then I had also recognized that not everyone had a father as old as mine. Long after raising a family and becoming a widower, he had again fallen in love, married, and late in life had a second family of three children. I am his youngest child.

I feel very fortunate to have inherited his canoe-camping journals and photographs. With every reading of the journals I appreciate them more. Of course Dad's journals tell his story, but they also tell about life a hundred years ago. He wrote about the canoe-camping trips in an approachable and down-to-earth manner, simply reporting their daily activities, the fun, and the hardships. His canoe trips were not heroic sagas or

risk-taking high adventure. He and his friends, all experienced outdoorsmen, went out into the woods to share that world with his sons and their friends for weeks at a time. Through the journals, I have gone along and gotten to know the men and boys who made up the camping party.

Dad's journals are gems to read, and they are obviously significant historical writings. No parallel chronicle of the times and region exists. My copies of the original journals will find their final resting place in a research library, but they clearly deserve a wider audience. I wanted to publish the journals so that others could paddle the rivers and lakes with my father in early-twentieth-century America. Because I am his daughter, I not only knew Howard Greene and many of the people in his journals but also had access to both his personal papers and my memories. For the past several years, I have enjoyed researching the places he went and the people who accompanied him, tracing their descendants, learning more about early-twentieth-century Milwaukee and the North Woods, and along the way developing an even greater appreciation of it all.

With the publication of *Border Country*, my long-standing wish is granted, and you can experience Howard Greene's trips with the friends he called "the Gang." Enjoy!

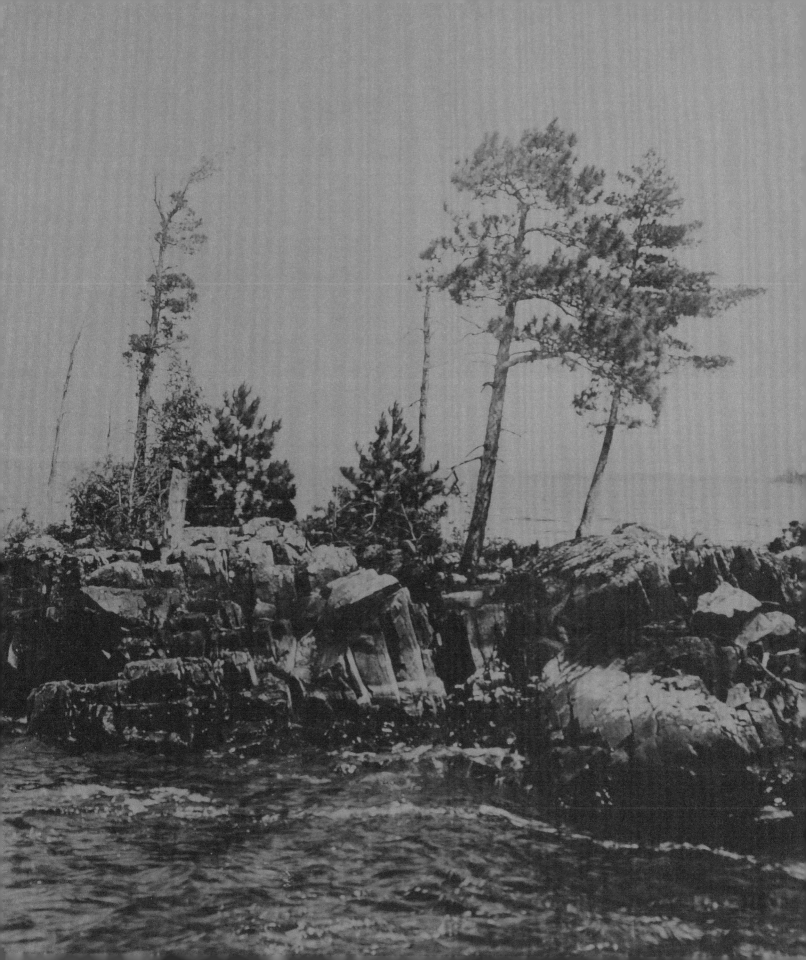

ACKNOWLEDGMENTS

Woods and waters have always spoken to me; my attachment to such landscapes has carried me through the pleasant work of exploring the world my father paddled and the more arduous tasks of organizing and writing the materials for this book.

To my daughter, Cora: I am so grateful for your sustaining interest and support.

Thanks to the family members who encouraged and actively supported this project. Elders gave time and energy to respond to my questions, even when that was difficult for them; without their memories of my father and their perspectives, my book would surely be less. My family helped guide my writing by critiquing information in question and by offering books and personal papers that could be useful.

My circle of friends has been understanding of both my focused life and my lack of time for them; many listened, some read chapter drafts, and a few gave me the precious gift of candid feedback. Thanks to my friend Tim, whose interest in photography, the northland, and the outdoors first drew him into the journals. He has been helpful throughout this process, asking good questions that sharpened my thinking, helping me with answers to others, and accompanying me to a few of the places where Dad canoed.

I appreciate my literary friends, who generously gave expertise and direction over the past several years.

The University of Minnesota Press offered tremendous enthusiasm for the project and editorial support. Heartfelt thanks to Erik Anderson and all at the Press.

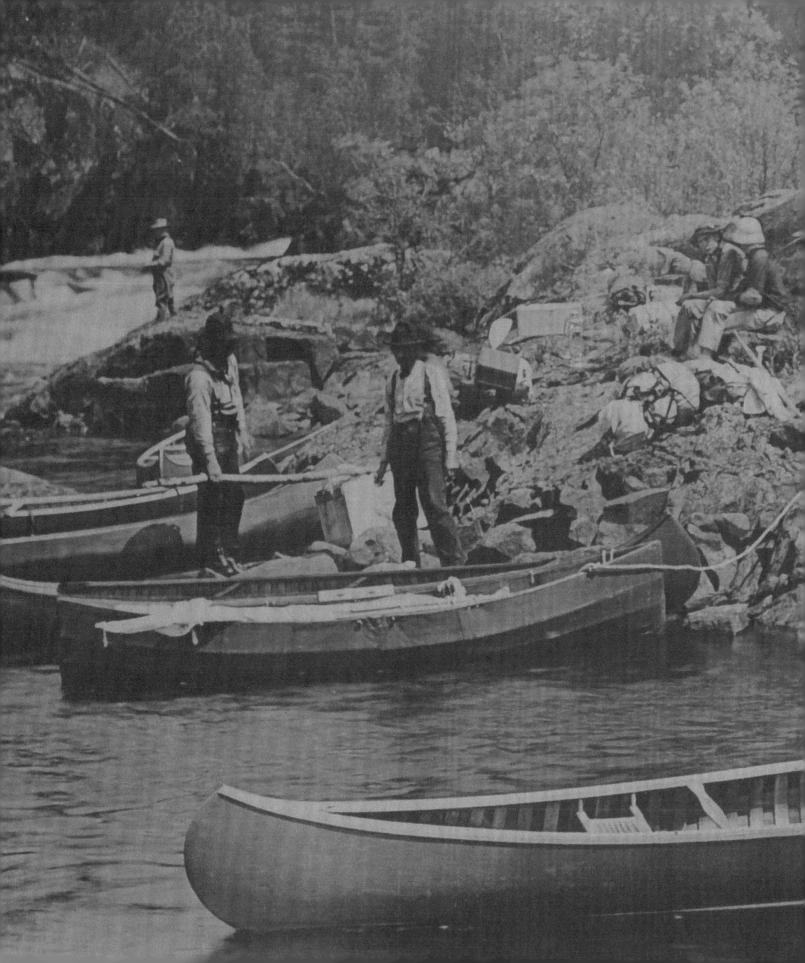

BORDER COUNTRY ⚶ A FIELD GUIDE

In the summers between 1906 and 1916, Howard Greene and a camping party composed of his friends, his young sons, and a few of their schoolmates made many canoe-camping trips into the north woods of Wisconsin, Minnesota, Michigan, and Canada—each one of three to four weeks' duration and each to a different locale or route. Over these many summers, the camping party became a close-knit group of men and boys who worked together, nurtured each other, and had some wonderful adventures. They called themselves "the Gang," and with each ensuing summer, the Gang ventured into ever more remote territory. Soon Howard Greene was called "Dad" by everyone—he was the trip leader, the very heart of the Gang and their summer trips. Dad was also the daily journal writer, a fluent chronicler of camp life and of the Gang's experiences during their long days of paddling on the rivers and lakes of the north woods.

Every day on all the camping trips, Dad wrote detailed notes. He also took hundreds of large-format photographs on the trail, illustrating his notes. Carrying his heavy Graflex camera, tripod, glass plates, and developing supplies into the woods, Dad recorded the places they traveled, the weather, their routes, how they camped, the people they met, and many humorous moments. After each summer's journey, when home in Milwaukee, he typed the narrative, developed and mounted his photographs, and inserted maps, drawings, and correspondence alongside his narrative, creating a complete leather-bound record of that summer's trip for all the members of the Gang. He would present a bound and numbered copy to them to remind them of their travels and experiences. Each of these yearly trip journals is a substantial book unto itself, containing around eighty typewritten pages and more than seventy-five large-format photographs.

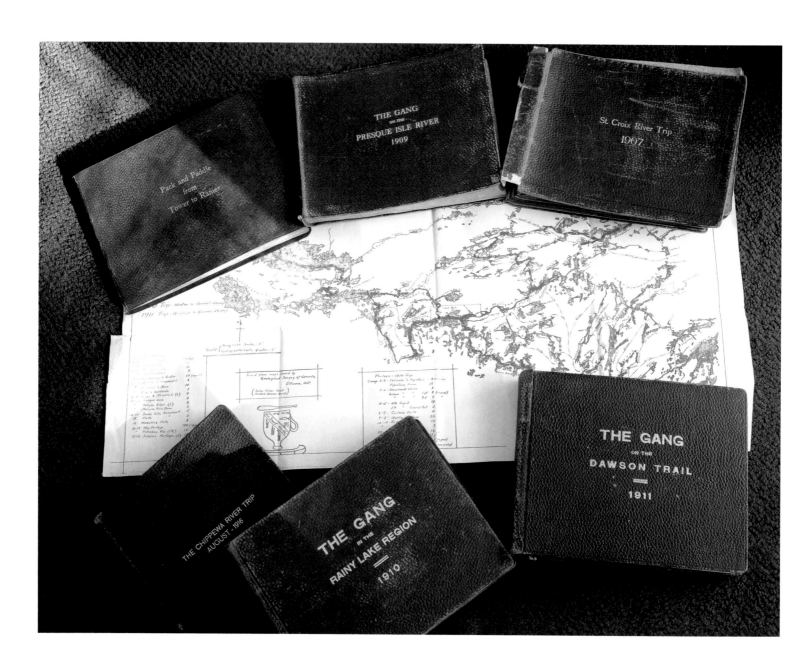

HOWARD GREENE

Howard Greene was born in Milwaukee in 1864 and grew up in the traditionally Yankee enclave there. His father, Thomas A. Greene, arrived in Milwaukee from Rhode Island in 1848 and became a successful businessman, providing well for his family and enabling Howard to attend a respected private school, the Markham Academy. In many ways, the Greenes were just another well-to-do family, enjoying a significant level of status and participating in the traditional social aspects of Milwaukee's east side. Howard went to college, returned home to work in the family pharmacy business, married, and had a family, continuing to live on the east side and participating in the life of the city.

In turn-of-the-century America, urban-dwelling men of means, well established in their business or professional lives, might take vacation trips to remote and wild areas, staying in rustic lodges or venturing out with guides to camp, fish, or hunt. They enjoyed a taste of adventure within the safety and security of a guide's arrangements and outfitting, and then returned to the city and their work feeling restored, later reminiscing with other men in their private clubs about their time out in the wilds. Howard lived in the same world with these men, but unique influences and traits led him to choose a very different route in his ventures into the wilderness.

Among these influences was his father, Thomas. A young man in the middle of the nineteenth century, he left Providence, Rhode Island, for the West, traveling on the Erie Canal on his way. A pharmacist and botanist by training, he became so interested in the plants and terrain along the canal that he wrote a small journal, cataloging the natural history of the canal.

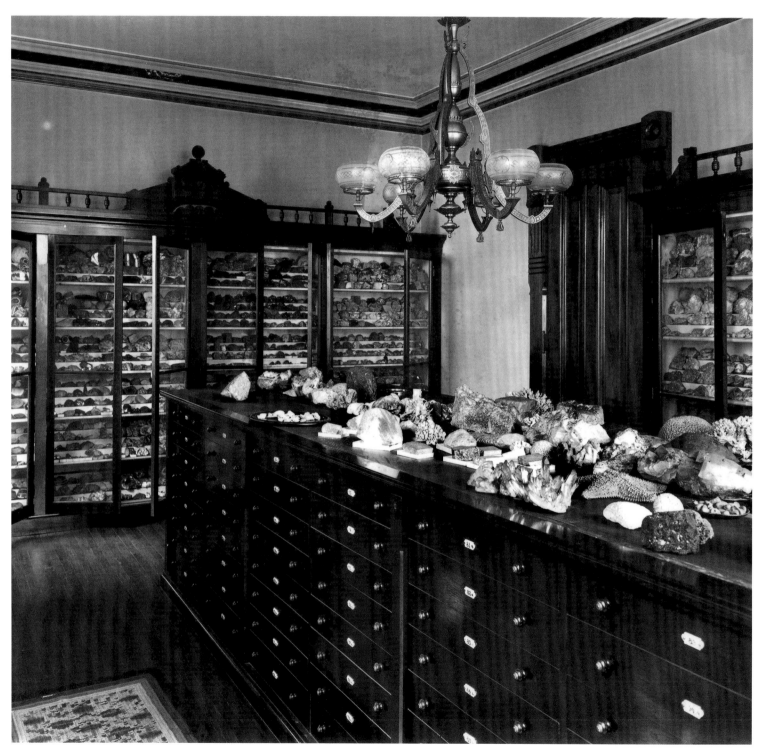

Thomas A. Greene's fossil collection. Photograph by H. H. Bennett. Image tone added. Courtesy of the Wisconsin Historical Society, WHS-111479.

Once in Milwaukee, Thomas married, established a business, and had two children. The wholesale drug business eventually flourished, allowing Thomas the leisure to again pursue his more personal scientific interests. Over time Thomas became the quintessential gentleman naturalist, establishing a significant collection of Silurian fossils[1] and collecting and trading specimens with other naturalists, including Increase Lapham.

Howard thus grew up living with a father who was a respected naturalist, in a home surrounded by his father's fossils, and having regular contact with other scientists and gentlemen collectors. This experience must have made a great impression on Howard and his sister, Kitty, as both developed a deep, lifelong appreciation of nature. The work Thomas invested in documenting and cataloging his fossil collection may also have given the Greene children an appreciation for recording scientific and historic data.

Howard went to college at the University of Wisconsin in Madison in 1881 and graduated in 1886, having earned a degree in the Modern Classical course. While at the university he studied under well-known professors, such as Edward A. Birge, professor of zoology and the "father of limnology"; William Francis Allen, professor of Latin and history; and John Bascom, president and professor of philosophy. He also knew Frederick Jackson Turner, both as a fellow student and later as an interim instructor in the history department. Turner became famous for his theory about the influence of the frontier on the development of American life and for his later book declaring the end of the frontier. During Turner's tenure as student and instructor, Howard was no doubt introduced to Turner's far-reaching ideas on the place of frontier in the American ideology. Turner's theories may have influenced Howard's choices to go out into the vanishing wilderness and away from civilization.

After graduation, Howard returned home to work in the family pharmacy business and married Louise McMynn, also a University of Wisconsin student (B.A. 1888). They had four children: Howard Thomas (born 1893), Charles (born 1896), John (born 1902), and Elizabeth (born 1906).

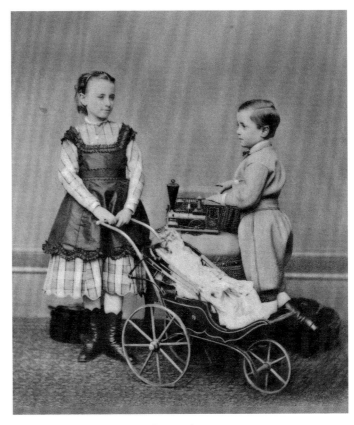

Mary Lydia "Kitty" Greene and Howard Greene, circa 1867–68.
Courtesy of the Wisconsin Historical Society, WHS-117495.

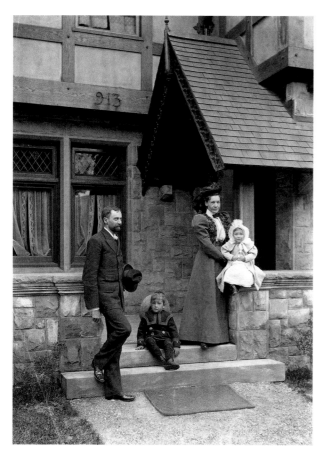

Howard and Louise Greene in front of their Milwaukee home.
Photograph by H. H. Bennett. Courtesy of the Wisconsin Historical Society, WHS-129811.

Howard's mother died in 1893, and his father in 1894, leaving Howard at age thirty solely in charge of the family business, which later became the Milwaukee Drug Company. In addition to marrying, taking the reins of the family business, and raising a young family, Howard was involved in various civic organizations, was a founding member of the University Club, and was on the University of Wisconsin Board of Visitors in 1897–98. Memberships in these civic organizations gave him friendships and intellectual pursuits that

carried over into his canoe-camping adventures with the Gang.

During the Spanish-American War, Howard served as captain and regimental adjutant with the Fourth Wisconsin Infantry Regiment (1898–99). His experience in the field with fellow soldiers and organizing a military unit may have further developed his interests and abilities, encouraging him to journey into wilderness areas and to do so capably.[2]

Howard and Louise purchased land and established a second home ("the farm") in the country at Genesee Depot, a short ride from their city home via the interurban railway to the stop at nearby Wales, Wisconsin. The farm became both a weekend and summer home for the family, and a getaway place for Howard and his male friends to escape the city and its social expectations.

In 1906, Howard was forty-two years old. His business was on solid footing, and he was established in Milwaukee as a community leader. Wearied by the constraints of Milwaukee's Edwardian society and by fifteen years of intense personal investment in the family business and in establishing his place in Milwaukee,[3] he looked to the north woods for some time away and relaxation with friends and his older sons. On August 4, 1906, they began a trip down the Wisconsin River.

On that first trip, Howard wrote daily, sending detailed letters home to his son Howard T., who had been unexpectedly hospitalized and could not join the camping party. The letters were an informal journal of the trip and formed the foundation for the journals he made in future years.

The trip on the Wisconsin was a good experience and just a taste of what was available. Howard wanted more: he wished to get his family out to experience nature and the challenges of canoeing and camping. Soon another trip was being planned for the next year, 1907, this time on the St. Croix River, with many of the same

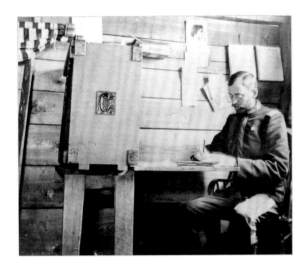

Howard Greene at a field desk in Alabama during the Spanish-American War

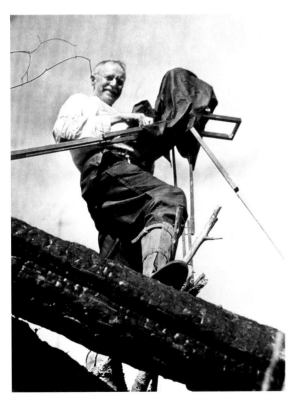

"Dad": Howard Greene

people in the camping party. The Gang was then established, and the tradition begun. Over the next ten years, Howard and the Gang made regular trips into the wilds of northern Michigan, Minnesota, Wisconsin, and Canada. His trips, which ended in 1916, at the time of the Great War, are preserved in the eight journals presented in this volume.

THE GANG

Howard Greene, or Dad, was the foremost member of the Gang. He was the leader of the trips, the journal keeper, the photographer, and the common denominator of the group.

Although the composition of the party varied slightly from year to year, a core group of adults and young men formed a tight-knit group called "The Gang." They shared challenges, days on end in the wilderness, and a lot of irreverent humor. Along the way, the boys matured and gained in camp and canoe skills, assuming more responsibility for planning and other tasks during these long outings.

Dr. Ernest Copeland (born 1859), also known as "Doc," "Cope," or the "gager," was an obstetrician practicing in Milwaukee and a lifelong friend of Howard and his family. A confirmed bachelor, he lived in rooms at the University Club and was an art collector, musician, and community leader. He was also the ultimate fisherman and hunter,[4] a very experienced outdoorsman, a natural history buff, and fellow prankster, who was often ready to instigate or join the horseplay among the younger campers.

William MacLaren (born 1877), most often called "Billy Mac," originally came to Milwaukee from Canada for a job as a department store manager. He was a widower and father to one son, who was older than the Greene sons and their friends. Billy Mac was an avid outdoorsman and supporter of the arts in Milwaukee.

Although he wasn't able to go on all the trips, his outgoing personality and enthusiasm and his easygoing manner made him a very valued member of the Gang.

William P. Marr (born 1869), referred to as "Bill" or "B.M.," was an executive with the Horlick Company. He was married and lived in Racine. Less flamboyant than Doc and some others, William is quietly present throughout the journals. Another capable outdoorsman, he was usually ready to join the group whenever a plan to go north was forming. He went on six of the eight trips.

The young boys in the Gang were all schoolmates at the Milwaukee Academy.[5] They are sometimes collectively referred to as "the brutes" in Howard's narrative. Howard T. Greene (born 1893) was Dad's oldest son. To avoid name confusion in the family and the journals, he was always called "Howard T." or "How."

Charles Greene (born 1896), Howard's second-born son, was the artist and creative free spirit in the group, a prankster and tease. He was always called Carl, instead of Charles.

John Greene (born 1902) was the youngest of the boys in the family. John (known as Jack) was not old enough to go on the earlier trips and went on three later trips with the Gang.

Clay Judson (born 1892) became a student at the Milwaukee Academy when his father, Major William V. Judson, was assigned work on the Milwaukee harbor by the U.S. Army Corps of Engineers. Clay was a close friend of Howard T. at school, where they were both in the school's mandolin club.

Other young members of the Gang included Fred Hanson and Charles Ilsley. Charles (born 1893) was called "Piffy" by the Gang, and Fred (born 1893) was called "Hannie" or "Heinie" during the trips.

Di, Carl's Airedale dog, was a favorite member of the Gang. She was even assigned her own sleeping spot in the tenting arrangements.

Two other young men went on later trips, when the Gang's original younger members were no longer available for extended summer journeys. William Allis Norris (called "B") and Mackey Wells were students at the Milwaukee Academy. William was a friend of Carl, and Mackey was the grandson of H. H. Button, Thomas A. Greene's business partner.

Beyond the core group, the Gang always hired a cook and one or two "wood butchers" to accompany them on the trip—men who were off work after the winter in a logging camp. These hired men were not

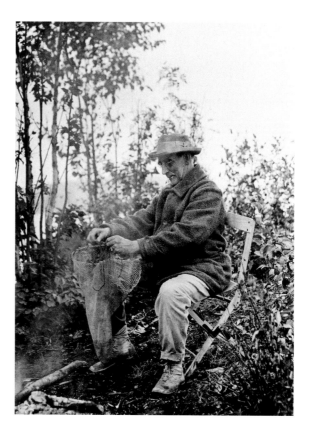

"Doc": Dr. Ernest Copland

"Jack": John Greene

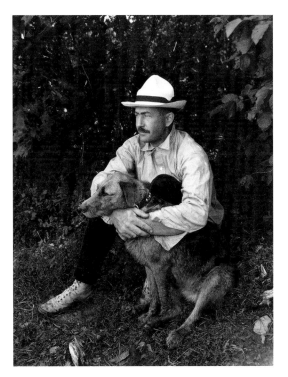

"Bill": William P. Marr (with Di)

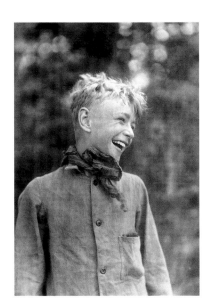

"Carl": Charles Greene

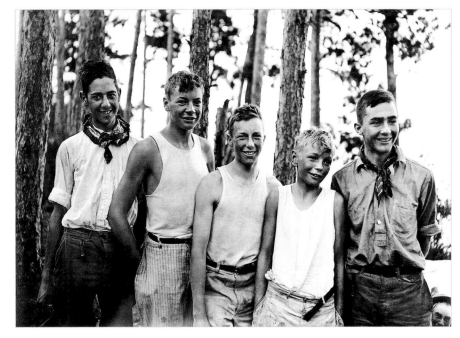

FROM LEFT: *"Hannie" (Fred Hanson), Howard T. Greene,*
"Piffy" (Charles Ilsley), Carl Greene, and Clay Judson

"How": Howard T. Greene

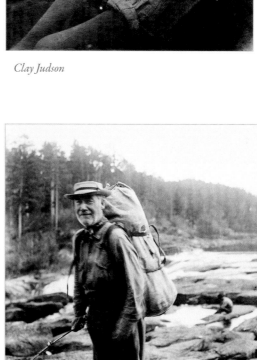

Clay Judson

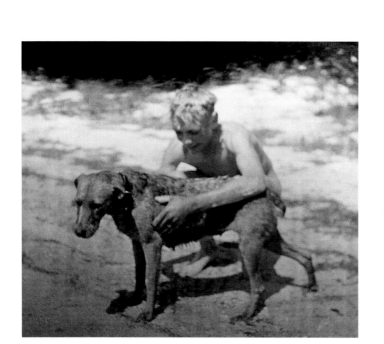

Di (with Carl)

"Billy Mac":
William MacLaren

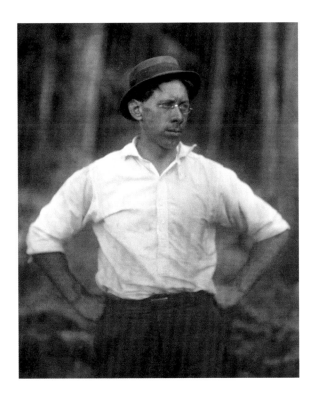

Wood butchers from the Gang's trip on the Dawson Trail, 1911.

guides; often they knew less about the region than their employers and sometimes had limited experience with canoes and maps. The Gang did all provisioning, planning, equipment procurement, and arrangements for the trips. The hired men's responsibilities were to cook, set up camp, and help while under way on the trips.

Typical of the era, the camp help tented separately from Dad and the Gang. Some of these men, especially those who joined them for more than one summer, blended into the camping party more successfully, while others stayed more to themselves. Dad and the Gang enjoyed their company. Dad often made photographic portraits of them in camp and included them in his daily narrative on all the trips.

THE ERA AND THE NORTH WOODS

Between the turn of the twentieth century and the Great War, the North Woods was going through significant changes, reflective of the nation and the economy. The exploitation of forest resources had slowed in pace and scope, as the lumber companies moved westward for new supplies of timber. Gifford Pinchot and Theodore Roosevelt (both contemporaries of Howard Greene) began working closely together around 1905 to further develop the forest reserves and U.S. Forest Service. Newly developed conservation laws set limits on industry, travel, and other uses of the North Woods.

The Gang encountered some of these changes during their trips. They became acquainted with the

Ontario Forest Rangers and their work in what is now known as the Quetico. On one of their last trips in what was later named the Boundary Waters Canoe Area Wilderness, Dad and the Gang found some portage routes and campsites clearly marked by the young Minnesota Forest Service. These fledgling conservation efforts were helpful but not yet strong enough to deter industry's use of dams for water power, which resulted in the significant rises in lake levels that the Gang saw during their last trip in northern Minnesota.

Shortly after the turn of the century, Frederick Jackson Turner had declared that the frontier had ended. Dad and the Gang were looking for, and often finding, frontiers—frontiers that were rapidly vanishing. Appreciation of wilderness areas and conservation efforts were just beginning when they were canoeing in the North Woods. Regional writers such as Calvin Rutstrum, Grace Lee Nute, and Sigurd Olson were young children, approximately the ages of the Greene sons. Conservationist and writer Aldo Leopold and artist Francis Lee Jaques, twenty years younger than Dad and his friends, were not yet established in their work with nature.

Significant changes in transportation were also just beginning to take hold. Travel throughout the nation was still primarily on horseback, by team and wagon, by steamship, on foot, or by rail. When someone spoke of driving, the reference was to driving a horse rather than an automobile. Automobiles were coming into common use in major cities but had not yet replaced horsepowered and other means of transportation.

During their trips the Gang traveled in much the same way as voyageurs, trappers, and prospectors had for many, many years. They paddled the rivers and lakes in wood and canvas canoes (or an occasional bark canoe), and they often included a wanigan or bateau for carrying heavier supplies and provisions. There were no guidebooks yet, and maps were often incomplete or inadequate.[6]

The Gang also observed use of the North Woods by Natives. Although some villages and settlements were being moved into reserves during the years of the Gang's trips, for the most part Native Americans and First Nations pursued traditional ways of life on the rivers and lakes along the Canadian border.[7] Howard's photographs and narratives about Ojibwe and other nations' villages provide a down-to-earth record of how they lived, with little of the staging often used by pioneering photographers such as Edward Curtis or H. H. Bennett.

Dad made these journeys shortly after 1900, with a wish to experience a world vastly different from his life in Milwaukee. The world he explored offered new adventures in new landscapes, including opportunities to meet and interact with Ojibwe people and their culture. But as readers will see in the journals that follow, he sometimes used language such as *squaw* and *buck* that today we find derogatory and offensive.

For a white man of nineteenth-century upbringing, Dad was remarkably open to learning about Native American culture. He was raised in a Quaker household, in a home that strongly supported the value of all people. His father, Thomas A. Greene, had written a school essay in 1843 about European settlers' mistreatment of Native Americans that included this line: "The injustice and wickedness with which they have been treated remain a stain on the pages of history. The rigors with which they have been mistreated will scarcely find a parallel in history." This essay was written at a time when such a belief was a minority view.

Ernest Oberholtzer, a 1907 Harvard graduate who lived in the Rainy Lake region for more than sixty

years and would become a leader in the protection of wilderness, was passionate about the Ojibwe people and culture. In his journals, he also refers to Indians and "squaws" in a matter-of-fact tone similar to the language used by Dad and the Gang.

My hope is that Dad's use of derogatory, antiquated language does not diminish for readers their enjoyment of his adventures, including his interest in how Native Americans lived, as well as his desire to meet them in ways that they deemed acceptable. These journals and their recording of history remain vital and important to us all now and are presented as a historical record exactly as they were originally written. A small number of annotations mark instances in the journals where disrespectful language or actions occur.

GOING INTO THE WOODS

Gentlemen of the early twentieth century described their outings as "Going into the Woods." These trips required heavy canvas tents, woolen clothes, bedrolls, candle lanterns, and huge amounts of food and supplies to make all meals during the three- to four-week trips. The equipment and provisions list at the end of the Dawson Trail journal is a good indicator of what the men carried and how they lived while in the woods. A man's "Outfit" was more similar to those of the 1800s than ones that would follow the First World War.

Sleeping bags had been invented, but a bedroll was still the first choice for experienced outdoorsmen. Dad's bedroll was made of his army blankets from the Spanish-American War, a pair of army-gray Hudson's Bay blankets with charcoal stripes at each end.[8] The men did not carry ground pads, instead using balsam, pine, or moss for cushioning when available.

Mosquito nets were not yet standard items on tents. "Mosquito bar" cloth was available, and the Gang was known to add a mosquito bar curtain to a tent. Tents did not have sewn-in floors; without a floor, tents offered minimal protection from mosquitos, flies, and punkies. On a clear and breezy night, a man might be more comfortable sleeping "bivouac style." Because the heavy, bulky tents and poles required purchase in soil, which wasn't available on solid rock shorelines, and because the men were frequently tired from a long day's paddle, they often slept bivouac style in their bedrolls, using the folded tent as cushion and ground cover. Tents did offer rain protection and warmth on cold nights, and a little linseed oil painted on the canvas made the tent more watertight.

The Gang's style of camping was a far cry from even mid-twentieth-century equipment. Could they ever have imagined Therm-a-Rest ground pads, Gore-Tex clothing, nylon pop-up tents, Kevlar, fleece, and freeze-dried gourmet meals?

•

Border Country: The Northwoods Canoe Journals of Howard Greene, 1906–1916 presents eight journals exactly as my father wrote them, taken from the original copies I own. They record the Gang's trips on the Wisconsin River, St. Croix River, Pigeon River, Presque Isle River, and Chippewa River, and three trips into the areas now known as the Quetico and the Boundary Waters Canoe Area Wilderness. Each of the canoe-camping journals is truly a personality in its own right.

Although Dad gave a copy of each trip's journal to the campers, many have disappeared over the intervening hundred years. At this writing, the only known copies of original journals not held by the Greene family are in Chicago's Newberry Library; in the Oberholtzer Foundation's Mallard Island Library in Rainy Lake, Minnesota; and in the possession of Clay Judson's heirs. My copies of Dad's journals, on which this book is based, will be donated to the Wisconsin Historical Society Archives.

I have written a brief introduction to each journal, followed by the original journal narrative. The introduction and additional background information in the notes are provided by me and are clearly demarcated from the journal's original narrative.

Unless otherwise noted, all photographs are my father's and chosen from among the photographs he pasted into the journals. The images here were scanned from his original prints; most of the glass-plate and film negatives were, unfortunately, lost in a house fire many years ago.

NOTES

1 Milwaukee-Downer College Bulletin, series 7, number 2 (1925): 7.

2 *Wisconsin Alumni Magazine,* June 1900. Many of Howard Greene's contacts around the state of Wisconsin were friends of his from the Spanish-American War. He often called on them as resources for his trip planning.

3 Howard Greene's letters, further verified by his journals' accounts of camping in the woods.

4 An article on the demise of the passenger pigeon listed Dr. Copeland as having killed a passenger pigeon in Michigan in 1895. His intent was not indicated.

5 The Milwaukee Academy was founded as Markham Academy (Dad's alma mater) in 1861 as an engineering and classical school for boys and young men in preparation for college. Dad received his diploma from Markham Academy in 1882. The school's name changed to the Milwaukee Academy in 1887 after Mr. Markham's death.

6 A listing of maps in the 1910 Abercrombie and Fitch catalog offered maps only for areas east of the Allegheny Mountains.

7 In keeping with the language of the era, the term *Indian* or *Indians* was used by Howard throughout his journals. Attitudes and beliefs about the Native population were becoming more positive but still reflected much of Theodore Roosevelt's historic, and often negative, views.

8 Dad's army blankets from the Spanish-American War were donated to the Wisconsin Veterans' Museum after decades of use by his children for camp, campouts, and summer vacations.

PUBLISHER'S NOTE ON LANGUAGE

Throughout the course of their many trips between 1906 and 1916, Howard Greene and his companions visited several Native villages. While there, the group often bartered for and purchased goods, as well as took many photographs. In writing about these moments in the journals, some of the language used by Greene in the early twentieth century to describe Native people they met is offensive and inappropriate. Knowledge and appreciation of indigenous peoples and their cultures by other ethnicities have advanced significantly in the one hundred years since Greene's trips. We have reprinted the original texts of the journals exactly as they were written to preserve the authenticity of these historical documents.

THE JOURNALS

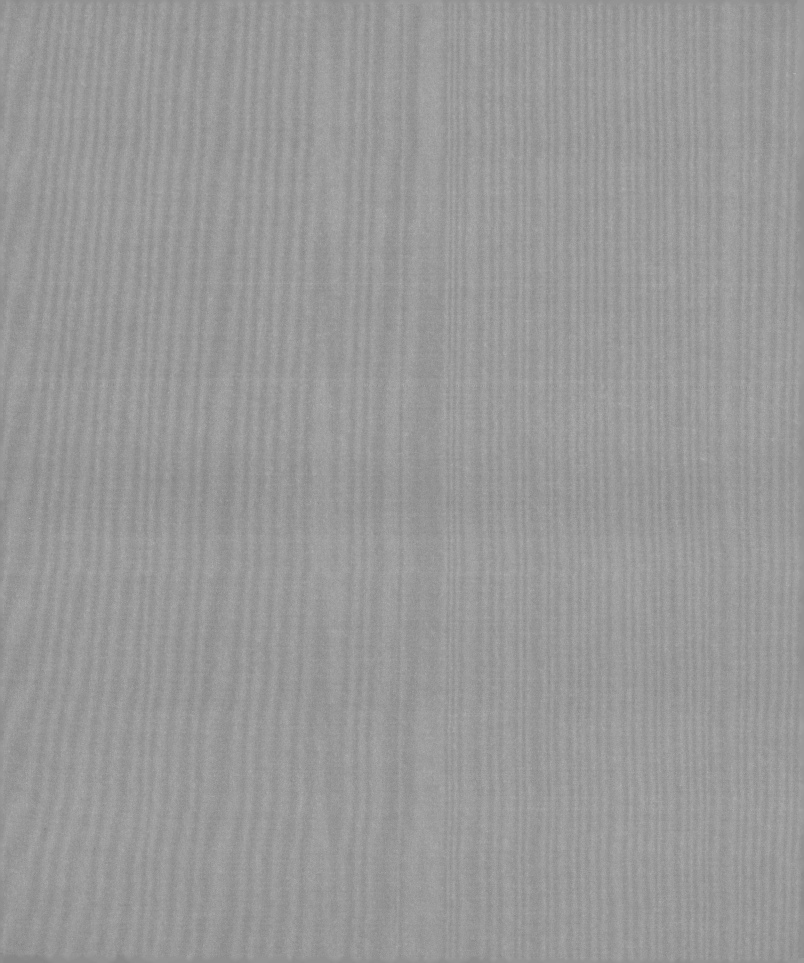

THE WISCONSIN RIVER

1906

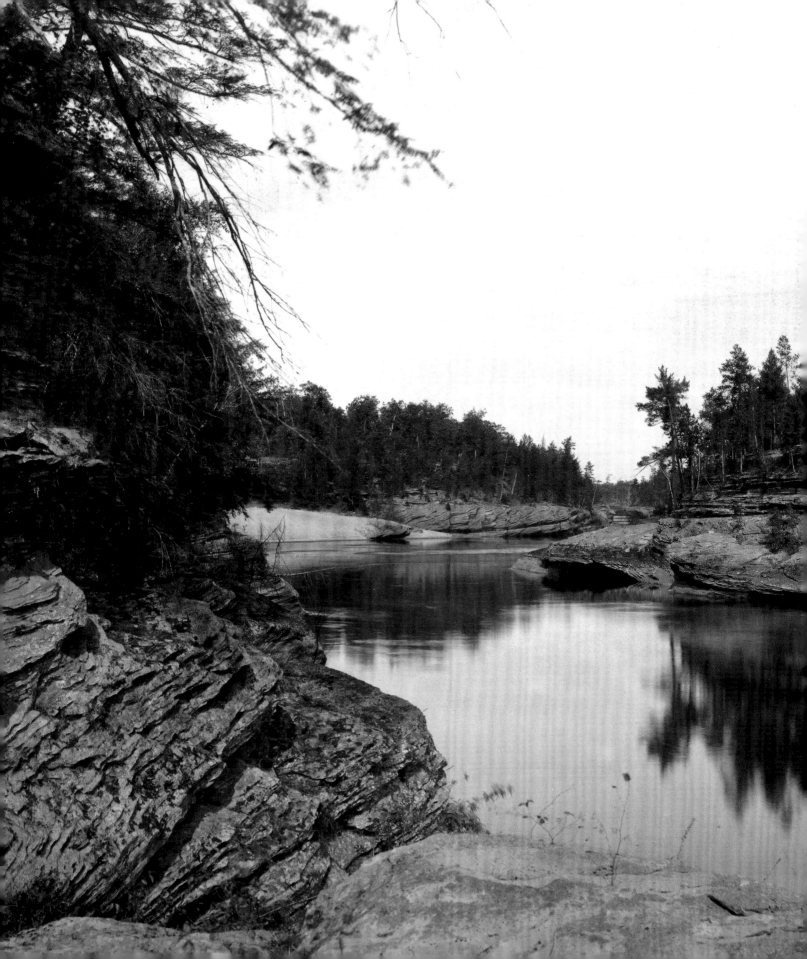

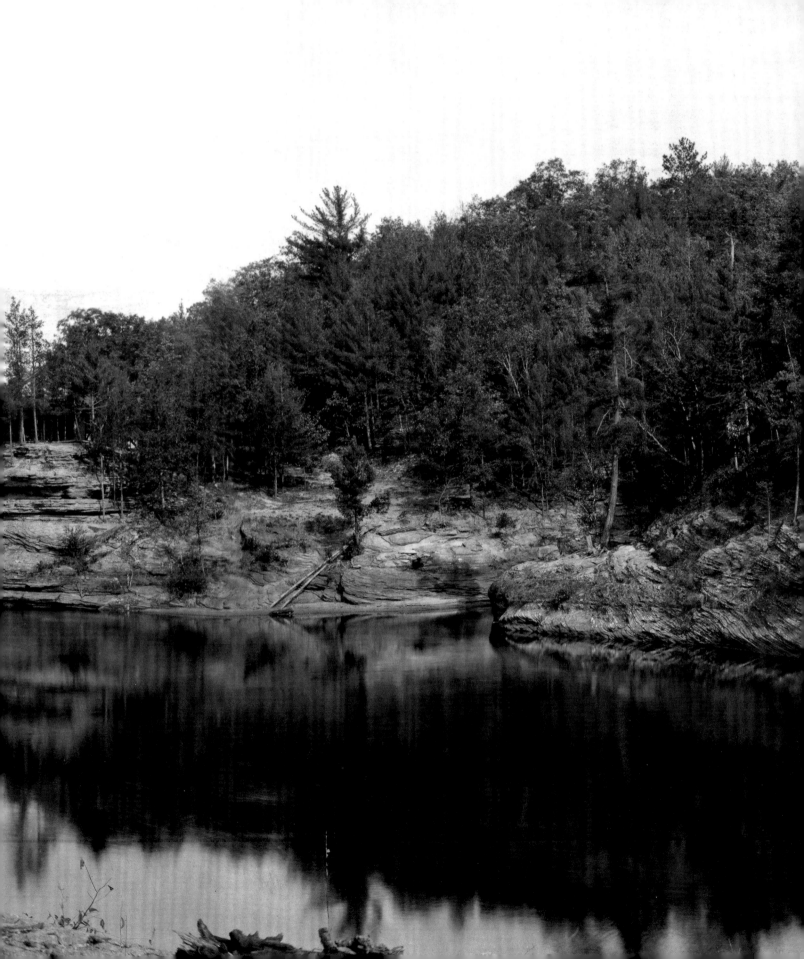

In reading Dad's journals it became clear that the men wanted to go a little beyond civilization or to be ahead of some newly developing change to the landscape. One such change was plans for the Wisconsin River. About 1906, a group of men who were prominent in the Wisconsin River valley began to meet together with goals of regulating the dams on the river, creating reservoirs, making "as uniform a flow as practicable," and ending "seven decades of anarchic ad hoc tinkering with the Wisconsin River" (as reported in the history of the Wisconsin Valley Improvement Company).[1] In his letters from the Wisconsin River, Dad described the scene in 1906:

4 miles below Wausau, Aug. 31 '06

My dear Howard:—

. . . We have commenced to make remarks about dams. The lumbermen got special laws passed by the legislature authorizing them to build and maintain booms and dams. When booms are put in they are obliged to leave an open space for the passage of boats, but they hog the whole thing and in consequence we are obliged to stand on the loose booms and pull our boats over as best we can, and then find our way blocked by another boom or worse yet, a pocket of logs or drift wood . . .[2]

Opposition arose from some resort owners. In 1907 the *Milwaukee Sentinel* published a list of Milwaukee residents who owned property near Eagle River and opposed a dam there. Around Milwaukee and at the University Club, such topics would have been discussed over dinner and social gatherings.

At the same time, a plan was under way to dam the Wisconsin River at Kilbourn City.[3] Dad's sister, Kitty Upham, had a summer home and land along the Wisconsin River; Dad would have been aware of the impact that the proposed dam would have on the natural beauty of the dells at Kilbourn. Canoeing the Wisconsin River before it became more developed and regulated would have appealed to Dad and his friends.

In August 1907, Dad, Bill Marr, Doc Copeland, Howard T., and Clay Judson were to embark on a trip down the Wisconsin River, from near Lac Vieux Desert to Kilbourn. Howard T.'s sudden illness delayed his start, but the group left, assuming he could join them en route. To keep his son abreast of their daily lives, Dad penned letters to him in Milwaukee. Howard T. was never able to join the group, so Dad continued writing, in hopes that Howard T. could at least feel as if he had been a part of the trip. Those letters eventually formed a trip journal.

Since this was the first trip the group had made, working relationships were new; the reader has the opportunity to see the various campers develop canoe and camp skills, and to see the men and boys begin to form the tight-knit group later called the Gang. At the beginning of the Wisconsin River trip, Clay was simply a school chum of Howard T., and neither Dad nor the other men knew him well. Clay had counted on his school friend being along on the trip and was suddenly thrust into the company of a group of men he hardly knew. To their credit, they became comfortable with and appreciative of each other; this bond was sustained and enriched throughout the subsequent trips into the North Woods together.

Railway mail service was remarkable during this era; letters went quickly to and from the camp and Mil-

waukee. Likewise, passengers could easily get around Wisconsin, catching a train in a remote area and connecting to a more regular route. Because of the efficient railway mail service and Dad's wish to keep Howard T. fully informed, there is an immediacy about the letters, a conversational quality that at times would rival more modern communication.[4]

In this chapter Dad's letters have been selectively edited. Many were exclusively about family news that would not interest an outside reader. Dad's photographs from this trip were not mounted within the journals as in later trip journals and were lost over the intervening years. A handful of images from other sources, such as the H. H. Bennett collection, are included and noted.

[M.G.P.]

NOTES

1 Michael J. Goc, *Stewards of the Wisconsin: Wisconsin Valley Improvement Company*, New Past Press, 1993.

2 At the turn of the twentieth century, dams were built anywhere and everywhere. There was no regulation. Lumber companies and other industries built dams wherever they wished. The gates used varied from primitive spillways to more sophisticated mechanisms, such as Tainter gates, invented in the 1880s.

3 The name Kilbourn City was changed to the Wisconsin Dells in 1931.

4 See the glossary for information on railway terms, service, and travel circa 1910.

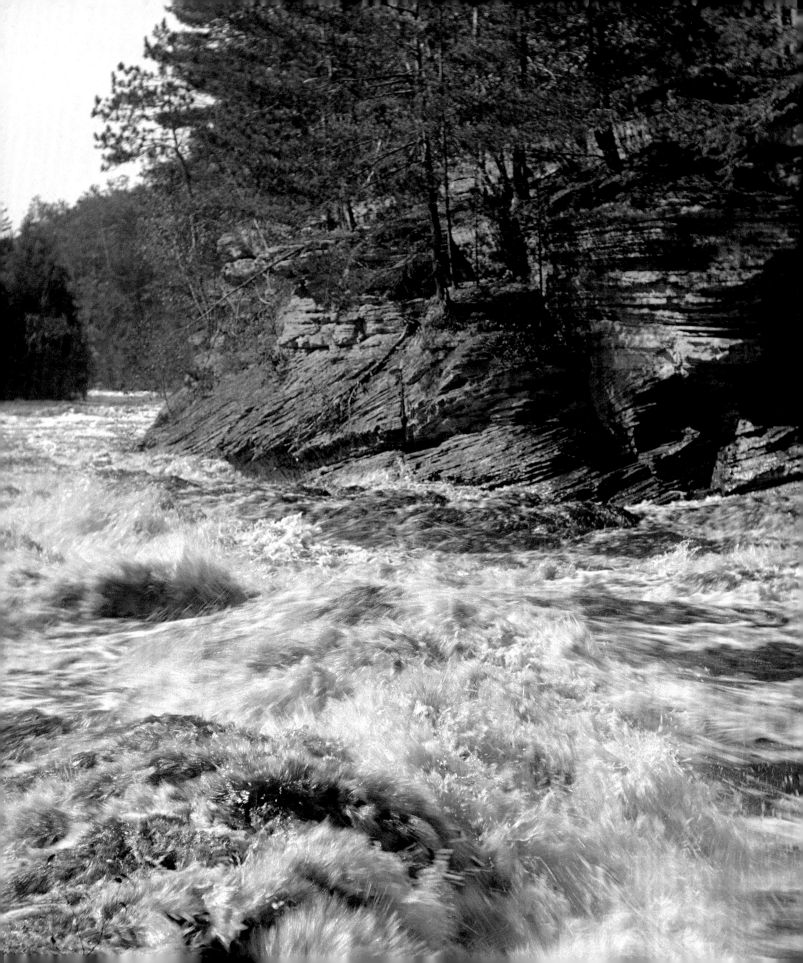

THE WISCONSIN RIVER
1906

In the early part of the summer of 1906 we made up a party to consist of

Dr. Copeland Mr. Marr

Howard T. Greene Carl Greene Clay Judson

and

Dad

to explore the headwaters of the Wisconsin River.

A man was engaged to help about our camp work and all our equipment had been forwarded to Conover, Wisconsin, when Howard was taken ill. His sickness rapidly developed into blood poisoning and before we left an operation had been made. It was expected that he would recover promptly and that he would join the party in a week.

These letters were intended to be merely a chronicle of our first week and when we found that Howard could not join then, they were continued so as to form a story of our daily doings.

FACING
The Wisconsin River.
Photograph by H. H. Bennett. Image tone added.
Courtesy of the Wisconsin Historical Society, WHS-126044.

SELECTED LETTERS

In Camp near
Rummeles, Aug. 4, '06

My dear Howard:—

We reached Conover early this morning. I had been so busy the past few days that I had not written Mr. Urquhart exactly when and how we would come and so he was not on hand. We cracked a box of rolls that had come by express and then Clay and I started off with three rolls and a piece of chocolate for each of us to walk to Rummeles, which is nothing more nor less than a siding like Knights Siding near Ashland. At Rummeles we hit a trail to the Portage Creek near which I knew Urquhart had made Camp. I located him so easily that Clay thought I had been here before and knew every trail and town. We were so hungry that we smelled breakfast before we found the camp.

Urquhart got a settler, Johnson by name, to hitch up a team and they went to Conover together to get Mr. Marr (whom everybody now calls, "Bill"), Carl and the baggage. Clay and I unpacked provisions, put some things in order and took a brand new canoe, that Urquhart bought for me, out on its trial trip. It is a peach of a canoe.

The Conover end of the expedition returned about half past ten and we had more packing and unpacking to do. We had sandwiches for lunch, put the camp in order and then all hands took a swim. The water is cool, but nice and gave us a good appetite for a corned beef hash, rolls and prunes at 4:30 dinner.

Mr. Marr and Carl are fishing up the river,—Clay and Urquhart are looking up bedding. Urquhart is a dandy. He is full of fun and nonsense all day long and his run of talk is very entertaining.

Tomorrow we shall commence to make expeditions to Conover and elsewhere.

The present plan is to break camp Thursday and go to Eagle River, where we shall make a camp that we can reach easily when you come. I'll write Cope to-day giving full particulars.

SUNDAY MORNING. Last night we spent fighting mosquitos and rain. The flies got under our tent early and kept us going all night. Urquhart says that the first night he was here three mosquitos got him by the legs, and tried to pull him out of his little tent. He shot at them with his revolver and they did not care, but when he began to swing an axe they left him and spent the rest of the night pulling at the walls of his tent.

All your camp stuff is in your canvas pack in the closet of my room at the University Club.[1] Your Khaki coat is at my office on the desk. Please bring your own tooth brush for I have had to give to Carl the one I bought for you.

Clay says, "Give Howard my love and tell him to come as soon as he can." Clay is a nice fellow about camp and everyone likes him. He will eat anything so far but, of course, he hasn't had one of Gager's puddings.

It is raining to-day and the Camp is nearly soaked, but everyone is happy.

[1] Members of the (all-male) University Club could maintain rooms at the club; some were the sole residences for men, such as Doc Copeland, a bachelor. Others were maintained by men for stays during times when their families were out of town at a summer cottage or on an extended trip away. The men would enjoy the comforts of home as well as the companionship of friends at dinners at the club. Women were strictly not allowed in the residence area.

Urquhart goes to Conover, where I hope he will get news of you. Capt. Howland was to wire me yesterday, but the last of us left Conover before we had his telegram.[2]

Affectionately,
Dad

I shaved yesterday and I am
wearing only a mustache now.

———∞∞∞———

In Camp near the city of Eagle River, Wis.
August 11, '06

My dear Howard:—

We were all so disappointed at not seeing you this morning. Not hearing any later news yesterday I had made up my mind you would be here with Cope, and I could hardly believe him when he told me you had been left behind. I hope your foot will soon be in shape so you can join us.

Now I will tell you the story of our trip since my last letter to you. I find I have forgotten exactly when I wrote you, but I believe I told you how Clay and I tried to reach Lac Vieux Desert by river. That was on Monday. Tuesday Mr. Marr, Clay and I went to Conover on foot. It was a tramp of about 12 miles for we went down to the Wisconsin River to mark a place where we could land for our mail when going down stream. There was nothing of any particular interest in that day but we had a good time.

On Wednesday I suggested to Clay that we go to Conover by canoe, then walk to Twin Lake, where Dr. Burgess is staying, get a fish and come back by canoe

again.[3] I had no idea how far it was to Conover by river, but I thought we could make it quick. It took us two hours and a half to reach our blazed tree near Conover, then we had a walk to the station of about three quarters of a mile and to the town. There is a telephone line to Sargent's, where Dr. Burgess is staying so I called him up and asked him to lunch with us the next day, as we came down river. It took us about four and a half hours to get back by canoe, and we were both pretty tired. Clay is gritty and hung to the job like a man.

Thursday we were late in getting under way. The first boats left our camp at 9:30. Clay took my canoe and I had Dr. Copeland's and we waited for Urquhart until eleven. Dr. Burgess did not come to Conover so we lunched and moved on until six when we stopped at a sandy bank and made camp. The place we stopped was an old chopping and looked like the country about Mowatts camp near Ashland.[4] It was so late that we did not set up a tent and everyone bunked under my canvas roll, which we pitched as a lean-to. We put mosquito net over our faces and even then the mosquitoes and flies kept us awake with their racket. We were up at five and under way a little after seven.

Let me stop for a minute to tell you that Clay never saw wild deer and when I showed him deer track and signs he was quite excited. Drifting down a little in advance of Clay, I saw a fawn drinking. Then I put Clay in advance and we saw seven deer, one, a fawn, crossed the river in front of us. I wish you could have heard Clay about his delight and excitement.

[2] Captain Howland, a fellow Spanish-American War veteran, was a slightly younger man employed as an assistant at Dad's firm, the Milwaukee Drug Company.

[3] Dr. Burgess, a well-known physician in Milwaukee, summered up north and was probably a friend of Doc Copeland as well as Dad.

[4] Neville Mowatt of Ashland, Wisconsin, was a color sergeant in Howard Greene's Spanish-American War unit, the Fourth Wisconsin Infantry Regiment, in 1898.

The first day we found a pine tree had fallen across the river, completely blocking our passage. "Urquie" chopped out a piece and we went through the opening. I think I have a good picture of it.

Now I'll resume the story of our trip, commencing with our early start yesterday. We paddled until eleven thirty and stopped for lunch exactly two miles from Eagle River by road, but about twelve by river.

We had a big swim, ate our lunch and were off. We left the Wisconsin River and paddled up the Eagle River to a dam where we camped at four o'clock. Carl and I went to town, a mile and a quarter away and came back with supplies and mail. The drinking water is poor and the spring we found was muddy. Clay does not drink coffee or tea and so he was very thirsty as well as being tired. In the evening Mr. Marr and I took him to town and brought back appolinaris[5] to drink until the spring clears. I made arrangements for a livery man to meet you and Cope this morning and bring you up to camp.

Cope came this morning and after he had pulled Carl out of his blankets, he put on his old clothes and went fishing. He has been at it ever since. Just now he and Mr. Marr are up river in a canoe.

In a straight line Eagle River and our first camp are about 14 miles apart. By river, I think we traveled nearly seventy miles. It has been awfully hard work and I am glad of a quiet day in camp to rest up and get up some change in grub.

We have had no fishing so far, but they say the fishing right here is good. I wish we would get fish for I am tired of salt junk.

You would laugh to see Carl. He is skinned down to overalls and undershirt and most of the time is running about in just plain overalls. His back is burned to a dull mahogany color.

I have not made many pictures so far, but I think that next week I shall send some plates to Milwaukee to be developed and printed.[6]

I am so glad Clay is with us. He takes camp life nicely, everyone likes him and he is thoroughly game. This morning he has been doing his washing and now is darning his socks. That reminds me that I ripped the seat out of my Khaki trousers last night and I must do some extensive darning before I do much else for I have to depend too much upon a frail pair of underdrawers.

Please tell Mother what I have written you, for I cannot write many letters.

> Affectionately,
> Dad

I believe I forgot to mention that I received your letter yesterday. I hope to hear from you again before long.

<center>⸎</center>

> Camp near Eagle River
> Sunday Aug. 12 '06

My dear Howard:

I wrote so long a letter yesterday that there is very little material left for one to-day.

Our trip down river was made so rapidly that we did not even try to catch fish and in consequence we had little to eat, and what we had was cooked in the tiresome style of the lumberjack cook. I began to take a hand at cooking in the morning and by last night we were living quite differently. The guide don't quite like our style as

[5] Apollinaris: a German mineral water called the "Queen of Table Waters" popular from 1895 through the early twentieth century.

[6] "Plates" can refer to glass-plate negatives or film-plate negatives during this period. Most of Dad's images from this time were on glass plates, but since the terms were interchangeable, he could be talking about negatives from a small pocket film camera or a large-format one, such as his Graflex.

well as his own, but he appreciates the greater variety. We are planning a big dinner for to-day, but what it will all be I cannot tell you for I am waiting for Cope to come back to camp and help out.

Cope fished all day and got only one fish. There are fish enough, but he wanted minnows for bait. Yesterday afternoon Mr. Marr and the boys went by canoe to Eagle River for supplies and brought back a piece of mosquito bar and this morning Cope & Bill made a net and started off after minnows. The boys and I stayed in Camp. I wanted to polish up our ovens so they would bake better and do some little jobs about camp, such as getting stale bread cut up for a pudding the Doctor is going to make. Clay and Carl have been playing on the mandolin. Clay is reading now and Carl is playing about camp. I can hear Carl talking now and I know Doctor and Mr. Marr have come back. Yes, and they have minnows too.—Cope is getting ready to cook.

Cope says he is going to cut off his mustache and if he does I will make a picture of him and one of myself so you will know what sort of men to look for up here.

Tell Mother I got Carl partly clean this morning, but he is dirtier than ever now.

I washed all my dirty clothes yesterday afternoon, darned holes in my breeches and drawers and have felt so respectable ever since that I don't want to wash. Clay is by all odds the cleanest member of the party,—he is so naturally and somehow does not seem to acquire dirt,—possibly because he has not cooked over the pine knot fire.

I'll quit now to help Cope with the cooking, and will continue this later if I have time.

Dinner—We had steak (brought by Copie) boiled potatoes and bread pudding. After that we were all doggy except Cope who caught a bass and then the camp went fish crazy except your Dad who took the chance to lie down and be quiet dog until the rest came back. Then I took Clay down river trolling and as we returned Carl and the Indian started up stream for fish. Clay and I had a swim. It is a great place. We can swim right into the current of the dam and then an eddy carries around and into it again unless we swim ashore. Now I'm smoking my pipe and writing you.

Cope shaved clean this afternoon. Tell Mother he makes me think of the transformation of Wagner.

There is another thing I wish you would tell Mother and that is, that if she will pick out the oldest pair of Khaki riding trousers in my closet at Genesee and will kindly supply buttons, etc. and thereafter will send them to me her kindness will be appreciated. If I have one more accident I can't come home and I don't dare wash these. I think she can send them as male matter.

I think we shall stay here about a week. It suits us and we can get fresh truck any time from the town. Mr. Marr will have to return on Saturday or Sunday and we must be near some railroad station at that time. We shall be a lazy worthless crowd while we are here for we are too comfortably situated.

Please tell Mother that I am not writing her because I am sending all the news to you. Give my love to her and to Jack.

Affectionately,
Dad.

Aug. 13, '06.

Cope made a bread pudding. Clay ate some of it and Clay is still rolled in his blankets. It was a mean trick to play on him but no one thought to warn him of the pudding.

Dad.

Camp near Eagle River
Tuesday, August 14, '06.

My dear Howard:—

Clay, Carl and I went to Eagle River this morning where I mailed you a short letter and I received your letter and two from Mother. We bought sundry supplies for our river trip and came back by canoe. While there I bought a pair of moccasins and mailed them to you. You may want them while your foot is mending, and if not you will find them nice to wear about the house at Genesee during the winter.

Well, we have had a big swim this afternoon,—one of the best I ever had and I want to tell you about it. We, means Clay and I principally and secondarily "Urquie" & Carl. We kept Carl well into shore for reasons that will appear later. To tell the story, I shall have to draw a little map showing the river which flows from the North and is dammed just above our camp.

The arrows show the current of the river. Where the water passes through the shutes of the dam it goes through with a rush and striking the bank below our camp, eddys back and rushes down again through the fall below the dam. Clay and I put up a scheme after lunch to take a canoe through the quiet water, get into the eddy and then bring it right into the shute of the dam and go down through the big current and see whether we could get in far enough to be tipped over. We took in some water and had some fun, then we ran the canoe ashore at the place marked, "XX" and swam out into the rush of water, and

we went through with a rush, often under water, and were carried by the eddy to shallow water where we would rest and start again. It took several attempts until I could swim into the main shute. Finally Clay climbed onto the dam and dived in. Carl says, "That swimming brought you back to the joy feels of boyhood, galloping, romping, jumping, Gee." That about expresses it.

Clay and I finally concluded we would quit and took the canoe to paddle back to our landing shown on the map. I asked Clay if he would take one more try at the dam and run in so far we would spill. Clay is a strong swimmer and is game to a finish. So we started back and ran in fast and broadside on and took in more water than before and we were thrown right back by the eddy, first from one side and then from the other. We went the rounds I believe seven times and then we caught our boat and emptied it out and our swim was over. I had to laugh at Clay when we were going round and round. I asked him if he would try it again. "Sure,—You're a gay old sport, Mr. Greene." Clay is so very careful how he speaks and never forgets himself. He is just finding out that the crowd is really all right.

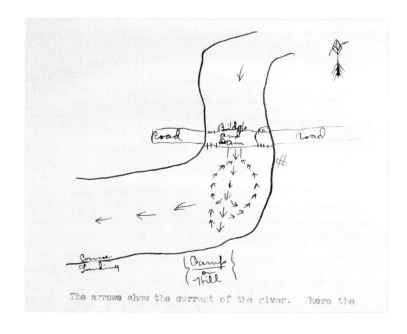

The arrows show the current of the river. There the

I'll be sorry to break camp to-morrow, but no one seems able to catch fish. Cope and Mr. Marr are fishing all day long and luck or no luck they never seem tired of it.

While your letter and Mother's letters tell me a great deal about you and your foot, I cannot make out whether you are afraid of being a nuisance at camp or whether you are going to be too peg legged to come up. Cope tells me that the Captain can bring you up when you are ready so you can travel in company, which will make it possible for you to come when your foot is in shape. Now, as to your being with us. Of course, you would miss the swimming and the tramping, but you could travel in a canoe like the rest of us, and it would be no bother to take care of you in camp. Someone is in camp practically all the time and you would find "Urquie" good company. For my own part I don't care much what I do as long as I am outdoors and I would as lief stay in camp with you as throw flies at fish that are not hungry. We have plenty of canoes and it would be no trouble to carry you from camp to camp. You talk it over with Mother and the Doctor, but don't think you would be a bother to anyone here. We all miss you greatly and would be glad to have you with us.

I have sent some plates to Milwaukee to be developed and printed and likely I shall send another dozen to-morrow. The prints will be delivered at my office and you can ask the Captain to show them to you before he mails them to me.

As we move on down river I cannot write you for there will be no place to mail letters. You cannot expect anything from me until next Monday or Tuesday, when you will get letters sent from Rhinelander on Saturday or Sunday.

Give my love to Mother. I am sending all the letters to you as you will have them first hand.

I go to Eagle River early to-morrow morning for mail and to mail this.

I hope you can join us before very long.

> Affectionately,
> Dad

In Camp below Rhinelander
August 19, 1906.

My dear Louise:—

I received a letter from you yesterday that was written on Wednesday after your return to the farm. On Wednesday morning, just before leaving Eagle River, I mailed Howard a letter which was addressed to him at Lakeside Hospital. I presume it was forwarded to him. When this reaches you Howard may be here, but I'll write of our doings which will interest Howard if he is still with you.

The map shows two rapids on the Wisconsin River between Eagle River and Rhinelander,—the "Otter Rapids" and "Rainbow Rapids." The Otter Rapids was said to be quite considerable and we were warned of rocks in the middle of Rainbow and were cautioned to look both over before running. When we came to Otter we started to make a survey, but found nothing alarming in the first half mile and so we took to boats and started to go part way down and land to make further observation. We landed below the whole rapid and waited for the rest of the boats to go through. The terror of the rapids may be real at very high water, but I found it tame.

I find the maps I made have been very useful. With a map and compass in my lap I have been able to get our location very accurately, and have marked our lunching places and camps and twice I have been able to locate more accurately by finding government survey lines. . . .

About four miles below is Hat Rapids, where there is a dam and a short portage. There are a good many gasoline launches at Rhinelander and they run up and down river on the smooth water.[7] Rhinelander is quite a place and there seems to be a good deal of trade going on in addition to heavy shipping from the saw mills and paper mills.

Bill Marr left us last night. He left his baggage at Rhinelander and followed us down for a last supper. He was pretty blue all day and was as sorry to leave us as were to lose him.

We all hope very much that Howard can join us Tuesday morning. We ought to have a good trip down and I think we shall finally go below Merrill.

Our next post office address is Tomahawk.

I hope some trousers are coming my way. My Khaki ones are only good for dish clothes and patches. My corduroys are torn and dirty, and the white ducks sat down beside a frying pan to play they were game.

⸺

My photo outfit is not very satisfactory. It gets damp and smells and sticks.

We had a nice swim Thursday night. After we had made camp all hands went into the drink. We came on a big high sand bank and we could slide from the top of the bank down the sand and land in a deep current. We couldn't swim up stream, so we had to walk up and play steamboat coming down.

Some of us go to town this afternoon and will mail this. To-morrow I'll go up again for mail and a telegram from you. If Howard comes Tuesday I'll take him to

[7] "Gasoline launches" were noteworthy at the time of this trip; outboard and gasoline motors powering boats were uncommon.

Camp and then we start down stream for Hat Rapids. We shall camp below the rapid and go on from rapid to rapid for camp. These rapids don't amount to much below here, at least we haven't heard anything of them.

I believe if you have my letters to Howard and this they are nearly a journal of our trip.

Everyone is playing mumblety peg except your

Affectionate scrivener,
Howard.

August 21, 1909

⸺

In camp below Rhinelander
Tuesday, August 21, 1906.

My dear Howard:—

When I reached Rhinelander on Saturday I tried to arrange for you to join us here if you wanted to do so, and last evening I received the Captain's telegram saying you could not come. I am sorry you cannot come, but if your foot improves and you want to see us eat grub like lumber jacks, you can come up at any time and have your blanket and stuff put in a bag for you.

There has been just one incident at this camp that would be worth the telling, but it is beyond the capacity of my fountain pen to tell the story as it really happened. It was so funny that I haven't quit laughing and yet I realize it might have been less humorous. We came down river late in the afternoon of Saturday and made camp on a little bit of even ground perhaps four feet above the river. On each side of us is a little gully so there is good drainage in case of rain. Weeds surround us on three sides and from the tent door to the river is only a good jump. Well, on Sunday night a thunder storm came up. I heard "Urquie" get up and fix our guy ropes. I realized that the tent was leaking some, but I didn't care for I was sleepy and a little water more or less would not hurt any of us. The trouble continued

and I told Urquie I would help him with the guy ropes if necessary, when turning I found that my blankets were in water. Well, as long as the blankets were not too wet I could keep warm and I did not mind that. Cope was getting wet and Clay, to avoid the edge of the tent, rolled from high ground into my wallow. Urquie got out with an axe and trenched the tent, but still the water came. Then the wind blew some more and Cope and I finally had to roll out of our sleeping bags and hold up the corner tent poles to keep our house on its feet.

At night Carl strips to a shirt and rolls into his sleeping bag. Carl slept through most of it, but the noise made him turn and he got into my ditch and woke up with a cold wet bottom. By the flashes of lightning I could see Cope holding up one tent corner and in the middle of the tent stood Carl in shirt tail firmly bracing up the 12 foot centre pole to keep it up right. The storm passed, or rather let me say that the worst of the storm was soon over. Everyone had a wet bed but the packs were still in reasonably good shape. Carl was a little stunned by the suddenness of it all and was cold. I had been so sleepy that I could not wake up until I had to get up and was half dressed and all wet. Cope was about in the same condition and for the same reasons, while Clay was laughing and apparently having the best time he had ever had. He is game all right. Urquie was all wet and all good nature.

The first thing we had to do was to recover our stuff. My coat had been doing pillow duty and was nearly dry and my hat had filled and floated to the tent door. My white ducks (they were once white, you know), were wet as a baby's diaper, but the watch was still ticking in the pool below my bed. My shoes were only half full of water, so I called them dry and found that they fitted the earth. Only the seat of my corduroy trousers was wet, and so I got into my complement of clothes, let my glasses drip dry and I was ready to do something.

Next, we had to look after the boys. We got a paulin and spread it in a less wet spot, piled the extra tent on that and then I opened your bed bag and put both boys into it, spread your blanket over them and covered the mixture with your poncho. I used your extra clothes on them as far as they would go, and in a minute both boys were asleep in our dripping tent. We had been wakened about midnight, it was 12:10 when my watch was rescued and at 2:10 we had them in bed.

The boys were so dry that they made us dry and the rest of us took a drink and bethought ourselves of the comforts of coffee and dry clothes. Dry wood was there none. The provision box had been left in the row boat, the boat had filled and the box was pretty near in the river. The sewerage system of Rhinelander, I may here remark, empties into this river and we superstitiously regard the stream as unclean at this point and avoid doing much washing. I took my long knife and pulled the tent poles for shavings for kindling. Then I read my last letters from Mother and Aunt Kitty, told the last stories of Jack and sacrificed the letters to a fire and dry clothes.

It took a long time to get that fire started and while we were at it Urquie and I saw one of the funniest sights I ever saw. There was a flash of lightning and it blazed on the axe he was using. A trail of fire ran along the ground between us, twisted snake fashion and neither of us felt a shock.

We had coffee and wet bread and said we were happy and contented. Another storm came up and we covered our fire, laid down on our wet blankets,—all hands slept except your Dad who loves to lie awake and think of the coffee he drank at dinner. At five the mosquito fleet assembled and attacked the boys and drove them out of doors. I made one of my celebrated corned beef, potato and onion hashes, baked a loaf of wet bread and shortly after six we were fed, had lines stretched and

our bedding and clothes distributed over this quarter section[8] for drying. We were dry by nightfall and need more sun to-day to dry the dampness of last night.

Yesterday morning Urquie and I went to Rhinelander to buy flour, sugar, salt, etc. for we abandoned the stuff that lay in the river. We are still as fastidious as city people usually are.

There is no fishing worth mentioning and I have added another man, whom we call "Dell," so that we can travel easier. I think we shall travel faster hereafter and we may reach a good deal south of Merrill before we return.

Cope asks to be remembered to all and wants me to say to Jack that if he finds Jack's wife up here he will send her home.[9]

We are going up to Rhinelander to mail this, and this afternoon we drop below Hat Rapids and go into camp. Our next address will be Tomahawk, and the next Merrill.

Love to you all. Affectionately,
 Dad.

I am going to send home some things
which can be put away for me until my
return. I shall do this probably at Tomahawk.

———— ✎ ————

Written on the historic spot on the Wisconsin
River, between Hat Rapids and Tomahawk, where
Major Howard Greene dried his wet trousers
and ate lunch on August 23, 1906,—it is a rock.

My dear Howard:—

Continuing the story of our trip. We left our old camp near Rhinelander yesterday, (Tuesday afternoon),

[8] A quarter section equals 160 acres.

[9] As Jack was five years old at the time of this trip, this is apparently an in-joke of some kind.

and paddled down to Hat Rapids, where some enterprising people dammed the stream to make a water power and to create a portage for us. We ran our canoes gently into the soft sand at the dam side sighted the dam and vicinity and dammed the whole thing. Carl saw big generators and became acquainted with everyone, while Cope and I lugged boats and baggage over the dam and talked about it. Then we ran down river through almost continuous rapids until about six o'clock, when we made camp, had a most delicious supper of salt pork, bread and potatoes and went to bed immediately to avoid thunder storms. Before Urquie could get up his tent we were hard at work trying to keep dry. For three successive nights we have had thunder storms and drying stuff has been our chief occupation. We started down stream this morning under cloudy skies and thundering rain and we shall camp as early as we can so as to dry out before night, by fire or by sunshine, as the case may be.

We started right into rapids this morning and after a half mile run we had to get out to look the situation over. With our heavily laden canoes we could not run safely, and so we made a long line fast to Cope's boat and let her down from rock to rock along the shore. It worked very well and we loaded up again and floated off.

Then the most remarkable thing happened. Cope caught a muskallonge weighing, I should think, 25 lbs. Carl shot it and we came up to see Musky landed. Pieces of him are even now in the frying pan. Musky was 37¾ inches long from tip to tip, and in her stomach we found a sucker, partially digested, that was over a foot long.

Then came another rapid, a crooked one, which we dared not attempt, and we again used our ropes to float the canvas down stream. The rocks here were slimy and slippery, and we had to be in water up to our knees much of the time. Cope's canoe floated through nicely

and then I thought I would let Clay into the game, so he, Cope and I took my canoe through. We just reached the end and I was wading to shore, when I slipped and bumped my seat on a rock in the riverbed. I scratched my shins, wet my tobacco, but I did not wet the bandana handkerchief I wear on my neck. The shirts are dry now, but the breeches won't dry so quickly and as there is another rapid in front of us I can't afford to change until we come to a place for an all night camp.

The river is beautiful. The banks here are heavily wooded and are high and at points like this they are quite rocky. We are due at Tomahawk to-night or to-morrow and we shall push right along for Merrill, where letters may be sent.

These film packs I took with me are fine in dry weather, but I have those which won't work and none that will work. If these don't dry out, I'll send in for more. Just at present I am using the little kodak I bought for you.

I received the package of clothes from Mother yesterday. For those much pants much thanks.

I may write later.

Affectionately,
Dad.

8/23 '06

Arrived at Tomahawk at 4:30 and go on to Merrill to-morrow.

⸳⸺⸳

In Camp below Tomahawk, Wis.
August 23, '06.

My dear Howard:—

I just mailed a letter to you and sent a telegram to Capt. Howland, or, to speak more literally, we stopped our fleet in midriver as we passed through Tomahawk and sent "Urquie" for supplies and mail.

I wrote you from our nooning place yesterday. The rapids below were interesting and then we gave our attention to thunder storms, which seemed inclined to meet us from any direction. We ran more rapids and then made camp and waited for our commissary boats to catch up.

The rain came on and the boys and Cope undressed to meet it. The boys went into the river, Cope looked on and I donned my rubber cape and sat down to rest, for I was somewhat jarred by the seat I made for myself in the morning, while lowering the boats through the rapids. The baggage was all piled up on the bank and covered with our rubber blankets, so we were happy. After about a half hour the supplies came up and the tent was soon pitched and the supper started. We ate muskellonge for supper, we ate more this noon and there is about enough for a fourth meal in the grub-box.

Our tent, which we borrowed of the Peninsular Box & Lumber Company has proved a pretty poor one. It has been wet and moved when wet until it leaks badly. We did not care much as it made but little difference to any of us, but the thunderstorms of Sunday, Monday, Tuesday and Wednesday nights have wet our stuff until we have concluded to paint it with linseed oil and be dry. We would have done it anyway if you had joined but, as I said, we could stand the leaks and did not care. There were three thunder storms last night and perhaps more. I remember covering my ear with a rubber blanket three times to keep the water out. Someway I have an aversion to water in my ears when camping and Carl feels the same way.

This morning we dried out our stuff, and it was really a matter of necessity this time, for all our tobacco was too damp to burn. This morning we put it all together and dried it out in a frying pan and now it is bully and we are happy again. We left camp at 12:30 and paddled nine miles to Tomahawk, waited for the grub boats and came down to this place where we are now at 6:40 P.M., awaiting "Urquie" and his boat.

This afternoon Cope caught another muskellonge, 38" long and nearly as heavy as the one he landed yesterday. Clay and I came up with the automatic and Clay put two bullets into him before he could be landed. The first bullet glanced under the skin and I gave Clay the bullet afterward.

The trip this afternoon has been very beautiful. At first we struck rapids and the slow deep river back of a dam. We haven't seen the dam yet but it is only a half a mile or so below us.

Our plan is to go towards Merrill to-morrow and we are due there Saturday or Sunday. My maps cover the country to that point and I believe our next town is Mosinee.

This will be enough for to-night. If I can do so, I'll have this mailed to-morrow.

Love to you all,

Affectionately,
Dad.

It is blowing up for a cold night.

———✠———

Approaching Merrill on
Sunday August 26, 1906.

My dear Howard:

I believe I wrote you last on Friday and mailed the letter at Tomahawk.

The Bradleys of Milwaukee have large land and lumber interests at Tomahawk and Mr. Robert B. Tweedy and Spencer Ilsley of Milwaukee are living at Tomahawk and are interested in the Bradley affairs.[10]

As Carl and I turned onto the main street at Tomahawk, the first fellow I saw was Mr. Ilsley. He was very cordial and nice and let his business take care of itself, while he showed me from store to store where I had

[10] "interested in the Bradley affairs": managing the Bradleys' Tomahawk venture.

errands to do or supplies to buy. Then we went to the Bradley offices, where Mr. Tweedy told me that when he saw me come in he thought I was a river pig looking for a job. A river pig, I may explain, is a certain style of lumber jack who makes a business of rafting logs down river, cleaning up after the drive. Mr. Ilsley got out his gasoline launch and took us down to the camp. Mr. Ilsley's family were away and he insisted that we all (guides not included) go to his house, which is on an island in mid river. We had a beautiful lunch or more properly speaking, a dinner, and we ate so much that it was with extreme difficulty that we broke camp late in the afternoon.

The funniest part of our stay at Mr. Ilsley's was the behavior of his two dogs, a dachshund and French poodle. They were accustomed to the smell of nice people, but hardly had we touched shore when the trouble began. None of us could get near them. They growled and snapped and would not come near us. Just before lunch the poodle came to the porch where we were sitting, and started to come up the steps, but he turned, sniffed Cope and ran away, barking furiously.

Cope and Carl did not unfold their napkins at table.

In the afternoon Mr. Tweedy took us to the Bradley saw mill. It is not a big one, (they cut only 100,000 to 130,000 feet a day), but in some ways it is very up-to-date. Clay had never seen a saw mill in operation and it was very interesting to him.

After lunch we had a present of fresh native meat. We had it roasted to-day and it tastes like venison. We are to have it as cold meat for supper to-night.

Back to camp we came on a gasoline launch. We broke camp at about 4 and started down river. Just below us was a big dam and paper mill and we had to carry our stuff over. We dropped down stream and camped in heavy hemlock timber at the end of an island.

Saturday broke heavy and misty, but we started down stream to look for sunshine. We found it and

then a thunder storm blew up and left us. We had rapids almost all day long. Finally we came to one which we looked over and concluded could be run. Cope and Carl were lowering their canoe on the other side, while Clay and I lightened ours of our heavy baggage and you ought to have seen us go into the riot of fresh drink. The whole show at the Dells is like the Sunday school superintendent's own class as compared with it. We did not take in very much water, and we had our fun.

I do not think I would have run that rapid with anyone but Clay. We had looked it over, picked our course and he was dead anxious to try it. I knew he would not lose his head and that he is a strong swimmer and so we did it. Clay paddles stern and I bow paddle. Just after we entered the rapid we missed our course a little and I never looked around for I knew he would right us if he could, and Urquie told me afterwards that Clay was paddling for all there was in it.

I believe I told you that we picked up a helper at Rhinelander whom we called "Dell." He is the most incompetent man I ever saw, in the woods, and we dropped him to-day. He really was fired at the Grandmother Rapids, (the one I just spoke of), but he did not know it.

Let me finish the story of Grandmother Rapids. After our run Urquie thought he would take the grub boat through. I said, "Good-bye" to him and told him to wave his spade to me if he got in trouble. I was carrying my camera and stuff down the portage when I heard Dell call that Urquie had swamped. I dropped my stuff and ran for our canoe. Dell was there first, but wouldn't venture out even below the fall. Clay made him unload our canoe, so that when I came up I could jump into a clear boat, and start into the eddy below the fall. We saw Urquie strike shore and knowing he was all right we started down stream after our flotsam. We picked up floating matches, tobacco and such stuff and then paddled up to the big box where are kept our flour and those things, and towed it ashore. Such a mess you never saw. The Pettijohns, flour, raisins, gingersnaps and prunes were having a bathing party. We cleaned it up on the river bank and then turned back to see how Urquie was getting on. The boat filled in the rapid, then the chest floated off and finally Urquie had to abandon his boat and swim ashore. The boat floated and he swam her in, shook himself off, and seeing that Clay and I were doing things he dumped out the water and using his spade for a paddle, crossed the eddy and explained his feeling to Dell.

I told Clay that the make-up of the party had changed at Grandmother's from four men and two boys to four men, an idiot, and a boy. Clay's sense and good judgment in getting cleared and ready undoubtedly saved some of our grub, and had Urquie been in trouble his coolness might have saved a good deal more. Anyone in sober senses ought to have seen things as Clay saw them, but the point is that he bossed the man and did things. Clay can't see anything remarkable in it.

Well down stream we went and a thunder storm over-took us. Clay and I unloaded, covered our stuff and lay down under the upturned canoe until the storm had passed.

Grandfather Falls or rapids is two miles long and has a fall of 95 feet. We had to portage that because it is said that no one ever ran it in a boat and told the story. Our party came together at the head of that rapid, where there is an old time tavern now utilized as a boarding house for a gang that is building a big power dam.

When we got together the rain met us and stayed with us. We were all wet through when we made camp at the end of the portage and we bedded down as comfortably as we could and put in a good night in the rain.

We painted the top of our tent while at Tomahawk and we like it better than the sieve top it had before.

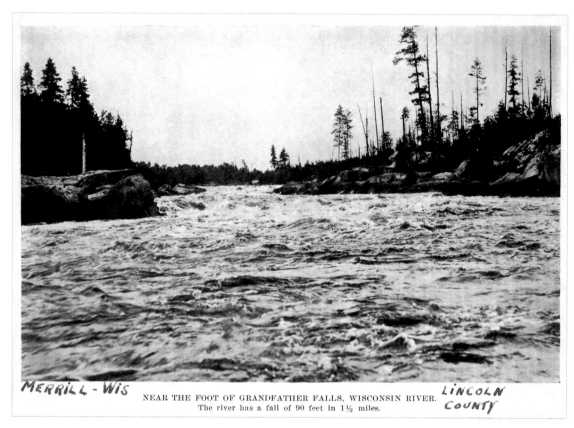

NEAR THE FOOT OF GRANDFATHER FALLS, WISCONSIN RIVER.
The river has a fall of 90 feet in 1½ miles.

MERRILL - WIS

LINCOLN COUNTY

Wisconsin River near Grandfather Falls, circa 1900. Courtesy of the Wisconsin Historical Society, WHS-108893.

This morning we built up big fires and dried our blankets and belongings, then we fired Dell and broke camp. We have made the run to Merrill including one portage over a dam and are now encamped in a bit of pine woods at the edge of Merrill. I have been writing this in the canoe and sitting at the camp fire.

Tomorrow we shall lay in some fresh provender at Merrill and go down river again. Wausau will be our next town, then Mosinee and Stevens Point. I don't know how far we shall go but we are having a good time. I should like to go to Kilbourn, but I don't believe we can even if I extend my vacation somewhat.

I hope we can pick up a good man at Merrill; it will lighten our camp work and enable us to travel a little more freely. As we are now we can't paddle fast for you see Clay takes my canoe and I have Mr. Marr's. Clay is alright, but, of course, he hasn't the strength of arm of a man. To-day Carl traveled with me, but heretofore he has travelled with Mr. Marr or Cope.

I do not think Carl is enjoying the trip as much as he expected. You see he can't be allowed to leave things lying around and someone is after him quite a part of the time telling him what to do. The discipline is good for him. Clay is very different. Of course, he is older and

has more sense. I keep an eye on him to help him with his pack and the heavy things and he appreciates everything done for him. I think Clay is enjoying the familiar association with the men and he thoroughly enjoys the splendid scenery.

I'll write you later from Wausau or somewhere. I hope your foot is improving and that I may soon have another good letter from you.

Love to you all.

Affectionately,
Dad.

At Merrill I received a telegram calling me home as Howard's illness had assumed a serious aspect. I was home for a day and finding that he was on the road to recovery, I rejoined the party and wrote up the journal of what had occurred in my absence.

H.G.

Somewhere
Between
Merrill and Wausau
August 29 '06.

My dear Howard:—

To resume my story I shall have to tread upon my own tail to the extent of commencing at the camp above Merrill from which I wrote the letter I gave you yesterday.

Carl, Urquie and I went down town on Monday morning where I received the telegram and where Urquie bought sundry things most needed in the kitchen and engaged a big woodbutcher named Williams. The latter joined at 3 P.M. and we immediately started down river. The first trouble was to find the boom lines through which we could make shore when we came to the dam. The natives had told me and shown me one dam, but there were two and we said several more.

Those I heard were mentioned at the unexpected first dam, but we had a comparatively easy portage. Clay's and my boat swung out followed by Cope's. We found a passage into the main river and trusted that Urquie would find it.

At the second dam was a grist mill and the miller let me go down in the basement to don my pretty clothes. I said Good Bye to the party and formally presented Clay with my roll of long brown paper.[11] I had supper at the hotel and as I left I could see the party still at the other end of the dam apparently regardless of grub or bedtime.

The story of the last dam I heard this morning. It seems that Urquie missed our course and got into some sort of a shute, where he put a line on the grub boat and started to lower her. There was a board Urquie couldn't see, the boat struck it, raised and turned turtle. Urquie brought a canoe up and as he says, "I rescued everything we didn't need." He saved the tent, however, and the grub box,

Our cook stove
bake ovens
water proof dressings
matches
Urquie's blanket
cartridges
frying pans
cook pots
knives and forks
silver and glassware

are all at the bottom of the river.

They made camp at the dam, said things, then laughed, bought a frying pan and started to keep house.

[11] Dad wrote his journal on a roll of paper, so he was passing the baton to Clay, who would write the journal in Dad's absence.

I was so delighted yesterday at the consideration they showed in waiting for me at Merrill so I could see all the river between Merrill and Wausau.

Yesterday they moved down river a little below Merrill.

Urquie and Clay met me at the depot and I heard the story as I came down to camp.

. . . .

I have just put nine pancakes, etc. into my insides and I feel better just now.

. . . .

We left our last camp just about one o'clock and came down river with a swift current until a mile or a few more behind us, when we struck dead water which meant a dam.

To be continued
Dad.

⎯⎯⎯⎯⎯

Just above Stevens Point,
September 2, '06

My dear Howard:—

I mailed a letter to you yesterday from Knowlton. At 12:30 we stopped for our noon mess at a place where the river runs North-east, and hardly had we finished lunch when a shower came up and we had to unload our boats, cover our stuff and get shelter. The boys and Cope found a barn while I, being lazy and sleepy, covered myself with my rubber cape, put my head on a log, put my hat over my face and went to sleep. It is really surprising how comfortable a fellow can be after a month in the woods. Urquie crawled under a canoe and went to sleep, while our squaw man paddled over to an island to see what he could see.

When the rain ended a nice old fellow came along and began asking questions about our camera. He seemed pretty nice and friendly, so I showed him how our boats were built and he told me how the road along the shore was an old time stage road and how near there the Indians used to make a short cut portage when travelling up-stream.

There was an old Indian cornfield nearby and at another place there was a heap of old chips where they made arrow points. He had some relics at home, he said, and so we loaded him in and visited his house. He has some of my ready cash now and I have two old iron axe heads, such as were used in trading with the Indians, and a few pieces of miscellaneous stuff of not much account. The man's name was Charles Gilbert and he is an old time river man of the days when they rafted lumber down the river.

The rain came up again and we soon made camp. It rained until midnight and then came a horde of mosquitoes, which drove us out doors to get a rest.

We left camp at 8 o'clock and are now waiting for the grub boats to catch up so we can show them the right channel.

Affectionately,

Dad.

Stevens Pt. at
noon.

Mother's Friday letter just received.

⎯⎯⎯⎯⎯

In Camp
Between Stevens
Point and Grand
Rapids, Sept. 3 '06.

My dear Howard:—

I mailed you a letter from Stevens Point Sunday noon. We made a short run to a dam, stopped, talked about dams and portaged it, launching directly into the rapids below.

Clay and I were first boat out and we bumped over a ledge of rock, took in a few buckets of water, and landed to empty out. Cope followed and he stopped to bail out. Clay went back to warn the others, while a heavy shower wet us down. There are some Sunday School rapids below and we went very carefully, not from fear of the water, but we were looking for Dr. Hay's Sanitorium,[12] where we proposed to have some fun. Finally a fisherman told us we were on his land. Cope sneaked up to his house, where under cover of the brush he could hear Mrs. Hay and Tommy talking at dinner. We dropped down almost in front of the house, landed and told the men to put up the tent and make all kinds of noise about it. In the meantime, Clay helped the racket out, while Carl, Cope and I took refuge in the wet brush and waited developments. We didn't get chilled in waiting, for soon a young lady appeared and fled, then she came back re-enforced by Mrs. Hay and another lady, and Mrs. Hay proceeded to order the intruders off the private property. "Urquie" tried to talk and Mrs. Hay read the riot act as Tommy appeared down the trail. Before he came up matters had reached a climax and Cope appeared upon the scene, followed by Carl and your Dad. Mrs. Hay looked at Cope for a minute before she recognized the new comer and by that time Tom and I had come up. Then there were doings and we were soon carried off to view the sanitorium buildings. We went back for supper, accompanied by Tom and his two boys, Harshaw and Donald, who were greatly interested in watching the manners of the wild men at mess. You would have thought we were dog eaters from their remarks. Then we went back to the house where we smoked and ate another supper a half an hour after

our first, and after a few more pipes we went to bed, promising to appear at 7:30 for breakfast.

We have been on the go for several days, so we laid up for a half a day to dry out bedding and wash clothes. Mrs. Hay offered us her laundry, which we declined for fear of interfering with their sewerage system. Urquie went to town this morning for supplies while we washed up our clothes. We dined at the Hays and we ate so much that we were all Haybellied when we left there this afternoon to tackle dams again.

The first dam is just below Hays and the second a half mile below that. We hired a farmer's team and went over both dams without remark. Then we paddled down about eight miles of most beautiful river, facing the sun all the time. We did not camp until seven, and I am writing this by camp fire.

To-morrow we make Grand Rapids and the next town on the river until we get to Kilbourn about 54 miles away as the crow flies. We shall stop at a big rock called Roche a Cri, where we shall go inland to Necedah for mail, etc.

I can't tell how fast we shall travel for several reasons. First, dams. There is one between us and Grand Rapids, one or more at Grand Rapids, and one at Nekoosa below Grand Rapids. Then we shall dismiss the subject until we get to Kilbourn, unless some of these people lie most extraordinarily. Second,—the river plays snake with itself above Kilbourn and we have to join in the game of tag with its trail. We ought to be in Kilbourn the last of the week and there we quit.

Possibly you might join us at Kilbourn for mess and to see our camp. I should like to have you see us and our camp. Cope says he ought to be home by the 8th, and he may leave us at Necedah.

Carl ought to have some clothes to wear home. A clean pair of Khaki trousers would change his appearance wonderfully.

[12] Dr. Hay was a physician from Milwaukee who had moved to Stevens Point to establish a sanatorium, or sanitarium, on the Wisconsin River.

Crossroads at Necedah, circa 1904.
Photograph by R. J. Altpeter. Courtesy of the Wisconsin Historical Society, WHS-41598.

I shall send two packs of film home to-morrow to be developed. I ought to have some good pictures out of this bunch.

Everyone is well and happy.

Mrs. Hay asked to be remembered to you and Mother. She was as much amused as anyone else over the way she was worked, yesterday. I asked Dr. Hay to send to Genesee our rifles, my revolver, and some Indian relics and some books of Clay's.

Affectionately,

Dad.

The rifles and revolver should be cleaned.

<center>⚬⚬⚬</center>

Milwaukee, Sept. 10 '06

My dear Howard:—

In order to finish the story of our canoe trip, I'll write this letter and start with our stop near Necedah, where Urquie mailed my last letter to you.

At the river bank there is a big bluff like those at Camp Douglass, called Peetingwell [Petenwell] Rock.

While Urquie went to town Carl, Clay and I climbed to the top of two of its points, then Urquie came back and we drifted a mile down river and camped in a beautiful grove. We had a long day's journey before us, and so we went to bed early.

This place is interesting to me. In 1898 I went with Lt. Col. Caldwell and his battalion on a march and our first night we camped near the big rock.[13] I liked the place so much that I have always wanted to re-visit it, but until now I have had no opportunity. Our second camp was at an old deserted river town, called Germantown, and is about 12 miles below the rock.

Friday morning we were up and packed early, but I held back to make pictures of the rock and some scenery and the camp waited with me. At noon we were at Germantown where we found that a very decent German ran the inn and served a cold mild beer. We were all thirsty and the beer tasted good to the men, while the boys lapped up pop.

[13] Dad marched with Lt. Col. Caldwell in 1898 as part of the Spanish-American War preparation.

We had our noon mess a little below Germantown, and then we loafed until three o'clock, too full of grub to stir out on the hot river. At six we were looking for a good camp and finding no spot to our liking we drifted on and on and into what is called the Big Dells. These dells are merely sandstone cliffs, and about as inviting for camping as a floor without flooring. Below the Big Dells we found marshes and mosquitoes and at 8:10 we ran onto a sandbar and as we could not see river, current or channel because of the fog, we decided that we wanted to cook our dinner then and there and sleep in the same place.

The water in the river has been high and this particular sand bar, which we selected as our abode, had not been out of water long enough to dry its crown. We ate an enormous hash, smoked our pipes, spread our big tent on the sand and bivouacked in the fog. When morning broke we found ourselves upon an island and aside from the heat of the sand, our morning was very comfortable.

This was to be our last day as free men and no one cared to move out of camp and towards civilization.

We breakfasted early and by degrees we packed up our stuff and then waited while Cope and Clay went hunting birds and while Cope shaved himself in anticipation of civilization. It was after ten o'clock when we finally started down river.

We were within sight of the Dells and soon drifted to

Moving pictures at the Inter-County Fair, 1905.
Photograph by H. H. Bennett. Courtesy of the Wisconsin Historical Society, WHS-8135.

the creek which flows past Stand Rock. I knew the various sights and so I was to lead the party at sight-seeing. The first excursion to Stand Rock, etc. finished them up and after that they would only follow into places where it was cool. We "did" Witches Gulch, and so on to "The Larks," where I tried to telephone your Aunt Kitty's but could not get any response. A bystander told me that everyone in town had gone to the Fair at the fairgrounds. I realized that if there were a fair and side-

shows Uncle Horace would surely be there, and so I led our crowd to the fair ground which is only a half a mile distant. It was not long before I had located the Upham family and then the fun commenced.

Aunt Kitty wanted to see the party and I led her to where they were leaning over a fence watching a ball game. "But where is Dr. Copeland?" she asked, and I asked Urquie where Cope had gone, but Urquie did not know. All the time Cope stood beside Urquie and

Lark's Hotel, Kilbourn (now Wisconsin Dells), early 1900s.
Photograph by H. H. Bennett. Courtesy of the Wisconsin Historical Society, WHS-69105.

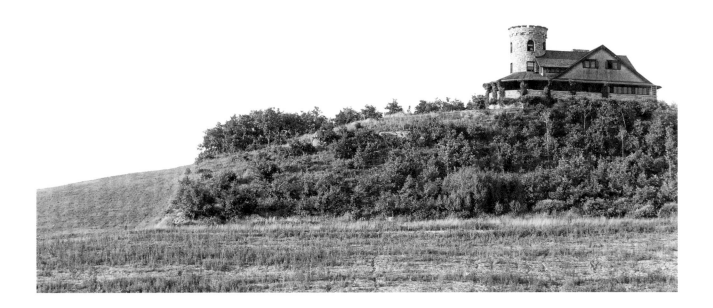

unrecognized. It would have amused you to have seen the good people of Kilbourn stare at your Aunt Kitty while she chatted with us. We would have easily passed as anything but gentlemen on our outing.

We reached Kilbourn at 5 o'clock and piled our boats up on a sand bar. The men put up their tent and we got out our better clothes to take supper at the Uphams'. Cope left on the night train.

Carl and Clay and I had the tower bed-room and we were up early for a bath and plunge before breakfast. The morning was mostly spent at Urquie's camp, where I sorted out our belongings and gave him directions for shipping stuff home. We came back to Waubeck in time for another bath, plunge and swim before dinner, and after dinner we were off about immediately for the depot, where we took final leave of Urquie and Williams. We were sorry to say good-bye for we liked them and it was clear that they liked us, but even a trip as enjoyable as ours had to end.

In course of time our photographs will be out and there are some incidents or our trip they will recall and which I can tell you later.

Affectionately,
Dad.

THE ST. CROIX RIVER TRIP

1907

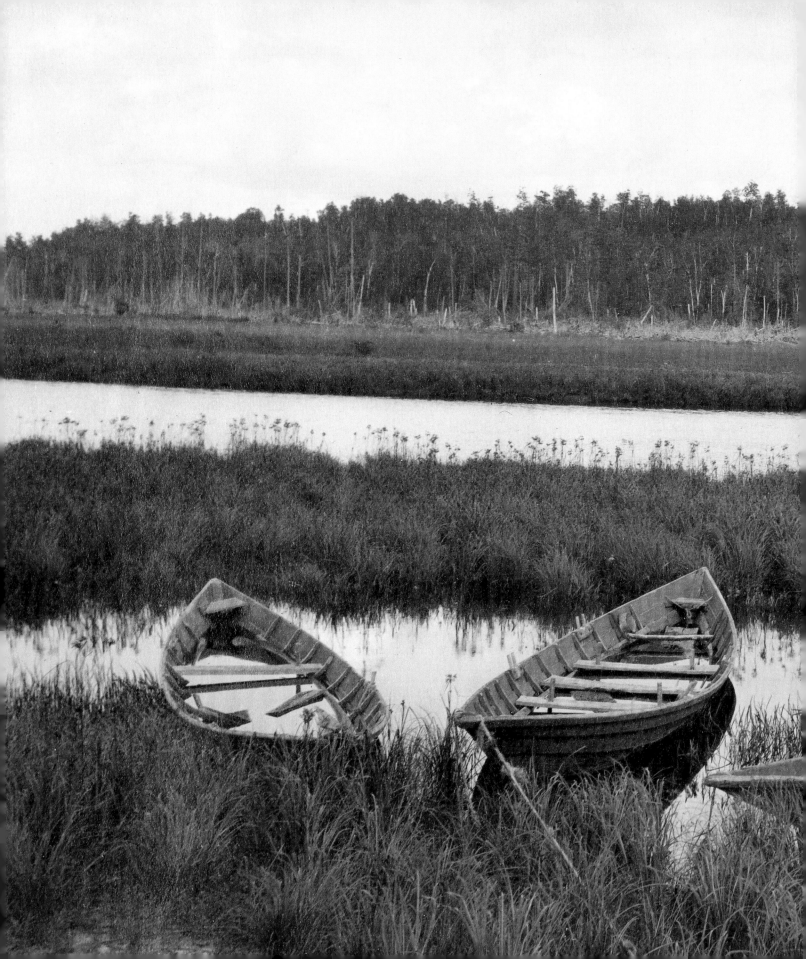

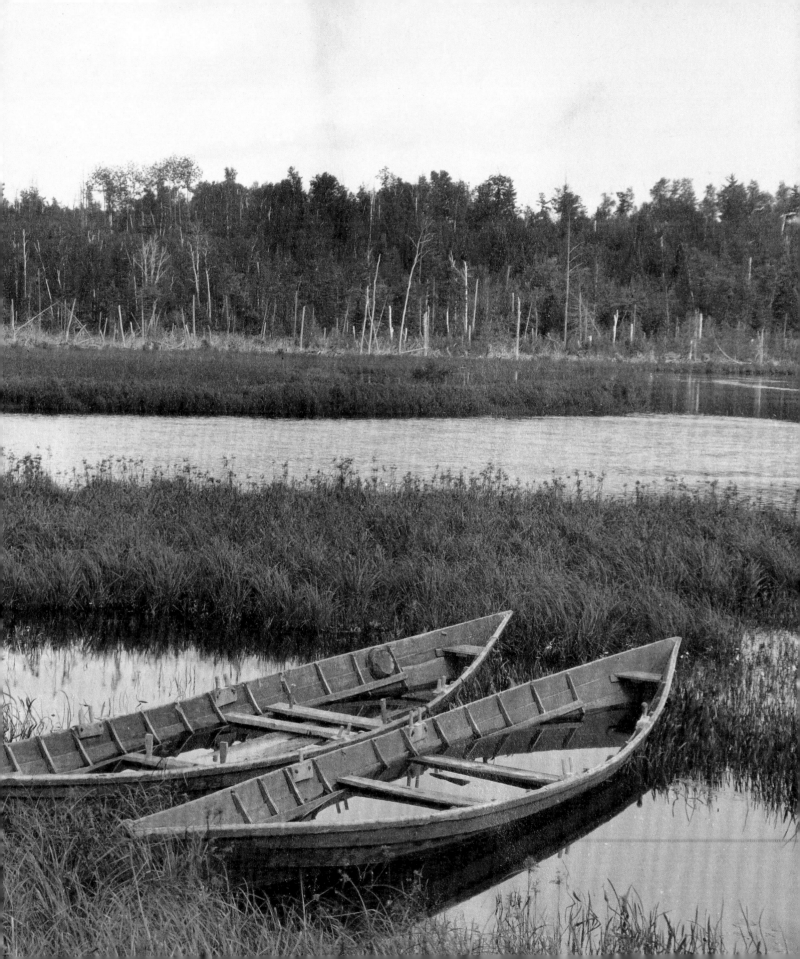

St. Croix River Trip

1907

Determining why Dad and the Gang chose the St. Croix River involves some educated guesswork, based on a combination of his social contacts, his love of history, and his Spanish-American War experience with the Army Corps of Engineers.

A contingent of Milwaukee men, who were members of the University Club and also corporate board members in Milwaukee, had established fishing camps on Wisconsin's Brule River around 1889; no doubt their camps and the region were discussed by the gentlemen over cigars and port at the club. In 1908 Arthur Tenney Holbrook was president of the University Club, while Howard Greene served as treasurer. Although there is no record of any of the Gang actually visiting the Holbrook camp, the Gitche Gumee Camping Club, or the others in the area, the Winneboujou Club and Nississhin Lodge, the Gang would have been very aware of those early lodges on the Brule.[1]

The Brule and St. Croix Rivers formed a highway between the Mississippi River and Lake Superior for both Native Americans and the fur traders. The portage between the two rivers, about a mile long, was historically important in communication and transportation of goods. Beginning in the 1870s, the Army Corps of Engineers was interested in developing a canal between the St. Croix and Brule Rivers. In 1894 a feasibility study was initiated to determine a shipping route from Lake Superior to the Gulf of Mexico via the Brule, St. Croix, and Mississippi Rivers. As there were obvious inherent challenges in building such a canal, such as the sixteen locks and eight hydraulic lifts needed to deal with a 767-vertical-foot change in elevation, the price tag for the canal was estimated at over $7 billion.[2] The issue died away, but it would have been discussed roundly at the club for the decade prior to the Gang's trip on the St. Croix.

The Brule would have been an attractive river to canoe but could not offer the length of trip the men were seeking. The St. Croix offered the length needed, and its northern reaches were still relatively unsettled.

Dad and the Gang left the Chicago and North Western depot on the Duluth-Superior Limited on August 14, 1907, headed for Gordon, Wisconsin, where they started paddling down the St. Croix River. On the river, the Gang experienced Native American villages and a log drive. They fashioned their own camping equipment and made their own music en route. The younger campers assumed more responsibility in camp, beginning to share the load more evenly with the men.

General railroad travel and logging terms are found in the glossary, providing background for the reader for this chapter and ones to follow. [M.G.P.]

NOTES

1 *From the Log of a Trout Fisherman*, by Dr. Arthur Tenney Holbrook, privately printed in 1949. Arthur Tenney Holbrook also wrote a pamphlet for the Wisconsin Central Railroad, "Jaunts and Camps in Northern Wisconsin for Health and Recreation," in the late 1800s.

2 *Big River Magazine*, May-June 2010, 21–23.

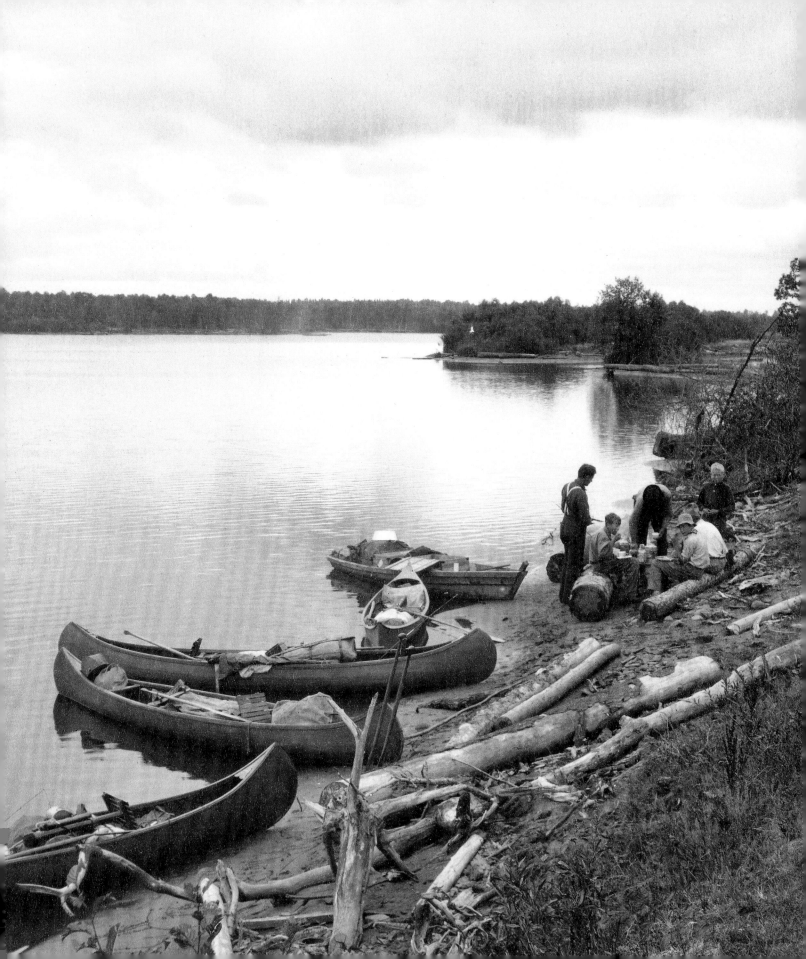

THE ST. CROIX RIVER TRIP
1907

Our Outing on the Wisconsin River in 1906 had been so successful that the same
"Gang" decided to make another canoe trip with Howard added to the party.
This Journal is written from notes made from day to day in Camp.

PRELIMINARY INSTRUCTIONS

1. All boats, tentage, provisions and equipment were shipped to Gordon, Wisconsin, about August 8th, and meat supplies, oleo, etc., will be sent by express on Tuesday, August 13th, 1907.

2. Wood butchers and cooks will leave Menominee, Michigan, on Tuesday evening, August 13th, 1907, reaching Gordon, Wisconsin on Wednesday about 9:30 in the morning. Camp will be prepared on the St. Croix River and all supplies taken to Camp.

3. The expedition will rendezvous at the Chicago-Northwestern Depot in Chicago on Wednesday, August 14th, to take the Duluth-Superior Limited, leaving Chicago at 10 P.M., arriving at Gordon at about 9:30 Thursday morning. Sleeping-car reservations have been secured.

> Howard T. Greene,
> Clerk.[1]

Milwaukee, Wis.
August 12, 1907.

Copy for Dad
Transportation.

[1] Howard T., age fourteen, was apparently appointed as "clerk" of the trip to give him some area of responsibility, but more likely to give him a sense of competence and skill. On the first trip, Howard T. had been ill and unable to go along, and it is easy to imagine his father giving him a leg up on feeling involved this year.

THE JOURNAL

THURSDAY
GORDON, AUGUST 15, 1907.

The gathering of the gang commenced on Wednesday with the coming of How, Carl and Di to Milwaukee. The first incident was Carl's long stop at the entrance of the Enterprise Building for the accommodation of the dog. Enough said.

———

Dad, How and Clay started for Chicago at 1:45 to buy school clothes for How. This errand was followed by dinner at the Annex and a drive through Lincoln Park. Bill joined at the Depot. Doc and Carl came in at 9:50 and after sundry tips had been misdistributed among porters, red caps and baggage breakers, the gang assembled and immediately adjourned to the Cafe's car to wet the starting of the outing.

Only one incident occurred en route,—A pretty woman and a very pretty daughter were assigned to an upper berth. The Conductor suggested to the boys that some of them move up, but no one moved. Clay referred him to "our father" who was in the Cafe' car.

"Which one?"

"The three men sitting together."

"Which one of them?"

"Any of them."

In hopes of winning a smile Bill offered to roost higher and the Conductor carried word back with Dad's compliments and regards. Clay won the smile.

———

AUGUST 16, 1907

Doc and Bill had uneasy souls and empty bellies and crowded into the Diner as early as possible. The rest followed later.

We arrived at Gordon about 10 o'clock and found Fred LePenske and Martin Fogerty waiting for us. Camp had been made within easy carrying distance of the depot and we spent the morning changing clothes and repacking our baggage and equipment.

The camp is on a creek beside the "Omaha" track. The new right-of-way of the Wisconsin Central Road crosses the St. Croix just below the camp.

Fishing commenced after dinner. Bill, Carl and Howard all fell into the creek and caught no fish. Then,

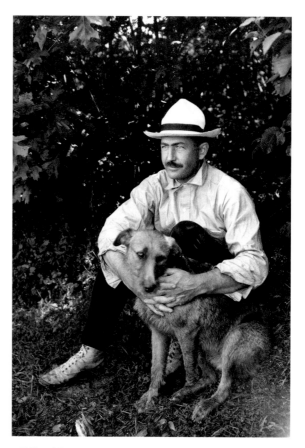

Bill and Di

while this trio went swimming with Di, Doc and Clay went up the St. Croix and caught two pickerel and a sun fish.

The grub meets general approval.

DINNER AT NOON:	DINNER AT NIGHT:	
Bacon	Bacon	
Boiled Potatoes	Boiled Potatoes	
Rubber Rolls[2]	Rubber Rolls	
Coffee	Baking powder biscuit	
Onions	Coffee	Onions
Bananas	Fish	Ham

In the evening Bill passed some

Pollock's Expert Stogies[3]

made at Wheeling, West Va.

Then Bill passed some "punkey dope," which Carl says makes him smell "like a 20th Century Skunk."

Clay has fixed the order of sleeping:

Doc	Carl	Bill	How	Dad	Clay

Front of Tent

The plan is to make a start down stream to-morrow and go into camp at a dam about eight miles below. We are to stay there several days and come back here by trail for mail and Clay's canoe, which has been delayed on the road.

. . . .

[2] "Rubber" rolls, rice with "flies" or with "cockroaches": Dad enjoyed making up silly names, especially for foods, driving home the point that their grub didn't always taste fresh.
[3] Pollack's Expert Stogies were cigars made in Wheeling, West Virginia, from the 1880s onward. *Stogie* is the common name, fashioned after the name Conestoga, indicating something sturdy. Pollack was the largest stogie maker in Wheeling, according to an account in the *Wheeling Daily Intelligencer,* September 14, 1886.

Last night was one of the worst any of us ever experienced. It rained; it was hot, and the mosquitoes were out in force. We rolled into our blankets about eight o'clock and no one slept. At ten Bill asked everyone who was awake to holler and everyone yelled. The men sat up and smoked and for diversion we threw the boys and dog about the tent and yelled some more. Then we tried to sleep and soon Cope snored peacefully, but no one else rested. Gradually the boys fell asleep, but there was no sleep for Dad or Bill. Finally they dressed and went walking on the Omaha tracks, returning to the mosquitoes at 1:30 A.M. At early daybreak Dad spread himself over two boxes, wrapped a comforter about him and slept until the Crazy Doc tied the dog to Dad's boot laces and called her. The dog got kicked and cussed, but Dad was up,—tired and cross. Breakfast was served at 6 o'clock, and we prepared to take down camp so as to move out after lunch at 1 o'clock. Clay's canoe has not come so we are short one boat.

We started at about eleven, leaving Fred and Martin behind. They were to wait for a noon freight which it was expected would bring Clay's canoe and would give us boat capacity for all our baggage.

This is how we travelled:

Doc and Clay
Bill and Carl
Dad and Howard

It was Howard's first experience in a canoe and we struck a bit of rapid water just after we pushed off. We travelled about five or six miles and pulled up to await the men. There is a dam about eight miles below Gordon, but by river about sixteen miles. The back water extends ten miles and we had a strong head wind. At this waiting place Doc & Dad changed partners, for Doc's canoe travels lighter and sits lower in the water. Fred LePenske came up in the boat, reported that the

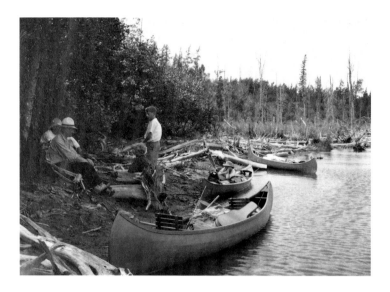

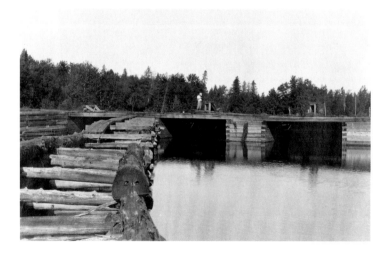

Fishing at Gordon Dam

canoe had not come in, and he had hired a team to take all our stuff to the dam.

The next few miles were hard paddling, but about five o'clock the wind subsided and about seven we came into our second camp.

This is the spot where some years ago Cope camped, shot a bear and caught bass in unlimited quantities, while a bear ate his prunes. There is good fishing without question, and we saw a man who runs a fishing resort coming in with a big bass and some smaller fry.

By nine we were in bed. It was a comfortably cool night and everyone slept well until six o'clock on

SATURDAY, AUGUST 17TH

when we found a big breakfast waiting for us with fish caught by Cope and Howard the night before.

Howard fished all day steadily, from early morning until nightfall, and caught four sun fish. Cope did likewise, trying every variety of bait and casting. He wore pajamas all day long and waded in them and dried himself by the fire in the evening.

Bill fished at intervals. During the morning he and Dad rigged up a mosquito bar on a rope with hangers from the tent roof and did sundry odd jobs of sewing and patching.

After dinner Dad read aloud the story "As one having Authority" and followed it later by some of Bunners poems read aloud to Bill. This was followed by flycasting for bass by Dad, Bill and Doc with no results. Dad gave up first, then Bill, and while Doc held out Dad made a picture of him from mid stream.

The evening lights were good for picture making and the following pictures ought to result:

1 Camp from the river below camp
2 Doc fishing with dam in background
3 & 4 Two views, (connecting), dam in foreground
5 Cook & Carl getting supper
6 & 7 Two portraits of Fred LePenske

After supper Bill, How and Dad went up stream in the rowboat, Dad rowing and How and Bill trolling with Dowijack minnows,[4] but without luck.

After nightfall we sat about the fire and talked.

. . . .

Prunes were cooked to-day.

At dinner we were talking about porcupines and Bill held that they should be protected by law, as they were the only animal a man could kill with a club. Then came a discussion as to whether they were really good eating.

"Do you know how to cook a porcy?" asked Fred.

"No," said Bill, "How?"

"Well, I'll tell you. An old trapper told me how. First, boil it slow in a big pot of water for two hours and throw the water away; then boil in fresh water for a half hour quick and draw off the water; boil again for an hour and a half hard, and then throw the whole thing away."

"That reminds me of our Engineer Corps where no one dared ask a question," said Bill.

SUNDAY, AUGUST 18TH,

All out at six o'clock. Martin has been raising dough during the night and we are to have fresh bread to-day and perhaps a prune pie.

A gentle rain is falling during the morning but not enough to keep anyone under the canvas.

Our tent fly is a great invention to-day. Bill and Dad shaved. Cope and Clay went bird hunting. Carl has learned some of the trees and Clay is gathering boughs of the different pines. Howard is reading and fishing.

[4] "Dowijack minnows": Dowagian minnow lure, a popular lure developed circa 1904.

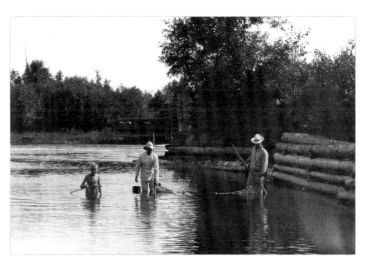

Trolling for minnows

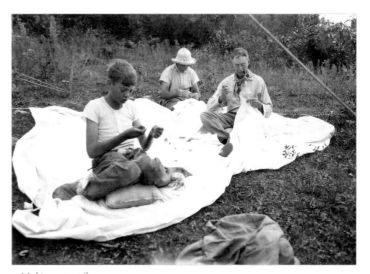

Making a tent fly

The dog is without a home. I have not seen her smile since she met us in Milwaukee. She seeks a soft spot on our beds and someone soon finds her and says, "Get out of there, Di." The grub is new and strange and she wears a tired look. She is ready to do anything with anyone just to try to be a good fellow.

Combat with wasps

There is quite a bit of standing timber about here. Elm, Cedar, Pine, Birch and Balsam; but there does not seem to be much logging. We are told that the drive is jammed below us.

The day has been rainy. It rained in the morning and in the shade of the tent fly sat Cope looking like an old woodsman.

At noon Dad mixed our first drink,—an Army Cocktail. We have commenced using erbswurst, and we had a splendid soup, beans, onions and meat for dinner.

Bill has commenced his adventures with wasps and is already the hero of several encounters with them, although the rest of the party have not been attacked.

Howard has pictured everyone in the party includ-ing Bill in combat with wasps, after which he industri-ously washed his clothes.

We had a hail storm at noon. The woods across the river seem to be an unexplored tangle. Some timber was cut for construction of the dam, but almost all the work roads have grown up. In the afternoon Dad, Bill, How, Clay and Carl went walking on the north side of the river. They got a big pine snake with forty-five young snakes in her. Dad got his lip stung and a picture of him as "Chief Big Lip" was taken.

Rain drove us to the tent early in the evening and then the rain fell in torrents. The tent leaked and leaked some more. The bedding got all wet, more or less. Carl had dropped into the men's tent and when I found him

there he was curled up with Fred in Fred's blanket and without a rag on him.

Dad made How's bed a little drier and then all hands tried to sleep. It was no use. How itched, Dad itched and Clay scratched. Dad sat up and found Di nestled by our feet and distributing fleas. We got up and while Dad said things all three stood in the river and cooled our legs. Then Bill and Doc got up and Bill lighted a fire and we dried out a little. Said Cope, "If I hadn't moved my bed, I wouldn't have been wet a particle." "Yes Gager," retorted Clay, "and if the dog hadn't stopped to leak he would have caught the rabbit."

Carl heard the noise and came out, naked, to join the gang and we sent him back to bed to keep warm.

Our beds were not so very wet and we picked out our driest blankets and were soon asleep.

The dog was tied outside the tent and kept moist all night.

· · · ·

MONDAY, AUGUST 19, 1907.

The morning broke cloudy, but soon cleared.

We can't stand this camp. There are city people who fish here and a woman is in the party. We learn that Clay's canoe has come, so Carl and Fred are going up to get it, buy supplies, mail letters and bring the canoe down.

We leave camp to-morrow if we get dried out. In ten days we should be somewhere near Grantsburg, Burnett County, Wisconsin, where we will get our next mail.

Everyone is to be busy, washing and drying clothes this morning.

MONDAY, AUGUST 19
- NOON -

This has proven to be a good drying day in spite of Martin's gloomy assertion that the clouds were moving the wrong way.

Fred and Carl started for Gordon with mail and express about nine o'clock. Carl has been so full of the devil that we were glad to have him taken out for exercise. They will have to paddle against a head wind and are not likely to reach camp until six o'clock.

There is a man named, "Mackey," who is either a lumberman or jobber on this river. His head man, "Moffat" was in camp this morning to look at the River. At Gordon we saw a lot of bateaux and logging outfit belonging to him. The logs are to be driven to Stillwater. On the way down we saw a steam barge evidently used in pushing logs through the dead water. There were several rafts with windlasses above the dam,—I presume to hold river booms.

Doc and Clay were out after blue berries this morning and the result was a blue berry pie for dinner. Bill and Howard brought in fresh berries at noon.

Cope, Bill, and How are out in a row boat, How rowing and the men casting.

Clay

Howard, Clay, and Dad washed clothes this morning. Two pictures of Howard washing clothes.

We are short bacon and flour.

.

There is a woman in the party of fisherman staying at the Thompson's. She is an enthusiast and at it early and late. She wears corsets and heavy skirts all covered with a blue gingham Mother Hubbard effect, which at times is very baloonish. She stopped at camp on her way home this noon to pass the time of day. Dad inquired,

"Well, what luck?"

"Nothing, only sun fish. This place is fished too much."

"We haven't got much, either"

"My, but your dinner looks nice! I guess I'll have to stay sometime"

Cope moved back into the shadow of the tent.

"We are living pretty comfortably here." Said Dad.

"I came up here last year, and I was sick and thin, and I got all right, and I've been getting fat ever since"

Here Cope retreated into a further corner of the tent and hid.

"Having a good time, young man?" This to Clay.

"You bet."

Then she went along. Doc said he was afraid someone would call him "Doctor" and then he would get the usual, "What will make me thinner?"

At noon we had blue berry pie, — — fine.

The afternoon completed our drying out process and we began to collect things for an early start to-morrow.

About six, Carl and Fred came back from Gordon in Clay's canoe—a good one. They brought letters telling of the wind storm at Genesee and Milwaukee and also provisions, etc.

The night was cold and we took to our blankets at eight o'clock and slept without being bothered by mosquitoes.

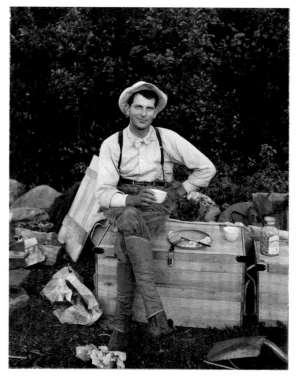

Fred LePenske

ON TUESDAY, (AUG. 20)

We were out early and as soon as our stuff could be dried out we packed our canoes and started.

Fred had traded our flat boat with Thompson, a settler who keeps a boarding house near here, for a heavy skiff, which would carry more stuff, and we set out about ten o'clock in this wise:—

Cope and Fred
Dad and How
Clay
Bill and Carl
Martin in the "Wannigan."

Fred afterwards shifted to the "Wannigan."

The first mile was in very shallow water,—then we

found more water and a rapid. Dad led through because it was a criss cross channel and Howard is not experienced in this sort of navigation. The other shot the rapid and waited for the "Wannigan," which had to be helped through.

The rest of the rapids we rode through and Howard soon got to know the looks of rough water. We passed the mouth of the Moose River at noon.

At 1:35 we came to a railroad siding just above the "Copper Mine Dam." There is nothing doing here. An old Irishman, who, with a dog and tom cat, tends company property, consisting of store house and railroad tracks, etc., is the only settler. The Company landed twenty-two million feet here last spring. The river banks show the effect of flooding. The valley is a broad meadow of marsh green.

We landed our baggage and stretched out on it to await the call for grub.

"Where is Di?" someone asked. Everyone thought some other boat had her, but she was left behind. She can't understand camp life and probably attached herself to the dam as being home. Cope said, "Let her stay," and threats of suit for abandonment had no effect, so Dad and Bill decided to walk back for her. By river we have travelled about five miles and the road is longer. At 3:20 they left, going West to the Railroad, then North to an old supply road a half a mile or so back and then following the road. The plan was to cross the St. Croix on the bridge and hit the main road for Gordon. The road is very rough and passes through two miles of cutover country, then it enters the timber and the low places are very wet. Several brooks cross the road and are not bridged. About four miles a main road is reached and leads to the bridge and also to a bridge across the Moose River. The latter road was more distinct and they took it and finally, as it bore too far north they stopped at "Arnold Lodge". This is a summer fishing and shooting resort of a man of that name. They left a few days ago. There is a living room with fire places, a bedroom with four double bunks and some other rooms. They got a drink and the people passed out some hot cookies. They were advised to go back, but did not like the idea. They were told that Arnold sometimes came across from the dam and that, although the trail was wet and had some windfalls, the girls went that way sometimes. They liked the trail idea and started that way. It soon ran out and they found themselves in a wet wood without trail, and with no direction to guide. They travelled for two hours, fording brooks and swampholes nearly waist deep, climbing over windfalls and all the while the sun was failing. Just at sunset they made the river, at the second rapid two miles below the dam. The North bank was a tangle of woods, the river was deep and so they made their way down to the shallower part of the rapid, joined hands and forded the stream, moving forward alternately, about five feet at a move. Fortunately they found themselves at a camping spot where the drive had at some time made camp and a tote road lead to the main road. They left the road by a new road, hoping to short-cut, and came out at a homesteaders near our first camp. He has a nice log house, (one room and a loft). He works in the woods in winter and spends his summers here, guiding Thompson's guests. He cooked two or three winters and his place is a model of neatness. They stopped to get their trail and learned that Di had dined with him and had been hanging about Thompsons' place and the dam. He showed them a trail to the dam, but advised them to take the road back to his place on our return. They whistled as they passed the dam, but got no response and so went on to Thompsons. The people there had seen the dog about supper time. After a supper of bread, butter, cake and stewed berries, they went back to the dam where Di was found. She was so delighted that she almost tore their clothes off.

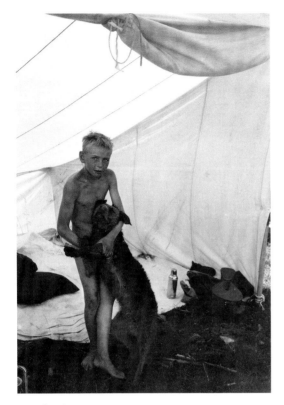

Carl and Di

The night was cold and cotton shirts and wet clothing were poor protection against the cold night air. They stopped at the homesteaders and warmed up on hot water. He asked them to spend the night, but the invitation was declined, for fear our party might start a search.

The return was easy, —They missed the road and walked a half mile out of their way and had to come back. The brooks and mud holes could not be seen and avoided as in the day time, and it was 11:30 when camp was reached. Everyone was in bed, but the men got up and warmed up a beef hash with coffee and blueberries for a midnight meal. After drying out by the fire, two tired men and a dog rolled into warm blankets, all glad to be back again. The river fog was over all our camp.

There are tracks of a cub bear near our camp. Bill and dad saw a herd of deer near the St. Croix Bridge.

The trip for Di covered

Mileage to Dam,	8
Extra mileage,	
Lost trail—woods	2
Wrong road—Afternoon	1
" " —evening	1
Return from dam	8
	20 miles

and not more than two miles of it was ordinarily decent going.

WEDNESDAY, AUG. 21 '07.

Breakfast at eight

Pancakes, sow belly, potatoes, coffee and blueberries.

Martin is baking again to-day—Bought flour, 25#.

Cope caught a pickerel for breakfast. Later he, How and Clay went out for another. Cope washed his dog with Grandpa Tar soap. Bill read Bunner and Carl cleaned guns.

8/21/07

In the afternoon Dad and How did their sewing and mending. The musicians played. How and Doc went walking and Dad made pictures of an old bateau and of four bateaux left in the river. Swim before supper, but water too shallow. The old Irish camp keeper came down and wanted us to get him some fresh meat, so after supper, Dad, How, Fred and the old fellow took a hand-car and rifle and went up the road 4½ miles to "Trouty Creek Dam," then half a mile further. The first mile and a half of the ride was very uninteresting,—all cut-over land; then we came into original forest with here and there a cutting.

The reflections in the dam pond on Trouty Creek

at sunset were very beautiful. We found deer track in plenty and also track of bear and a cub, but we saw no deer. The return trip was mostly down grade and we came in just at dark.

The day started with a row because the boys would not get up when Doc called them. Several rows resulted and finally Doc grabbed Clay's head in both hands and remarked he had the forceps on and proceeded to assist in the birth. This was followed by the birth of Howard who gave wrong presentation and was dragged out foot first. It was then discovered that the tent contained triplets and Carl was born with so many struggles that no one could tell what the presentation might have been.

As the boys were taken out they were thrown into the river.

We left the Camp and our old Irish friend (Cope's college friend) about nine thirty and went down to the dam (Copper Mine Dam). There is no head on and we went through. Clay tore the canvas on his canoe and as it was necessary to repair at once we stopped for lunch at 11 o'clock.

How and Dad were first under way, Howard being inexperienced in canoeing and wanting to travel slow. We had swift water most of the way and some was very swift. There is quite a log jam about five miles below the dam.

At 3:20 no one being in sight we made a fire and sat down. Finally the Wannigan came in sight, having

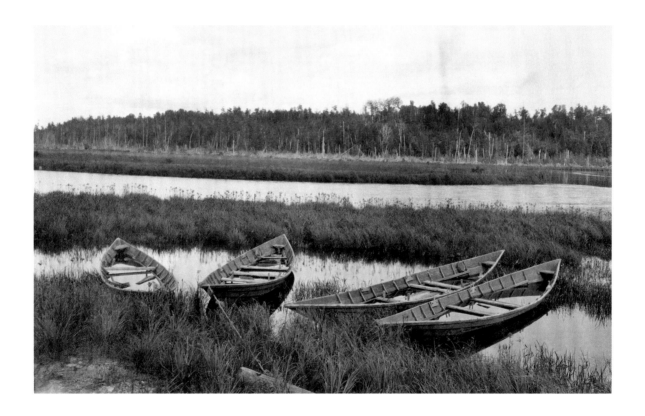

left the dam before the other canoes. They had come through without mishap. We stopped at the first camping site we found,—just at the head of a sharp rapid. Gov't. Lot 2: 33:43:14 W.

There is a brook just below the falls (Rocky Brook). There are several homesteaders on here but no houses in sight. Deer signs are plenty. Indians have camped near here recently.

At noon Bill found a single shot Winchester 22 at the dam. It had been lost only recently and cleaned up nicely.

The other canoes came in about 5:30. We had fried pork and gravy for supper. The boys had a row with the Doc and went to bed.

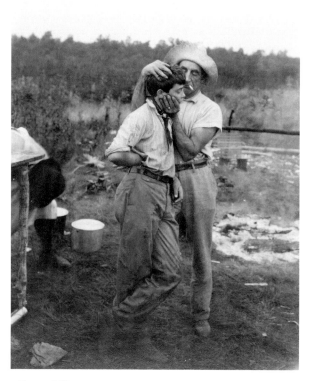

Doc and Clay

In going through a rapid Doc struck a stone wrong and in righting up broke his paddle and fell into the drink. All hands hauled up to help empty out and it was found that Doc's fish rod was missing. Everyone went wading for it, Bill found the rod while Clay in his exultation hollered and fell in full length in the river.

FRIDAY 8/23

Doc was up early and took a walk to the wooded hills back of camp. Usual row with boys to get them up at breakfast time. Doc & Bill went fishing. Fred got potatoes from a homesteader. How and Dad took a walk back of the camp. No fish. Bill mended his paddle with a copper plate and Dad wrote journal. Doc, Carl and Clay are out after berries. We have had plenty of berries at every camp. No bear signs or tracks here to-day.

Fish trap is below us,—about two miles or so. We will go down to-morrow if the weather is good.

SATURDAY, 8/24

Friday afternoon Dad worked on a tent fly: Doc fished: How and Clay did German: and Bill mended a paddle. Fred had learned from someone that a Norway Pine, a short distance from the camp but on the opposite side of the river, was on the highest point of land for several miles around and that from it could be had a long view up and down river. Fred, How and Dad started to find it. They crossed the brook (Rocky Creek) three times, (How being carried on Fred's back), and finally were rewarded with a wonderful view of all the country. Travelling down river one sees the river bottoms and only occasionally sees the hills. They appear to be fifty or a hundred feet high and the back country gently rolling. The hill we climbed is 200 feet high, possibly 300, and the path follows along the brook. We were there about five or six and after a thunder storm. The lights were very beautiful.

On return to camp we found some abandoned Indian tepees and a camping place where they have had their fires. We decided to break camp early and while Dad and How made pictures of the Indian tepees, etc. the others were to go to the Norway pine to see the St. Croix Valley.

How and Clay have become Damon and Pythias for the purpose of combatting the Doc.

SATURDAY, 8/24

About noon we found Fishtrap Rapids. How and Dad went through all but the worst, broke a bottom board of the canoe and led down the rest of the way. We tied up for lunch, about four miles South of our old Camp. The water is very low and we were in and out of our canoes nearly all day. At 4:30 we camped on the first decent high land we found after watching the shore for several hours.

Logs are all along the river banks.

The camp ground is very rough and we had to make up some bunks with boughs.

In the evening Bill played his "mule" and we had a big fire.

It is a cool evening and we are free from mosquitoes.

MONDAY, AUG. 26

The steady rising of the river during Saturday night warned us to move on while the flood was on and canoeing was easy. We decided to lunch at camp and start at noon. The morning was spent drying clothes, cleaning guns, etc.

We left camp at noon sharp and drifted along rapidly through very attractive country. One place there was an abrupt fall of water,—this was very near the Minnesota state line.

About 3 o'clock we came to the Ferry at Pansy. Doc went to the Village with Clay and letters were mailed.

The rest of us waited at the shore where we made pictures of Sam Keen, who claimed to be a full blood Chippewa.

Sam opened the conversation "Bonjour." Then he took a drink and offered his bottle. I said, "No," and he said "mushaway." I couldn't recall the word for a minute. Sam winked and explained to the boys.

The running drive is going on just below the ferry and they are breaking two big wings of logs. There are

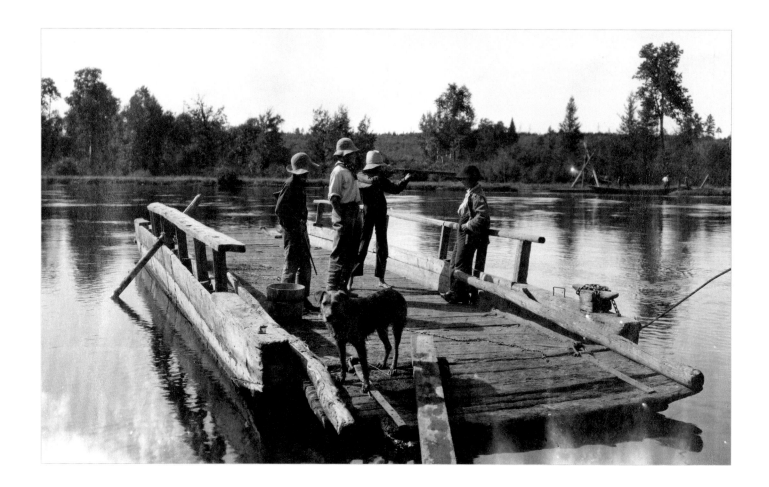

not less than 75 men in the crew with two Wannigan boats. Below there is another Wannigan and a smaller crew. Sam said he was working on the drive. He said he owns two horses, a squaw, a lot of girls and one boy.[5] He wanted Carl to stay with him.

Clay reported beer to be had at Pansy and Doc asked him to bring some bottled beer down. I was dressed in Pajamas and did not like to go to the store. Some kids, ten or twelve years old, playing at the ferry, got a bottle

of beer and a rifle and brought them down to entertain us. Bill and Dad declined to drink with them and they were greatly disappointed for they bought it to drink with us. The rifle was a 3040 Winchester and they fired at floating chips with our boys.

Some men drove up on the Minnesota side and hollered for the ferry. No one came and so we got a volley of cuss words that brought Bill and his canoes out. He carried them across for nothing. They were Swedes after booze and supplies. By this time Sam was pretty drunk and began to pose for his picture, and we had him going proper when a crowd came down to take a bateau across. Sam went with them and then wanted his picture made from the opposite bank. We told him he

[5] In the next two entries, the gang visited a Native village, and on the following day, another village. During these visits, terms such as *squaw, papoose,* and *half-breed,* which are no longer acceptable today, were used to describe Native settlements and people.

was too far away, so he came across and I got a picture of him in his bateau and two portraits. Our Wannigan boat had come up and Fred bought flour, Cope bought beer and so we pushed on.

The store was a typical traders' store with saloon where liquor was sold without discrimination to whites and half-breeds, Indians and children. One of the boys, (white-12 yrs.) told me he had walked down to spend Sunday. He lived about 12 miles away.

Down river we found an Indian village shown on the map. It is on a high plateau overlooking the river. There are four houses and a church. Carl made friends with a young man, Richard Primoux, (¾ white I should say), and bought Dick's grandfather's bow. There is an Indian who says prayers in the church every Sunday and once a year a priest comes.

The grave yard at the church is interesting as showing the survival of barbarism. There are two graves marked with nice headstones,—flowers are planted at some graves, but the older graves are covered with kennels for tobacco, etc. for the use of the dead man on his way to spirit land.

We were up early Monday morning and left camp at 8:30, and went down stream with a big run of logs. We found two Indian canoes and having heard there was a village at that point we took up the trail to Bill William's place which we found consisted of two squaws and the old buck himself. One squaw was squatting on the ground, smoking and watching a fire over which they were drying blueberries for the winter.

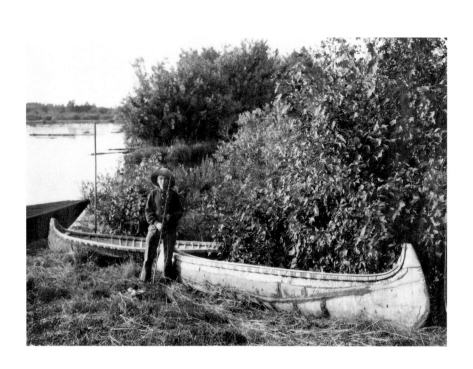

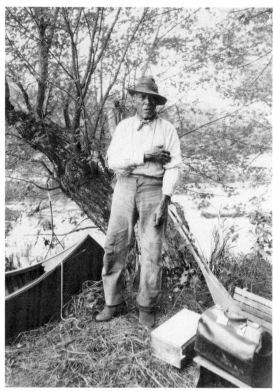

Bill Williams

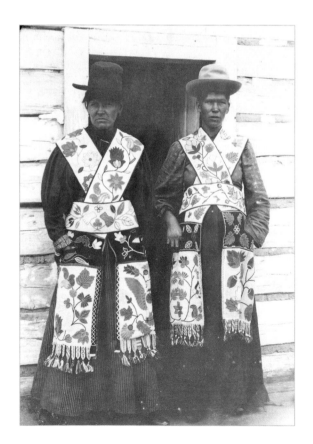

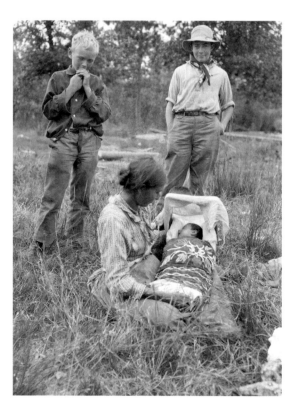

The[y] sold a pair of moccasins to How for $2.25, but would not let us take pictures. Showed us lynx and muskrat skins, and he had a whistle and tom tom. Bill Williams went to the landing with us and for 25 c allowed me to take two pictures and told us of the village of Tamarack, Minn. ½ mile down.

At Tamarack we found four houses, an old squaw, two young squaws and several litters of children. We bought two cross belts beaded, a belt and a tom tom for $20.00.

They would not let us make pictures until they had their hair combed and beads put on.

We made our seventh camp after about 10 miles run to-day. Bought potatoes, chicken, etc. from homesteader and mailed letters home.

AUG. 27, 07.

We left the Homesteader, Wright, at 8 o'clock. The party poked along with a riverfull of logs, and drifting rapidly until 11 o'clock, when they stopped to fish in a bayou where three little pickeral were caught.

We lunched on the point of an island, where many lumber jacks had camped before and where mosquitoes were thick. Opposite the island was an Indian's house with several canoes. We dropped down and paddled up on the other side of the island, the main channel being jammed with logs. We found an old squaw, a middle-aged squaw and papoose, a young squaw, a girl and the usual number of kids. They could not speak English, but Cope bought a pair of beaded moccasins, $2.25, and we made pictures. It was here that Martin made a trade with biscuits as the medium of exchange.

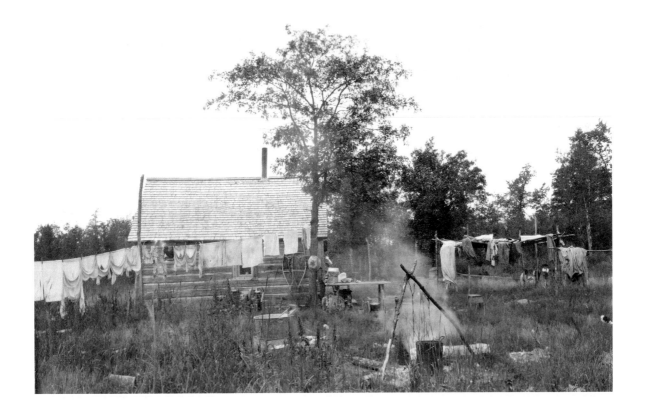

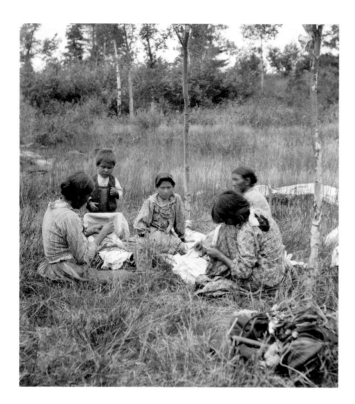

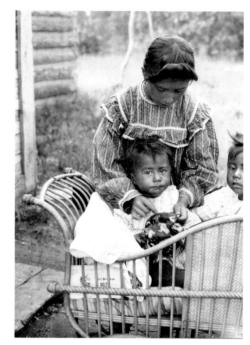

At about three o'clock we came to a high bank with many springs and a peculiar red clay resembling pipe-stone. There was an Indian house with squaw, girl and two kids on the bank, high up. The squaw and girl ran away when they saw us and would not parley. Nothing would tempt them to talk. We looked about and left. After we were in our boats two bucks appeared but had nothing to say. They wanted to know where the drive was, and after being told they gave us to understand by signs that they could not talk English. We could not find a camp site and at 5:30 pulled up on a mosquitoey bank and decided to move on to an old saw mill a little farther down steam. It is a beautiful place, and we decided to camp for a day and provision at Ekdall about three miles away. We made camp after six and had supper at 8:00.

The night was cold and we slept uncommonly well, and were all out at 6:30.

About nine Dad, Bill, How, Clay and Fred started for Ekdall. Ekdall is on the map in one place and exists in about two,—a store and a post office a mile and a half apart. We bought

Dried Apples
Shoes and Socks for How
Socks for Clay

Dad sent home a box of photographic plates and bead work we had bought of the Indians.

The place was four miles away, the sun was hot, and we were all tired when we reached camp, a little after noon. We had two of the chickens which bought of Wright, tomatoes, stewed with our two weeks' old rolls.

It was so hot that no one wanted to do anything after dinner, and we dozed around,—then Dad, Clay, Carl and Bill washed clothes.

Bill and Dad shaved, and just then the head of the drive appeared around the bend of the river. First came the timekeeper and he went off after supplies; then came a Wannigan boat which tied just above our camp. They all came over and evidently wanted our camp ground. There came one or two bateaux breaking centers and wings. They passed us by,—mostly boys and Indians and a few old rivermen. The second Wannigan, a flat boat, passed, and then came the rear, and they cleaned up some large logs in front of our camp. I made pictures as fast as I could, taking chance shots. The drive has passed us and the water had fallen nearly a foot by evening.

Music by Clay, & Bill after supper.

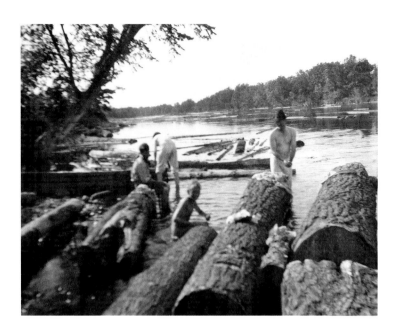

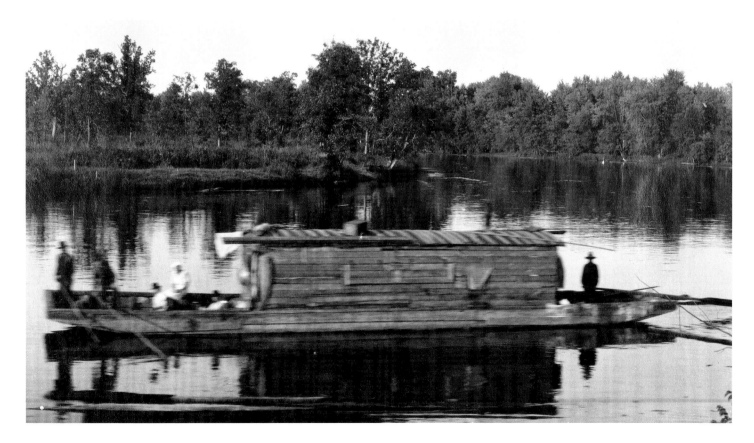

Fred and Martin tell us stories of the lumbermen and woods. Queer expressions, like

"Yankee punk" came in.
"I heard the Yankee punk last night."

remarks a Jack to his bunkie. This is a way of saying that he is going to get his time and quit.

Fred told us to-night of a Jack who had come out of the woods hanging about Iron Mountain, drinking for several weeks. He got bragging he could lick anything, and one remark leading to another a fight was arranged between the jack and a big Newfoundland dog. Rules barred the jack from choking the dog, but allowed him to bite or throw the dog about. The fight took place in the back room of a saloon, and the man won the fight and five dollars.

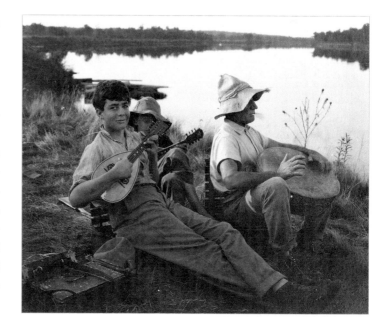

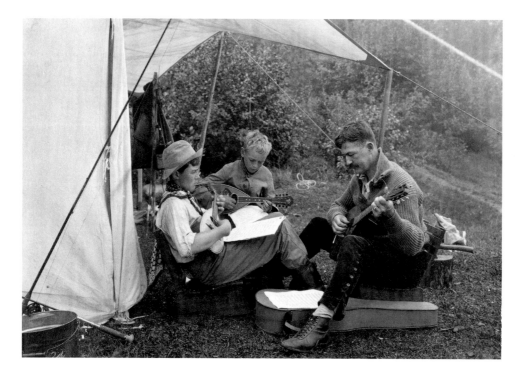

AUGUST 29-

In the morning Bill, Doc and How went fishing without luck, but had a nice trip up stream. Dad, Clay and Carl in camp. Doc working on a tent fly. The only incident of the morning was a visit from the owner of a nearby saw mill, (capacity 15 to 20M a day), and a visit to his mill. They are paying for Jack pine about $10.00 to $10.50 per M in bolt.

In the afternoon, How, Doc and Bill worked with Dad on the tent fly. Then How went out to learn the secret art of handling stern paddle. There is a colony of owls here about, and Howard had three rifle shots at them. He pulled feathers twice, but did not get his bird.

In the evening, Doc, Dad and How went after the owls with a gun, and How had two gun shots both of which he missed.

AUGUST 30, '07.

We awoke to a foggy, misty morning. We were packed and off at 8:30, and drifted along slowly for the first mile, looking for owls. About three miles down we struck the drive and ran our first rapid. Howard and Dad took in a good deal of water. The jacks were greatly interested in our little boats in the rough water.

Our men borrowed a bateau to carry our luggage through the Kettle Rapids and Fred took our own wannigan through empty. What looks to be nearly the whole drive is held up at these rapids. Large wings and centers have formed, and the water is rough and quick.

We stopped about 12:30 or so at a camp and met our old friend, M. Moffat, whom we saw at the St. Croix Dam. We had a good lunch. Below us was the worst of the rapids and we went through one by one.

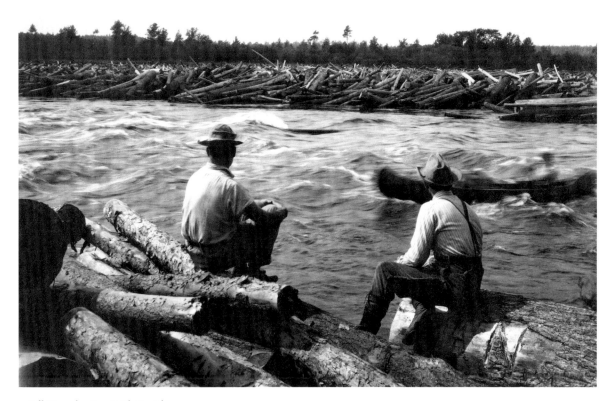

Bill Marr shooting Kettle Rapids

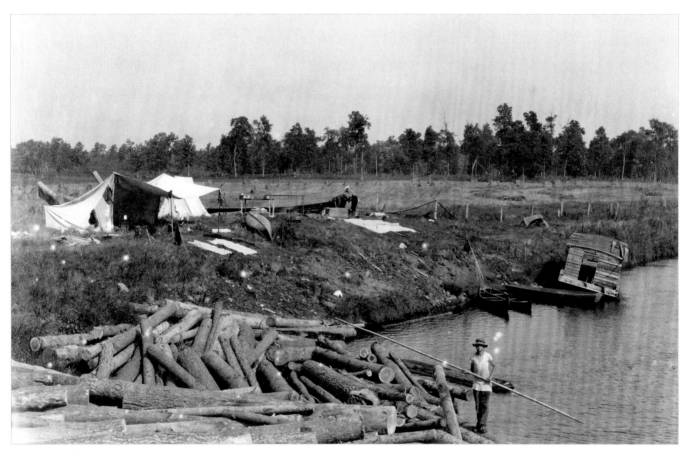

Camp near Northern Pacific bridge

Howard chose the roughest place and took in considerable water.

Just off the river trail is a young growth of hard maple and ironwood,—very close and with a fine carpet of ferns, etc. Doc found it and Dad tried to make a picture.

We had intended stopping at the road leading to Grantsburg at about 4 P.M., going in for mail and express and returning in the evening, but Bill had asked Fred to run to the R.R. bridge. Our total day's travel was about 25 miles, (no less). How's canoe got to camp about half past six, and the rest came in about an hour later. They had found a bass hole and had excellent fishing.

We are camped along the Northern Pacific right-of-way, in a hot sunny camp. There is a good farm near by. This morning Bill, Fred and Dad will go to town, (Grantsburg) to lay in supplies, get mail, etc. There is only one train which goes up at 11 and returns at 12:00. We have twenty minutes to do our buying. We are about five miles from the main line, (St. Paul to Duluth), and on the Minnesota side.

Bill will go home Monday. We shall probably go down stream to spend Sunday.

AUGUST 31, '07.

Last Journal ended at our Camp #9.

The Northern Pacific crosses the St. Croix about our camp. Once a day on week days a combination freight,

passenger, mail and express train goes from Rush City, Minn. to Grantsburg, passing here about 11 o'clock, more or less, and returning, passes Camp at about 12:30 noon.

Fred, Bill and Dad took the train. Bill took his "Carry All" to the platform where trains are signaled to have it there if wanted on his return. On second thought he concluded to take it to Grantsburg, and Carl was to meet him on the return to give him his creel, etc., in case he went through. It was hard for Bill to make up his mind, and harder yet to say good-bye to the camp, but he showed signs of going.

At Grantsburg the depot platform swarmed. The drive had been a failure. Moffat and the lower crew were going out and a lot of people were going to the State Fair at Minneapolis. During the fifteen minutes' stop of the train, Dad had only time to get his two express packages, (rifle and film), and send a telegram to Capt. Howland (subject to delay in transit on account of the strike). Bill got the mail and reported that he was going home. No bad news, but thought it was best.

We got the prints from the first two packs of film, 23 good pictures, which were enjoyed by all the camp.

Bill and Dad sat on the car steps and looked at pictures. Carl met us at the flag platform with Bill's creel,—and Bill was gone.

The afternoon started in hot and sultry. Dad went to the river to wash some clothes and bathe. Howard followed and soon came Doc & Clay. We loosened logs from the jam and tried riding, always ending in a tumble. Finally the game appealed to Martin's lumberjack sympathy and he came in to teach the boys to dance a log. We were in the water an hour and a half and were merely cool and sleepy afterward.

We went to bed early. The first part of the night was warm and no one slept well at first.

NORTHERN PACIFIC RIGHT-OF-WAY
AT BRIDGE ACROSS ST. CROIX RIVER
MINNESOTA.

Carl is washing his shirt this morning because it has become offensive to the camp and he is chasing about camp in his usual negligee of breeches and nothing.

SEPT. 1, '07.

We plan to make St. Croix Falls about Saturday.

The morning was spent about Camp. I used Viscol on all my leather goods. Doc & Clay went walking. Fred went to Benson's Siding for supplies, if he could get them, and to get a letter mailed. He came back with supplies.

At lunch Doc and Dad tried to enforce the rule of boys on one side of the table. It ended in a running fight, the boys doing the running. Clay took refuge in his canoe, from which vantage point he talked back. Doc up and after him, running into the water a few steps, catching his canoe and turning him over in the stream.

Supper consisted of

> Fried Salt Pork with slumgullion
> Baking Powder Biscuit & Syrup

The evening is cool.

Carl and Fred travel in Bill's boat.

All sat around the camp fire and heard stories of the woods people, and a general discussion of the various kinds of vermin that beset humankind in the woods.

A cold night.

MONDAY, SEPT. 2, '07.

The day has been a lazy one for all concerned except Martin, who had butchered wood and baked pies all day long.

"Doc's Tormenters"

Dad

We left our camp at 12:30 and paddled slowly down stream, favored by a North wind. We went about five miles and camped at the very end of Burnett County. Our #10 Camp is on a beautiful table land, a point on the river beside a brook trout stream but no trout.

We scared up two woodcock and later saw a flock of prairie chicken flying across the stream. Cope and How were after them and brought back two from the Minnesota shore. Doves are plenty and How shot one, thinking it was a wild pigeon. The river is much prettier than it was above.

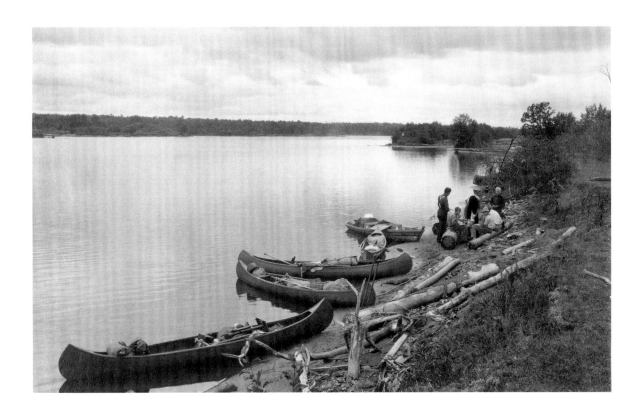

Doc went walking,—so did Howard and Dad. Then all sat around while Dad shaved. Doc drew pictures and the boys bothered.

In the afternoon the boys bothered. How and Dad went walking. Clay went walking. Fred, Cope, How and Dad shot off a score with the 30-30 Martin and decided it was not properly targeted.

How and Clay studied a *little* German,—a *very* little.

To-morrow we go down about ten miles to the Trader River, where we hope to find a good camping site.

Over the camp fire to-night Fred related a story told of John LeMais, a Canuck Cedar jobber of Escanaba, Michigan. LeMais is rich now, but at this time he was only "A hay wire jobber," and had a little camp. He had gone to town and returning was lost just back of his own camp. He could not raise a sound out of the wilderness but the echo of his "hello." A big owl went, "Hoot."

"I am John LeMais."

"Hoot"

"I am John LeMais from Escanabay"

"Hoot"

"I am John LeMais from Escanabay ze big ceday Job-bay. I am lost in ze wood." His cook heard him and told the story.

TUESDAY, SEPT. 3.

We made a late start,—9:30, and with a good current travelled rapidly. The wind was at our backs and the boys made sails of coats and ponchos and by noon we had made six miles easy and tied up for lunch. The country is becoming civilized and uninteresting.

After lunch we began to feel the back water of a dam. The Trader River is behind a boom and tangle of over-flown land. We made our Camp #11 on the Minnesota side in a beautiful wood. On the upland is a prosperous

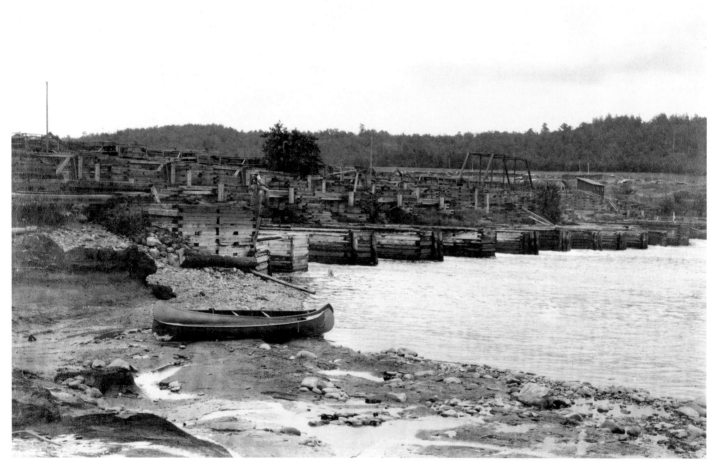

Nevers Dam

looking farm. We had our stuff unloaded by 4:00 o'clock, so Cope and I started for the village of Wolf Creek which lies on the Wisconsin side somewhat below us. How said he could go too and then the other fellows tagged along, but as they not only over-loaded the canoe but monkeyed, Clay and Carl were set ashore and allowed to make their way back to camp. Clay tried log dancing and wet the whole outfit of clothes he was wearing.

Cope, How and I went about two miles below camp

before we could make the Wisconsin shore and then walked to the Village where Howard wrote a postal to his mother, Cope sent one to Jack. We bought flour at a mill and sugar, peaches, gingersnaps, candy and peanuts at the store. We made the trip in two hours.

Supper was late and then rain began to fall so we went to bed. On our trip down river we found plenty of duck and so Howard and Cope planned to go down early in the morning with their guns.

WEDNESDAY, SEPT. 4 '07,

Cope and Howard failed to get anything this morning. They saw duck but could not drop their paddles in time to shoot. We left the old camp at 10 o'clock and paddled down to the dam. We found we could make our way through the end of the log jam and then the portaging of the dam was easy. We stopped for lunch. The dam is sixteen feet high. The damkeeper opened one and then another sluiceway and we spent our time trying to get our stuff higher and higher up the bank.

There is a peat or lignite formation on the Minnesota side, but I could see no trace of it on the Wisconsin side. Below the peat is a sand formation stratified and nearly turned to stone and in places tilted. I made a number of pictures.

The dam was opened to give water to float two steamers stranded below St. Croix Falls. They tell us that the dam at St. Croix Falls is 50' high and the back water extends to this dam when the river is full.

At 3:00 o'clock we loaded and pulled out. There is a big back eddy and there is a half million feet of logs going through the dam. We dropped down about a mile and a half and camped on a flat on the Minnesota shore. There is a wooded bluff about 800 feet back from the river.

THURSDAY, SEPT. 5, 1907.

We made St. Croix Falls at noon in a light rain. We found that by hurrying a little we could catch a train for St. Paul right after lunch.

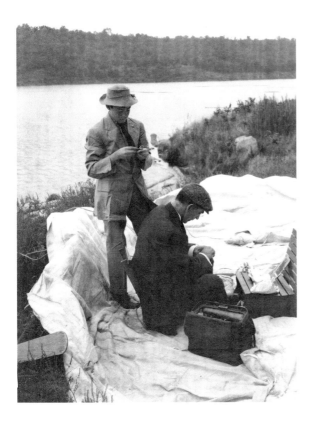

We had a nice ride to Dresser Junction and had supper in St. Paul. Fred and Martin were to pack and ship our camp outfit. For weeks it did not come, then it began to drift in from Gordon, St. Croix and elsewhere. The fact is that the boys felt bad when we left them and they proceeded to drown their sorrow. They drowned so much sorrow that our outfit was really never recovered. Then there was a fight of which I never learned much, but this I know, that Fred explained the condition of his face to his wife by saying he had gone over St. Croix Falls.

MAY 26, 1909.

Martin's old enemy, "King Alcohol," has finally got the best of him. Last Winter Martin was working in the Camp near Wausaukee when he got on his last drunk. As usual with Martin it was a case of snakes and he went off into the woods where he was found dead.

THE GANG ON THE
PRESQUE ISLE RIVER

1909

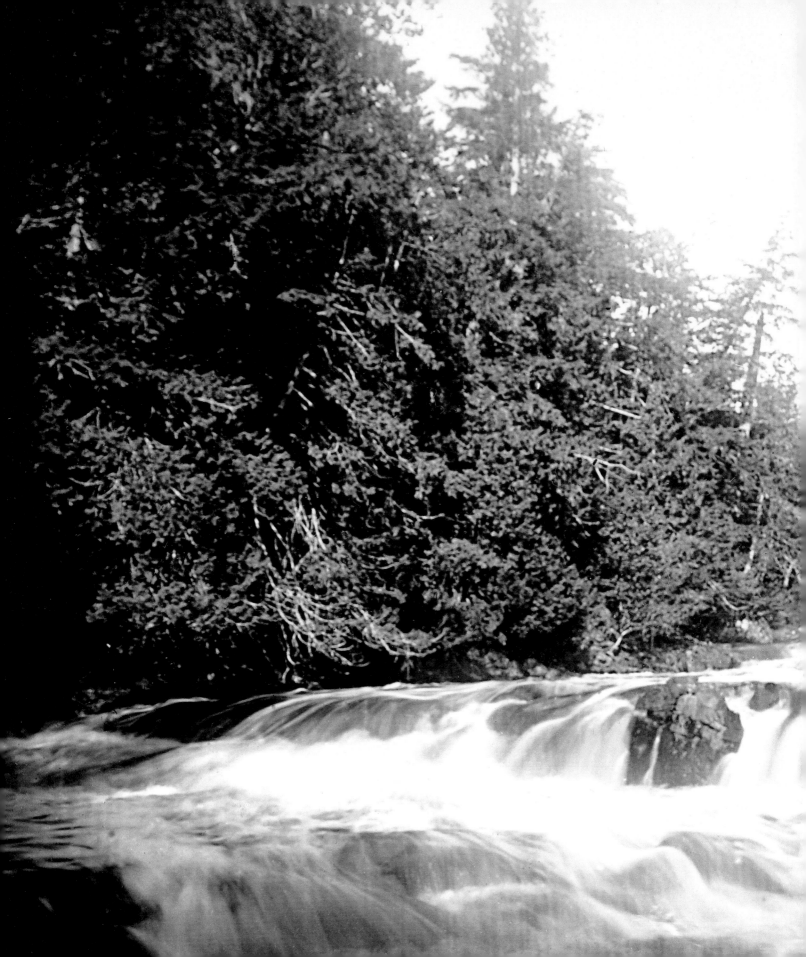

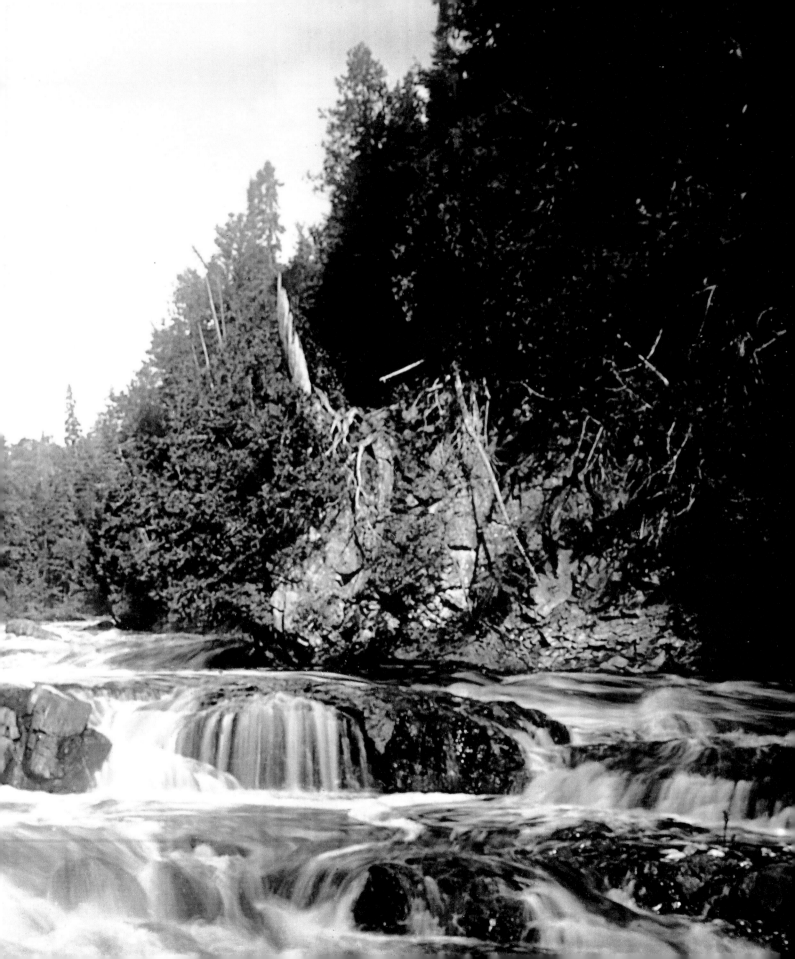

THE GANG
ON THE
PRESQUE ISLE RIVER
1909

In 1909, northern Michigan (now called the Upper Peninsula) was mostly wild country and rivers. Within today's Porcupine Mountains Wilderness State Park are old-growth forests and wild rivers cascading down to Lake Superior. On the eastern edge of the park lies the Presque Isle River, bordered by hiking trails and visited by both hikers and tourists entering the park by car. Many years ago when I first came upon the Presque Isle, I found it beautiful but intimidating, even from the safety of a well-traveled footpath.

A second trip to the Presque Isle, with Howard Greene's journal in hand, began as innocently as his trip, stopping at the former railway crossing in Marenisco and seeing scenes very similar to the town he saw more than a hundred years ago. A side trip to Yondota Falls outside town jogged my memory of seeing the waterfalls on the lower part of the river, leaving me to wonder how it might have been for Dad and the Gang to see Yondota as one of the only impediments to paddling the river, and then to be thrown into the continuous strong currents, rapids, and waterfalls that characterize the Presque Isle's steep descent to Lake Superior—and to have no way out but to continue on.

Adding to the peril of this 1909 trip was a torrential rainstorm in the area on July 25, 1909. The *Glidden Enterprise* of July 28, 1909, reported a "fierce rainstorm, a continual pour of rain for twenty-four hours. Which raised Bad and White Rivers to overflowing their banks, washing away bridges, culverts and dams. . . . At Morse the water is over the tracks to the depth of eighteen inches at the depot. . . . Ashland is cut off from the outside world, it cannot be reached by rail from any direction and the losses there alone amount to a half a million." A note from the Ashland Experimental Farm reported total July precipitation at 9.31 inches, with 4.9 inches of that total coming in one twenty-four-hour period.

In the journal Dad refers to reports of heavy rains but may not have had access to enough information before they left Milwaukee on July 30 to gauge the full impact. Even when they learned that the area had experienced heavy rains, they couldn't know how that would affect the river they planned to paddle.

With Dad's trip journal in mind, I returned to the steep banks of the Presque Isle River. Watching the current hastily snatch chunks of driftwood and immediately carry them out of sight, I was far more impressed than on my first visit so many years earlier. How did the Gang survive?

The Gang survived, in good health, with no major or permanent injury. The Presque Isle became the bar by which all other trips and experiences were measured. They were never as hard and were often pale in comparison.

This journal includes fewer photographs than some of the other journals. The Gang's focus on the task of canoeing eclipsed taking pictures. Also, the photography outfit got soaked in the rapids—some images were lost.

Not all was lost, however. Dad's notes and enough images of the trip survived to give a reader a very rare opportunity to canoe the Presque Isle River.

[M.G.P.]

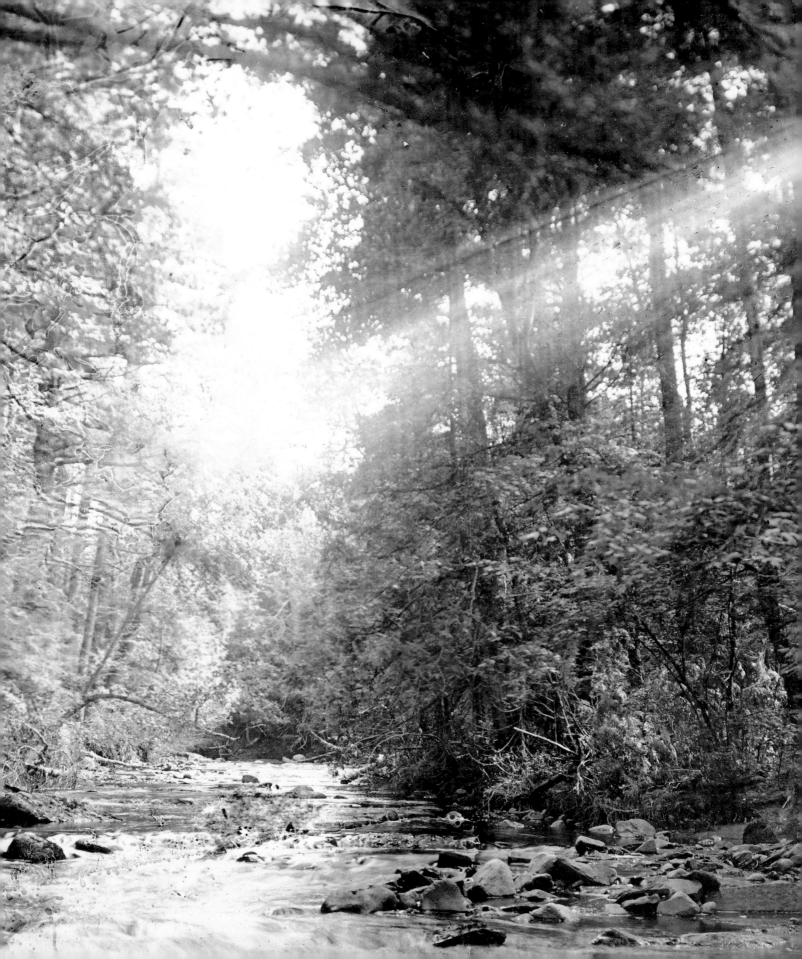

THE GANG ON THE
PRESQUE ISLE RIVER
1909

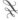

Of this journal seven illustrated copies have been printed,
numbered from one to seven and owned by:

————————

No. 1—Ernest Copeland

No. 2—William P. Marr

No. 3—Howard Greene

No. 4—Howard T. Greene

No. 5—Charles Greene

No. 6—William MacLaren

No. 7—Charles F. Ilsley

————————

A few copies without illustrations are reserved for private distribution.

MILWAUKEE, DECEMBER 25, 1909.

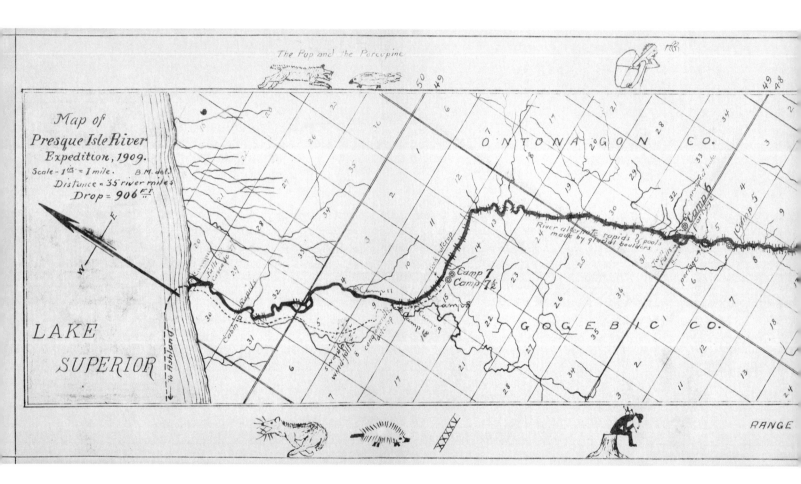

The Pup and the Porcupine

Map of
Presque Isle River
Expedition, 1909.
Scale - 1 in. = 1 mile. B.M. del.
Distance = 35 river miles
Drop = 906 Ft.

LAKE
SUPERIOR

ONTONAGON CO.

GOGEBIC CO.

River alternate rapids & pools
made by glacial boulders

Camp 7
Camp 7½

Camp 6

RANGE

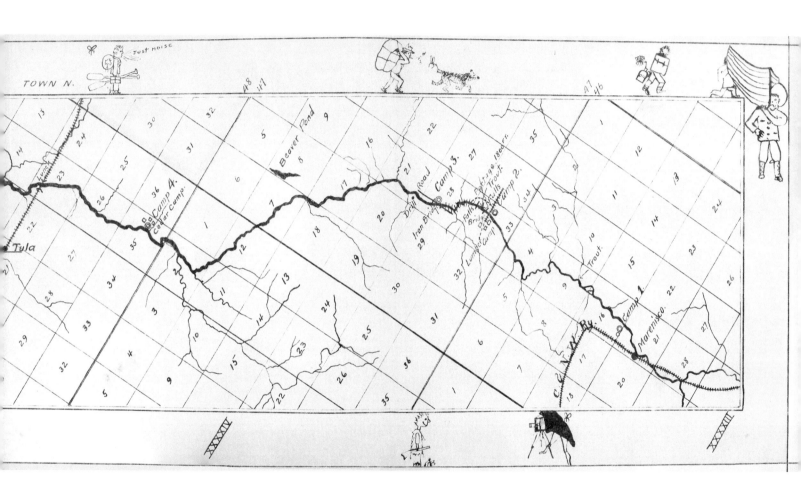

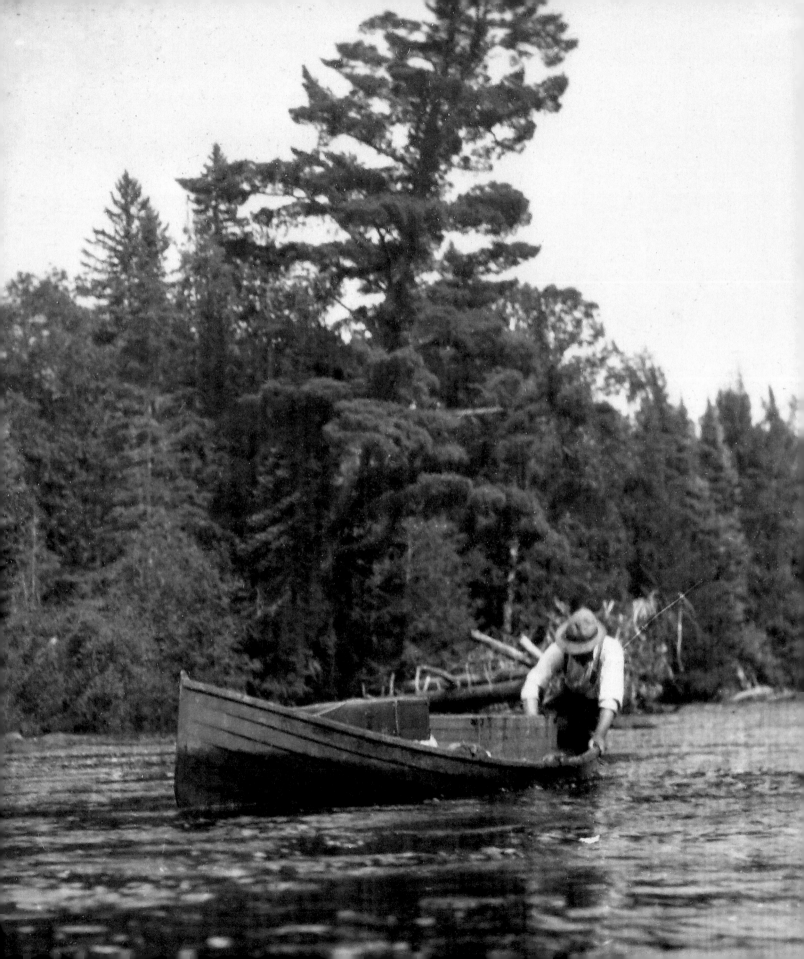

THE PRESQUE ISLE RIVER TRIP — 1909

In casting about for a new scene of operation "The Gang's" attention was drawn to the south shore of Lake Superior where the frequency of rivers and the scarcity of towns indicated a well watered, unsettled country. The longest stream of all appeared to be the Presque Isle River and it was more attractive than other rivers because there was only one town on its entire length.

I wrote to my friend, Fred W. Foster, of the Foster Lumber Company, operating at Fosterville, Wisconsin, to know whether the stream was navigable and I expected a prompt and definite reply as to the character of the country traversed, but Fred could only tell me that their Company's mill pond was formed by the River and that below the mills was an extensive windfall, making the stream impassable for several miles. He advised that we start at Marenisco where the stream would certainly be large enough to float canoes.

I then wrote another friend, Capt. Ernest A. Scott of Ashland, whom I thought could learn something of the country from lumbering men or timber cruisers at Ashland. He wrote me concerning the River:

"I am told that you will have a hard trip down the River, especially if the water is low, as there are many rapids and falls, as well as windfalls across the Creek. * * * * * * Ashland and Ontonagon are the nearest towns, Ashland being forty-five or fifty miles away and Ontonagon a little less, but Ashland would be better, as you would have better scenery and better railroad connections when you did get out. There are no fishing settlements there but you would find fishermen's houses along the Lake. You would not be likely to meet any tugs or boats, as the big boats pass about twelve miles out. You might catch a tug at the mouth of Montreal River or Bad River, as they haul logs from there."

In a later letter Capt. Scott said:

"I talked with a man today that has often been to the Presque River and he says that it will be impossible for you to make a canoe trip down the Presque River. He says that there are miles of rapids at a stretch and the brush on the sides of the Creek so thick you would find it impossible to portage past the rapids. He says, if you want a fine trip, start from here with a gasoline launch and go to the Presque. I don't want to discourage you about the trip, but would advise you to look into it thoroughly before you attempt to go down the River. I am told the scenery around the Presque is wonderful and that you can catch all the fish you want."

Through Senator Kreutzer we learned of one T. I. Laughlin of Eagle River, Wisconsin, a timber broker, and we wrote to him for information in regard to the River. He replied:

"In my judgment, you could not have selected a more interesting canoe route in all of Michigan. You will not be able to traverse the upper River, that is from Fosterville to Marenisco, in canoes, but you can put your boats in the main river at Merenisco, and will meet with but few slight obstructions where it will be necessary to portage your boats and other equipage a short distance. Aside from those (I call them) diversions, you will have a most enjoyable trip if weather conditions are

favorable. For about a mile inland from the mouth of the River, you will find just the place you want to camp in for the balance of the summer."

The information, forwarded to Bill, brought this comment:

"It will probably be good fishing and not frequented by tourists with sunshades and long armed gloves. It looks good to me—perhaps not enough water for canoes, but a nice short trip where we can take our time about moving along."

To "The Gang" of three preceding years was added Mr. William MacLaren, who appears hereafter as Billy or Billy Mac. About a week before we were to leave, Clay was taken ill with typhoid fever and his place was filled by Charles I. Ilsley.

Through Mr. R. H. Pangborn of the Peninsular Box & Lumber Company, we secured the services of Fred Carr, who is familiar with the ways of the woods, and Joe Paris, who is to cook and help about camp.

Our maps were obtained from G. F. Sanborn & Co. of Ashland. They are apparently made up from the Government Survey notes.

HOWARD GREENE.
Keeper of the Journal.

CIRCULAR OF INFORMATION:

All available members of "The Gang" of the years 1906, 1907 and 1908 with the addition of

Piffy Ilsley and
Billy Mac

will leave Milwaukee at 8:40 P.M. on Friday, July 30, '09, from the Chicago and North Western Depot.

Bill Marr gives notice that he will quit at the mouth of the Presque Isle River on Tuesday, August Eleventh.

On Sunday, August Twenty-Second, a tug will be sent to the Presque Isle River for the rest of the party. Sleeping accommodations have been engaged on the train leaving Ashland that evening.

Mail for the party may be sent in care of Capt. E. A. Scott, Ashland, who will forward it on the launch which takes Bill Marr on the 11th.

In case it becomes necessary to reach any of us see Mr. F. W. Dickens of the Fidelity Trust Company, who will know how to get word to us.

CARL GREENE,
Clerk.

THE JOURNAL.

The assembly of "The Gang" commenced at noon with the arrival of Howard to do sundry last errands. Carl was to leave the farm with the dog Nimrod at 6:20 P.M., and reaching Milwaukee at 7:30, would be in plenty of time to join Cope, How and Dad at the University Club. A telephone message came that Carl's train was late and would not arrive until 8:15, so Cope took a carriage to meet him while How and Dad shook off the last of their city clothes and went to the office to pick up the camera cases and await Cope, Nim and Carl. All were assembled at the depot at 8:30, where we found Mr. and Mrs. Ilsley and Myron MacLaren, who had come to see us off.

For an instant the porter looked dismayed at the packs, but a little silver lubrication brought forth a smile and our stuff was safely stored away.

All the men were thirsty and no one had a thing to drink until the porter brought in some beer for us at Sheboygan—and how good it tasted!

We were up in time to see the Wisconsin River at the railroad bridge above Rummeles where Clay and Dad left the rest of the party for their "Farthest North" expedition on the trip of 1906.

At Watersmeet, 292 miles from Milwaukee, we left the train to take a local freight for Marenisco, which is 30 miles further west. We had breakfast and waited for a train to be made up and cars loaded for various lumber camps along the line. There had been a cloudburst near Ashland the week before, the line was washed out and all the streams were in full flood. We left Watersmeet two hours behind schedule. An obliging train crew let us have the lookout seats in the caboose and we had beautiful views of new country with no towns and only occasional clearings. At noon we reached Marenisco where our two men, Fred Carr and Joe Paris, met us. They had gathered our baggage and established a camp a half mile below on a cut-over hillside.

Chicago and Northwestern Depot, Milwaukee

CAMP NO. 1.

The amount of baggage looked impossible to transport, but we had seen that sort of thing before. We had a light mess of

<div align="center">

Rye bread,

Bacon,

Boiled potatoes,

Tea.

</div>

After mess Billy Mac and Dad opened up mess stores, filled grub bags and grub cans, fitted the field cooking outfit and showed the men how to utilize our various utensils, while Bill and Doc carried the big tent to the top of the hill and pitched it.

The river has a broad valley, the hills are wooded and the view across the valley is very fine. The river itself is tortuous and just now is in full flood.

For dinner we had

<div align="center">

Corned beef hash and onions,

Beer furnished by Cope,

Bread,

Rice with flies,

</div>

and it was all good.

In the evening we went up town to get someone for an emergency address and to learn what we could about the stream. There was no station agent there. We were told that E. A. Ormes, a general merchant, looked after miscellaneous business in the freight and express line. We found that Mr. Ormes was a Chapter Mason, and he offered his fraternal offices in forwarding any emergency message that might come. A telegram could be sent to him via Gogebic, which is thirteen miles to the East, or via Wakefield, which is eleven miles to the West, and it would be repeated to the Gogebic Lumber Company by their private line. We bought sundry supplies and arranged with the Gogebic Lumber Co. store to furnish us with oleo, for ours had not come.

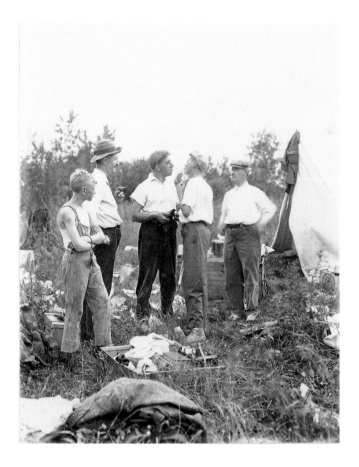

We got the most varied information on the subject of the River. This seems to be pretty well established,— that the River is clear for eight river miles, then there is a rapid. The book-keeper at the Gogebic Lumber Co.'s store showed us some pictures he had made of the rapid at high water. They indicate a sheer fall at one place and plenty of rapid water. They told us that an old lumber camp was near at hand and a well worn trail afforded an easy portage. The length of the portage is said to be all the way from a quarter of a mile to two miles, and the fall from eighteen feet to fifty feet. Mr. Ormes told us that several parties had started down and had come

back, but, he said, "I don't believe they knew how to handle boats or they would have found out what the River was like." Some people told us that the River from the rapids to the Duluth, South Shore & Atlantic Ry. bridge is good water.

We turned in about nine o'clock and fed mosquitoes all night. No one slept and Nim was miserable. There was one night on the Wisconsin River, in 1906, on our trip from our first camp to Eagle River, when we slept beneath a fly—which was much worse than this night.

Everyone was out of blankets at five o'clock.

This was the order of sleeping in the big tent:

D O C	H O W	B I L L	C A R L L	B I L L Y MAC	P I F F Y	D A D

Front of Tent.

Doc and the boys started out for raspberries and before they had many berries rain began to fall. It rained until about eleven o'clock and everything was so wet that we decided to remain here until Monday.

The men lighted a fire under our tent awning and we had breakfast of

Coffee,
Pancakes,
Rice with flies served cold,
Bacon,
Raspberries.

After the rain ceased we went to Marenisco and bought beef, eggs and lemons of the Gogebic Lumber Company. We got good fresh water at a pump near the town, for the river water was dirty from the flood.

Doc and Bill went fishing and for a two o'clock Sunday dinner we had

Fried rice with flies in croquettes,
Trout,
Bread,
Fried potatoes,
Apple pie,
Prunes.

Making biscuits

In the afternoon we sorted over our baggage to reduce it by everything which we could leave out. We dropped out for shipment the following day:

All the musical instruments,
An extra blanket of Cope's,
How's tackle box,
The film developing outfit,
The blue printing outfit,
Some extra tools,
Extra trousers of Cope's and Dad's,
Carl's tackle box.

Billy Mac promises to supply the shortage in tackle.

We had two callers. Mr. Ormes, who rode up on his Indian pony, told us that our oleo came in last night by local freight from Wakefield. This was good news, for we had a better quality of grease than we could get here. Our second caller carried a load of poor booze and told us of a boat he had lost on the river during the recent flood.

There was a game of baseball in the afternoon at Marenisco between the married and single men. The score was 7 to 8 in favor of the bachelors. It was as noisy as a game could be.

For supper we had

Fried eggs,
Trout,
Prunes.

We turned in at eight o'clock in a well smudged tent and slept splendidly.

MONDAY, AUGUST 2.

We were up a little before six, and commenced to air and pack our baggage. Fred made up boxes of our surplus stuff and shipped it home from Marenisco. At 12 noon we had dinner of

Broiled beefsteak,
Apple pie,
Prunes,
Boiled potatoes,
Tomatoes,
Bread.

The only replenishing of supplies was to buy

Yeast cakes,
Dried apples.

The former we should have bought at Milwaukee, and the quantity on the latter should have been five pounds for a cook who can bake pies.

At half past one our boats were loaded. Bill's canoe carried the medium sized chest; the two other chests were in the bateau. We were loaded full, but in smooth water we can carry everything. On another trip by canoe in a new country we ought to leave our mess chests and grub cans and in place of them take paraffined food bags packed in waterproofed sacks. These would pack lower in the canoes and could be portaged in a pack strap.

We drew lots for partners, and traveled in this way:

Bill and Howard,
Cope, Nimrod and Carl,
Billy Mac and Joe,
Dad and Piffy,
Fred in the Wangan bateau.

We shall keep close together as the boats are heavy, and the contradictory stories we have heard warn us that the River is unknown and the safest way to travel.

The River banks are low and wooded to the shore with spruce, cedar, soft and hard maple. In places there is a lot of good cedar in quantity to warrant cutting.

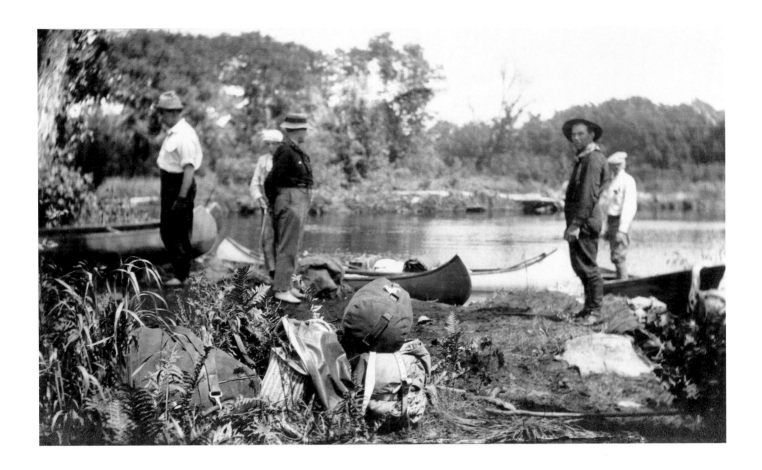

Here and there we found traces of roads cut to the water's edge but we saw no indication that the stream had ever been driven. The drift wood was mostly old tree trunks and branches mixed with a little slab from the mill at Marenisco.

The River was about two feet higher than normal and with a full current we traveled rapidly. At half past three we came to an old camp and stopped to take a look. A spur from the C. & N.-W. Ry. crosses the river and extends a mile south. There was a jam of driftwood at the bridge, which Fred broke with his pike pole and we camped on the south bank just below the bridge.

CAMP NO. 2.

Below us was a rapid, a fall, and then a cascade in a rocky gorge through which the river tumbled end over end. Only a little of the country had been cleared and the camps were abandoned at least two years ago. It was a big camp, badly managed and a lot of good material rotting among beer kegs told the whole story.

An exploration of the river below showed an old work road trail around the falls on the south side, making a hard portage three-quarters of a mile long. The trail was beautiful and passed through a heavy growth of cedar and spruce with some hard wood. We planned

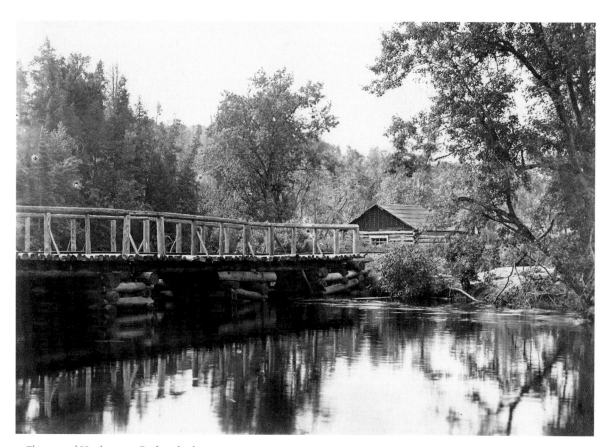

Chicago and Northwestern Railway bridge

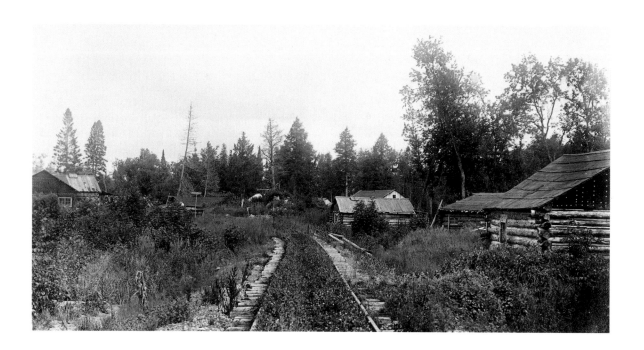

to stay here one day at least for a portage and possibly two days if fishing is good.

While Joe prepared supper, Bill, Cope and Billy Mac tried their rods and brought to camp a few trout. Mosquitoes are thick but if we have a fairly cool night we will be comfortable.

The night was warm and the mosquitoes attended us in full force. We were all up and out at five and fought mosquitoes and flies until breakfast was ready. The flood of two weeks ago made a breeding spot of every low place in the woods and millions of mosquitoes came to life every warm day.

We had for breakfast,

Coffee,
Prunes,
Trout,
Fried potatoes,
Oatmeal.

Joe set dough for bread last night and baked today.

For dinner we had

Steak hash with onions,
Baking powder biscuits.

In the morning everyone went fishing except Dad, who wrote journal and made some pictures along the upper part of the falls. This was a slow piece of work, for the points of view are along the rapids on wet rocks difficult to reach with a camera in hand.

In the driftwood above camp there lay a light, clinker built boat which Howard loosened from its place, and with some help brought to camp. It was jammed and leaky, but with some repairs could be made to serve us as an extra wangan, which we ought to have for working our way through rough water.

In the course of his fishing along the bank, Cope found a pool which he proceeded to utilize as a bath tub. In the afternoon Bill, Piffy and How went down to bathe and came back to complain of the "smelly" condition of the rest of the camp.

After dinner Fred explored the trail where we shall have to make our portage and to gain such knowledge as he could of the River beyond. He reported that below the cascade there was rapid water for about two miles; then an iron bridge where he met a man who was teaming for a diamond drill outfit, working in the vicinity.

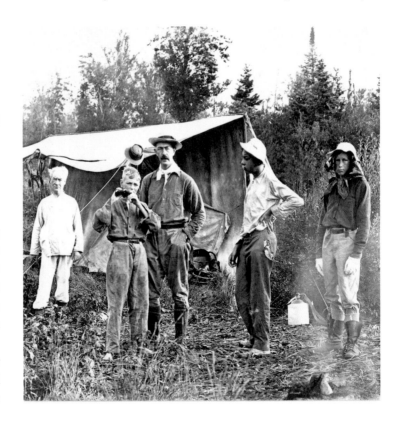

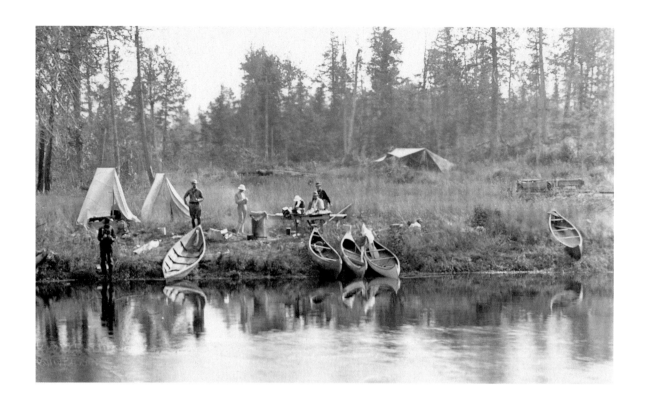

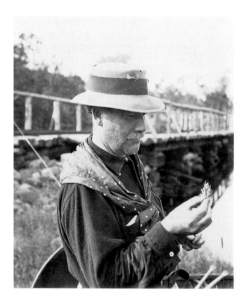

Bill Marr

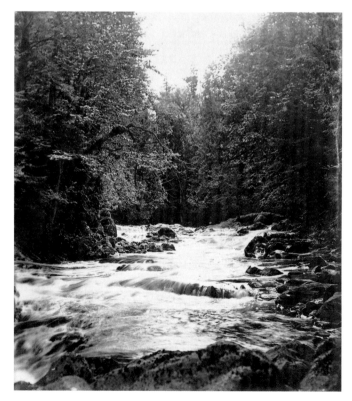

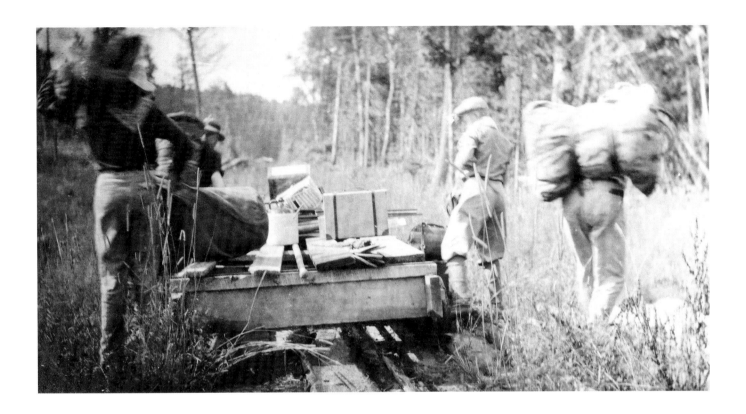

Supper time we had

> Trout and bacon,
> Raspberry pie,
> Baking powder biscuit,
> Pancakes,
> Fried potatoes,

In the afternoon Dad made more pictures and then developed twenty-two plates,[1] getting twenty good negatives. The evening was rainy and the mosquitoes did good work in keeping us from resting.

[1] Although Dad reported sending his developing outfit back to Milwaukee, he must have brought some materials to develop negatives on the trail.

WEDNESDAY, AUGUST 4.

We were all out early getting ready for the portage and after a breakfast of

> Raspberry pie,
> Bread,
> Pettijohns,
> Berries,
> Coffee,
> Prunes,
> Apple sauce
> Bacon and trout,

Joe makes excellent bread.

The boys found an old push car and ran it up to the camp where we loaded it with bedding, etc., and shoved

it along about four hundred feet to where the trail com-
menced. Fred and Bill portaged the canoes and the rest
of us made three trips across during the morning, and
returned to camp about half past eleven for a fine din-
ner of

<div style="text-align:center">

Dynamite soup,

Bacon,

Trout,

Boiled potatoes,

</div>

and we again tackled the portage. The men, Joe and
Fred, portaged the boats, chest and mess outfit. We
had a long rest in the woods where Dad made two pic-
tures of the tangled growth, while the men carried their
loads across, and at four we started down stream. It was

continuous rapid water for two or three miles and even
with the help of the high water we had to be in and out
of our canoes all the time. The banks were steep and
wooded to the water's edge with spruce, cedar and bal-
sam, all of which was very pretty, but we caught only
glimpses of it, for our eyes were on the water and the
sudden turns and twists of the river.

CAMP NO. 3.

At about a quarter to five we were all at the bridge and
soon the wangans came in. There was a little cleared
space, at the top of a little hill where an engineering
party camped while making a river survey. From marks
on a tree at our last camp it appeared that the party

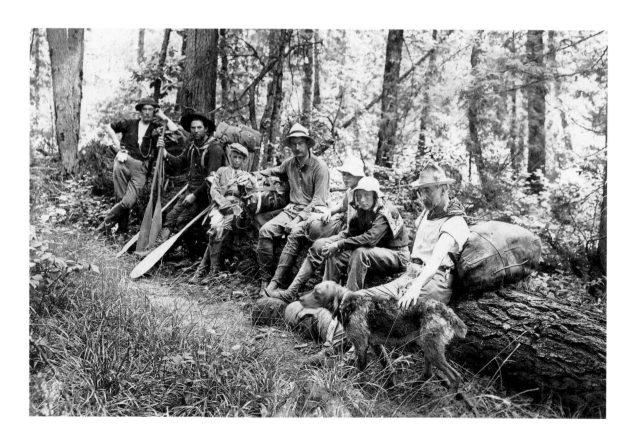

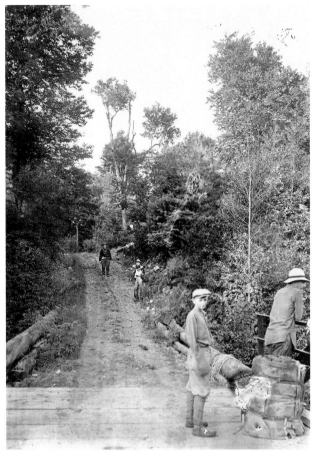

came from Madison, Wisconsin, and that they were mapping the river. We found that some levels had been taken about the falls. It was a clean spot and we camped where they had camped, utilizing their tables, seats and tent stakes.

We had supper of

> Bacon and trout,
> Fried potatoes,
> Bread,
> Tea.

We are using more tea than on any of our previous trips.

This camp was reasonably free from mosquitoes.

THURSDAY, AUGUST 5.

We passed a fairly comfortable night, for the mosquitoes were not so thick on the high land at our camp. We found a sign nailed on a tree, showing the section line between 21 and 21 crossed the road 60 rods to the North and that the corner was 60 paces to the East. Bill and Dad located the corner, which had been marked very recently by survey. A passing teamster told us we were in the N.W. of the N.W. of Section 28.

Those of us who slept late were awakened by the cries of a dog in pain. In a flash Carl was out of his blanket and came back to report:

"They are pulling Nimmy's teeth out with forceps!"

"Who are?"

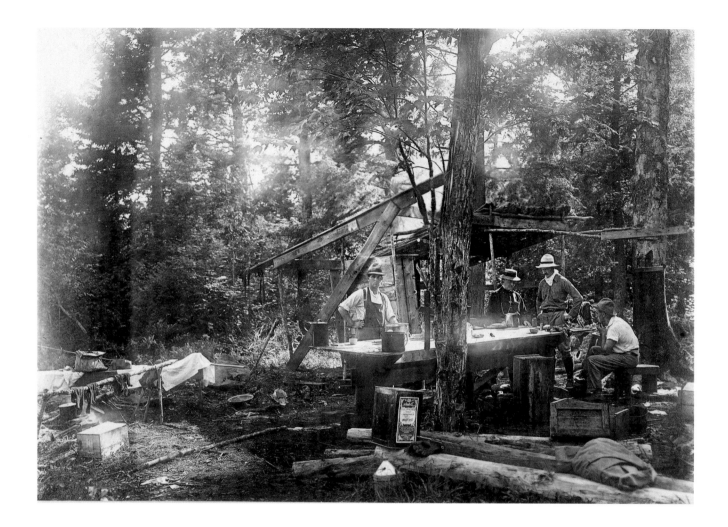

"Doc and Billy Mac."

"How do you know?"

"I saw the forceps. They are hurting her terrible. What are they doing it for?"

The yelps ceased and we heard the dog jumping around and happy in Doc's caresses.

Nimrod had had his first experience with a porcupine during the night and came into the camp with his nose full of quills. His friend Doc pulled the quills out with forceps and won Nim's gratitude.

About a mile away someone had started exploration with a diamond drill which Bill and the boys went up to see. They had a combination of diamond and drive drills and were about forty feet down. They also had an artesian well near by, 800 feet deep, where we got some good drinking water.

Dad changed plates and had to repack some of his photographic kit which delayed our start until eleven. For several miles we had a succession of rapids and rapid water that took all our attention so we hardly saw the river. We stopped at about noon to wait for our wangans and as there was no place to cook we made a lunch of hard tack, deviled ham and brickstein cheese. Nimrod ate the rind of the cheese.

In the afternoon we struck a continuation of rapids for about a mile and then came to quiet water. At about half past two we ran into a jam of driftwood going clear across the river, and extending several hundred feet down stream. On one side we found that by making a short portage through a swampy place we could get into a run of water and so pass the jam. The boats came up promptly and in three-quarters of an hour we had portaged, were loaded and off. The river became deeper and slower so that we had to paddle. The country was low and we looked for camping places, but until quarter after five we saw nothing but marshy banks. Then we came to a small clearing and an old lumber camp abandoned apparently eight or ten years ago. We quickly established camp and entertained mosquitoes.

Dad changing plates

Diamond drill operation

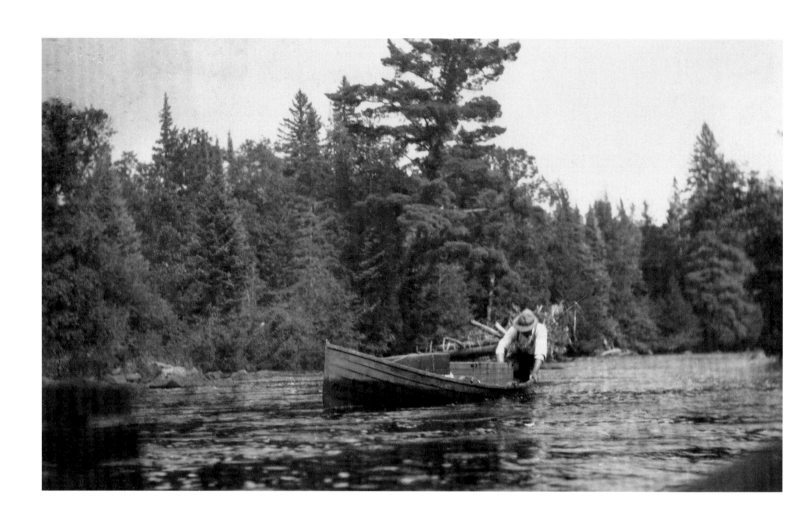

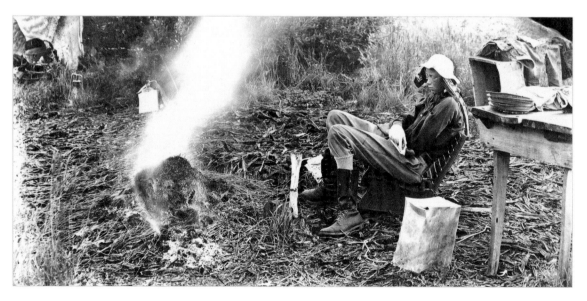

CAMP NO. 4.

On the way down we saw one deer and on a bank we found the trail of beaver. Doc fished, but got nothing for his labor. In the evening Doc, Dad and Carl paddled up stream with a rifle looking for deer and found only mosquitoes.

Our tent was well smudged and we slept until daybreak.

FRIDAY, AUGUST 6.

At daybreak when the mosquitoes recovered from the effects of the smudge and came at us in full force, we breakfasted on

Corned beef hash,
Bread,
Coffee.

The night was too much for Piffy. He was homesick and weary.

We started down stream at quarter to eight. We came to the steel bridge of the Duluth South Shore and Atlantic Ry. at quarter after nine. The river was quiet and we paddled, we believed, about six miles from our last camp.

Carl had a shot at deer and missed.

It was evident that we should have to spend more than our allotted time on the River, and Dad wrote Capt. Scott, asking him to delay sending the launch with our supplies until August 12. We wrote some hurried letters home and the boys took them to Tula, which is a mile and a half west of the River. Tula consists of one house and a section house. Cope and Billy Mac gathered raspberries. Bill tried for fish, while Dad made

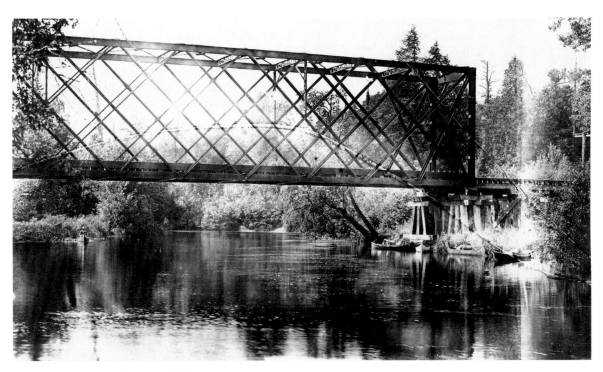

Duluth South Shore and Atlantic Railway bridge

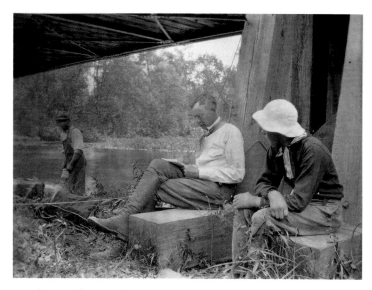

Dad writing the journal

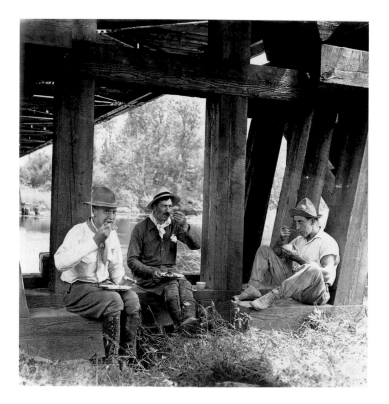

a picture and wrote journal. A section crew came along on a hand car and we learned from the foreman that the water had been about ten feet higher than it now is and that forty-five miles of the road had been washed out two weeks before. He also told us that we would not get down to the Lake because of rapids, falls, etc., etc.

We lunched at the bridge and had

Corned beef hash left from breakfast,
Cold canned salmon,
Bread,
Rice with cockroaches,
Tea.

We left our morning camp at twelve o'clock for the mysterious, mythical and unknown part of the river.

A little way down the river Carl and Cope found a young doe lying dead with her head in the water. The carcass was perfectly fresh. There was no gun shot wound and it looked as if she had fallen when going down the steep hillside and either broken her neck or had been stunned by her fall and strangled in the water. We took the saddle with us after trying some of the fresh meat on Nimrod.

We traveled until half past four. For a while the river was clear, then came a small rapid, then another and another, some larger, some smaller, and we were out of our canoes half the time. How far we traveled we can only guess, for when we were checked by rapids and had to proceed so carefully we could not judge the distance traversed. It was a very pleasant experience for we were so close that everyone's mishaps were observed and were the subject of all kinds of joshing. Pictures were impossible, but it is hoped that Bill and How have some results from snap shots.

CAMP NO. 5.

We made camp on a heavily wooded island, where we had to clear a space for tent, kitchen and everything. Our supper was

Ham,
Fried eggs, not done very successfully but still edible,
Bread,
Fried potatoes,
Coffee.

The air is cool and we are free from our usual enemies, the mosquitoes.

All of the boats have been bumped and scraped, and the boat we found at our Camp No. 2, leaks like a sieve.

SATURDAY, AUGUST 7.

During the night it rained. We were using our fly for a 'paulin to cover our baggage, but the trees gave us good shelter. We were all out by six and Dad and How had baths. There was a succession of showers which interfered with drying our blankets, which were pretty wet after yesterday's travel in the rapids. Fred and Bill tried to repair our leaky boat and everyone was busy about camp.

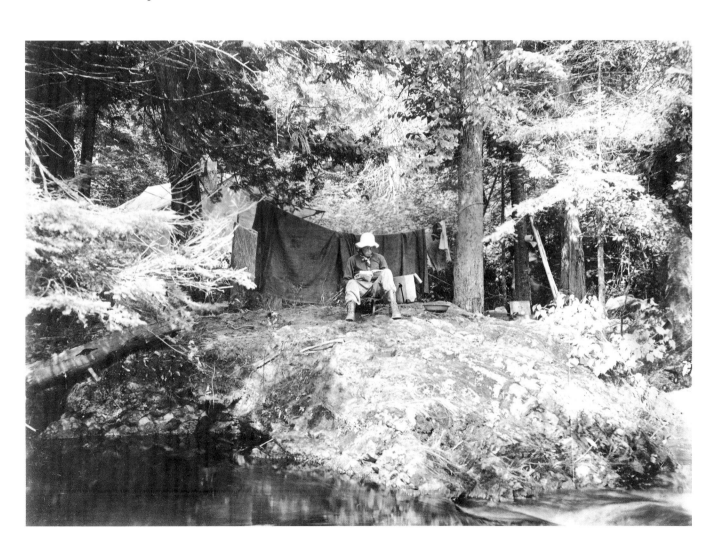

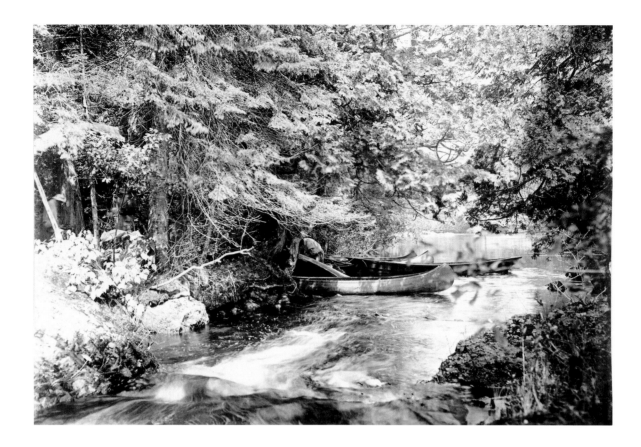

Fred found a place on the other side of the island where beaver had been working but after felling a large ash tree they gave up. There were occasional signs of trappers along the stream. They had cut stakes high up, indicating winter work in deep snow. Our saddle of venison, except what we boiled for stew, spoiled and was thrown away.

We had a light lunch of canned salmon, biscuit and dynamite soup, and we left our camp at noon. Just below the camp was a rapid. Dad struck a rock badly and as Fred was giving him a lift the canoe turned and nearly half filled with water before she could be righted. Fred grabbed the camera case and in a few minutes they had the photo outfit dripping out on rocks in midstream. The canoe was soon dumped, baggage replaced and the procession of boats moved forward. The rapid brought

troubles to Carl and Doc, and they landed on a little rock island to bail out. Carl was on the island, dry shod, and Doc, after bailing out, made after casts with his flyrod and waded in to his neck. Carl on the rock was ordering him out of the water in the same tone he uses to Nimrod. "Here, Doc, come here—come here." And when Doc finally came in he was batted over the head as Doc bats "Nimmy," and then Doc did as Nimmy does—took to the water again. When he next came ashore Carl had him by the collar before punishing his dog Doc.

The River was a succession of rapids and smooth water. Carl shot at deer during the afternoon. By three o'clock we had passed twelve rapids and came to a stop at two rocky gorges on either side of an island to explore it before trying it with our boats. The woods were deep and it was after four before it was determined that

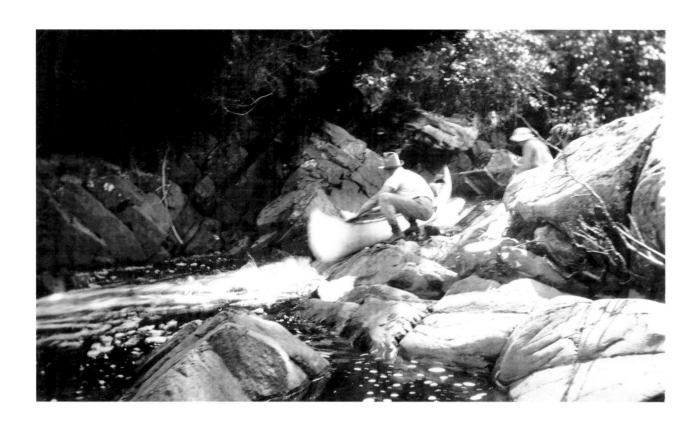

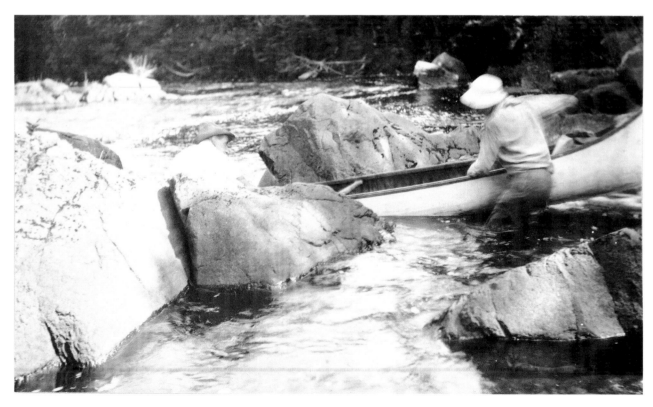

we would have to make a portage of about 1200 feet, carrying our canoes, and that our camp would be in the deep woods because there was no place along the river. The men, Joe and Fred, marked a trail and we portaged all the things we actually needed for the night.

CAMP NO. 6.

An open place was found near a hole where within five or six years someone was prospecting for iron.

Venison stew,
Biscuit,
Coffee,

made up our dinner and we took to our blankets early for rain was falling. The night was cool and the mosquitoes left us alone. We had a good night's rest.

SUNDAY, AUGUST 8.

Rain fell continuously until noon.
 Our breakfast was

Venison stew,
Figs,
Biscuit,
Coffee.

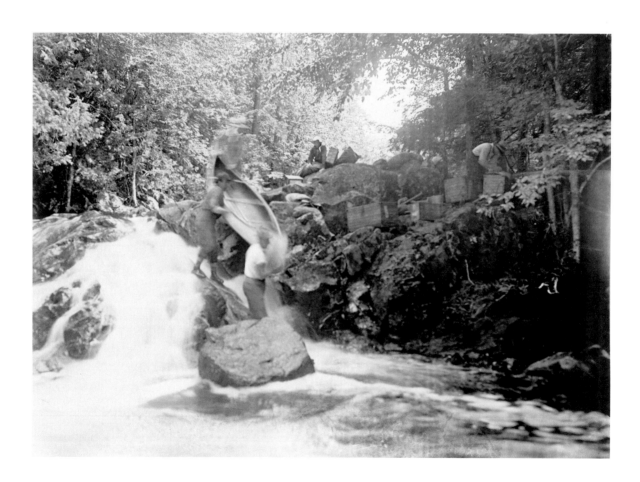

We rigged up long lines to dry our clothes, and we were busy all the morning drying blankets, which were wet in the rapids yesterday, oiling boots and leather work, while the men portaged some of our heavy stuff.

Carl took the rifle and went out on the river to look for deer. Dad cautioned him that in case he saw a bear he must save his shots and put them in at short range. Carl said that if he saw a bear he would leave him alone. Dad told him how much his mother would like a nice bear skin and Carl replied:

"Yes, and think how much the bear would like a little Carl skin."

We planned to get out at about dinner time, but the tentage was too wet and we decided to make an early start in the morning and travel as fast and as far as possible.

We arranged a noon meal of

Army cocktail,
Ham,
Boiled potatoes,
Coffee,
Figs.

Carl has composed a song for Doc's benefit to the tune of "Every Day is Lady's Day for Me."

"Every Day is Lady's Day for Doc,
He is at their disposal all the time,
His money it is doubled
When they come to him in trouble,
For every day is Lady's Day with Doc."

In the afternoon Doc and Bill went fishing. Bill caught three black bass on a phantom minnow, and Doc, because he would use only a fly, caught nothing. Dad and Carl tried to make pictures, but there was no photographic light and they came back. Dad was tired and took to his blankets, missing supper.

Supper was marked by a new dish, which will appear frequently hereafter.

Hot corn bread,
Corn beef hash,

Everyone went to bed early so as to be ready for a long trip tomorrow.

MONDAY, AUGUST 9.

The day broke bright and clear, permitting a picture to be made of the camp.

We had

Bass,
Hash,
Coffee,
Prunes,
Corn bread,

for breakfast, and by eight o'clock we were under way and going through a little rapid below our portage.

The wangan we had picked up at Camp No. 2 is very leaky and was not worth the labor of carrying her through the woods. They cut her adrift, and as she came over the fall in about as good shape as when she started she was allowed to rejoin the fleet in her old capacity.

Today our order of traveling was changed to make Dad's labor lighter. Piffy traveled with Bill and How traveled with Dad. How had stern paddle and was to do the work in the water. From eight until ten o'clock, there was the usual succession of clear water and many rapids with one short portage. Then there was a halt to explore a gorge and pick our way. There was a waterfall of ten feet and we had to cut a trail and portage our stuff. We took a lunch of

Sardines,
Hard tack,
Cheese,

and went on. There were three or four rapids rough enough to make us all leave our canoes.

Carl and Cope were ahead looking for fresh venison and the rest of the boats coming up together started a big buck out of the alders. In his fright he took to the River and ran past Bill Marr's canoe. Billy Mac scared him into a stage fright with a yell and still the buck ran into Fred's boat at the sight of which he broke across the River and may be still going for all we can tell. At about half past two, we found that the River was becoming more narrow, the sides more abrupt and the current more rapid. It wound through several miles of gorge—all rapids and with beautiful turns. There is no way of estimating the total fall, but it was well over thirty feet at one run between its turns. At a little before five, we stopped to check up because Bill's and Billy's canoes were in rear. When Billy finally came in he reported Billy Mac as coming slow and somewhat done up. When Billy Mac came in he was much exhausted. He had been riding, as we all do in rapid water, sitting astride the stern in order to be able to jump in and save the boat from rocks. In jumping off he had been jammed in the lower ribs by his swinging boat, the wind was knocked out of him and he was in a good deal of pain.

Billy Mac gets a short arm jab from his canoe.

CAMP NO. 7.

We made camp at once on a sloping spot on the hillside and got into our drier clothes. Billy Mac could eat no supper and was put into his blankets at dusk.

> Corn bread,
> Ham,
> Boiled potatoes,
> Coffee,

The night was cold and our beds were reinforced with stumps and stones so we slept well.

TUESDAY, AUGUST 10.

We breakfasted at about seven on

> Coffee,
> Corn bread,
> Ham,
> Boiled potatoes,

Fred explored the country for two miles down river and found deer trails running north. Below us as seen from above, appeared a rapid extending for a mile to a sandstone ledge and from there on, the River was broad, shallow and rapid.

We dried our wet clothes. All of our bedding was more or less wet from our experience in the rapids and Dad found that the water had gotten into his plate box, dampening some of the pasteboard boxes, but apparently not damaging the plates very much. The final development will tell the story.

We lunched at twelve, on

> Dynamite soup,
> Cold corn bread and biscuit,
> Potted ham,
> Tea.

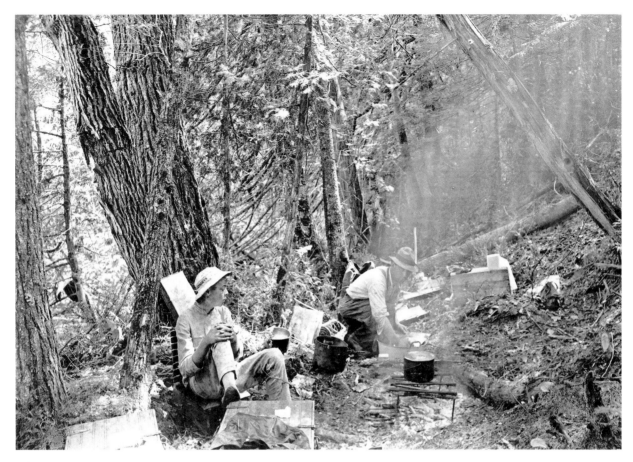

Camp 7

Porcupines: We have seen them all the way down River. They are prowling along driftwood and do not seem to have any fear of us, on the contrary, they are rather curious until we get within striking distance when they trundle their prickly carcasses off into the brush. This morning Nimrod, Doc and Bill went walking; Nimrod found two porcupines and tackled each one of them, getting his mouth and nose full of quills and then going to his friend, Doc, to have the quills pulled out. A "porcy" was in camp this morning and has spent the day in a tree within thirty feet of our tent.

It was our plan to start down right after lunch, but Cope said he felt like a spavined horse, and every one

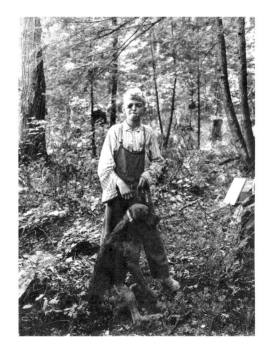

except Carl was more or less in the same condition, so we decided to postpone our start until early Wednesday morning. Billy Mac is sore and lame from his accident and he will travel as passenger with Bill. How, Bill and Dad will keep together in rough water and in that way How can handle his canoe. He has height, strength and experience and is a good man except in a very strong current. Piffy will have to travel as baggage with Fred.

The afternoon was rainy. Bill and Carl went exploring, while Dad and Billy Mac wrote journal, the Doc slept in a canoe bottom, and How with Piffy gathered boughs to make our beds easier.

Doc reviewed the character of the trees he has seen. He says, "hemlock predominates, cedar comes next, hard maple is next in order, then white and yellow birch and ironwood. There is the flowering maple, ash and spruce. Ground hemlock is everywhere. There are a few very large pine trees, regular busters."

Sitting around camp we have been discussing the subject of personal cleanliness in camp, and the Doc holds that this camp is the best we have ever had, as no one has mentioned towels or soap. Of course, the cook washes and no one criticises that, but no one finds it necessary to wash in the morning or before meals.

Our work in the rapids keeps us fairly clean and this journal records several baths that have been taken. At our first camp the cook shaved, and thereafter no one shaved until we camped at the county bridge where Cope, Dad and the two Bills showed clean faces to the mosquitoes. Between wettings in rapids, Carl's face bears the greatest variety of dark tinges.

Our maps do us little good except as a basis for dead reckoning. The course of the River is platted only approximately and the notes of the falls, rapids, etc., are no guide whatever. According to the map there is a po-tato patch near the River with a trail leading to the Lake Shore.[2] We felt that we ought to find that patch for it ought to show from the river as a clearing. We ought—according to our calculation—to be near the field, but we can't find a sign of it.

According to a geographical map of Bill Marr's, the altitude of Lake Gogebic is 1289 feet above sea level. Tula and Lake Gogebic are approximately on the same level. Lake Superior is 602 feet above sea level. According to these figures we shall drop nearly seven hundred feet between Tula and the last Camp. How much we have dropped and how much more we have to drop is a matter of curiosity to all of us. The map indicates a big fall near the mouth of the river, but the maps are evidently made up from government survey notes and the topographical features appear for the most part on the section lines.

About seven o'clock Bill and Carl came in, the former tired, the latter looking for trouble. They found a River about three miles away.

They meandered a River for two miles and in returning they passed the Camp and came out a mile up stream. Carl carried the rifle and had fired, but in these heavy woods we had not heard a sound.

[2] The potato patch is indicated on a map from 1848 (U.S. Bureau of Land Management, Survey Plat and Field notes). At that time the "New York and Lake Superior Mining Company" had made a trail and roadway six miles inland from the mouth of the Presque Isle River, had built cabins, and had two men prospecting in the area. The potato patch shown on the 1848 map was apparently part of this enterprise. A two-year exploration for copper yielded no significant results. Thanks to Michael Rafferty and Robert Sprague, retired rangers in the Porcupine Mountains Wilderness State Park, for providing this information. They are coauthors of *The Last Porcupine Mountains Companion* (Nequaket Natural History Associates, 2012).

Our dinner was the usual

> Corned beef hash,
>
> Biscuit,
>
> Tea,
>
> Army cocktail.

It was raining so hard that we had our mess under the tent awning.

WEDNESDAY, AUGUST 11.

It rained hard all night. Our tent was on such a slope that we could not trench, and our blankets were well soaked. We lighted fires in and around the tent, and proceeded to dry out. The sky was overcast, and threatened more rain. The river had risen and was quite a flood, but we believed we could get out in the early afternoon and make three or four miles, which would help Bill and Piffy on their tramp to the lake shore where the launch was to meet them Thursday morning.

We had

> Corn bread,
>
> Coffee,
>
> Corned beef hash,

for breakfast, and at noon we had a light lunch of

> Bacon,
>
> Biscuit,
>
> Tea,
>
> Prunes,

and loaded to start down the river in this way:

> Piffy as baggage with Fred
>
> Howard had Clay's canoe,
>
> Dad had his own,
>
> Bill took Billy Mac for baggage,
>
> Cope had Carl,

and we all started in together, intending to travel close, so we could assist each other in case of trouble.

Bill's canoe filled within two hundred feet of Camp and the wangan swamped at once. Cope and Howard reached shore with some difficulty. Dad, in passing, saw the trouble, and tried to stop, but the current was too swift. In turning he lost his paddle and jumped out in a fall to hold his boat. He could not do more than hold fast until Cope came up by shore and the two together had all they could do to make the rocks on shore. We made what Billy Mac calls

> "CAMP No. 7½"

about five hundred feet from our last camp. The disabled canoes and wangans were brought up and we made camp on a flat shore at the water's edge. We were all busy at once, stretching lines and gathering wood to dry out.

We had a good dinner of

> Corned beef hash,
>
> Boiled potatoes,
>
> Coffee,
>
> Army cocktail.

and by nightfall we were dry and comfortable.

Fred, Bill Marr and Piffy started afoot for Lake Superior at quarter of six. Fred will take our provisions, etc., from the launch and will bring us bacon and a few things to relieve the monotony of canned corn beef, unless Bill receives a message to stay and finish his vacation. We estimated that it would take them four hours to go down and Fred would be back in camp sometime the latter part of the afternoon or in the evening.

Our meals to-day have been

> BREAKFAST:
>
> Corned Beef Hash,
>
> Coffee,
>
> Corn Bread,

LUNCH:
The last of the ham,
Dehydro potatoes,
Rice.

DINNER:
Salt pork and ham,
Dehydro potatoes,
Coffee,
Fried Rice,
Biscuit,

The day was spent very idly. All the men shaved. Dad fussed with photographic plates all day long and brought out some good negatives. Even Cope took a nap. The boys fired the rifles and revolver and then cleaned the guns and oiled up.

The River has risen steadily all day. If the water recedes as rapidly as it rose, we may be able to go through with our boats except in places where a portage would be necessary anyway. During the afternoon the sun came out.

We have all been impressed with the rarity of animal life along the River. Among the birds we have seen a few duck, blue heron, king fishers, bittern and pileated woodpecker. The small birds are almost absent.

The woods are full of strange and many colored forms of fungus growths.

FRIDAY, AUGUST 13.

Fred had not returned when we rolled into our blankets last night. He did not return during the night. He ought to have plenty of grub at the Lake and as the trail is not difficult to follow we are not worrying about him.

The River did not rise during the night, and we shall look about for a place to portage during the day. Our grub is getting low but we are eating less in this stationary camp. The sun and breeze gave Dad a chance to dry out photo material and all hands were busy with odd jobs of mending, oiling shoes, etc., preparatory to a move.

In our last day's canoe trip we passed from granite formation to glacial drift and are now at the edge of sandstone formation.

The moist atmosphere has permeated everything, even the tobacco in the screw top tin had to be dried out. Photo plates dry very slowly and we got no direct sunshine except what streaked through the tree tops. In the afternoon the sky was overcast.

Our menu for the day has been:

BREAKFAST:
Salt pork,
Coffee,
Dried potatoes,
Biscuit.

LUNCH:
Dried eggs,
Tea,
Biscuit,
Rice balls,
Pickled onions.

SUPPER:
Rice balls,
Fried potato balls,
Cheese,
Figs,
Pickled onions.

Fred has not returned to camp, and while no one is worried, all show their concern by conjecturing what may have happened.

Dad made a few pictures and fussed with his slow drying-plates. The camp was busy cleaning rifles,

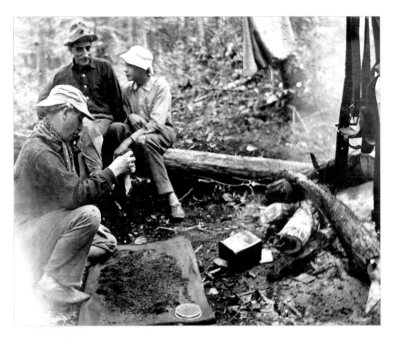

Drying tobacco

Morning came and no Fred. We had about six days' provisions and could not stay here in camp. We were obliged to move to the River's mouth and there be prepared to work our way to Ashland or Ontonagon, if need be. Dad preferred Ashland, as he knows people there who would help us out.

As to Fred, we cannot explain his failure to return and we fear he has met with some accident. If that is the case, it would be a mere chance if we found him unless we can find the trail which appears upon the maps. We have been unable to find it or the potato patch to which it leads.

We spent the early part of the day in fixing up camp in such condition that we could abandon it for a week or more if necessary and protect our valuable stuff from the porcupines who abound here. The camera case and the case of photo material were swung by wires from the ridge pole of a tent; the developed plates in Billy Mac's creel are to be carried with us. The canoes were all hauled up above possibility of a flood and all extra baggage rolled up and put in the baggage tent. Each fellow made a soldier's blanket roll of rubber blanket, a single blanket and such stuff as was absolutely necessary for a four or five days' trip—extra socks, a comb and one shaving outfit for all of us, and extra bandanas. The cook's outfit was put in the smallest possible pack with food and his blanket and extra pots were distributed as hand baggage among the party. We took the big tent fly for a shelter. We left a sign, showing when we had left and our destination, and at half past nine climbed the steep hill in the rear of our camp to get on the high

mending shoes and odds and ends of camp equipment, getting ready for the trip to the lake. The River was still in full flood but not rising, the rapids in front of us still impassable for our canoes.

At supper time Nimrod barked and we thought Fred had returned. Investigation proved it to have been a deer that had come within fifty feet of our camp in his curiosity to see what we were.

Fred or no Fred we shall have to get out of this in the morning. If Fred does not show up by that time we shall abandon everything except our grub and blankets, either work out by trail or take the best canoes and work out toward Ontonagon or Ashland by river and lake. Dad has about fifty developed plates which will be carried.

Billy Mac is much better and will be able to travel and do some work to-morrow.

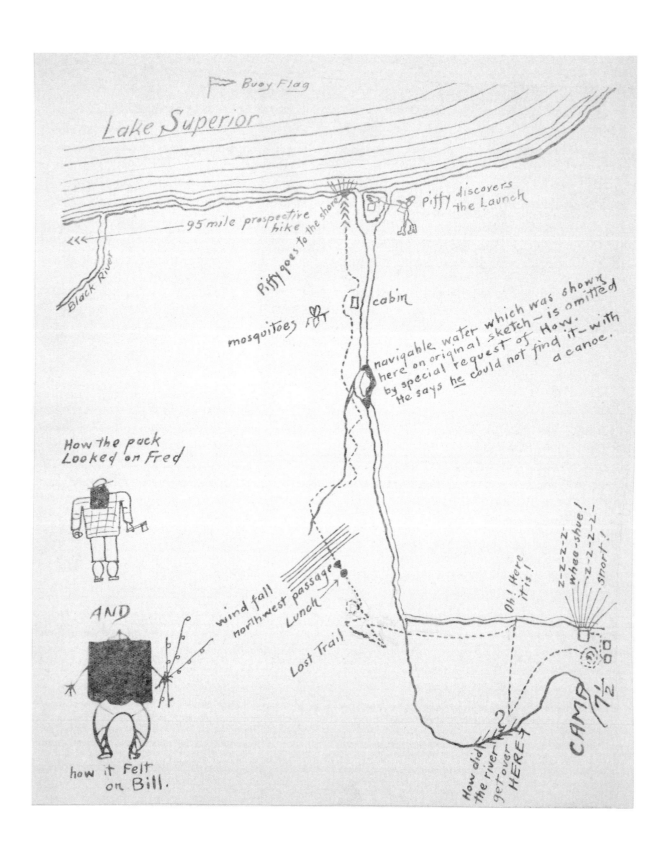

land which would be comparatively free from gullies. We were heavily loaded and marched only a short distance between rests. At half past one we had gone about four miles and had crossed the river which Bill and Carl found, and were on the high land on the farther side. The banks are 150 feet high and very steep. How far we were from the mouth of the River we did not know. We halted and Cope went down to locate himself. He was gone a half hour when we heard him shout so he could get our direction. We called and fired the rifle and were startled to hear an answering whoop from the opposite direction. It was almost a quarter of an hour before Cope came in and almost at the same time Fred joined.

Fred had returned to camp, and finding that we had started for the lake he had dropped his surplus baggage and started for Lake Superior with a small pouch containing mail and some new tennis shoes and socks Billy Mac had ordered.

Fred's account of his own trip is modest but interesting. They left camp Thursday morning and worked their way through the woods to the lake shore reaching there at half past one. They found some fishermen who took them to the island where they had a tent. There they spent the night with the fishermen and at two o'clock on Friday the launch came in, bringing grub. Bill and Piffy left and as the hour was late, Fred spent the night and left there at six Saturday morning for our camp. He reached camp at one o'clock, and finding that we were gone he started for the lake to meet us. It was the incident of firing the rifle for Cope which enabled him to find us, otherwise he would have gone to the lake that night and have stayed there until we came.

We had lunch, Hard Tack, Cheese and Ham, and descending into the river valley followed the little river to its mouth. On the way we saw some beaver cutting. Up to this point no mention has been made of Amy merely because our tobacco can held out, and we did not need her plumpness. The last of our tobacco can was dumped into our pouches and Amy clung to Billy's waist. Traveling through the tangled woods she disappeared from sight and great was our sorrow, for some of us had been in camps where the 'baccy ran out. In rearranging his trousers Billy had let her thoughtlessly tuck herself inside and it was not until after lunch when a further rearrangement of trousers became necessary that we discovered how she had coyly stowed herself away. Amy was still with us and our lives were saved.[3]

At the junction of the River, Cope rested and the rest swung the baggage from saplings out of the way of the porcupines. Then we went back to Camp 7½. Cope calls it 7¾ now, and we had a dinner of

Fried bacon,
Biscuits,
Pancakes,

We all went to bed right after dinner.

SUNDAY, AUGUST 15.

We slept poorly, for we were overtired. Dad, Billy Mac and the kids lazied about camp during the morning, while Doc and Fred let their canoes down stream a mile and marked a trail for our portage.

After lunch this portage began and by supper time we had most of our stuff taken about a mile down stream. We had to cross three ravines with very steep slopes and one was fortunate indeed if he did not slide down with his pack, and as for getting up on the other side, it was a scramble on all fours. We made a camp on high ground in a beautiful little opening beside a tall pine tree and we called it

CAMP NO. 8.

[3] Amy was the Gang's communal tobacco supply.

The men made one trip across the portage after supper and then we all went to our blankets. We were very tired and we knew that we had another big day's portaging before us.

Our menu during the day was as follows:

BREAKFAST:
Hash,
Oatmeal,
Coffee,
Left over biscuit,
Hard tack and corn bread.

LUNCH:
Scrambled dried eggs,
Potatoes,
Left over biscuit, etc.,
Tea.

DINNER:
Bacon,
Potatoes,
Corn,
Coffee.

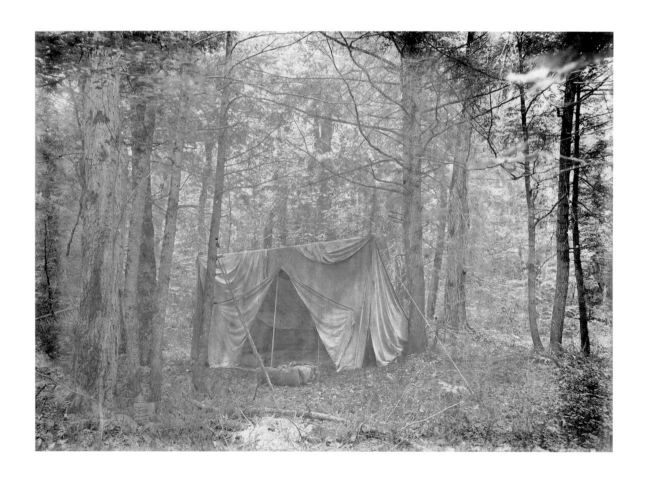

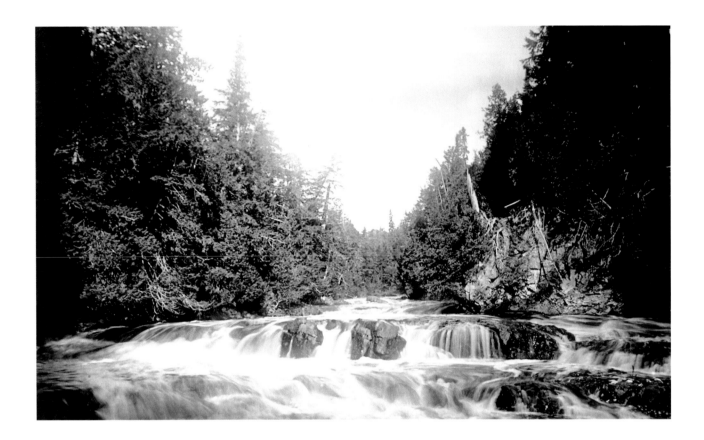

MONDAY, AUGUST 16.

The deer are very plentiful all about here and Nimrod spent a good part of the night driving away the deer and porcupines who were curious to know what we were doing in their woods.

Early in the day a new portage began on a trail which Fred had marked out and which Carl and Dad cleared of overhanging boughs so that the carrying would be easier.

We had breakfast of

> Oatmeal,
> Coffee,
> Corn bread,

At dinner we ate up the last of our bacon with some boiled potatoes and ate the last of a large bottle of olives.

For supper we had

> Potatoes,
> Tomatoes,
> Corn bread,

From now on our meat will be corn beef unless we can catch some fish, and from the appearance of the river it looks as if we would have no time for fishing.

In the afternoon Dad started with his camera, going directly toward the river from Camp No. 8 and working his way down through a little opening in a rocky cleft to make some pictures of falls and rapid water in the River. It took him over three hours from the time he left camp until his return. The River banks were precipitous, and climbing them with a camera was very difficult.

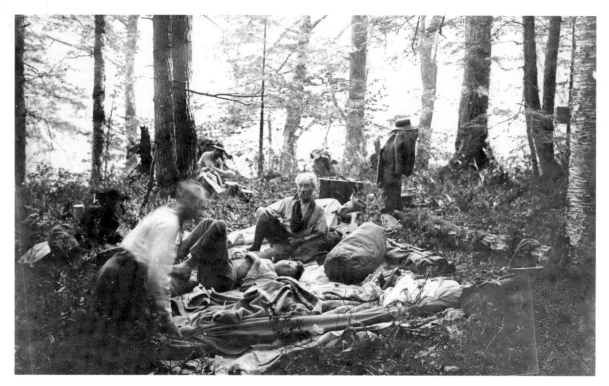

Bivouac camp

CAMP NO. 9.

This was our first bivouac camp. There is a sharp decliv-
ity of about twenty feet to the River, and when our ca-
noes are brought up in the morning we shall be able to
load and commence our River work again.

At Camp No. 9 we abandoned our two largest mess
chests and a lot of other things that were not absolutely
necessary and only added to our discomfort.

During the afternoon while Fred and Doc were let-
ting boats down stream the Doc made a slip and went
under water, still having hold of the tail rope of his ca-
noe. A moment later Fred saw him smoking a cigarette
and he exclaimed, "Where in hell did you get it?" He
wondered how a man watersoaked from head to foot

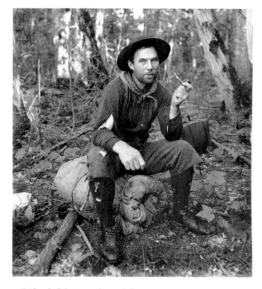

"Chief of the Rough Necks"

could find a cigarette and dry matches in such a place as that. He did not know that Doc carried a supply in his hat.

Dad has a boil just under his belt, which has been coming on for several days, and keeps him from being a useful member of the party in portaging. This is the first day that anyone made any attempt at washing. While on the portage to-day Carl saw a porcupine that had taken refuge in a hole under a tree and Nimrod was frantic because he could not get the porcy out.

Billy Mac is much better and has done heavy portaging work to-day.

Mosquitoes are plenty, but we are looking for a cold night, which will keep them away. Fred is feeling better, and is in a laughing mood, but Joe is soft in the muscles and sore and out of temper. To-day we measured out the whiskey to see whether it would last, and we found that we have three quarts left of the two gallons which we had when we started.

Little River

TUESDAY, AUGUST 17.

We had a beautiful night at our Bivouac Camp No. 9. The air was clear and we could see the stars plainly through the tops of the big trees. We had a large camp-fire which lasted all night.

Our first duty was to gather up all our stuff prepara-tory to our start. Fred and Joe brought the last of our equipment over from Camp No. 8 and the last boats were brought down the River.

While we were waiting for the boats Carl made a monocle from a pair of Billy Mac's broken colored glasses. Then he found one of the Doc's half-smoked cigarettes, and with this and Nimrod, whom he called his dog "Twowser," he was doing one of his specialty acts as a "Havud" boy. At first he would not stand for

having his picture made, but was bribed with the price of a new fishing rod. At ten, we were loaded and started down river and at three o'clock in the afternoon, we came to where the little river empties into the Presque Isle and found our baggage all right and unmolested. Carl went down by foot with Nimrod and rifle look-ing for deer. In all we traveled one mile to-day and we had to walk almost every step of it, working our boats through rapids and occasionally making short carries over cascades or where driftwood had obstructed the stream. We all hung close to the left bank of the River except Cope, who liked the looks of the River on the other side much better. He found rougher water and could not rejoin us because the water was too deep for him to work his way across. Four times during the day we had the pleasure of seeing him draw his canoe up alongside of the bank, throw out his baggage and dump the water out. At one point Fred had to work his way across the stream with a big pike pole to help him.

BREAKFAST:

Coffee,

Erbswurst,

Corn bread,

DINNER:

Corned beef hash,

Prunes,

Corn bread,

Coffee.

SUPPER:

Pancakes.

CAMP NO. 10.

Just at dusk two men suddenly came into Camp. One was an old Indian and the other a French half-breed.[4] They said they were looking for the "mysterious" potato patch and asked questions about the trails which do not exist. They had very little to say. They stood around for a moment or two and vanished into darkness. Fred did not like them. He said you could not tell who people are in these woods or what they were up to, so he slept with his clothes on, rolled up in a blanket across a well marked deer trail by which these men came into Camp.

While Dad was making pictures this afternoon two of his plateholders fell apart. This was the result of exposure to damp atmosphere. Carl mended them, but it is doubtful that both will not leak some light.

While dinner was cooking Doc caught a few trout which will vary our menu to-morrow.

[4] Here, the term *half-breed* referred to someone of mixed race. Though common at the time, we now understand such language to be offensive.

WEDNESDAY, AUGUST 18.

We had a hearty breakfast of

Fish,

Corn bread,

Baking powder biscuit,

and at ten minutes to nine our boats were loaded and we started down river. The water is falling and we hope that we will be able to travel in our boats. All day long we were in the water working our canoes along and making short portages.

The rocky formation which at Camp No. 7½ was trap rock, changed to red sandstone at the little River, then into conglomerate sandstone, and to-day about the middle of the afternoon we struck a shale formation, which was very slippery and very dangerous underfoot.

About the middle of the afternoon we had a cold lunch of

Corn meal,

Potted ham,

and traveled along until ten minutes after five when we made camp on the East side of the River. Those of us who were on the West bank could not cross alone with our canoes and had to wait until Fred could work his way across with a pike pole and add his weight to ours in going across the stream.

At noon to-day we held up to make a short portage where there is a beautiful fall over conglomerate rock, and while we were admiring the scenery a doe with her two fawns crossed the stream within three hundred feet above where we were sitting. Carl had traveled along the bank of the stream all day with his gun and dog looking for deer, and the dog had evidently started out the doe who was leading her fawns where the dog

could not scent them. Carl was with us when we saw the deer cross, but his rifle was ashore and his remarks on the subject could never be published in a Sunday school paper. One of the men asked Carl if he could follow a trail along the River bank and Carl replied that he could not follow the trail any more than he could chew his own tail.

While we were portaging to-day over the water-fall How's feet slipped from under him and he swam down the fall feet first. He was laughing so hard that he was nearly waterlogged by the water running into his mouth.

Fred is a wonder of strength and his doings in rough water were astonishing. He seldom gets wet much above the waist, but to-day his feet slipped as he went into some very difficult water up to his arm pits and he exclaimed, "I wet the bottom of my heart that time."

CAMP NO. 11.

We built a big fire to dry out our wet stuff. Our canoes are leaking faster than we can bail them out. This is our second Bivouac Camp. It is a beautiful Camp under hemlock trees.

THURSDAY, AUGUST 19.

We had our usual breakfast of

> Corned beef hash,
> Corn bread,
> Coffee,

and then started to look around. A little brook comes in close to our camp and we found the remains of a trapper's lean-to. It looks as if these fellows had worked the river just as long as there were any beaver to be found on the river or its tributaries.

Abandoned trapper's camp

At a quarter before nine Joe had baked some biscuit for our lunch and we started down the river.

Fred in Bill's Canoe
Dad alone
Cope and Carl
Billy Mac and Howard
Joe in the wangan.

There was enough depth of water so we could ride, and we made very rapid progress for a mile or so over rapids through swift water. In making his way through a rapid where the River turned sharply, Dad's canoe took in water, turned, jammed his foot between the canoe and a rock and the outfit came out a capsized wreck in the quieter water below. Joe coming up rescued Dad's bed roll, but Howard's clothes, the tripod and a small axe were lost. Dad was unable to move much on account of the rap given his foot and had to get help to fish out his camera outfit, which lay in the water. After this How took charge of Dad's canoe. Carl assisted Billy Mac and Howard in shallow places while Dad lay quietly on his back in the canoe ready to be dragged along until he could walk.

During the morning Doc and Joe, being together at a shallow spot, saw a big doe quietly feeding. She looked them over and went on feeding. Doc took the rifle and worked around to good range and fired twice, missing both shots.

The map shows an island half a mile long. We had a long passage through the Easterly channel. The island is flat and looks more like the flooded islands of the Wisconsin and Mississippi Rivers than the rocky islands we have seen above. There were several patches of brakes which almost looked like tropical growth.

At about two we ran into shore for our lunch of biscuit, deviled ham and coffee. An investigation of the photographic outfit showed that the Panoram was thoroughly water soaked and probably spoiled, the 5×7 camera was fairly dry and will require only inner repairs; the plate-holders are all coming apart at the corners and the plate box was all soaked. It was disheartening to see thrown away so much effort to illustrate this journal. While the rest of the party drifted down river a few hundred feet Carl and Dad sorted over the photo stuff to see what might be saved, and then took the things down to where the others had sorted baggage to get what was needed for the night at Lake Superior. Dad had so far recovered that he could make the portage with a light load and by moving slowly. Keeping this slow pace it took Cope, Carl and Dad ninety-five minutes to walk the two miles to the new Camp on the Island at the mouth of the River. The trail leads near the River on the Eastern Side. The River itself is a series of cascades and waterfalls, the finest fall being just above the Island where the River breaks over a large ledge of shale. The Island is of the same formation and is sparsely wooden. This Island has been, so Fred tells us, a fishing station and there is an old dock, net, reels and weedy camping places to indicate that people have been here.

When Dad took off his boot Doc found a well swollen ankle and sent the boys back for the Doctor Shop Can so he could bandage the foot in adhesive plaster. Dad will be out of the game from now on as regards all camp work.

CAMP NO. 12.

There was a cold wind from the Lake, everybody was short of clothes and this circumstance developed the reason why Bill Mac's pack has been so large. He not only produced dry socks for the crowd, but extra trousers, shirts, coats and everything to replace our stuff that was at the other end of the trail or had been lost.

We supped on

> Bacon,
> Boiled potatoes,
> Coffee and
> Biscuit.

It was a bright, starlight and cold night. We bivouacked on our tent fly, turning one fold over our feet. The dew fell almost like rain and by morning everything that was not under canvas was quite wet.

Nimrod had a great deal of trouble during the night with a porcupine who would not move away from our camp and seemed interested in Nimrod's angry growls.

FRIDAY AND SATURDAY,
AUGUST 20 AND 21.

We have been in our new Camp long enough now to begin to get the benefit of our new stock of provisions. We made a good breakfast of

> Pettijohns
> Coffee,
> Biscuits,

and by noon we shall have over the last of our cooking utensils and shall celebrate with a dinner of

> Cold canned corn beef,
> Fried potatoes,
> Pancakes and maple syrup,
> Tomatoes,

Joe set some bread last night and by this evening we shall have bread again.

This morning everyone except Dad commenced work on the last portage. We shall abandon Dad's and Clay's canoes as worthless. Both leak faster than one can bail out with a sponge. The wangan will be turned adrift and if she comes through she will return to the P. B. & L. Co. Doc's canoe with some repairs will be a good boat. Bill's canoe is in fair shape and will be sent to Racine.

During the afternoon the watersoaked photographic outfit was brought up and Dad commenced work under the shelter of the fishermen's dock, washing the paper off developed plates and drying them out. It is surprising to see that a good many of these plates are going to print as fairly good pictures. The plates which had been exposed but not developed were then opened in a dark bag, the paper scraped off as well as possible and some good negatives were obtained from these. In fact, very few are entirely spoiled. This work continued through Saturday morning and the whole outfit of old and new plates were dried and ready to pack. On Saturday morning Carl had taken the plateholders which were brought in in parts and had patched up four so that they looked all right and would fit the camera. Into these plateholders some of the unexposed wet plates were put and Carl made a tripod with four branches nailed to an old soap box. With this outfit Dad made pictures of the rocky island upon which we were camping, the falls above, the cascades over the shale, and a few of the River with the Lake beyond. These plates are all more or less befogged and lightstruck, but even in that shape they complete the picture story of our trip.

We did not set up the tent at this Camp. The nights were clear and cold and we slept in the open. Ever since Nimrod lost two of the party at Camp No. 7½ he has gone around early in the morning to give everyone an affectionate lick to see that we were all there.

On both Friday and Saturday evenings we had magnificent sunsets on Lake Superior, scenes which all of us will remember.

Amy has given out entirely. She is only a shadow of her former plump self, and to-day she was discarded as

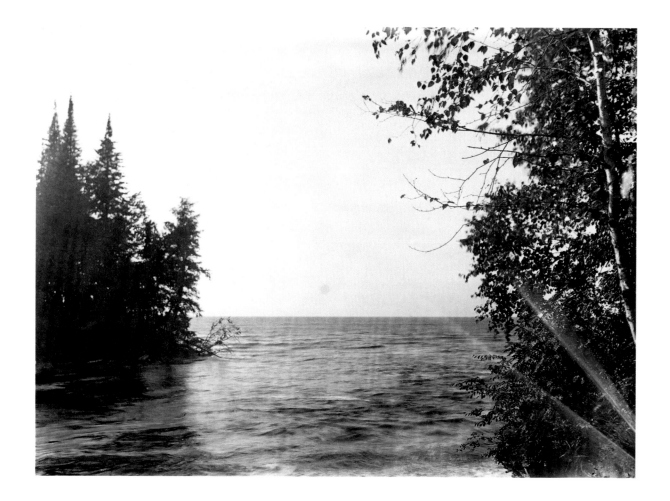

a worthless old jade and we put what was left of her into our tobacco pouches.

Our condition for tobacco is getting something desperate, but Dad says that Scotty will surely have something to smoke when he comes down with the tug to-morrow, and he is sure that he will have a few bottles of beer tucked away somewhere.

On Friday afternoon we saw a gasoline launch head in and make directly for our Camp. They stopped at the pier from the River mouth and called but we could not hear them. Then they asked us to get a boat and come out. We replied that we had no boats and then they put off a man in a small boat who wanted to inquire whether we were the party that was going out on Sunday and whether we would be ready to start on that day. He said that the tug which Capt. Scott had engaged could not come, and that a large gasoline fishing launch would be down for us. Dad and Carl interviewed him and both were very much troubled at seeing a launch put in for us, as we thought something had happened and some member of the party had been called home.

Out in the Lake Northwest from the Camp some fishermen have their nets set. On Saturday they came down with a large gasoline tug and tried to lift them. The waves were too high and they gave it up and made for the mouth of the river. They landed at the pier and came in to talk. They had no fish in the boat but prom-

ised they would give us some fish early in the morning if the waves had subsided so that they could raise their nets. We had quite a talk with them and promised them one of our damaged canoes. We told them that we would have some provisions left over and that we would put them under the shed if they would like to take them home. According to their own account they are not making very much of a living, and they seemed to appreciate the prospect of some free provender.

Friday evening a stranger with a light clinker built boat pulled up to our camp. It was after supper but our men were still eating and asked him to come over and get a bite to eat with them. He did not give a very satisfactory account of himself, but we suspected him of being a game warden sent down from Ontonagon to find out what he could about us. He made his bed somewhere in the woods near our Camp and was in and out during Saturday. In reality he was after some fresh venison and had more reason to regard us with suspicion than we had for distrusting him.

Saturday afternoon everybody went into the lake to take a bath. There is not much chance for swimming. The beach is soft gravel and one can wade out there and sit down and enjoy a bath. We had commenced to wash occasionally during the day in preparation for our return to civilization.

SUNDAY, AUGUST 22.

We were all up early and packed our baggage so as to be ready when the tug came for us. Everyone abandoned his oldest clothes, and some of our comforters, including old clothing and the extra provisions were tucked safely under a 'paulin in the fishermen's shed. All of Howard's extra clothing had been lost when Dad capsized on Thursday, and he borrowed a clean suit of the Doc's union underwear. From Billy Mac he got a pair of trousers, which, with the assistance of several blanket pins were reduced to How's waist measure and he abandoned his old trousers, which bore generous patches of sail cloth.

There is no one of the party who will ever forget the picture of Howard putting on a union suit of underwear for the first time. He put it on in the right way, but was surprised to find that it did not cover in all places.

Cope told him that he had it on hind side before, and Howard proceeded to reverse the order and did not half discover that he was being exploited until he found them laughing at his extreme difficulty in buttoning it up at the middle of the back.

A little after eight our gasoline launch came in sight and shortly after our friends, the fishermen, appeared, and loaded up a lot of their stuff on our launch, which they took out of the tug which was lying at anchor off the mouth of the river.

Scotty was with them of course, fatter than ever and just as good natured, and he saved the lives of the party with two small packages of Durham, a box of cigarettes and a few bottles of beer.

Nimrod had been thoroughly miserable traveling in a canoe and he absolutely refused to put foot on the launch. He was unceremoniously thrown on board and then thrown across to the other boat where he lay on the floor a tired, homesick, abandoned, seasick pup.

Just as we left our moorings we had the pleasure of seeing the fishermen wave a hearty farewell to us from the tug where they uncovered what to them must have been a rich harvest of provision and clothing.

The Lake was rough and early in the day the sky was overcast and threatened rain. In fact, it did rain early in the morning, but not enough to wet us much.

During the morning we had a beautiful view of the range of Porcupine Mountains and at about four o'clock we reached Ashland. The boatman had a little gasoline stove and he cooked some bacon and coffee,

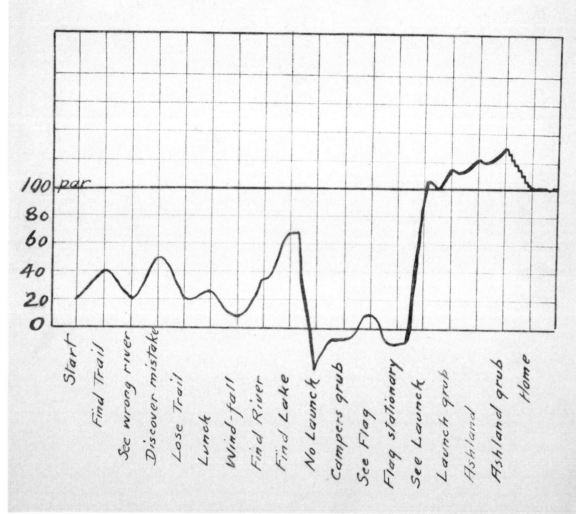

Cross Section of PIFFY'S HOPES

as He and bill came out.

which, together with our lunch, made a most magnificent dinner, which everyone enjoyed except the poor seasick pup.

At Ashland we transferred our baggage to the depot and gave shipping directions to Fred for the two canoes which were left and all of our heavy stuff. Dad and How had a dress suit case of clean clothes awaiting them and in dress and general appearance they entirely eclipsed the rest of the party. The only one who looked nearly respectable was Billy Mac, who wore a jacket buttoned up to the throat and bore so close a resemblance to the Rev. Dr. Sanderson that we called him "Sandy."

We all left on the evening train for Milwaukee, and in the half hour of delay we saw the devastating effects of the cloudburst over Ashland and Odanah.

With this ends the story of the hardest camping trip "The Gang" has ever had. It has been one of unusual experience, not without considerable danger, and we are very fortunate in that we had no serious accident. There is no member of the party whom we would not all be glad to have on another trip. Fred has been an ideal man for his work and the only weak person has been the cook, and Fred alone can describe him adequately.

PIFFY AND BILL COME OUT.

Bill Mar's Letter to "The Gang"
Received Through "Scotty."

"Many titles suggest themselves for the narrative, but the above will suffice. They came out chaperoned by Fred. The Cotillion was held in the virgin forest on the south shore of Lake Superior, etc. You all know where (Camp 7) Piffy "came to" in the south end of the tent a little before dawn and said, "It is four o'clock, Bill." Bill segregated this utterance from Doc's manly breathing, understood it, and wished it were true. A while later sounds were heard near the cook tent. Piffy and Bill untangled themselves from the sleeping gang, added shoes to their toilet, investigated the grub pile, said "So long," crawled under their packs, and started.

TIME 6 A.M.

Route: Northwest along Presque Isle River.

General Conditions: Wet, moist, humid, slippery, damp, dam damp.

Bill had the big pack; wouldn't let Fred have it until 6:30 A.M. to save his face.

Sudden appearance of river on their left running

West—Watell! Consternation and consultation. Decide it is Potato Field Creek much swollen, and swing to the right to find Presque Isle River as a guide. Surmise correct. Cross P. F. Creek 8 o'clock. Hunt old trail. Follow it half a mile by old blazes. Piffie in the van with eagle eye for blazes or any old thing leading OUT. Lose blazes—hunt half an hour—decide on Northwest Compass course and hike again. Piffy again in van as compass man. Consider him in the van for the rest of the story. Even wanted to sit in front car of train and chose most southern room in Hotel in Ashland.

HARD TACK AND CHEESE LUNCH ABOUT TEN. Windfall over swamp, with Bill carrying the pack.

Getting too far from river, swing to north course. Find creek which is on map and stay between Creek and River, bearing over towards river. Many coulees and bluffs.

SAMPLE BLUFF:

"Bill, let me carry the Pack."

"No, Fred, I can carry it a little further."

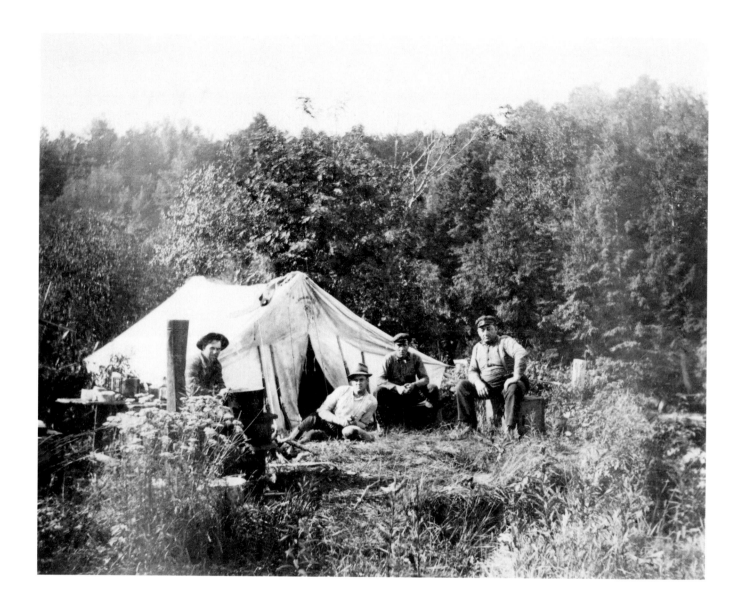

"Piffy discovers river at Island—quiet water. Looks better for those left behind. Stick to river bank. Many mosquitoes. Bad going. River full of falls and cascades. Looks worse for those behind. Find cabin. Scenery beautiful, but canoes will not run on this kind of scenery. It has to be traversed by alternately sticking one foot in front of the other and stepping on it. Cool air indicates nearness of Lake Superior. See deer. Piffy discovers lake. Slide down to lake shore and see camp across river. Piffy runs around point and scans horizon—no launch. Hopes drop 114 points. Camper brings boat over and all cross to camp. Explain situation. Campers there since Tuesday morning—no launch. Tough looking bunch, but Bill and Fred had seen worse. Decide to eat their grub and share tent until problem worked out. Campers have right woods spirit and agree.

Thursday night. No launch. Campers from Besse-mer—probably one saloonkeeper and two miners. Four rifles and one shot gun—after deer, duck and fish. Plenty of beer and more coming via Black Creek. Fishermen at Black Creek with launch. Suggest a way for Bill and Piffy to get out to Ashland and straighten out tangle for those left behind—especially grub question. Supper of bacon, fish, coffee and bouillon. Oh, that bouillon! Bill will make one next winter for "The Gang." They must promise before hand to eat it. Go to bed. Regaled by an hour of Bessemer translation of Bocaccio. Bill can only hope Piffy has fallen asleep. Old, mangy, dirty, decrepit hound suffering from locomotor ataxia tries to steal our bed clothes. Remarks by John ? ? ? ? ? ——— Hound runs out after deer after being kicked out—fervent hopes he will never come back—which he doesn't. Talk about psychological suggestions! All feel glad Bill's bed roll was packed out.

Morning: Plan if launch does not come from Ash-land or Black River by noon Bill and Piffy hike over to Black River and from there to Ashland via fishermen's launch or Bessemer. Ashland or bust. Great excitement. Eleven o'clock. Boat coming away out in lake—looks like sail boat. Stationary for an hour. Excitement sub-sides. Looks like flag. Prepare to hike. Campers prom-ise to take care of supplies if they come and Fred go in and report. Piffy discovers launch. Suppose it to be fishermen. Really is Ashland boat stormbound since Wednesday night—in charge of Bruce. Quick shift of plans. Piffy's letter suggests he would better go home. Bill's letter did not come.

Launch leaves at one o'clock. Nice trip of nine hours, a little cold and rough. Bill stays on his back seven hours and doesn't eat. Piffy eats whenever asked and looks hungry between eats.

Arrive at Ashland. Go to hotel. Pay Bruce $15.00— Telephone Capt. Scott. When John ? ? ? was asked if he knew Capt. Scott, said he was known from Ashland to hell. Does that mean Ashland was Piffy's paradise? Had a nice visit with Capt. Scott while Piffy ate. Went to bed. Oh, you spring mattress! Train at 6:30 A.M. Bum ride to Milwaukee. Piffy almost jumped off train before it arrives. Discovered automobile. Great discoverer on the home trail. Bill arrives home back way. Airs out bag-gage. Still airing.

Notes: Billy Mac's cigarettes make good mosquito smudge. Took photos of campers and got name and ad-dress to send prints.

Fred took the destruction of his shoe pack to heart, so Bill asked Capt. Scott to take out a pair of No. 8s to him."

THE RAMBLES OF THE GANG
IN THE RAINY LAKE COUNTRY

1910

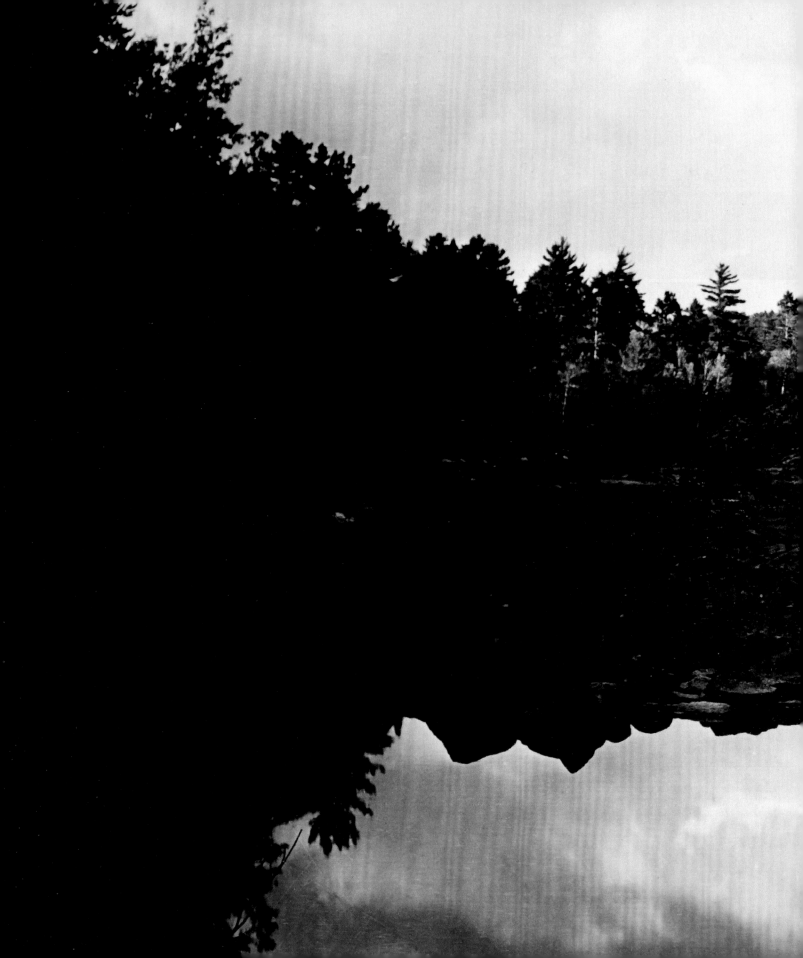

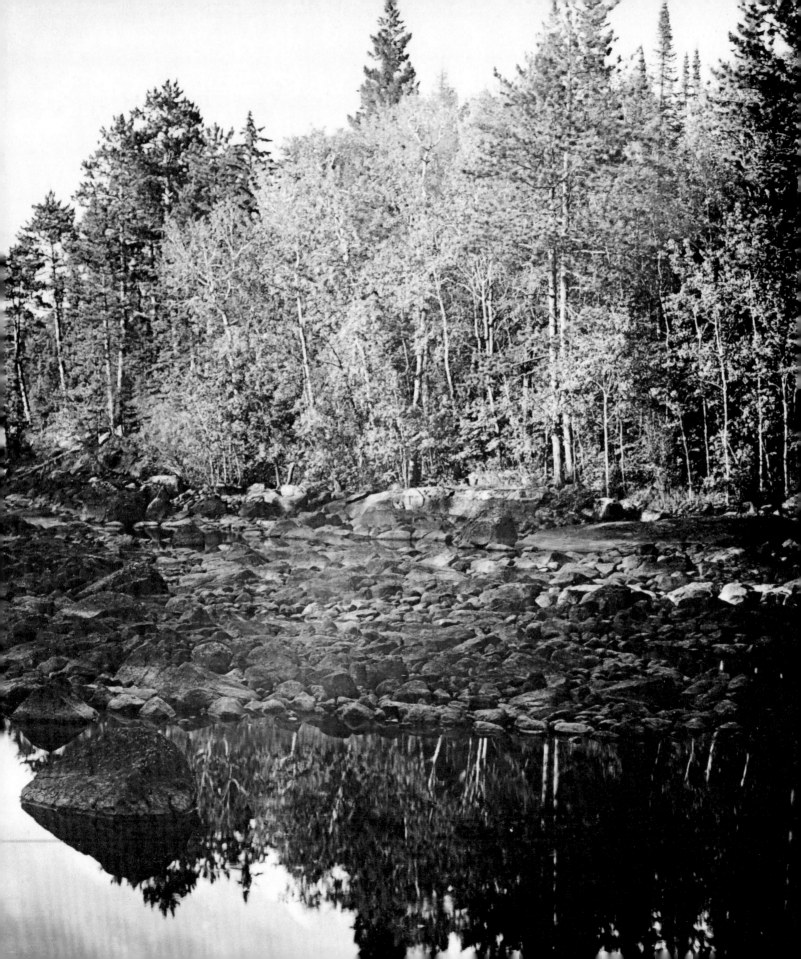

Having tested themselves on the dangerously challenging Presque Isle River in 1909, the Gang looked toward the Canadian border lakes for a bigger trip in 1910, going out for three weeks into a new part of the country. The trip tallied about 1,100 miles, including train travel from Milwaukee to Winton and canoe travel from Ely to Ranier.

The Rainy Lake trip is probably the richest experience they had, as it was filled with adventures as they made their way through a vast network of poorly marked waterways. With the best maps available, which were often very inadequate, and with no guides as to where they would go and what they would see, each day brought discoveries.

The landscape was not the pristine, old-growth forest that they had seen in northern Michigan (the Upper Peninsula). As Dad described it on about the sixth day of their trip, "This is all burned over country and the only things that were picturesque were our canoes moving along." Major forest fires had plagued the area that summer and were a concern even as they began their trip at Winton. The landscape improved, however, as they paddled, portaged, and camped farther into remote areas.

The North Woods was in a period of great change that summer as commercial exploitation was tapering off, and recently created state and national forest services were making an impact on a new and different use of natural resources.[1] The Gang enjoyed contact with Ojibwe culture, vestiges of the timber and mining industries, and local fishermen, such as the ones they encountered early in their trip at a small loading dock near Fall Lake. The fishermen were sending fish to the Chicago fresh fish markets.[2]

To those who know about Rainy Lake in the early twentieth century, the name Ernest Oberholtzer will be familiar. It would seem possible for Ernest and Dad to have met, but there is no indication that they did. Their considerable age difference (Ernest was twenty years Dad's junior) and the fact that Ernest was not firmly established on Mallard Island until after World War I perhaps prevented them from becoming acquainted during Dad's trips in the area.

Imagine, if you will, being one of city-dwelling youths and men coming upon a steam tender towing wanigans and York boats, lumberjacks in a "bateau" collecting stray logs, petroglyphs, and Ojibwe families drying blueberries and making moose jerky. What was it like to travel for weeks in a remote area and share a campfire, then to pose while Dad took a night photograph by the new technology of "flash light"?

Camping technology of the times remained basically as it had been since 1900, but the addition of Bill Marr's folding canoe created a stir and gave the Gang endless subject matter for jokes and jibes on this trip and future ones. While good-naturedly complaining about his

THE GANG
IN THE
RAINY LAKE REGION
1910

"tub," the Gang went on its usual way, patching canoes, mending paddles, making sails, and improvising with whatever supplies they brought to make things work. Their improvisation and skills play a significant part in the success of the journeys.

The Gang was also quite wealthy in knowledge of natural history. The reader is encouraged to study the lists of species seen and the descriptions of the region's geology that follow the narrative of this Rainy Lake summer. [M.G.P.]

NOTES

1 The journal references a new hotel being built at Kettle Falls in 1910. This hotel is the "old" one that people visit now while touring in Voyageurs National Park.

2 Every fisherman had an icehouse; as soon as the day's catch came in and were cleaned, they were iced. On shipping day, ice was refreshed, to keep the fish fresh on their way by wagon, boat, or train to a major railroad route. Before being loaded at a depot, fresh ice was again added, allowing a catch from Lake Superior to arrive in Chicago within a few days, ready for sale in the markets there.

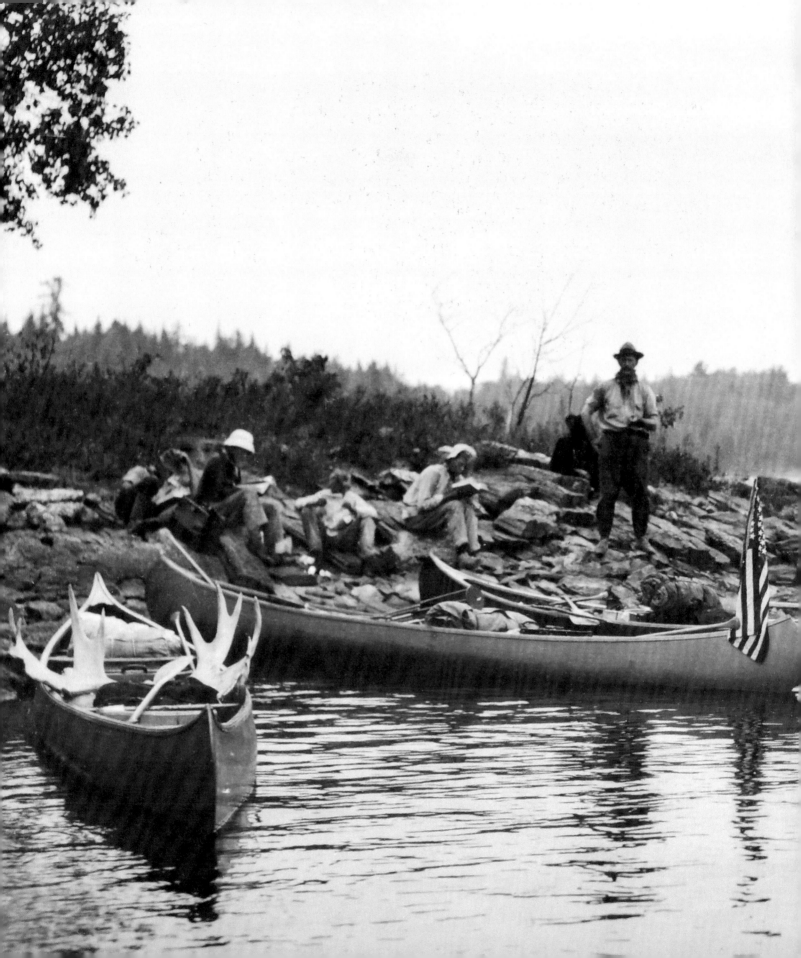

THE RAMBLES OF THE GANG
IN THE RAINY LAKE COUNTRY
1910

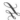

This Illustrated Journal is Limited to Nine Numbered Copies
and is Printed for the Members of

———————————

THE GANG

1 Dr. Ernest Copeland

2 William P. Marr

3 Howard Greene

4 William MacLaren

5 Clay Judson

6 Howard T. Greene

7 Carl Greene

8 Charles F. Ilsley

9 Frederick Hansen

———————————

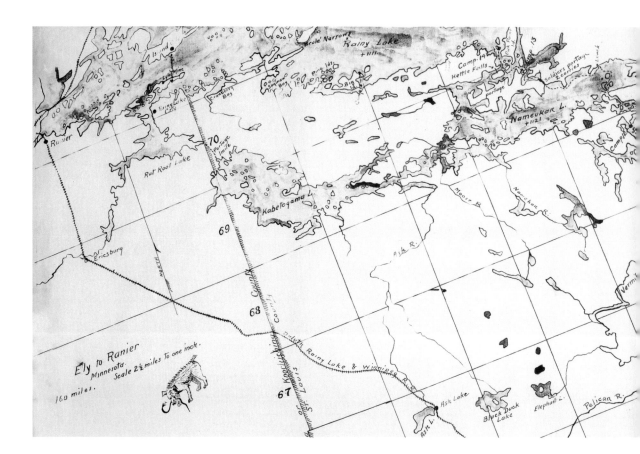

FOREWORD

When the gang set out on its "1910 Outing" it cast about for some new territory which would not in its essential feature, resemble the four preceding ones. It also had in mind the beautiful trip down the Presque Isle, which, while it presented some hardships, was still the most beautiful and entertaining of all. It was therefore after much deliberating, that the Rainy River trip was finally decided upon. It devolved upon B. M. (Billy Marr) to procure data preparatory to the definite plans. It was first proposed and approved, that the Little Fork River to the Rainy River, would offer splendid opportunities for canoeing and camping, but investigation on the part of B. M. caused the gang to change its plans.

While the Little Fork River was accessible, it was not navigable at this particular season, as logging was being done, making it impossible to handle our canoes freely. This project was therefore abandoned and B. M. immediately got into communication with Shepherd & Co., of Duluth, procuring maps of the Canadian as well as of the American boundaries. The information thus obtained, finally led to the Rainy River trip which proved to be the most enjoyable, and which brought us through a territory most picturesque as well as of historic interest.

It was there that the early settlers of the Northwest, the Jesuits and the trappers struggled in the early days of the Northwest settlement, and was the scene of many Indian uprisings, in which both governments had more than passing difficulties.

The entire trip covered not less than 1100 miles, beginning at Milwaukee and ending at Rainer [Ranier]. Rainer is one of the new towns on the American side, close to Fort Frances on the Canadian side, which was a Hudson Bay trading post. There remains today only the remnant of the old trading post which was partly destroyed by fire a few years ago.

International Falls, another town on the American side is the most prosperous of them all and the party took general interest in the wonderful paper plant of the American and Ontario Power Co.,[1] erected a few years ago at a cost of several million dollars.

Beginning at Winton, the trip practically consumed twenty one days. Our little flotilla of six canoes, began its journey down the Rainy Lake region at Winton. Most favorable weather conditions favored the party. During successive days the unguided party found its way among myriads of islands, touching the shores here and there for exploration or for rest, the details of which are fully explained in the journal which follows.

BILLY MAC.

[1] The power company was the Minnesota and Ontario Power Company. Edward W. Backus, a timber baron and president of the Minnesota and Ontario Power Company, became the primary opponent in the conservationists' fight to preserve the boundary waters area.

The trip on the Presque Isle River in 1909 was so successful that it was decided to have the same gang and to add Frederick Hanson, to whom various names were applied:—"Hannie" became "Heine," and this in time received several additions by way of elaboration. The party as it started was divided into three groups:—The men:—Doc, Bill, Billy Mac and Dad. The brutes:—Clay, Hannie, How, Piffy and Carl, and lastly Di, the Eyredale dog.

The trip was to be carried out as first planned except that all of the men felt compelled to cut down the three weeks outing to two weeks and accordingly would leave us at Little Falls, leaving Dad alone to the tender mercies of the brutes for the trip across Rainy Lake.

On the evening of Friday, July 22, we assembled at the Chicago & Northwestern Railway Depot in Milwaukee, and crowded the Duluth sleeper with our luggage, packs, paddles, oars and handbags. Mrs. Greene rode as far as Wales where she left for the farm and thereafter the noise gradually subsided, berths were made up and Billy Mac produced sundry cold bottles of beer for the men and ginger ale for the brutes and then we went to bed.

SATURDAY, JULY 23, 1910

By a piece of great good fortune the men awoke early and as soon as the diner was put on at Spooner they had breakfast. As they came back to the sleeper the boys were just appearing from their berths. This was to be our last quiet meal.

At Duluth, we transferred our camp stuff to the Iron Range Depot[2] and our suit cases to the Hotel Spauld-

[2] The depot referred to is the Duluth, Missabe and Iron Range Railroad depot, at Endion, near the outskirts of Duluth.

ing, where we met Mr. Lee, the manager, to whom Billy Mac had a letter. Everyone followed his own whim in doing the town until twelve o'clock, when Billy Mac, Cope and Dad met and sought a moment for retirement at the bar. Hardly were we seated when Clay rubbered in and we let him stay on condition that he would not alarm the other brutes. Clay took advantage of the situation, ordered beer and lighted one of Doc's cigarettes. There was a row when the beer was poured into the cuspidor and the cigarette broken, but we escaped a visitation from the other brutes.

At dinner the brutes were assigned a separate table where Hannie took advantage of the tactical position and ordered a bottle of beer for himself.

After dinner we made a few purchases and then exchanged our clothes for our woods outfit and at 3:35 we took the train and left for Ely, where we were due at 8 P.M. For thirty miles or so the road parallels the lake and then turns abruptly to the north, passing through cut-over country. The road bed was excellent and the road carries large tonnage in iron ore. The only town of any importance is Tower. We had heavy rains during the afternoon which must have quenched the forest fires.

At Ely Fred Carr met us and he had arranged to have us go to Winton in a three seated rig that carries mail. There were too many of us for the rig, so Dad and Fred waited until another conveyance could be secured to carry them and their baggage. We found that we were short one shipment containing photographic material and other things for Dad. Here the journal divides for the two parties had different experiences in reaching camp. Driving over Fred said that Shomer, who had been hired as cook, had refused at the last minute to

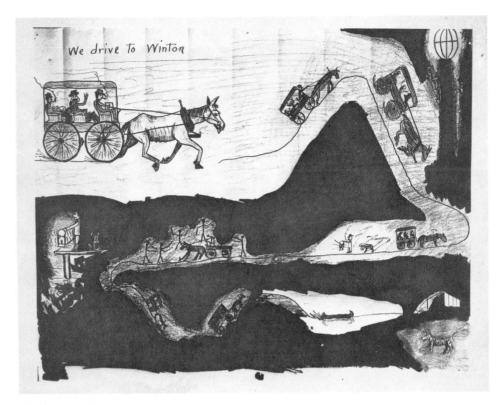

Carl's map to Winton

keep his engagement and Mr. Pangborn had sent his father in his place. The other man is Billy Boucher. On reaching Winton we were told that the other party had preceded us by about fifteen minutes, and we drove through a lumber yard where two of our canoes had been left. We opened one and having loaded some of our baggage, I paddled across a bay to the camp. To our surprise we found no one there, so Fred called Billy and sent him down the road to find the missing members of the party. It was then about half past ten. The beds in the big tent had been made up and most of them were more or less wet by the heavy rain of the afternoon, which beat through fly and tent. After stirring up the fire and waiting a while for Billy he returned without having found our party. Fred and Billy then started out with a canoe for Winton, while Dad stretched himself out in a poncho in front of the fire. It seems that their

driver had taken them to another dock farther up lake and there stood and shouted and signaled with lanterns where they could not possibly have been seen or heard from camp. After exhausting all efforts to reach us they drove back to Winton where Fred and Billy found them and guided them to a road in rear of the tents.

The new Amazon tent is all right, and has been named the "Private Car." It will be occupied by three boys who sleep in this order.

H		P
A	C	I
N	A	F
N	R	F
I	L	Y
E		

In the big tent, known as "The Sleeper," five of us are quartered thusly:—

	B				H
C	I	D	B	D	O
L	L	O	M	A	W
A	L	C		D	A
Y	Y				R
					D

Front of Tent.

During the last two weeks the papers have printed a good many stories on the subject of Forest Fires and if we believed half of all that appeared in to-day's papers we would be looking to see all the north woods ablaze. At Duluth the air was hazy as if from the smoke of forest fires. During the morning and afternoon heavy rains fell and even where woods have been afire the fires have been quenched by the rain.

From Duluth we wrote home saying that the forest fire story had been greatly overdrawn. We felt that even if the fires started up again we should be perfectly safe in the vicinity of large bodies of water.

From what little we could see at night, Winton on Fall Lake is quite a place. There are two saw mills, only one of which is running at the present time. The inhabitants are all employed about these mills and in the woods and there are only small stores. Ely seems to be the last place for general business and there are no towns, except Winton, to the north.

SUNDAY, JULY 24.
CAMP ONE, NEAR WINTON.

The mosquitoes held high carnival in our tent last night and no one slept well. Dad was up and dressed at half past four and the rest slowly followed. Our six o'clock breakfast was

Pettijohns with condensed cow.
Coffee and bread.

After breakfast the real work of camp commenced and lasted through the morning. Cope tried to fish, and

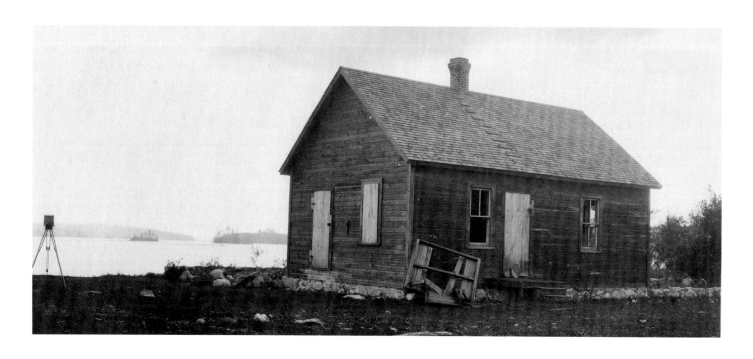

Hannie caught a small pickerel; Bill unfolded and set up his new collapsible canoe;[3] the boys aired and dried the bedding and put the tents in order, while Dad, with Billy Mac, packed the provisions and general camp supplies. This list of bags and how they were packed indicates about how closely we estimated the mess-bag requirements:

Large Bag—Bacon and ham sausage.

Bag No.

1—Flour.

2—Flour.

3—Lump Sugar.
 Corn Meal.
 Beans.

4—Flour.
 Corn Meal.
 Fried Apples.

5—Chocolate in tins.
 Cookies in tin.
 Matches in tin.

6—Flour (2 bags).
 Rice.

7—Pettijohns.
 Currants.
 Raisins.
 Figs.

8—Tea.
 Pancake Flour.
 Cookies.
 Salt.

9—Brown Sugar.
 Sapolio.
 Pettijohns.
 Prunes.
 Beans.
 Erbswurst.
 Tea.

10—Tobacco.
 Prunes.
 Pancake Flour.

11—Tobacco.
 Pancake Flour.
 Chewing Gum.
 Ivory Soap.
 Blazer Matches
 in tin.

12—Tobacco.
 Doctor Shop.
 Maple Sugar Bricks.
 Laundry Soap.

[3] A few folding canvas canoes were available in 1910. Nessmuk mentioned the "Osgood Folding Canvas" in his book *Woodcraft and Camping*. The Acme or Eureka brand folding canoe was also sold as a boat in a bag circa 1910.

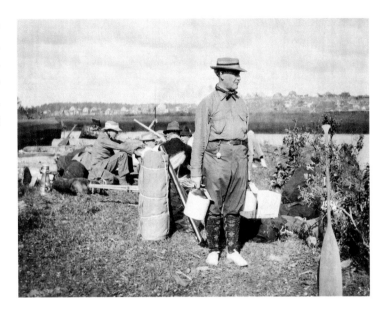

We are using two of our packing cases for canned goods, and besides these we have very little of the mess outfit to carry in separate packages.

We dined at high noon on

Pork and beans, beautifully cooked.
Canned salmon.
Bread and coffee.
Prunes.
Hard tack and brickstein cheese.

The outlook is for good grub. Mr. Pangborn is evidently afraid that he will not be satisfactory to us and that he is too old for this sort of a trip. He cannot enter into the easy way of having a good time with us as Fred and Billy Boucher do.

In the afternoon we all sought light work. Bill made a mosquito headnet; Doc and Billy Mac found a very few raspberries, and then we gathered at the big tent and abused the brutes. We are camped near the Winton post-house, a rough cabin on the shore of the lake.

Fall Lake is about three miles long and is not particularly attractive, for the timber has been cut off and there is only a growth of small poplars where once was good pine. Between this and Newton Lake there is a small fall or rapid of six feet drop, which may require a short portage. Our plan is to leave here early to-morrow morning for the lower end of the lake. We shall start early and make camp there. In the afternoon Fred will go back for supplies and our missing express package and will return by nightfall. On Tuesday we will make our portage and pass through Newton Lake.

We had a visitor in camp to-day who told us to follow this lake until we came to a place where a logging railroad passes along the west shore. There he tells us we can make a portage by train to Bass Lake, but the map shows us that if we follow this advice we would follow a longer route than the one we had planned—that is, through Newton Lake into Bass Lake. Bass Lake is large and irregular and the logging road would land us at a distant arm of the lake.

MONDAY.

CAMP TWO.

AT NORTH END OF FALL LAKE.

JULY 25TH.

Last night we went to bed at eight o'clock, and hardly had we taken possession of our blankets when the mosquitoes renewed their assault of the previous night. This time they were more determined in their attacks. We heard the curfew bell at Winton and no one could sleep. Finally Cope took his bed roll out in front of the tent. Rain began to fall followed by so cool a wind that we raised one end of the tent to see whether the mosquitoes could not be blown out. This was measurably successful and so How and Dad pulled their blankets into the open. The change was somewhat for the better for one could at least keep covered in the cold night air. From the "Private Car," came Carl and Hannic about

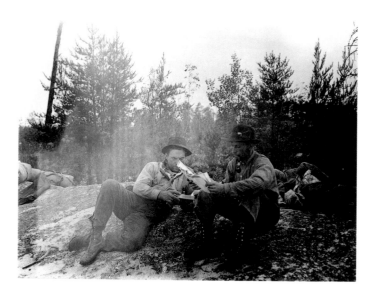

1 A.M. to compare notes on the mosquitoes. To-day we talked the matter all over and we decided that while we have heard better singers and a greater chorus we never experienced any which had longer and sharper bills which they were so determined to present.

As soon as we were awake, about 5 A.M., we commenced to roll our blankets and carry them down to shore.

We had a light breakfast because we wanted to get out as early as possible. Mr. Pangborn showed us he could cook bacon and pancakes very acceptably, and these with coffee, was our entire menu.

We left the old camp at about half past eight, traveling in the following order:

Doc and Clay in the Doc's canoe (Clay was not feeling well after his night's fight with the mosquitoes).
Dad and Hannie in the 18 foot guide canoe.
Howard and Piffy in Clay's canoe.
Billy Boucher and Mr. Pangborn in Bill's wangan.
Fred Carr and Billy Mac in the 20 foot guide canoe.
Bill Marr and Carl in Bill's collapsible canoe.

We had doubted the ability of our canoes to carry our baggage which looks very bulky, but in reality loads compactly and we could easily have handled two hundred or three hundred pounds more in either guide canoes.

We had a head wind and had to hold fairly close to the west shore to avoid the rough water. Just before noon we reached the end of the lake. We explored the dam and the rapids in the river and in the woods saw several partridge. We found a trail running along the river, and we determined that by a short portage over the dam we could lead our canoes through. There was no place for a camp, but nearby was a launch and dock used by fishermen, and a road leading from the dock through the woods to a little cabin on Newton Lake. We found a good camping place on a rocky point on Fall Lake near the dock where we shall camp for the night. During the afternoon Fred and Carl will go to Winton with the fishermen in their launch and will pick up our missing supplies returning with them this evening.

We had hardly finished lunch when the fishermen appeared with a "skid" drawn by an old horse. They had three big cases of fish which go to the Chicago market for fresh fish next Friday morning. They had lake trout, pickerel, bass and white fish, and soon Billy Mac came in with a look of pride, carrying a big live whitefish.

Doc went fishing and in a little while he reappeared with a string of pike, pickerel and bass he had caught in the river by casting from the shore. The Doc is trying to make our canned fish useless. Hannie cleaned

the fish first to learn how. Everyone is indolent—the result of sleep lost fighting the mosquitoes the last two nights. Bill, Billy and Dad had a swim. There is a good spring at the fishermen's house, which is better than the lake water.

Just as we finished supper the launch returned from Winton with our missing express package and the extra supplies Fred and Carl had bought, together with some beer Cope had sent for.

In the party of fishermen were two men whose names we learned were J. S. Campbell and J. B. MacDonald, who are rangers in the Canadian service. They had a shack which had been burned when they were away and they had consequently run into Ely for supplies. Mac-Donald wore a sweater vest with a T and the seal of the University of Toronto, and he told us he had won his T in football. After supper he came to our camp and looked over our maps, telling us a good deal about the various portages we shall have to make.

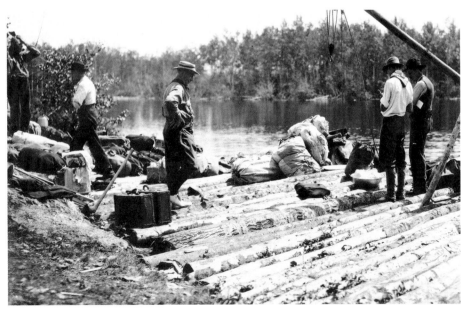

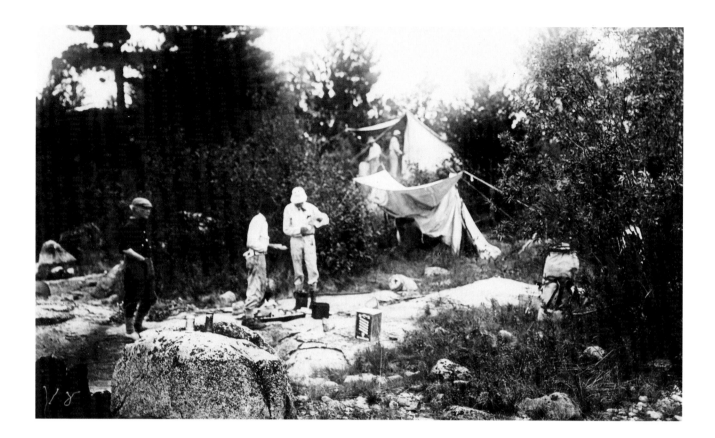

The fishermen brought back a jug of whiskey and held high revel at their shack in the evening.

We went to bed about nine o'clock after thoroughly smudging the tent and had a good rest for the first time since we have been out.

All of the photographic stuff was repacked and the only thing we need is potatoes which we could not buy at Ely or Winton.

TUESDAY.

CAMP THREE.

JULY 26TH.

We were up at about five o'clock and immediately packed our stuff for the short portage to Newton Lake or Pipestone River as they call it up here. The trail, an open one, is 500 yards long, and leads to a dock where we piled up our stuff. There are two men at the shack, Frank Savois, a Frenchman, and an old half breed, Joe (Bluebeard).[4] They all had bad heads after making a night of it, but Frank got out his big white horse and jumper and hauled two loads of dunnage for us.[5]

The passage between lakes was easy for the canoes—first a low dam and then a course through boulders. We rode most of the way and then led through the shallows to the lake. Bill and Howard managed in some way to capsize their wangan and went in all over.

At the shack MacDonald gave us some written directions as to rapids and portages, particularly on the Namekon [Namakon] River, which seems to be the short passage but is not covered by our maps, it being in Canadian territory.

[4] At the time common, the offensive term *half-breed* was often used to describe people of mixed races.
[5] A jumper is a primitive kind of horse-drawn sleigh or sled.

When we left at about half-past nine Savois said he would go over to the next portage with his horse and help us with our baggage. We had some difficulty in finding the portage because the location was not indicated on the map. Dad investigated an old railroad right-of-way thinking it might lead to the next lake and found three ant hills beside the right-of-way three paces in diameter and about three and a half feet high. We finally made the dock at eleven thirty and found MacDonald and Savois with his horse all ready to carry our stuff across. The portage is hilly, and is about eleven hundred feet long.

Last night Mr. Pangborn set some bread and baked during the afternoon, but it had stood too long and was sour.

Piffy is under the weather this afternoon— probably he cannot stand the change to camp life easily.

The rapid is easily crossed—there is only a small cascade over which the canoes have to be lifted.

As we came into the portage we met some of the American Rangers bound for Ely. They will return about Friday. We are now in the American Forest Reserve and cannot lawfully fish or carry guns.

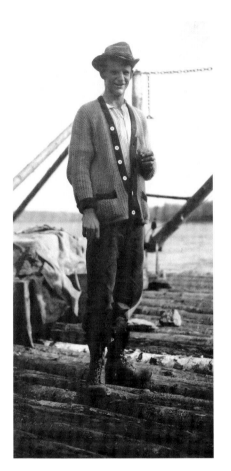

MacDonald's Directions:

"American portage. Left side of Basswood Falls. Shoot both rapids below or take Canadian portage on right. Paddle to left of large island to portage on left side of same island. Straight ahead below falls to Bay and one-half mile portage, or take turn to right and shoot its shore rapids. To next portage about one-quarter mile on left hand side. Shoot next two rapids. Along river to portage on left hand side (about 4 miles to portage). Portage (Twin Falls) about 2 miles paddle. Portage on left side (short) about 10 miles to Crooked Lake. Curtain Falls portage on left side. Shoot rapids below falls. Follow shore line on the right to Bottle Portage about 5 miles paddle. Small rapids and low water to portage in Grassy Bay.

"J. S. Campbell,
"J. B. MacDonald,
"(Rangers.)"

MacDonald and Savois shared our lunch, smoked their pipes and departed during the afternoon. Savois charged a dollar and a half for the early morning portage and charged only two dollars for the noon portage, although it meant an eight mile walk.[6] He brought a little dynamite with him to get fresh bait for us.[7]

This afternoon our fishermen brought in some splendid pickerel and pike and they put back many more than they caught but would not kill.

Our camp is in the deep brush and about fifteen feet above the lake. The tents are scattered here and there, wherever the men could find place to set them up.

[6] For wage comparison, a cook or a two-horse teamster in a logging camp earned about $1.00 per day.

[7] Dynamiting for fish and bait was a common enough practice but was frowned upon by more established fishermen and outdoorsmen.

The plan is to get an early start and go to Basswood Falls—about fifteen miles away, where we have our next portage for our night camp. From now on we shall have to push if we make Kettle Falls in time for the Doc, Bill and Billy Mac to end their vacation on schedule time.

MacDonald tells us that Canadian maps can be obtained of Interior Department of Ontario, Toronto, Canada.

And he gave us his address after October 1st.

> J. B. MacDonald,
> School of Applied Science,
> Toronto, Ontario,
> Canada.

In the evening Piffy and Hannie, while canoeing, heard a noise in the woods which they thought was a bear. Carl investigated the place and found an Indian grave marked by a flag. Carl came back to camp and took Dad out to see it. There were the remains of an old tepee, part of the frame of an old shack and a children's tepee. The grave was at least two summers old and was marked by a new flag of curious design.

We went to bed at little after eight o'clock.

WEDNESDAY.
CAMP FOUR.
JULY 27TH.

Doc began by being disagreeable to everyone in camp. The air was cold and coats were comfortable. We left camp at ten minutes after six Bill with Carl; Dad and Hannie headed for the point of land on our left where the Indians had been and Dad made views up river, down river, and pictures of the tepee and grave. Billy Boucher and Mr. Pangborn came up and the latter with pious hand placed some wild flowers on the grave. The grave was boxed and boarded over, and over it was a roof of rough boards covered with felt building paper. On the grave was an old graniteware cup, a broken cup and a plate, and on the platform over it was laid a stick about five feet long, decorated at intervals with bunches of old fish lines, bits of cloth, bits of string, and what was particularly interesting, a little skin bag about

an inch long, which was enclosed in an outer cover of green bead work. The flag was new and from appearances had not been exposed to the weather for more than a week or two. The tar paper over the grave had fallen to pieces, and inside of the tepee the raspberry bushes were at least two years old.

During the morning we met some lumber jacks in bateaux who were collecting stray logs and later we met a tug acting as tender, and still later another tug towing wangan house and cook boats. We followed our maps carefully by compass and made our run by shortest line and without difficulty.

On a rocky point at the entrance to Basswood Lake we found the remains of an old tepee and Dad made a picture looking north up the lake.

This is all burned over country and the only things that were picturesque were our canoes moving along, sometimes under sail but generally by steady paddling.

At about half past eleven we came to Basswood Falls on the Canadian side and looked the situation over. We portaged on the American side where one portage passes both falls. By noon we had all our stuff across and Mr. Pangborn was getting up our lunch of fried pike, fried pettijohns, tea and cold biscuit.

Below us at noon were two small rapids which we could run and Cope did run the first, but the rest went

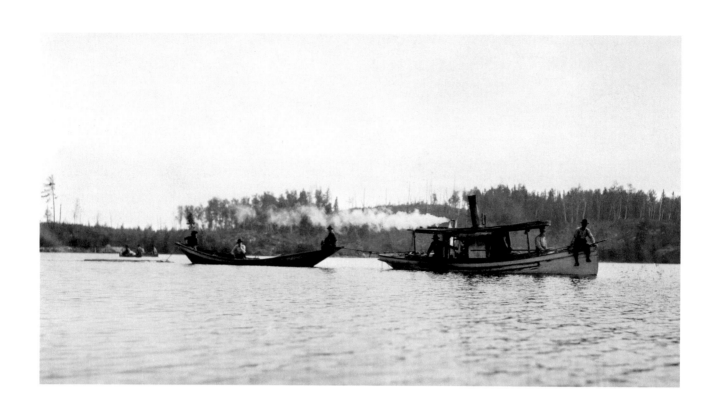

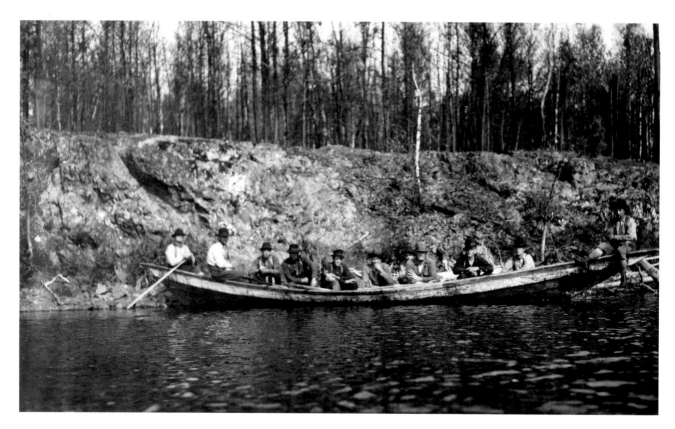

through with a lead line[8] because we dared not risk our provisions and supplies so far away from a place where we could refit.[9] After a little smooth running through a narrow gorge we came to a small rapid which we could easily run, then some more smooth water and then a rapid which we investigated from both American and Canadian sides and returned to our own side. Fred, Billy Boucher and Dad led through all boats except the tub which Bill floated through empty. The rest of the party portaged a part of the duffle while the rest went through in the boats. The cascade here does not amount to much except that the channel is crooked and full of large boulders and there is no channel for boats.

As soon as the party and baggage were assembled at the end of the rapids we decided to make camp. The fishermen got busy at once and Carl caught a blue wall-eyed pike,[10] which Cope says is a rare fish. They caught a good many pickerel which were thrown back at once and a few yellow pike.

Doc and the boys, except Piffy, went swimming; the men spread tents on the ground for a bivouac camp and the cook was obliged to get up a bigger and better dinner than we have yet had. Our menu was

<div style="text-align:center">

Corned beef hash with dehydro
potatoes and onions
Tomatoes
Hard tack
Tea
Canned peaches
Ginger cookies brought by Doc.

</div>

We had biscuits baked for to-morrow.

Just after our camp was partially established two men came up stream in a canoe. They are apparently going to Winton for supplies and asked a little tobacco. They and Bill looked over our map and had a long talk.

[8] A lead line was used to guide the canoes through the rapids.

[9] *Refit* means to re-outfit, or replace supplies.

[10] A blue wall-eyed pike is a blue walleye or a blue pike. Some border lakes had large numbers of these fish; others few. There has been a seventy-five-year-long debate on whether the fish is a variant or species, but in the Gang's experiences, this fish was a rarity.

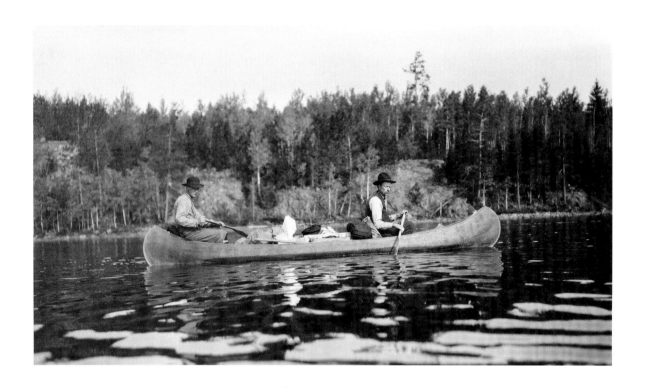

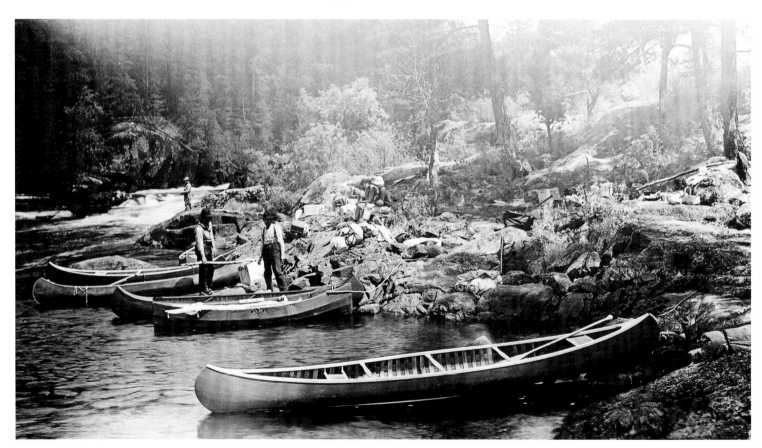

They tell us we are ten miles from Crooked Lake and that we have two small portages to make and two rapids to pass through; these we can run. These men were Canadian forest rangers.

All day long we have been traveling through country more or less burned by recent forest fires. Sometimes the burned district would cover many miles and sometimes it would just fringe the borders of the river. Had we been here before the last heavy rain we would have been in dense smoke all the time. To-day our party found and put out a smoldering fire on the Canadian side.

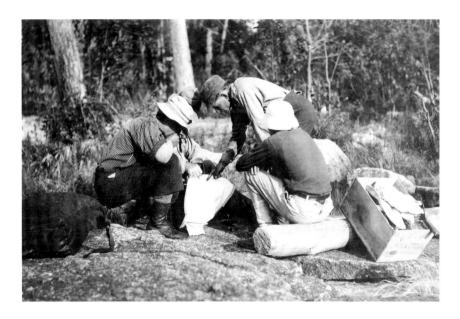

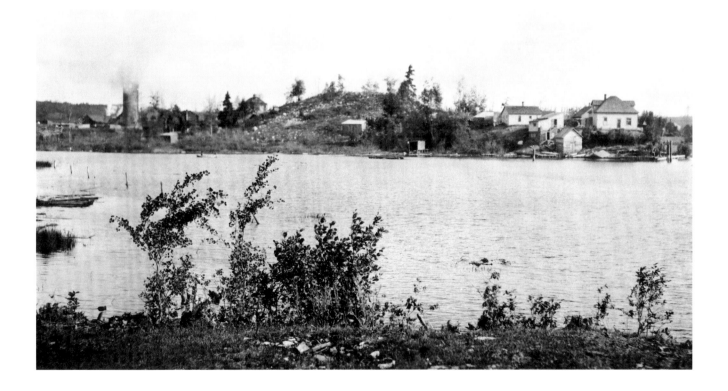

We were to be up at five this morning, but Cope played Jack at the farm an hour earlier and there was no sleep to be had. Bill and How went swimming and then we had breakfast and were started at six down river. We came to three rapids—one we roped, one we ran and one we roped part way and ran to the end. At nine o'clock we ran into a large bay and found a beautiful little cascade leading out, but it was untraveled and so small that we knew we had not struck the right place to portage. Howard, with Fred's help, worked his boat through. Dad and Hannie ran ahead and found the main passage on the other side of the island and summoned the others. When Fred came up he found the main portage where three boats were carried through. Dad and Billy Boucher worked their canoes through the river and made a short carry at the very end. At eleven o'clock the portage was finished, and we paddled on for only a few minutes before we heard the sound of more rapids. At this portage the river divides—the carry was short and over a smooth granite trail. We decided to lunch while the cook was busy. Everyone except Dad and Piffy went fishing. Piffy sat still and Dad wrote Journal and made pictures of the two cascades to be known according to their size as the cascade and cascaret.

After dinner we set out and at five o'clock made a camp on an island at the east end of Crooked Lakes. The camp ground is a bare rock and we gathered moss

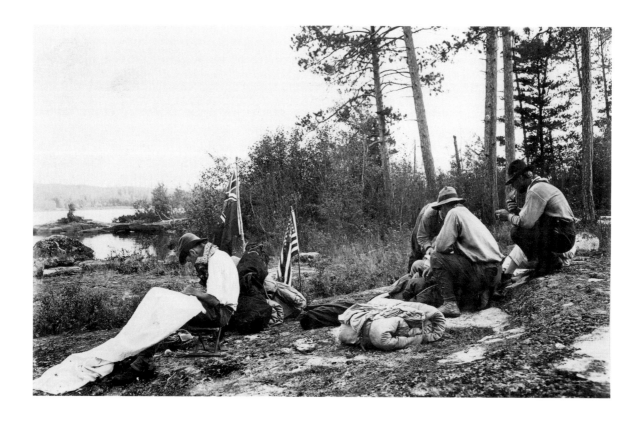

on which we shall sleep to-night, to put under our tent,—our second bivouac camp.

During the afternoon Cope and Clay saw a cow moose and in one place where Howard and Dad landed to look for a camp site there were both deer and moose tracks.

We are trying to reduce the weight of our provisions and to use up what we have. We had to throw away our ham sausage to-day—it had spoiled. The provision list is working out in queer ways because we have had so much fresh fish. At every place we stop a few fish are brought in and only the best of them are kept.

During the afternoon we passed a granite cliff fifty or more feet high, wonderfully colored in streaks of pale olive green, red and black.

Piffy continues silent and apart. Cope, Dad and the boys (except Carl, who was fishing and exploring,) had a swim before supper. One can dive from the rocks into deep water. We used soap.

During the afternoon we passed out of the burned district and have been in better looking country.

During the evening Bill took the long canoe and with three boys explored the neighboring lands to ascertain our correct position on the map.

FRIDAY.
CAMP SIX.
JULY 29TH.

About three this morning and just as day was breaking Cope quietly called us to see a moose which was feeding in the water very close to camp.

We started at about noon and for a while we followed a north and westerly course among the islands, stopping from time to time to check up. We have the best maps obtainable but they are grossly inaccurate in that there are many islands not shown and the Canadian shore is only sketched in. We crossed between two

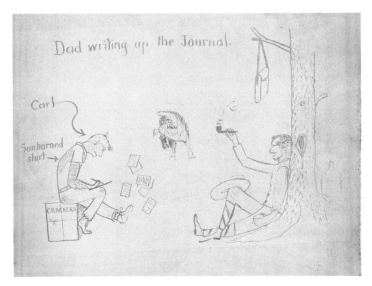

"*Dad Writing Up the Journal*"

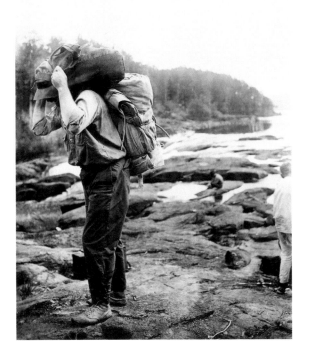

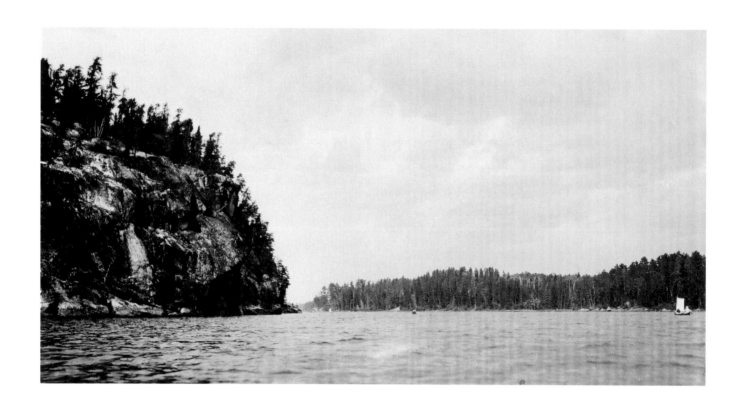

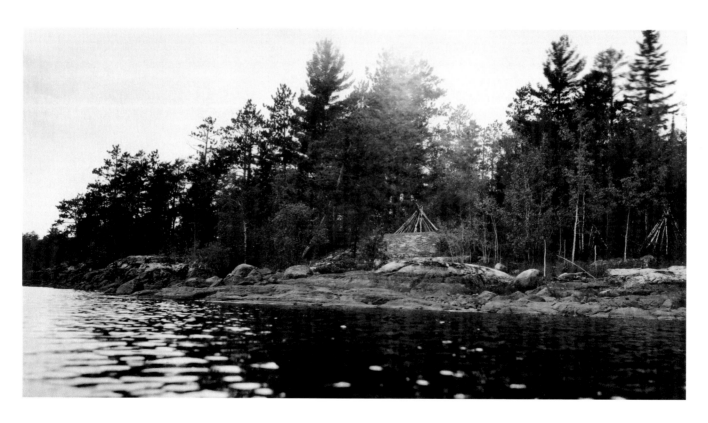

islands, where, on account of the low water, we had to work the boats through, clearing the passage of stone as we went. Then we crossed the mouth of the first deep bay extending to the south and entered some more uncharted islands. The wind had freshened and we had agreed to meet at intervals and check courses with Dad and Billy Mac who were to be the navigators.

Cope ran a mile ahead on a north course and stopped. Bill and Dad stood in to check as agreed. Bill went to see why Doc had stopped and Cope then signaled Dad to follow. This led us finally three miles or more into Canada and we had it all to retrace, and then from the point where Bill and Dad had stopped to work out three ways before we finally struck the southwesterly course we were to follow. We stopped at about noon on our course and had a lunch.

Here we got out our American flag.[11] Indians camped here and had a tepee two wickyups and had eaten a moose.[12] We made a short run toward the mouth of the second bay on the American side where we were held up for two hours by head winds and threatening thunder and wind storms. At about four o'clock we pushed along crossing the mouth of the second bay and camping on an island opposite its west point.

The camping place we selected is in a grove of Norway pine, but there was hardly enough soil to hold tent stakes so we made a bivouac camp. Hannie worked on

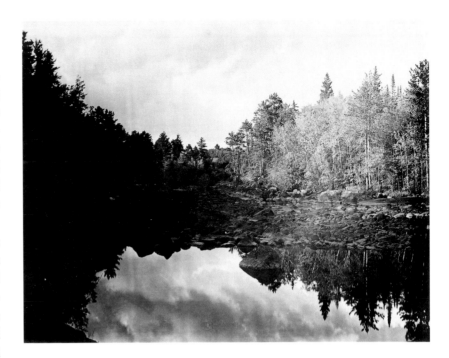

a sail for Dad's canoe—Cope, Billy and Bill caught fish for supper.

We went to bed at 8 o'clock and had a little rain early in the night.

SATURDAY.
CAMP SEVEN.
JULY 30TH.

All awake and up at five and at six thirty we had eaten our breakfast and were started, one boat following another on a westerly course for the American shore and Curtain Falls.

It was a straight easy course to navigate. Cope and Clay, as usual, ran ahead and around the course and saw a cow moose and her calf. There were a good many sea gulls on this lake. Cope and Clay found a small rock island with a gull's nest and a young gull. The lake was full of beautiful islands once. There is a good trail through second growth leading to a rough, rocky beach below the falls. The falls itself is a cascade with two little rapids below the landing.

[11] The Gang carried ensigns of flags of both countries, changing them as they crisscrossed the border.

[12] A wickiup is an oval-shaped Native American dwelling, made from a frame of saplings driven into the ground and covered.

Dad made pictures of the members of the Gang as they started over the trail.

We had dinner and at half past twelve we started across Iron Lake for the next portage. Iron Lake here appears to be about three miles across, and we are told that there is a small portage above Bottle portage. We paddled along together through the river running three little rapids and held a westerly course, finally coming to an outlet which from description we knew to be the Falls from Iron Lake into Lac La Croix. The outlet is divided by an island and the stream on both sides of the island runs over a ledge of granite tilted at an angle of about thirty degrees, while the opposite side of the stream is an abrupt granite wall. There was no indication of a portage on either side so we paddled along the shore of Irving Islands finally coming to a point where there were two abandoned Indian tepees. This indicated that we must be near the main traveled route. Here the party lay to while Dad started to explore a bay opening to the north. This was about three o'clock. Finding that the bay divided Bill offered to explore one passage. The bay proved to be a large one and the dividing land an island. The boats met and continuing the exploration Bill

found a beach of large rock leading to a smaller body of water at a lower level, three hundred feet beyond. At high water this is a main water route and could be traveled easily in boats. There is a dead blazed tree on the left entrance and there are signs of old camps. On the right bank where the land is low there had once been a camp, probably of Indians, in cold weather, for there are stones with old logs where the edge of the square tent stood, and an old moccasin was found in the grass. On the left bank on the downstream side we found where Indians had cut an ironwood branch this year for the bark, and also a stump of a sapling cut above snowline, showing that trappers work this route in the winter.

We unloaded both canoes, sent the boys back a mile for the rest of the party and while they were gone we portaged our loads and decided that to-morrow we must lay up for repairs, rest and changing plates.[13]

The rest of the party came up and while they worked Dad and Bill had a swim.

Billy Mac and Dad ordered a supper of cold corned beef, salmon, deviled ham, sardines, pickles, hard tack, brickstein cheese and tea. The change in fare was agreeable and everyone enjoyed it.

After supper, Bill, Fred and Dad explored the water below. They found a dry water course of wonderfully piled up rocks and at its head a reedy pond and at the ends of the pond were blazed trees. A way had been opened through the pond where canoes had been worked through and a well worn trail was found, five hundred paces long, leading to Lac La Croix. In the pond were swarms of newts. Carl came up and caught

[13] As film negatives became more commonplace, the old term for changing "plates," or glass negatives, persisted. Throughout Dad's later journals it is hard to know which type he was using. If his negatives had not been lost in a house fire, this wouldn't be a question to resolve.

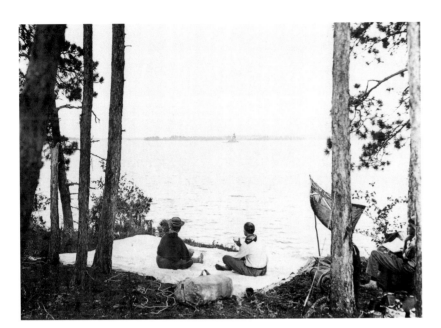

ing, ten o'clock, we are all dry, but everything is moist.

There are an abundance of deer and moose tracks to be found about this place. Clay saw a deer this morning. Clay is busy studying trees and shrubs, Carl is butting up against arithmetic, while Hannie, How and Bill are sleeping.

The working out of this passage, Bottle Portage, required a good knowledge of the woods, for until the trail is actually found, it must be located by signs of cruisers, rangers and Indians in passing through. These signs must be picked on sight from canoes, for a man ashore would never work his way from point to point. The maps are far more accurate and give only the general course and larger islands. From the fact that there is an Indian village on Lac La Croix it may be inferred that main courses will be more easily followed as we shall find their old camps and routes.

some to take to school with him. On Crooked Lake we passed miles of country on the American side that was burned over at least ten years ago and is now covered by a fine second growth. We had a bivouac camp on the rocks.

CAMP EIGHT.

About noon the clouds in the north broke and by one the sky was clear. We had lunch and then started at our work of repairs and drying plates and repacking supplies. We left Camp Seven at three o'clock and after a few minutes paddling came to the long portage, 500 paces. Each of us made three loads, and then Bill, Billy Mac and Dad started off to explore the dry channel which is the main water course at high water and is the International boundary line.

SUNDAY.
CAMP SEVEN.
JULY 31ST.

We were up a little after five and breakfasted. The morning was cool. Cope advised an immediate move to the new portage and then tie up for the rest of the day, but Bill and Dad refused to move—Bill until he had repaired his tub and Dad until he had changed plates and developed some plates to test his photographic outfit. Hardly had they commenced to work before the rain came up, tents were set up as well as circumstances would permit and all took to shelter. The clouds are not heavy, but it may be an all day rain. At the present writ-

This channel is a wonderful heaping up of boulders, shelves of granite rock hollowed out by the water with walls of granite. There were a number of hawks—evidently a brood of them. Several pictures were made

and the camera was left at the mouth of the river to be picked up by canoe later. Along the banks of the lake were granite cliffs and all wooded with a beautiful growth of Norway pine. They were met on the way to camp by Howard and Carl in a canoe and the boys went on to get the camera.

We had supper at half past six. After supper Doc, Bill, Dad and Clay went out to explore and catch fish for breakfast. In a few moments Doc landed two pike.

Everyone went to bed early. We had a beautiful bivouac camp on top of a cliff. The night was cold and we were shut in by a heavy fog.

MacDonald told us that as we came out of Bottle Portage we would see on an island directly in front of us a shack built by Canadian Forest Rangers. We located the shack all right, and in the evening Carl went over to investigate and reported that he found a shack without a floor—the men slept on the earthen floor, the door was hung with moose skin hinges. Carl proceeded to make deductions from what he could find and brought to camp his proofs that they had fresh potatoes from a potato peeling, canned milk from an old milk can, that they had two rifles, 32 and a 30-30 empty shells, that they had moose meat from the bones, that they lived on dried fish from a specimen taken from the cabin; and finally that they were Canadians and intelligent from stray bits of the Review of Reviews and some English papers he found. It is safe to say that our Herlock Sholmes found everything there was to see.

CAMPS EIGHT AND NINE.
MONDAY.
AUGUST 1ST.

We awoke a little after five enveloped in a cool fog.

The men have brought over the last of the canoes this morning.

As soon as breakfast was finished Cope and Clay started over the trail to see the old water course men-

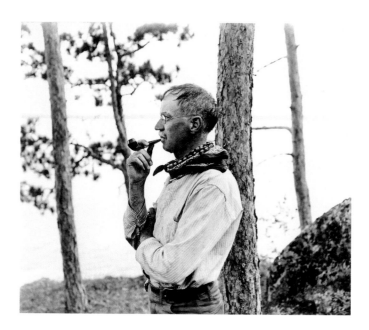

tioned in yesterday's journal. While they were gone Billy, Bill and Dad shaved off an eight days' growth of beard.

Dad and Hannie started out at eight o'clock so as to let Dad make pictures of the camp and of the lake from one of the cliffs near the camp. The air was almost absolutely still, the fog had just lifted and the western view was illuminated by the morning sun.

The navigating course was easy, following the shore of Irving Island, then following Coleman Island until 1 o'clock, when we stopped near the end of the island for a lunch of beans, rice, hard tack and tea.

In passing close to the cliffs at one point in Irving Island Cope found marks of hands in red paint, reaching from near high water mark about eight feet up. He called the others. On further investigation we found figures of a bull moose and calf and an Indian smoking, all of which were photographed and a picture taken of the cliff. It was the most curious thing we saw during the day.

As we came to the end of Coleman Island the country became more flat and the rocky shores are of mica schist instead of the granite we have been passing since we started.

At our lunching place Dad changed plates so as to have a fresh supply for pictures at the Indian Village at the mouth of the Namekon.

We reached our noon camp at one o'clock and left at a little after three, cutting around the head of Coleman Island and then heading for a W to WSW point on the Canadian shore near which we expect to find the Indians. We made the point at a quarter after four, after paddling four or five miles. Hannie and Dad went a little further to an island where they could get a better view of the shore.

It seems that Hannie left his rod with a reel borrowed of the Doc at our nooning place. How and Piffy came to the island, threw out their baggage, and with

Petroglyphs on Lac La Croix

Hannie started back to find the fish rod. It will be a good two hours' job of paddling, but the lake is smooth and they ought to make it easily. The price to be paid for this service by Hannie is to be two dollars and a half.

At the narrow entrance at the upper end of Coleman Island Hannie made four casts and pulled out three pike.

CAMP NINE.

One hour and thirty-five minutes was the actual time it took the three boys with a light canoe to find Hannie's rod and return to the point where we are to bivouac for the night. The boats were left in a little bay and our camp was on a high point. The brutes were pictured in the ensemble of

"Love is a little flower."

We can hear tom toms of an Indian dance, but they sound far away. We went to bed right after supper.

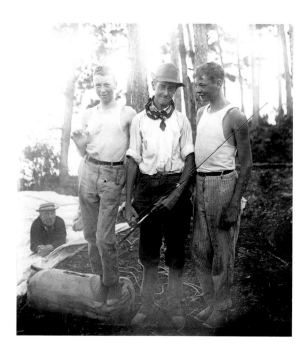

We left Camp Nine at about seven and after about two miles paddling we came to the Indian Village at the head of the Namekon River.

About a mile from our camp we found an old shack which Hannie and Dad proceeded to investigate. Hannie found nettles and Dad found that the house was a one room shack now falling to pieces, that there was a stable in poor condition and on the roof of the stable was a magnificent pair of moose antlers which he appropriated. There were hoof prints of an Indian pony[14] about the beach and there were three enclosed patches where potatoes were growing.

The village lies in three sections—one on the west bank of the river was apparently untenanted, one section nearest to the lake was uninhabited, although in it was a new circular dance house, and a third group of buildings located a little further down stream was the part where the life of the village centered.

As we approached the village dogs barked, some little Indians scooted for the cabins, and as we came nearer two bucks came down to the shore.[15] They looked over our canoes, commented favorably upon Bill's tub to his great delight until one of them showed by signs how heavy it was to paddle. One, a little elderly man, said that the moose antlers in Dad's boat were his, but he

[14] The Lac La Croix Indian Pony Society is currently making efforts to protect the remaining numbers of a breed of Indian pony from this region.

[15] In this long and detailed entry, the group spent a good amount of time meeting and interacting with members of the village: bartering for goods, taking photographs, looking at beadwork. A number of now-offensive terms were commonly used for the people they met.

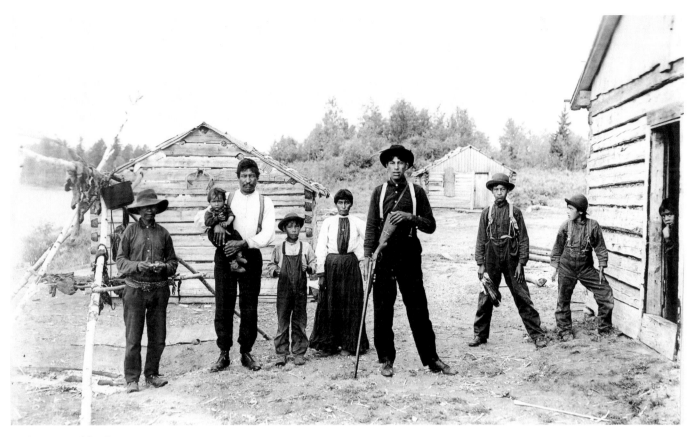

John Otter and family

made no claim upon them and nothing more was said on that subject.

For a while things moved slowly in our making acquaintance. Finally someone asked about bead work and the old Indian went to a house to get some to show us. Dad produced the camera and the Indian who appeared to be the leader said we must pay him for the privilege. We gave him fifty cents and as Dad commenced work he said that for three dollars we could make all the pictures we wanted. Asked if he were the chief he said he was the counsellor and that he was a nephew of Blackstone, the chief. Later he said that there were three counsellors and that they were of the Blackstone tribe.

Dad gave him the requisite three dollars and the first subject chosen was John Otter, the counsellor, who could not stand for a picture alone, but insisted upon a family group, which, after some discussion with the squaw was duly arranged and every member of John's family of age to appreciate finery came out dressed in his best and brought the kids. The young squaw, a son's wife, was resplendent in a purple skirt, while the eldest son wore a whole arsenal of firearms. John stipulated that a copy of the picture be sent to him in care of the Indian Agent at Fort Francois, to which Dad agreed. A picture of the elderly brave was made in front of John Otter's house, where he was leaning up against a rack where venison or moose meat was being jerked over a slow fire and where a raw deer hide was hanging.

These Indians have no church or school and they

bury their dead beside their houses without sign of Christian custom. This grieved Mr. Pangborn who meditated. We expected some objection when we came to picturing the graves, but the three dollars was omnipotent.

Over an apparently new grave near John's house was built a shelter of boards painted red. The short flagstaff was decorated with bluejay and woodpecker feathers and bits of red and green cloth. Pebbles were set around the house in ornamental lines. At the base of the staff was a little box containing a glass tumbler and playing cards. A frame covered with birch bark protected the house and over the birch cover was placed an axe.

John said his own squaw was not much good in bead work, was too lazy, and commended the squaw whose bead work was first shown us. When we came back to that house which was near our landing we found they were working on a new canoe and were jerking and smoking moose meat.

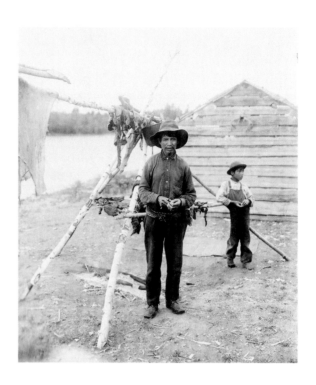

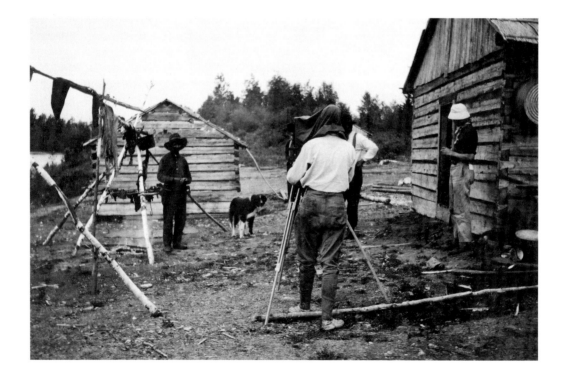

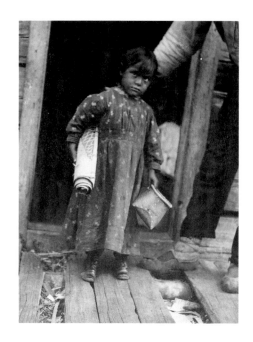

Back of the house were two graves and one was apparently quite recently made. Like the one described near John's house it was boxed in and the box painted red. Red and green cloth bands with blue and white feathers decorated the spirit flag staff. In a box was a miniature canoe and paddle, tobacco, bread, a spoon and a pipe. Two silver dimes and tobacco tags were tacked on the end of the grave. On the shelter over the grave rested an axe. At one corner of the grave was a little pile of fire wood, sheltered under birch bark. The flag was of white cloth on which was sewn a red cross. The other grave was less elaborate, but the spirit had been provided with a plug of tobacco of ample size. The shelter was of hemlock bark and there was the usual axe.

Other graves we saw at the deserted end of the village were either gone to ruin or bore the usual flag of white with a red cross.

At the same end of the village was the new building for dances, but as the door was tied fast we hesitated about forcing an entrance. Bill opened the door and finding that we were unmolested Dad tried making a photograph of the interior. The house is about thirty-five feet in diameter. At the top the center was open for smoke or ventilation. About the edge were strewn large pieces of hemlock bark and in the center was a rough circle of seven board seats. Between the seats and the bark circle was a path well worn by the dancers. The floor was strewn with bits of finery—evidently a dance means a real rough house.

Near the dance house was an oblong enclosure about fifteen by sixty-five feet made of tamarack or spruce stakes about two feet long, driven into the ground and surmounted by a railing. At the center of each of the narrow ends were openings about two feet wide. At each corner and about two feet outside were long poles each ornamented with a little round block and in the center of the enclosure was a similar pole. Opposite the gates at each end and inside the fence was a smaller stake about the height of the fence. Whether this enclosure is for some game or for a ceremonial purpose we cannot say, but there are paths worn by feet passing along the long sides inside of the enclosure.

Near the dance hall was a building framed up with light poles and covered with hemlock bark. The door was tied with a string. Inside were tom-toms, bows and arrows and a pile of birch bark.

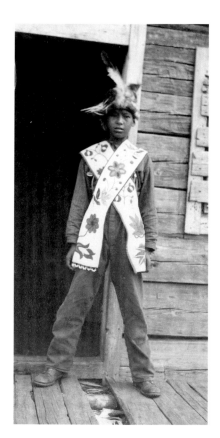

Near the dance hall was a small circular space, say about six feet in diameter covered by a sort of wickyup frame without a door and with stakes driven into the ground between the upright poles. There was no covering to the frame work and the only effect of the whole

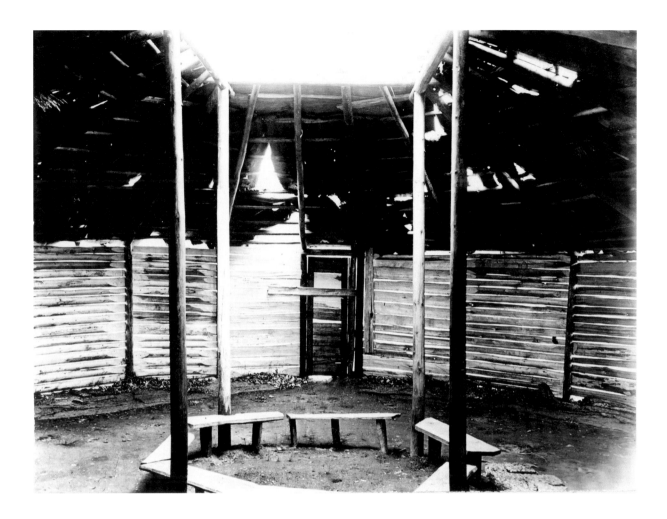

business was to keep clear a bit of turf over which small branches had been scattered.

John Arthur told us that some of his people had gone across the lake to a Big Medicine Dance and that the dance would be continued that night.

Carl had two little adventures at the village. When we first landed and before our three dollar peace had been made, Carl pursued the subject of bead work a little too closely and one of the squaws chased him out with a stick. Later, in going from one part of the village to another he followed a trail leading through underbrush. Some of the little Indians saw him and ran for brush where they ambushed themselves, and when

Carl came along out they sprang, giving Carl a proper start. They were probably playing "White Man" as our boys play "Indian." Carl bought a nice bead belt for two dollars.

We left the village at ten thirty and paddled into a head wind until noon on a southwesterly course. We lunched on an island on cold biscuit, ham, potted tongue, sardines, cheese and tea. Dad had exhausted his plate holders and changed plates at noon. We left the island at about half past one and bucked a head wind which interfered with our progress until we were nearly at the end of the lake which we reached at five thirty.

At one place where we stopped to rest, the rocks,

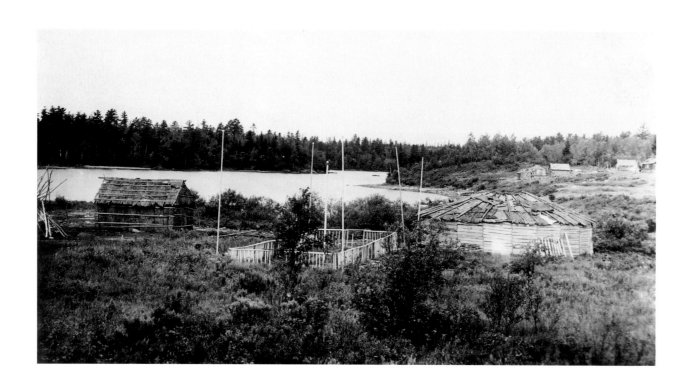

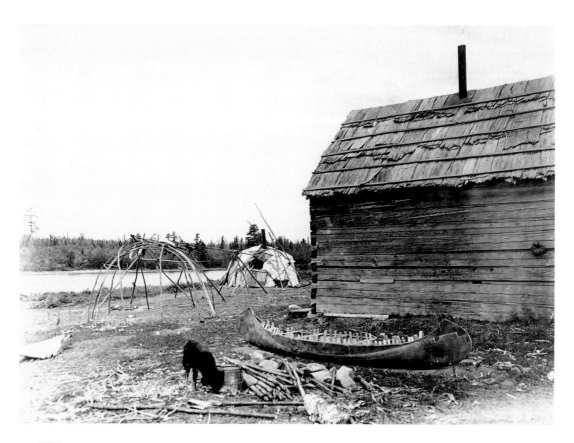

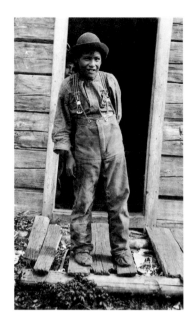

which seemed to be like mica schist was turned sideways and split so as to look like a basaltic formation—on either side of it was granite rock. A small picture made may show the formation. During the last day or so we noticed occasional streaks of white crystalline quartz running through granite. We have not seen this before.

While we were looking at this "basalt" formation we heard some shots and saw a canoe below us, but we could not see whether they were Indians or white men. As we paddled down the lake we found a little camp of Indians near a shallow spot where they were probably shooting sturgeon. We stopped to parley. An old squaw and two younger ones appeared, dogs barked and the kids cowered in the bushes and peeked at us. The sight of a hand camera drove all to the bushes and then one of the young squaws appeared and offered us a small pail of blueberries for fifty cents. We bought willingly but Hannie thought they should be thoroughly washed before being eaten. He never knew before that blueberries were a wild fruit. Carl bought a pair of beaded mocassins for two dollars; Cope gave the old squaw a cigarette, and Dad tried to stalk for pictures for the old squaw and the one who sold us blueberries. The youngest squaw fled at every approach. They really had no fear of the camera, but they explained by signs that they had better clothes up the lake. They were probably part of the Namekon River settlement and said they were Blackstones.

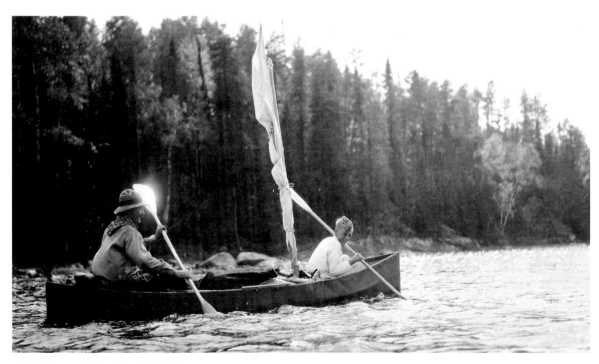

Bill Marr and Carl sailing "The Tub"

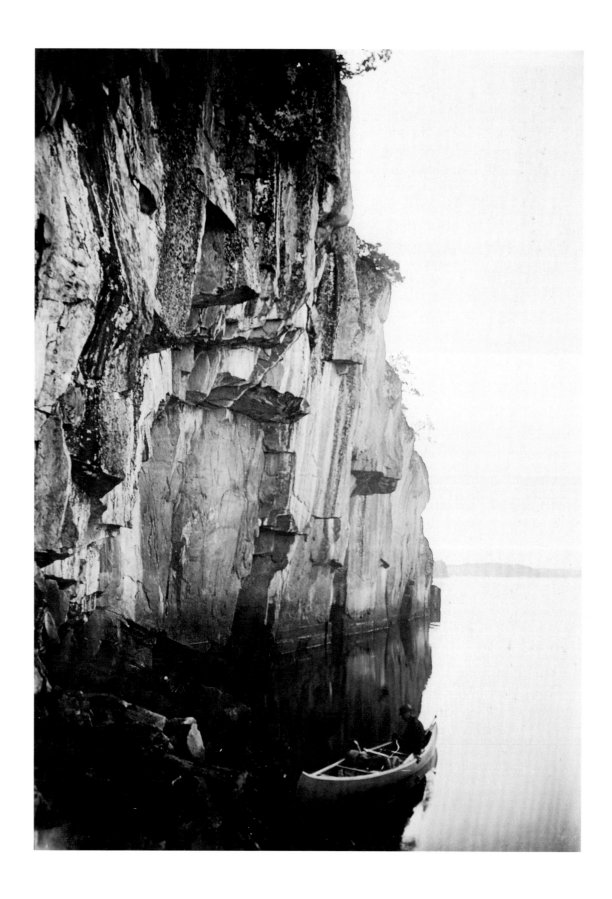

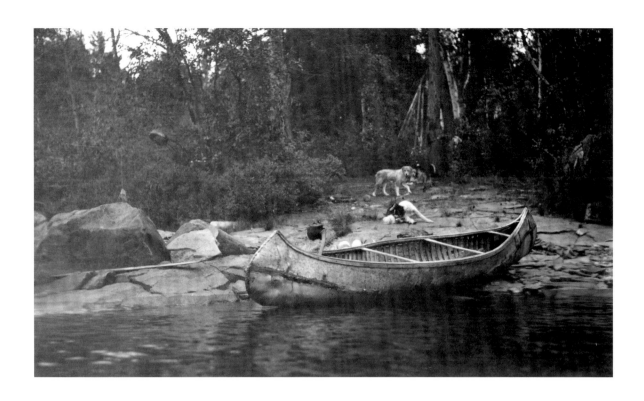

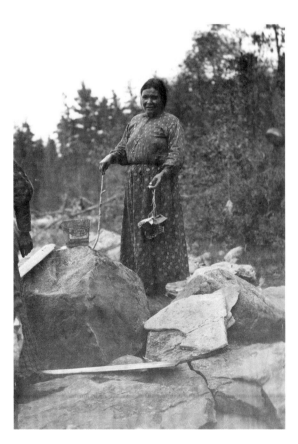

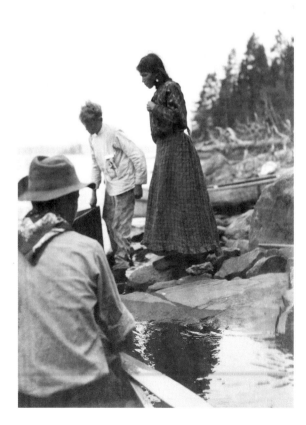

About a mile from the end of the lake on the American side we passed under some high granite cliffs topped with Norway pine. The cliffs are beautifully streaked with black, probably lichens.

In high water the level of the lake is over six feet above its present level.

We found a good camping place at the end of the lake and a well worn portage which Fred reported was two hundred and fifty paces long. There is only a small flow from Lac La Croix to Loon Lake except in high water. The fall is twenty-nine feet.

The sky was overcast and as a little rain fell we had our tents set up and slept with the front sides open.

For dinner we had pike, biscuit, corned beef hash, blueberries and tea.

WEDNESDAY.
CAMP ELEVEN.
AUGUST 3RD.

When How and Dad awoke this morning at quarter after five they found Doc still asleep and they began the day by pulling him out of his blankets.

We had breakfast of fried ham, pettijohns, biscuit,

coffee and blueberries, and while Pangborn was baking apple pies for lunch we portaged all our stuff. We left promptly at eight and found a good wind blowing from behind us so that the canoes provided with sails made good time on the south run, but the west run called for some strong paddling. The portage at the end of Loon Lake is short and easy. The water course is very rocky and only a small amount of water passes through it except in high water. There must be a larger flow than appears because there is a swift stream below which could not possibly be supplied by the trout stream looking affair we saw.

There was good fishing at the end of the portage and after the men had caught enough for dinner, we left at eleven o'clock, and after a half mile easy run came to a rapid, which we had to portage. This was easy as it was only about two hundred feet. Here we found that a considerable party of Indians had camped and killed moose. They had killed some blue jays and left the feathers strewn about. After this the river became very tortuous. There was a very considerable fall but no current. The bed of the stream was much choked with grass and this probably checked what would otherwise have been a continuous rapid.

About noon we passed a birchbark canoe and small fire. The Indian was in the woods felling a birch tree. We made noon camp at about half past twelve at a bend of the river, and while we were at lunch the Indian passed. Our lunch was apple pie, bacon, tea, and biscuit.

At half past two we left our noon camp and followed the turning, twisting stream to where there were open bottom lands. The stream is weedy and

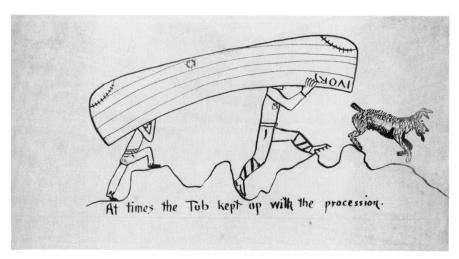

Portaging the Tub

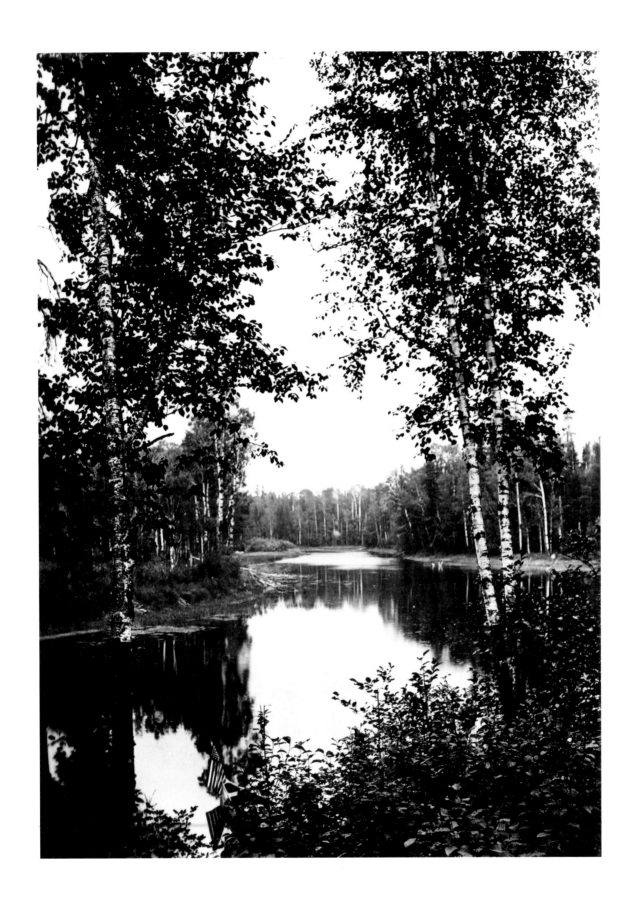

there are frequent sand bars which keep the stern paddle busy. We passed two low down whites in a birch canoe and later two more at a little camp. They are probably dynamiting fish.

Late in the afternoon we entered little Vermillion Lake and encountered a strong head wind. There have been light forest fires along the shore.

We worked about half way up the lake and made a bivouac camp for the men and set up the "Private Car" for three of the brutes. This was at about half past five.

While we waited for supper we were discussing the map and our route and Hannie butted in with curiosity at Hannie pitch. Dad told him that the next portage was Soldiers' Portage, so named from the fact that troops had used it during the Riel rebellion. Hannie asked the length of the portage and was told half a mile. Someone, seeing that Hannie was startled and was in a gullible mood stretched the length to three-quarters of a mile, and from that it was jumped to a mile and three quarters through swamps and morasses, through which we would have to follow a trail to be cut and blazed by Fred. Hannie has no high boots and the prospect of a very long portage through swamps and woods is very discouraging.

By the time this story was worn threadbare it was discovered that we were running short of baking powder and that we would have to subsist on crackers made of flour and salt which, while nourishing, were exceedingly unpalatable.

Hannie sat apart and pondered. He talked to his fellow brutes who only enlarged the story of the portage from what MacDonald had told them.

As time approached for turning in Cope showed Hannie how the roots of the trees had been burned away and how they might fall, so Hannie was induced to test all of the trees about the tent.

About supper time we had some beautiful showers

which passed up the lake. The lake at this point suggests the Hudson river with its mountainous hills.

We had a beautifully cool night without rain.

THURSDAY.
CAMP TWELVE.
AUGUST 4TH.

We were up at a little after five and had a breakfast of pettijohns, pancakes, bacon and coffee, and forthwith loaded our canoes. We had soon passed through little Vermillion Lake, bucking a head wind, and after a very little trouble we passed the shallow narrows into Sand Point Lake.

Some portraits were made in camp this morning.

We ran against a heavy wind for an island on the American side, where we stopped to rest, fish and loaf. Carl lighted a fire, we had our chocolate and cracker rations, and it was a quarter after ten before we were ready to buck head winds again. We plan to work up the American side as best we can from point to point.

Hannie has written letters, and is looking for a launch to take them to Harding. While stopping at the island we could hear the chug chug of a gasoline launch, but it was some distance away.

At quarter after ten we ran for a point on the American shore, where we had our lunch of fried croppies, caught off the shore, bacon, biscuit, prunes, fried pettijohns and dehydro potatoes. Then we smoked and loafed, waiting for the headwind to subside. How and Piffy cleaned their canoe and had a swim.

After lunch Doc and Hannie went down the lake about half a mile to the mouth of the river to try the fishing. This is Hannie's story:—"After an hour's fishing Doc, being disgusted with his bad luck said: 'Here goes one more cast and then we go back.' I was paddling slowly at the time when suddenly with a swish and a swash Doc's line went out at a terrific rate. Doc told me to paddle back as he had struck a snag. However, he soon discovered his mistake and drew an enormous pickerel to the surface.[16] The fish broke water and ran for the bottom at a terrific rate. We then set in to accomplish the hard task of landing the fish with Clay's second rate pole and reel. After fifteen minutes hard paddling and fighting, Doc finally jumped off onto a sand beach and grabbing the line in his hand drew the tired pickerel onto the land. The fish weighed between fifteen and twenty pounds and was a yard long."

The Artist

[16] *Pickerel* and *pike* were interchangeable terms circa 1900; what the Gang called pickerel would be considered a pike now.

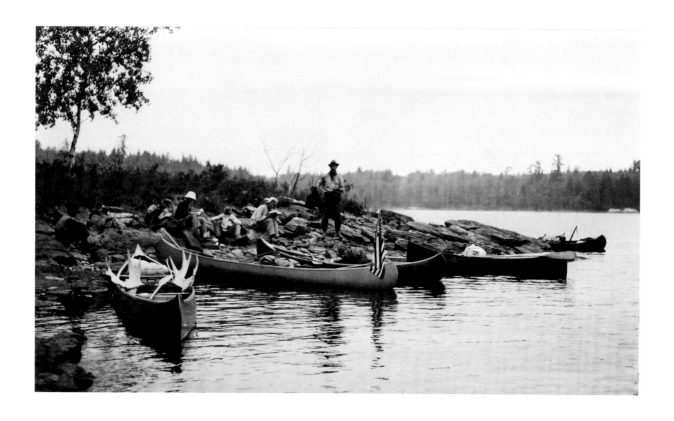

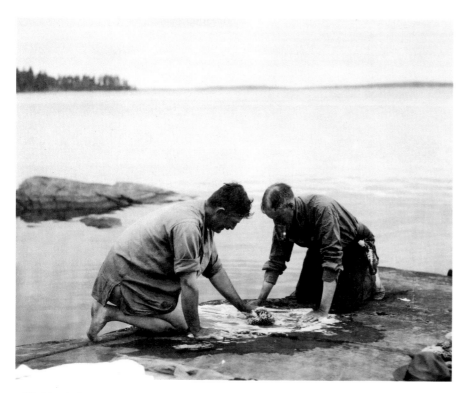

Washing clothes

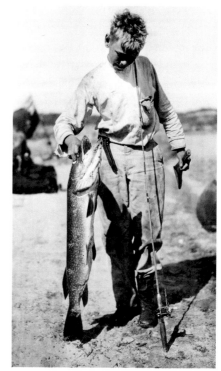

We left our mooring place at twenty minutes after three and bucked head winds to a point on the Canadian shore, where we pulled up to compare notes. Traveling in these waves is too hard for Bill and his tub, and we decided to rest for an hour or so. Bill found a sand bathing beach around the point and all of us except Carl went in. Carl has not washed nor been swimming since we went into camp.

We have ordered a supper of fried pickerel, bacon, biscuit and potatoes and after supper, if the wind has subsided we shall push on for a point one or two miles ahead. Otherwise we shall bivouac where we are. There are big boulders strewn about here. Dad washed some of his clothes.

After supper we left our camp and headed for a point a mile away on the Canadian side, then we passed Sand Point where a sand spit runs out to an island and then on a mile further packing through the dark to a headland that gave promise of at least a smooth granite shelf for a bed. We made the headland all right, scrambled up about twenty feet and found our sleeping place on the smooth granite top. The night was cold and the sky was clear, and we had wonderfully beautiful starlight, and at the north the aurora lasted the whole night.

We passed some Indians traveling across the lake this morning.

FRIDAY.

CAMP TWELVE.

AUGUST 5TH.

The sun shone in our faces and woke us all very early, but we pulled our blankets over our faces and it was nearly six o'clock when we finally rolled out.

The kitchen is "downstairs;" in other words, it is on a ledge lower than our beds. Pangborn spilled the coffee this morning and scalded his leg, but not badly.

In roaming about on the rocks back of our bivouac Cope found the nest of a night hawk with one egg and one young one. Dad made pictures of the young and old birds. They so closely resemble the rock and lichens that it is difficult to distinguish them even after they have been pointed out. Pictures were made of the mother bird and also of the young one and the egg in the nest.

Dad made a picture down the lake with camp in foreground. We left camp at about half past seven and explored the extreme Northwest end of Sand Point Lake to find the outlet to Namekon Lake. The connecting river has rocky shores generally well wooded and is very beautiful. The rock here looks basaltic in character, but it is slightly inclined and not regularly crystallized.

On reaching Namekon Lake we encountered a Northwest headwind and we found that instead of a clear lake there were many islands. We chose a Northwest course which was well sheltered, then turning north we almost crossed the lake. At eleven o'clock we had gone to the end of the furthest island and after looking over the situation we decided to head for the Canadian shore by a Northwest course. It took until nearly half past twelve to reach the shore. The water was very rough and the tub labored so hard in the waves so that Billy Mac's and Dad's canoes stood in close to the tub. This was the hardest paddling we had.

We lunched on hot corn bread, cold corned beef, onions, prunes, tea and dynamite soup. Then we tried to sleep until the wind should subside. Some of the party went into the woods to explore a lumbering road and they found that it came to an end in the forest, showing that the timber that has been cut here has been worked out by the lake.

At quarter after three we left our noon camp and worked along the shore looking for the roof of an old lumber camp which is the mark given us to locate Soldiers' Portage. We came to a camp of two Canadian Rangers and from one of them we learned the location of the portage. The ranger we talked with was a clean

cut intelligent fellow; they had a neat camp and were chiefly occupied in watching forest fires. Here Hannie learned the truth about Soldiers' Portage. On the American side we could see fires at several places.

As we entered the bay at Soldiers' Portage we met an old Indian who ran his canoe out to meet us. He was very jolly but could speak no English. Back of him were four canoes containing women, children and dogs. These canoes ran around an island to avoid us. At the portage we met another Indian family with dogs. They were squatting about a smoldering fire, betraying little curiosity as to us, but they objected to having a picture made.

Soldiers' Portage is first a short portage to a creek, then a passage down the creek and another portage to a slough which leads to Rainy Lake. We made our Camp Thirteen on a rocky point at the entrance to the lake, just as the sun was setting. While supper was cooking three pike were caught for breakfast.

The night was cold and the mosquitoes were active all night.

Prune syrup is the basis of a good army cocktail.

SATURDAY.
CAMP THIRTEEN.
AUGUST 6TH.

We celebrated the fact that we did not have to travel by having our breakfast at half past six.

Howard, Hannie, Piffy and Carl were sent up to Kettle Falls and Carl soon returned with the information that the launch would leave shortly and would not leave again for International Falls until Tuesday. We wrote hasty letters and the men who were going to quit agreed to stay here until Tuesday. The boys bought bread, moose meat, pies, cake, canned peaches, baking powder and sugar. The boat will pick up our party at Brule Narrows, or any other point where we signal them.

The morning has been spent loafing. Doc and Bill explored this end of the lake and found on an island opposite our camp a tepee and a lot of canoe material and a rack for drying blueberries. Billy Mac helped everybody. Fred Carr and Billy Boucher shaved.

Pangborn asked leave to quit and Dad agreed to let him off at Kettle Falls so he could take the boat to International Falls. This request was expected and was gratefully received because he has been almost useless and has not teamed with the other men. Hardly once has he smiled or even looked contented. From daybreak to nightfall he has been the picture of disconsolation and discontent. He is slow in every movement and

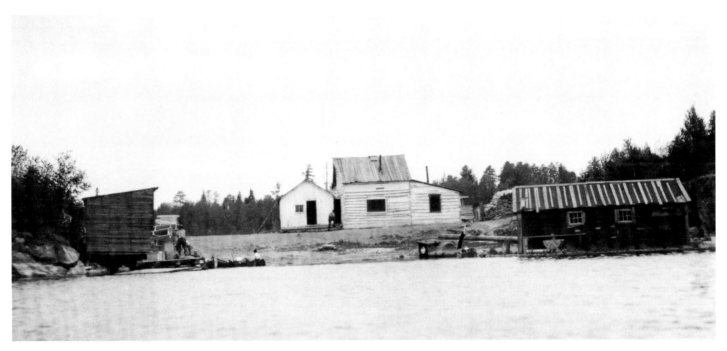

Kettle Falls

cannot remember where things are or what he has been asked to get for meals. He is constantly calling on Fred and Billy for the simplest things like finding his flour or corn meal and he is either too fatigued or too lazy to keep the mess outfit cleaned up. In consequence our ovens are dirty and the biscuits underdone.

Just after Pangborn had received leave to quit he confided to Billy Mac that this had been the hardest experience of his life, although he campaigned in the army for over three years and had been lumbering and cooking and blacksmithing. He thought this was a trick played on him by his son Redmond, who, while a good boy and nice to him, was always playing tricks, but of all his tricks this was the worst. Billy assured him that his own son would not have done it as a trick on a man of his age, but Pangborn was not convinced. This was the crowning touch to the humor of the whole Pangborn incident because we have been considering whether this was one of Redmond Pangborn's tricks on us. It is a good joke, but if the old man had been really hurt it might have been a serious incident.

We packed up very slowly during the afternoon and finally left our Camp Thirteen at a little after three and went directly to Kettle Falls. There are three settlers in the vicinity of the Falls and at the Falls there is a house and dock where fish are shipped and the woman sells a little stuff in the way of general supplies.

We stopped long enough to get some more bread and some string beans and to drop Pangborn who will stay there until Tuesday's boat takes him to International Falls. He has twenty dollars for board and expenses, so we have no further responsibility for him. Bill folded his tub at Camp Thirteen and left it at the Falls in Pangborn's charge. We moved down the channel to the edge of Rainy Lake and after looking over the ground about a fisherman's shack we selected a camp ground on an island opposite, where three tents were set up, as rain was threatening.

We had supper and as there was nothing else to do and it was raining we went to bed.

When this expedition first set out Hannie was promised an initiation into the "Camp Life with the Gang," and various doings of Hannie's were noted and extra duckings in the lake have been promised as a part of the ceremony. Hannie finally lost faith—he felt that the INITIATION, like Soldiers' Portage, was somewhat of a myth and so this morning he was unceremoniously pulled out of his blankets and carried out to the point to be thrown in. Hannie protested he could not swim, but that only assured us that he would never come back and in he went. He swam off and came out none the worse for wear, but with a temper somewhat ruffled by his early morning bath.

At Camp Thirteen Pangborn had been told to bake bread and when we reached our Camp Fourteen and were clearing up after supper we found a tin cracker box with a bread mixture, but we could only guess that it was ready for successive workings and raisings. Dad gave it up as a bad job, because it meant sitting up the greater part of the night, but Billy Boucher said he would try it and during the night we could see the glare of his fire lighting up the woods.

We had several light rains. The air was warm and we had plenty of mosquitoes.

This evening as Carl was paddling alone along the opposite shore he heard the cry of a wild cat. He said he thought of all he had ever heard about lost souls and men lost in the woods, and he came back to camp as quickly as he could paddle.

As we landed here and investigated the place Dad stepped into the heavy growth of balsam to see how wide the island was and stumbled onto a cache. Under the law of the woods we could not disturb it. There are two rotten logs on which a well nailed up good sized box rests. This is covered by birchbark held in place by a large stone and about it are piled balsam boughs. It is so well concealed that the owner himself might have trouble finding it.

<div style="text-align:right">

SUNDAY.

CAMP FOURTEEN.

AUGUST 7TH.

</div>

The night was not a restful one to us. The mosquitoes bothered some, the air was warm and it rained. Dad was to be chief cook, but when he appeared at the kitchen Cope and Billy Mac were ahead of him. We are cleaning up what was left over from Pangborn's regime and so our breakfast was a little mixed. We had

<div style="text-align:center">

Coffee,

Fried Pettijohns,

Fried Dehydro,

Bacon,

Bread.

</div>

In the mess outfit we found some spoiled fried fish and bacon which had been "saved." After breakfast the grub sacks were all taken out and an inventory made of the supplies on hand and in each. This enabled us to have a general cleanup which was satisfactory and sanitary.

While breakfast was in the cooking Cope and Clay had a falling out and as a consequence Clay was to be thrown into the lake. Carl, who had been inciting the row was dancing about in high glee when one of Clay's flying heels caught him and sent him into the lake. Carl's remarks to Doc were not intended for this journal. Carl lamented his contact with water more than the discomfort of the accident, for he is trying to go unwashed for three whole weeks.

During the morning Doc and Bill explored the opposite shore and found skinned carcasses of three wild cats, where some Indians had camped, also a fish pen.

Dad developed some plates and wrote journal. There is very little life to the camp, for the impending departure of Doc, Bill, Billy and Hannie is reducing the party to small proportions and neither those who are leaving nor those who will remain like the signs of departure.

Poetic Justice

When breakfast was ready both our men were fast asleep. During the windy rainy night it was difficult to bake and raise bread and it was quarter after three when they finally left the kitchen. The bread is good for toasting and out of the dough Billy made some doughnuts and rolls which are good.

The day has been rainy and cloudy and it is perhaps fortunate that we were not moving and going into a new camp.

Last evening we heard Hannie and his tentmates in a dispute as to something to do with a rope and Hannie insisted upon doing something with his own rope. This morning we saw what had happened. Hannie had rigged a clothes line in front of his tent upon which he hung his clothes during the night. It was a marvel worthy of a picture. The inventor claims it is a masterpiece but he has not explained how his tentmates could rig lines or what would happen to his clothes if the night were foggy. The outdoor world will still wait for man to devise something better than boots and clothes for a pillow.

When the rainstorms came up to-day Billy called Hannie's attention to threatening winds and particularly to a small Norway pine near the brutes' tent which leaned slightly and Hannie required no further suggestion. He promptly borrowed a lariat and roped the tree to a larger and firmer one. We made a picture of the roped-in leaning tree. Fred had more than an hour's laugh over it, but Hannie does not realize that anything had happened.

On the mainland Cope and Bill found two cabins. One long deserted was probably built by a white trapper. The other was more recent and was the home of an Indian family last winter. There was a small iron stove well protected from the leaky roof by birchbark—a lot of rabbit skins were lying about the floor and parts of them had been used for choking the seams between the logs and about the door and windows. The windows were probably taken from the older house. In the cabin were two little pairs of snow shoes and two larger pair. A leanto of balsam boughs next the door sheltered their wood supply from the snow. On a rack outside were the remains of three carcasses of wild cats from which the pelts had been taken. Near the Indian cabin is a pen where Indians have kept sturgeon. The shore is a stinking mass of sturgeon heads.

The night was warm and more or less rainy.

Doc and Bill put out a set line but up to to-night have caught nothing.

At the end of the island Cope found a Norway pine which he called his Japanese tree from its shape.

Billy Mac brought up two books for the boys and promised that before he left he would give each one a book. This day was set as the day for the distribution and after lunch the boys drew numbered slips of brown paper and were arranged in line. Billy then distributed A.B.C. and Mother Goose books. After the howl of disgust they fell to fighting for each other's books and then all began to read aloud until the men driven from camp took refuge at the end of the island and waited for the talk to subside. Carl laughed until he cried.

MONDAY.

CAMP FOURTEEN.

AUGUST 8TH.

Cope was the first man up and he cooked our breakfast. After breakfast Bill and Doc went out fishing. Billy Mac did sundry odd jobs about camp and Dad worked at developing plates and writing journal. Heine and Carl went to Kettle Falls for more pies and bread and the other boys washed, repaired canoes and did sundry jobs. Fred oiled up all the leather work.

The grand event will be dinner to-night.

The afternoon has been most disagreeable. Bill, Billy Mac, Piffy and Dad took baths, all the men shaved and several members indiscreetly washed underclothes. Bill washed his pants.

Thunder showers passed by us and some stopped to visit us at intervals during the day.

We have arranged to reduce our baggage and equipment by sending home the small Amazon and one A tent. Hannie, Doc, Bill and Billy will leave to-morrow and the rest of us will take the eighteen and twenty foot canoes and Clay's canoe, which will hold all our surplus baggage.

Several parties of Indians passed us to-day going East. They took no notice of us although our camp is easily seen from the channel where their canoes pass.

For dinner we had a bouillon, otherwise known as slumgullion, which was truly a wonderful compound. It contained:

Baked Beans,
Pork,
Corned beef,
Tomatoes,
Onions,
Hardtack,
Bread,
Rice,
Dehydro potatoes,
Milk and raisins.

The combination was at once tasty and noisy.

As preparatory for his departure Doc took a bath with SOAP and WASHED his hands and from his David produced a pair of new brown linen trousers which created a disturbance among the boys. In the melee Dad, adjusting a loosened guy rope and line guy from under the tent fly received a swipe in the face from the Doc's muddy balsam branch. The Doc knew that extreme violence was necessary to hit at anything that threatened his immaculate panties.

After dinner we kept the camp fire burning as darkness fell, later Dad made a flashlight picture of the camp, while Carl took Hannie away in the canoe to lift some fish nets on the point opposite and to give Fred the chance to fix a little game on Hannie. Fred quietly felled a good sized balsam back of the "Private Car" tent and stood it up close to the tent. Doc and Billy Mac took the opportunity to readjust some of the guy ropes of the tents so that they could be slipped at the proper time. We went to our blankets at about nine o'clock, and just after everyone was supposed to

be quieted down for the night Doc crept around the "Private Car" tent and let fall the balsam over Hannie's end of the tent. At this signal Billy Mac let the two guy ropes out and one end of the tent suddenly collapsed over Hannie. During the disturbance that followed the two men returned to their blankets and we saw Hannie come dancing out with the startling information that a tree had fallen upon him and this was followed by a long explanation from Hannie to the effect that he was quite onto the game. The whole show was blamed to Piffy, Hannie danced around in his

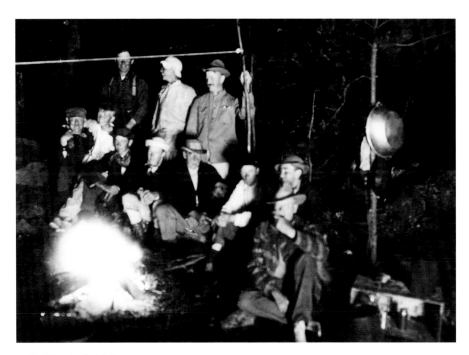

The Gang by flashlight

BVD'S and straightened up the corner of his tent. This was the closing incident of his initiation, for there is no more time for Hannie to bite on anything else.

TUESDAY.
CAMP FOURTEEN.
AUGUST 9TH.

We had a rainy night and the outlook for clear weather to-day is not at all favorable. The continued rains have made the lichens and moss on the rocks very soggy and slippery.

Dad dried the last of the good negatives which he developed yesterday and packed up all of his photographic outfit except the cameras, three rolls of extra film and two dozen plates. Billy Mac has agreed to take the whole outfit to Ranier where he will have it packed in a box and shipped by express to Milwaukee, there to await development.

We have abandoned and will have taken down to Ranier Bill's wangan, the Doc's canoe, one A tent, the small Amazon tent and a tent that was brought up by the P. B. Co. men.

About 8:30 the weather seemed to clear and we packed our boats to continue our journey. Clay and Piffy will travel together in Clay's canoe with a comparatively light load of baggage. Fred and Billy will take the twenty foot canoe packed with most of our mess outfit, their personal belongings and the tentage. Just as we were getting under way the launch came down and we bade farewell to the Doc, Billy and Hannie. We cleared the island just in time to catch the wash of the launch and to see Hannie standing on top of the cabin waving a farewell, while Pangborn was in his customary disconsolate attitude.

We headed for a point on the American shore about one-half mile distant and then took our course for another point a little farther away. While passing along the shore we met a fisherman who had his shack up on shore and who told us he had his camp on the southern end of an island, the point of which we were heading

for. The wind becoming heavier we decided to take shelter toward the south of the island and stopped at his camp to look things over. He had a home made gasoline launch, an old tent patched with bits of cloth and bark fastened on with pine gum while all around were scattered fish guts. A rain storm was blowing up and we liked the camp so little that we crossed the narrow channel to the mainland and found fair shelter under the white pine trees. As soon as the storm had passed and the wind had gone down we took up our course for a point about two miles ahead crossing the narrow entrance of a bay on our left and on our right passing a handsomely set up camp of three marquee tents. The wind was too strong and the waves too high to make it safe for us to continue a westerly course and we ran in on the lee of the point at eleven o'clock. For lunch we ate up things that were left over.

The wind continued strong during the afternoon and good sized waves broke over the rocky point warning us to keep close in camp. Carl and Dad worked at compound proportion and the other boys talked and read stories while Di-hunted around for the rest of the party.

At five o'clock we concluded that it was time to get supper even though nobody was hungry. At noon all of our left overs had been chucked into the slumgullion pot and for supper we finished the slumgullion, boiled tea and finished off with Kettle Falls cake and pie.

At half past six the wind had shifted to the North and was not as strong as it had been during the afternoon. We decided to tackle the heavy swell and to avoid turning our canoes in the rough water we ran out backwards and then changed our course to a point about three miles away. Without stopping there we again changed our direction to another point to the southwest and a mile beyond and paddled along facing a sunset almost as gorgeous as those we saw last year on Lake Superior. When we reached the point we found it was rocky, without a landing place and heavily wooded. We could not make camp here and rather than run along the shore we decided to run to an island a little more than a mile distant. The island proved to be not less than two miles away. We reached it and passed a little beyond. It was dark when we reached a landing place. Carl had started Doc's acetylene lamp which was very useful in making our landing. It gives a small but brilliant illumination. We made a bivouac camp.

The night was quite cold and we had a brilliant display of northern lights in yellows and with some streamers of a greenish hue. These lights did not disappear until dawn. These were by far the best northern lights we have seen. The order of sleeping was:

How Clay Piffy Dad

Carl's tentmates have threatened to insist on his taking a ducking to-day on account of the cold weather.

Heinie makes all safe.

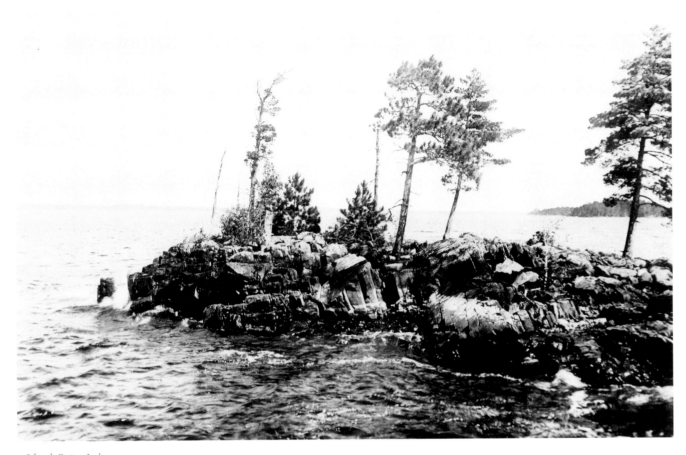

Island, Rainy Lake

It was so dark when we went into camp last night that we cannot tell definitely where this camp is situated and we will have to check it up by our courses today. The favoring winds of last night helped us so much that we do not know how far we have gone.

How and Dad woke up at 4:45 and started work on breakfast.

It was 7:30 before we had the last of the camp equipment packed up and were under way. Our first course was about two miles in a southwesterly direction. Time: 50 minutes. This brought us to the rocky prom-ontory of an island where we stopped to compare notes on our course. After looking things over we decided to take a southwesterly course to an island about a mile away, and then finding that the wind was not strong enough to be dangerous we shaped our course more to the west, and at 9:30 we ran into a sheltered bay on another island about three miles from our last stopping place where the brutes prepared the daily issue of hard-tack and chocolate. Here we checked up our course and tried to locate the Brule Narrows from a launch which Piffy had seen entering a passage to the N. E. We could not see the opening but we located our position on the map as being of one of two islands off the mouth of Saginaw Bay.

We left our resting place at 10:15 taking a course of N.N.E. and a half hour later Piffy and Clay, being ahead, located the Brule Narrows and signaled the other canoes to assemble. In the narrows we took a course SW. by W. encountering a slight head wind and moving along rapidly. Half way through the narrows we met the launch which took our quitters to Ranier yesterday. She was then on her return trip and had several ladies on board. After we passed the launch we headed for a point on the American side about two miles away, which we reached at eleven forty and stopped for lunch.

The purple flower which grows so plentifully all through this country is now going to seed. We gathered some of the seed for Doc.

We took up our course a little after one o'clock, making a straight westerly run of a little over a mile to a point where we found two fishermen in their usual bad smelling surroundings. They had a boat and a gasoline launch and were establishing a more permanent camp by setting up drying reels. The westerly wind was so strong that we did not consider it prudent to take a westerly course for four miles, nor did we want to take the longer course following close to the American shore. We concluded to follow the shore for about a mile and then finding that the wind had subsided we took up a westerly course for three miles to an island which we passed, then to another and then it was decided to run to the long island on which Lyle mine is located. We made camp in bivouac at five o'clock. Howard, Clay and Piffy went swimming.

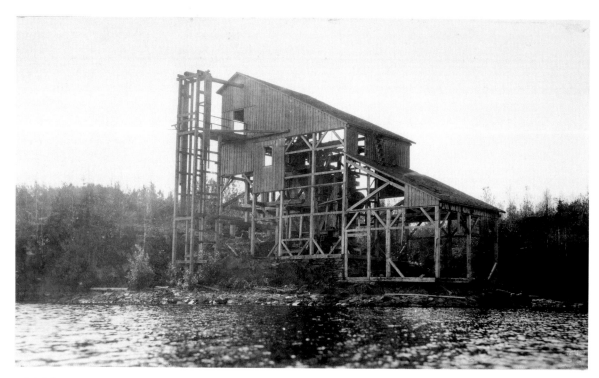

Lyle Mine

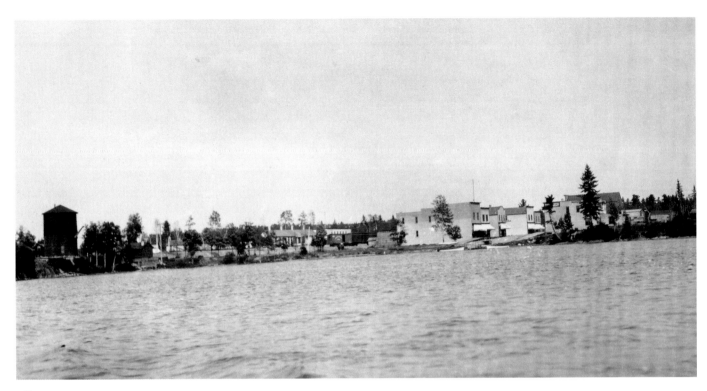

Ranier

CAMP SIXTEEN.

As soon as we had our boats unloaded Carl and Dad went swimming. This is Carl's first voluntary bath. The water was very cold. Howard made some baking powder biscuit and with Billy's assistance they made doughnuts from some of the dough. Di ate a few doughnuts. The biscuits were first rate.

After supper Piffy and Carl took the small canoe and went to Island City. They were quite sure that they heard a moose or deer come down to the lake. They returned home about dark and reported that Island City consisted of two houses. While they were gone Howard baked up another batch of biscuits, pettijohns and prunes for to-morrow's meal.

Our camping spot to-night is very beautiful, the ground is covered with heavy moss and the pine trees are far enough apart to afford sleeping space for several parties as large as ours.

There were enough mosquitoes, but not enough to be annoying. The moon being quarter full shone brilliantly clear and beautiful on the placid lake.

THURSDAY.
CAMP SIXTEEN.
AUGUST 11TH, 1910.

How and Dad were up at 4:45 and while Howard attended to the preparations for breakfast Dad took his last nap.

Our breakfast served at 5:30 after Howard had with much difficulty succeeded in getting his brother brutes out of the blankets—Clay and Piff jumped up, grasped Howard by the legs and dragged him unmercifully over the juniper bushes on his back.

We packed up and left camp at 6:40 and ran to Rainy Lake City, reaching there at about 7:30 A.M. Rainy Lake City consists of one log house, inhabited by

a fisherman, and the remains of an old mine and stamping mill. On an island opposite are the decaying timbers of other mining shafts. We followed the northwest channel and the lake idling along with sail set some of the way. We took the American shore when the wind came up to go to Ranier.

During the last day we have been able to see the

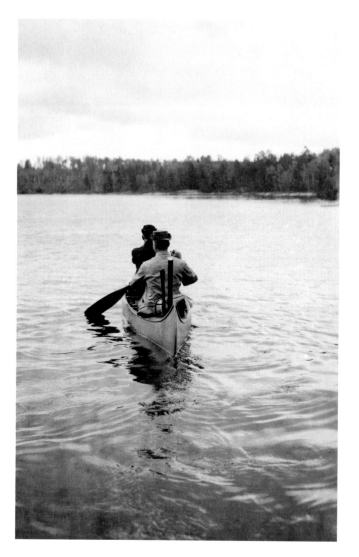

smoke from Ranier, International Falls and Fort Francis. We heard a factory whistle blow. While coming away from Rainy City we saw a newly built double story house, evidently intended for a summer home. Near here we saw a speedy motor boat, evidently a pleasure craft. All of these things are getting on our nerves. We are drawing too near to civilization to continue this sort of life and we shall probably cut our journey short, leaving Ranier Friday night. At 9:15 we stopped at a little island to let Clay leak and to check up our map.

At 9:40 o'clock we stopped to get our location. Toward the southwest a long bay opened and before us was a point that might be an island. Clay and Piffy were sent to explore for a passage and they soon returned under full sail to report that it was a deep bay and no outlet. We could not locate our position on the map and decided to work out into the lake in the breeze and follow a northeasterly course through what seemed to be a main passage. We made splendid time and passed a large island and tried at various points to break through to the West, but none of the openings looked promising. We finally rounded a point bending our course again to the Southwest and paddled along about a mile to where there was a house and some buildings of a fishing station.

During the morning we heard the puffing of a swift motor boat, nicknamed by Dad the "Sewing Machine," and when we came to the station we saw the boat run in ahead of us. They told us to follow our present course for about two miles to where we would find a house on the point of an island, there to turn our course to the right and follow along the lefthand side to the open water at the end of the lake. It was eleven o'clock when we got to the deserted house on the island and we stopped for lunch.

To the West of us a quarter of a mile distant lay the island where we had our early lunch and we were then at

one of three outlets of what the boys had reported was a bay. We took up our course after lunch and paddled to the outskirts of Ranier when we took to the bushes to cast aside our wornout trousers and put on our best camp clothes. It was exactly ten minutes after two when we ran our canoes on the sandy beach at Ranier. Dad went up town to get the mail and found a letter from Billy Mac which said that the Ranier House kept by Barker was a good place to stop. He found that the train would leave at 2:35 A.M. and that there was not enough to see either at Ranier, International Falls or Fort Francis to make a long stop interesting. We went back to the boats and gave Fred directions for packing up some of our stuff and then chartered a launch which took us to International Falls, where more letters were waiting for us and we crossed over to the Canadian side to see Fort Francis and get a better view of the big paper mill.

We had a splendid supper at the Ranier Hotel and a little later our boys and Dad in the twenty foot canoe ran out to a sandy beach where everyone had a good swim and bath and put on cleaner clothes.

We had a good many provisions left over. There were several pieces of bacon, about seven pounds of coffee and quite a little assortment of canned goods. This year the Gang has consumed more tea than on all of its previous trips and have used less coffee than on any trip. The abundance of fish has reduced the amount of bacon we have used and our failure to have a good cook who could make good bread has left us with quite a considerable quantity of flour. Everything that we had left over was either given to Billy, who has a family, or was traded in at a boarding house near the landing. The coffee alone will appear as a credit on the general expense account.

We had comfortable beds and rooms at the hotel and were called at two o'clock to take the train for Duluth. We were fortunate in getting lower berths for all five of us.

AUGUST 12TH, 1910.

We reached Duluth at about 8:30 in the morning and just as we were leaving the depot we met Harry Wild and some other Milwaukee boys who had just come in and are going into the woods to-night. We shed the last of our camp clothes at the hotel and put on very wrinkled suits. It was eleven o'clock when we finished breakfast and we lunched at one.

Dad met some old friends, Capt. O'Neil and Edward Whalen. The boys and I wandered around town until a quarter after five, when we took the train for Milwaukee. Howard, Carl and Clay were dropped off at Wales early the next morning so that Piffy and Dad were the only ones to reach Milwaukee. At the depot we were met by Mr. Ilsley and Billy Mac, and ends the story of the Gang's wanderings in 1910.

Thus ended the cruise of the Gang. Pangborn's burns proved serious because he gave himself no care, would not see a doctor until he reached home. It was not until the early part of October that he was able to return to work.

JOURNAL OF THE
INTERNATIONAL BOUNDARY TRIP, 1910.

DEPARTMENT OF BIRDS, ANIMALS, FISH, TREES, SHRUBS.

Editor-in-chief, Dad · *Chief Naturalist, Doc* · *Editor of this Department, Clay*

For an ideal camping trip, this last trip of "the Gang's," along the international boundary line, might be taken as a model. A long stretch of uncivilized country with a large expanse of uncut forest, harboring all sorts of animal life, a string of beautiful lakes, full of fish and affording fine canoeing, furnished all that could be desired in the way of location and surroundings. The personnel of the "Gang" was all that remained to give us the wonderful time that we had. I might say that the trouble, which is absolutely necessary to an ideal camping trip, was furnished in just the right degree by the portages and adverse winds.

BIRDS.

On the first two days of the trip, before we had begun to travel much, twenty-six birds were seen. Altogether on the trip fifty different species were identified. The number observed at first shows what could have been if we had not traveled so steadily thereafter. I believe one hundred birds could have been seen if we had done nothing but look for them. To me the most interesting bird life seen was the Heron Gull's nest, the Night Hawk's nest and the Pileated and Arctic Woodpeckers. The Gull's nest was found on a rock about eight feet high out in the water at one end of Crooked Lake. A young bird was found wedged in between some rocks at the edge of the water. He swam off when pushed out, but was not big enough to fly.

The Night Hawk's nest Doc found near one of our camps. There was one egg and a nestling which were hardly distinguishable from the bare rock on which they lay. The parent bird let us approach very close to her. The Pileated Woodpeckers were quite common and we could hear them in the woods most of the time. Doc and I saw three Arctic Woodpeckers, a bird I had never before identified.

The following is a list of the birds seen.

JULY 24.
1 Goldfinch
2 Redwinged Blackbird
3 Robin
4 White-throated Sparrow
5 Kingfisher
6 Purple Martin
7 Cliff Swallow
8 Barn Swallow
9 Tree Swallow
10 Spotted Sandpiper
11 Night Hawk

16 Cedar Waxwing
17 Song Sparrow
18 Downy Woodpecker
19 Partridge
20 Wood Duck (Doctor)
21 Flicker
22 Black and White Warbler
23 Myrtle Warbler
24 Great Blue Heron
25 Heron Gull
26 Song Sparrow

JULY 25
12 Water Thrush
13 Redstart
14 Kingbird
15 Chicadee

JULY 26
27 Pewee

JULY 29
28 Mallard Duck
29 Loon

30 Canada Jay
31 Yellow Warbler
32 Sparrow Hawk
33 Jack Snipe

JULY 30

34 Junco
35 Bald Eagle
36 Blue Jay
37 Crow

AUGUST 1

38 Oven-bird
39 Arctic Woodpecker

AUGUST 2

40 Marsh Hawk

AUGUST 3

41 Cow-bird

AUGUST 4

42 Fish Hawk (Doctor)
43 Humming Bird

AUGUST 6

44 Pileated Woodpecker
45 Chestnut-sided Warbler
46 Little Brown Reaper
47 White Breasted Nuthatch
48 Philadelphia Vireo
49 Red-eyed Vireo

ANIMALS.

By far the most interesting animals seen were the moose. Most of the "Gang" had never seen them before and so we enjoyed many thrills of excitement when the first cow moose was observed on the shore of one of the lakes. Moose and deer track were always very common on the banks of the little bays and inlets of the lakes where the animals had come to feed on the lily pads. If our canoeing had been closer to the banks of the lakes we would probably have noticed more of the smaller animals. Though we did not see any wild cats, yet we thought we heard them, and some old skeletons were found at a trapper's winter camp. At Ranier we looked through a taxidermist's place, and saw skins of bear, wolf and fox which had been trapped in the country through which we passed.

The following animals were seen:

1 Muskrat
2 Northern Chipmunk
3 Red Squirrel
4 Moose, two cow moose along One cow with calf
5 Deer, one Doe, one Fawn
6 Porcupine
7 Common Chipmunk

FISH.

For the first time since it was found the "Gang" had plenty of fish. Doc and Billy Mac caught all that we could use, and many times we had to throw back a good string. Pike and pickerel were the most numerous, the former being the best to eat. The biggest fish, a pickerel, which weighed about fifteen pounds, was caught by Doc. The pickerel we caught averaged about four and one-half pounds, and the pike about two and three-quarter pounds. The largest pike was a little over five pounds in weight.

As we were packing our things at Ranier I thought I would take a last cast with my rod. As I threw out the spoon the rod collapsed and fell to pieces like the "One hoss shay." It had just managed to survive the trip and the hard usage given it by Doc had been too much for the poor thing.

The first four fish in the list were caught by us. The other two were caught by fishermen whom we met. The blue pike is a beautiful and rather rare fish. Only a few were caught.

1 Pickerel
2 Yellow Pike
3 Rock Bass
4 Blue Pike
5 White Fish
6 Lake Trout
7 Sturgeon.

TREES.

Though forest fires had gone through in some places and some of the shore looked bare and desolate, by far the greater part was covered by untouched pine forests. This was true, especially of the Canadian shore. The Norway Pine was in more abundance than any other species. The White Poplar was very common too. In all about twenty-two varieties were seen.

1 White Poplar Aspen
2 Mountain Ash
3 Long-beaked Willow
4 Balsam Poplar
5 Spruce
6 White Pine
7 Norway Pine
8 Balsam
9 Cedar
10 Juniper
11 Jack Pine
12 Tamarac
13 White Thorne
14 Black Ash
15 Silver Maple
16 Large-toothed Aspen
17 Canoe Birch
18 White Elm
19 Burr Oak
20 Black Thorne
21 Cherry (Black or Red)

SHRUBS.

Of the shrubs I suppose the dogwood and sweet gale were the most numerous. The beaked hazelnut was common. About twenty species were recorded.

1 Juneberry
2 Red Osier Dogwood
3 Salicacial Myrtilloides
4 Round-leaved Cornel
5 Speckled Alder
6 Meadow Sweet (Spirea)
7 Bland Rose
8 Sweet Gale
9 Bayberry
10 Prickly Gooseberry
11 Long-stalked Green Osier
12 Mountain Maple
13 Beaked Hazelnut
14 High Blackberry
15 Bush Honeysuckle
16 Sand Blackberry
17 Fly Honeysuckle
18 Wild Red Raspberry
19 Common Wild Gooseberry

GEOLOGY OF THE 1910 CRUISE.

A MONOLITH BY B. M.

The country through which the Gang traveled in the summer of 1910 was simple and primeval, and with the exception of sedimentary deposits accumulated by the younger members of the party, the study of its geology takes us back to the very beginning of things.

ARCHEAN AGE.

When the crust of the earth cooled and the vapors of the air condensed, there was formed a primeval ocean in which the American continent did not exist. The sediment at the bottom of this ocean stratified and hardened to a known thickness of 30,000 feet. These first rocks are known as granite, gneiss, schist, diorite, and hornblende, and they bear no evidence that life existed at that time.

HURONIAN OR ALGONKIN AGE.

Further cooling of the earth caused the crust to shrink, and the side-pressure on these rocks folded and heaved them up, melting and metamorphosing some of them. The first land to be thus thrust above the primeval ocean was the LAURENTIAN RIDGE, extending from Labrador to the center of North America, thence north to the Arctic Circle. This ridge was in places higher than any mountain existing in the world today. Then the rains and the seas and the internal fires worked upon these Archean rocks, disintegrating and dissolving them, and precipitating sediments and ores at the bottom of the seas. Thus were formed the great iron deposits of this region, with the slates and quartzites found with them.

VOLCANIC OR KEEWANEAN AGE.

Northern Wisconsin and Lake Superior district was the scene of the greatest volcanic action the world has known. The melted interior of the earth burst through the Archean crust and poured out lavas which are now known as diabase, gabbro, melaphyr, quartz, parphyr, and felsite. The copper deposits of this region were made at this time.

Then came the sedimentary ages, which were not in evidence on this trip excepting as noted in our opening sentence.

CAMPS 1–2 were on Keewatin greenstone.

CAMP 3 was on Keewatin greenstone on east side of river; the west side showed mica schist. Going down Pipestone River we were in mica schist until near the entrance to Jackfish Bay where the granite formation began. Basswood Falls was over a ledge of granite, and

CAMP 4 was on a table of the same rock. Solid granite shores led us through Crooked and Iron Lakes to the entrance to Lac La Croix on the north of

CAMP 8–All of Lac La Croix was in mica schist until it turned south to portage into Loon Lake, where granite again showed and continued through Look Lake; Little Vermilion Lake was in granite and granitoid gneiss. We slept on several of these flat rocks and they made very gneiss beds. This will not occur again.

CAMP 12–Sand Point Lake was in granite, and the channel to Namekon Lake was through mica schist on

edge, with beds of gneiss and veins of quartz. Namekon Lake was in granite up to

CAMP 13–Kettle Falls was over a ledge of mica schist, which rock constituted the south shore of Rainy Lake, nearly to Fort Francis, where we began to find glacial drift, till, and soil. The whole country traversed was rock, with very little covering, and the surfaces were generally worn round and smooth by the action of glaciers of a later age.

THE VALUE OF THIS YEAR'S TRIP.

To me the greatest attraction of this year's trip is the small amount of work performed by individual members as compared with the Presque Isle Expedition. Of course some of us had to do more than our share of the labor. For instance Handsome Hannie had to keep the trees from falling on us. Now this is the most unreasonable part of the trip. Why wouldn't someone help him in this most important task? Billy Mac escaped one of his jobs, that of losing Amy, but did you ever notice the tender and affectionate manner in which he carried the jug when Dad wasn't watching to see that none of its contents leaked, a habit which it had at most inexplainable times? Clay and myself I think had the most difficult job for we had to prevent the Doc from smoking more than his daily allowance. The Doc is perfectly honest about the matter so the task is not so difficult, but at times he has most strange lapses of memory which can only be accounted for by his extreme old age. I really felt sorry for Piffy as he was unable to hear from someone for over a week. This is most difficult to bear when one is accustomed to hear from people every other hour. Carl had perhaps the easiest work for he merely had to help paddle a twelve-foot, so-called, canoe of Bill's. What is so exasperating as being pathfinder for the gang at portages and then to have every person go a different way? Yet Dad did this and kept his temper which is the most remarkable event of the whole trip.

H. T. G.

THE FISHING.

The Rainy Lake Trip will always remain in my memory as one connected with marvelous fishing. Before the middle of our journey was reached almost every man in camp had become an enthusiastic fisherman. This was due not only to the quantity of the fish, but also to their gameness.

Next to a trout, a pike fights hardest for his liberty. In the lakes we traversed, wall-eyed pike were numerous, and since we caught them mostly below rapids, unusually gamey. Spoon hooks lured them out of their hiding places, and it was very easy to land five or six good fish in half an hour. Several times we struck a large school, when we could haul out the fish as fast as we could cast out our spoons.

Large pickerel were also common. They were very much more gamey than these fish usually are and tore our lines often. The largest we caught weighed about twenty-five pounds, and took fifteen minutes to land.

The fish were not only plentiful in these lakes, but also of the finest type. A pike is known for his firm, tasty meat, and, accordingly, we enjoyed eating our fish as much as catching them.

SINGING OF THE 1910 TRIP.

One of the most important factors of the International Boundary Trip was the singing. It was one of the principal features and too much praise cannot be given to the younger members of the party for their excellent work, which I am sorry to say, was not entirely appreciated by all. It may indeed be said that much more time was spent in the training of our voices than in the research of natural history, and probably to more advantage.

In addition to the Greene-Ilsley combination, which rendered many a splendid selection, there was the Camp Quintet composed of Carl, Heinie, Clay, Howie and Piffy. Every Sunday the quintet gave concerts at which many touching ditties were sung. However, these ditties were not always received with the greatest approval by the older contingency who often showed their disap-

proval by driving the singers out of camp. One of the quintet's specialties was on ode to Doc, which was recited with great pathos and which went as follows:

"Love is a little flower
Which grows by the wayside
It comes we know not whence
It goes we know not whither."

It took many days to learn this poem well and to get the Doc accustomed to it before the final recitation of it was given.

On the whole, the singing on this trip was very successful, more so than on any former one, and the good work, which was due to hard practice, often under difficulty, was very commendable. PIFF.

CARL'S SAY:

Here is my little essay on the camping trip. I think it was the best trip that we have taken yet for the following reasons:

1st. That we were WAY OUT of civilization and even settlers for the last stretch on Rainy Lake.

2nd. That personal cleanliness was not enforced until after a certain clean (?) person went away.

3rd. That we did not run out of grub and have to start walking.

4th. That we could take our time and when we were tired we could, if necessary, camp an extra day if any of us were tired.

My only suggestion for next year is that not any member of the party shall be allowed to pollute said lake water until the end of the camping trip or on very hot days.

Taking everything, all in all, it was the most successful trip that has yet been taken. CARL.

THE RAMBLES OF THE GANG
ON THE DAWSON TRAIL

1911

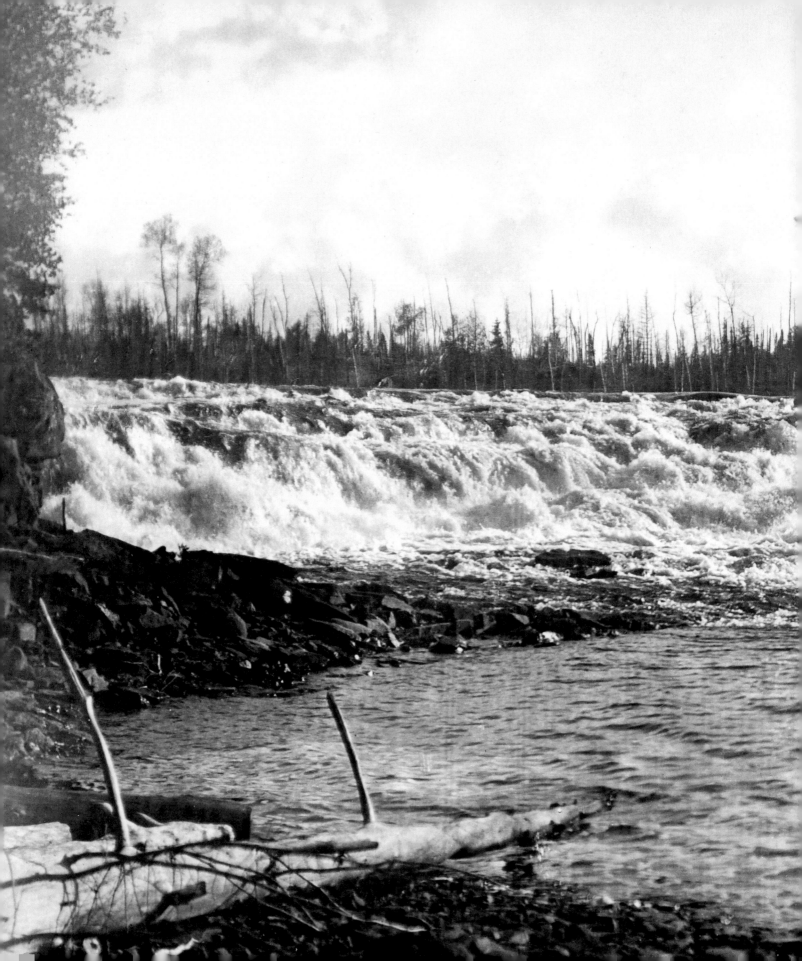

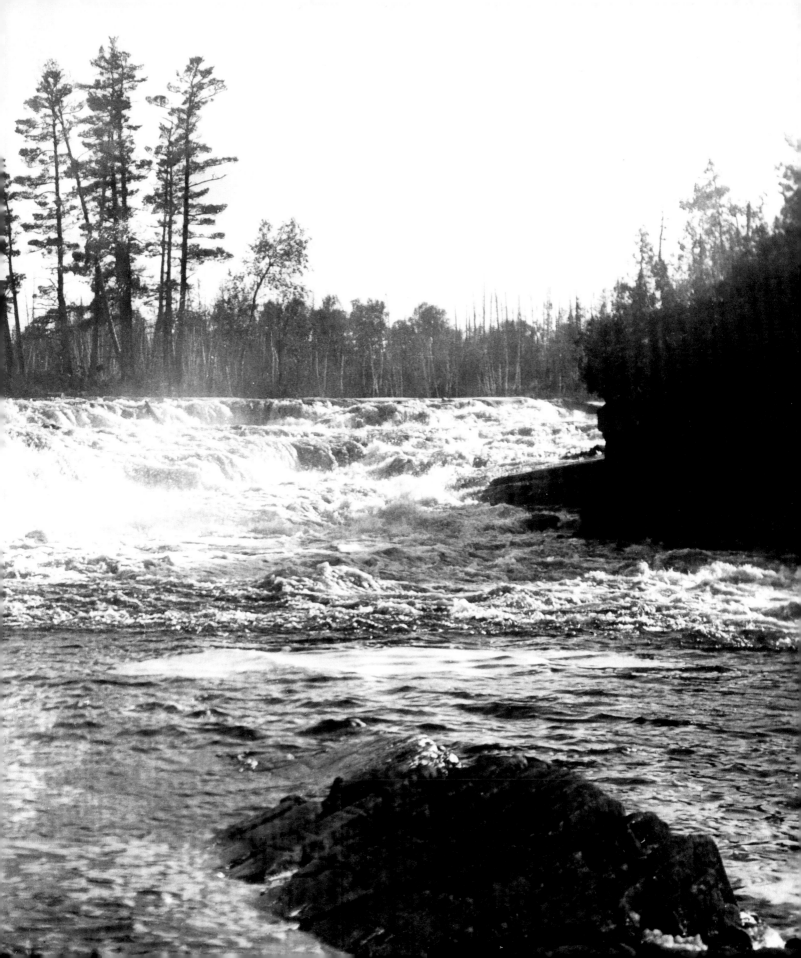

Howard Greene was a historian as well as an outdoorsman. This trip along the Dawson Trail provided a bit of all the things he loved: history, adventure, and interaction with the new Canadian forest rangers, local fishermen, and the Indians living throughout the area.[1]

The trip origin and much of the route were within Canada, requiring the Gang to prepare an exhaustively detailed list of equipment and provisions for Canadian customs at Fort Frances. Their list, shown in the concluding pages of this journal, is as informative and interesting as the narrative of their journey. Nothing tells more about *how* they camped than this document.

In 1858 the Canadian government commissioned S. J. Dawson to survey the country between "Lake Superior and the Red River Settlement and between the latter place and the Assiniboine and Saskatchewan."[2] A primitive road following much of the survey route, from Thunder Bay to the Red River settlement, was completed in 1871. The Dawson Trail is often associated with the Riel Rebellion of 1885, when it was used to supply military assistance to the Red River settlement. Because of the challenging and boggy terrain, dams, bridges, and corduroy roads were constructed, and traces of these remained at the time of the Gang's trip in 1911.

Although the Riel Rebellion and the construction of the Dawson Trail occurred early in Howard Greene's childhood, the history and the trail lived on for decades. Some parts of the original survey route continue to be used as roadways in Canada. The Hudson's Bay Company Archives in the Archives of Manitoba provided a copy of the original survey route.

Dad's hand-drawn map, included at the beginning of this journal, was completed after the Dawson trip in 1911 and is based on maps issued by the Geological Survey of Canada, using the Seine River and Hunter's Island sheets. Details of both the Rainy Lake and Dawson trips are shown on the map, including routes, portage distances, days out on the trails, and camps.

This trip provided more contact and experiences with the Indians in the region. Since their first trip on the St. Croix River, the Gang had gradually become more interested in the culture and artifacts they came upon and were more at home in Native American villages and campsites. At the same time, the Gang's growing familiarity with Native cultures led, on occasion, to less respectful behavior. Historically, this was not unusual but can be uncomfortable for a contemporary reader. It may be helpful to remember that the journals were simply personal records written in the context of the early twentieth century, never intended for publication. To maintain their candor and authenticity, the trip narratives are presented here in their original and complete form.

THE GANG

ON THE

DAWSON TRAIL

1911

In the many decades preceding the twentieth century it was common for Natives and others to mark trails with Norway (or red) pine trees; a single, tall Norway stood out in the landscape. The Dawson's tall Norway pines helped guide the Gang on much of their canoe route through from Windigoostigwan to Ranier. Dad was fond of these trail markers. On this journey, he noted many of them and made a number of pictures of the Dawson pines as he encountered them. By the time of the Gang's later trip in 1915, from Tower to Ranier, new dams had been built to supply power for the paper company at International Falls, and Dad was sad to see that an old Norway pine he had photographed in earlier years had died from the resultant rise in lake levels. [M.G.P.]

NOTES

1 Although Dad referred to their route as the Dawson Trail, it is more accurately called the Dawson Survey Route.

2 S. J. Dawson, Esquire. C.E., *Report of the Exploration of the Country between Lake Superior and the Red River Settlement and the Latter Place and the Assiniboine and Saskatchewan* (Toronto: John Lovell Printer, 1859).

THE RAMBLES OF THE GANG
ON THE DAWSON TRAIL
1911

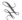

Dedicated to "THE GANG" and privately printed for them—

———————

Dr. Ernest Copeland

William P. Marr

Howard Greene

Clay Judson

Carl Greene

Howard T. Greene

William McLaren, *in absentia*

———————

LIMITED EDITION

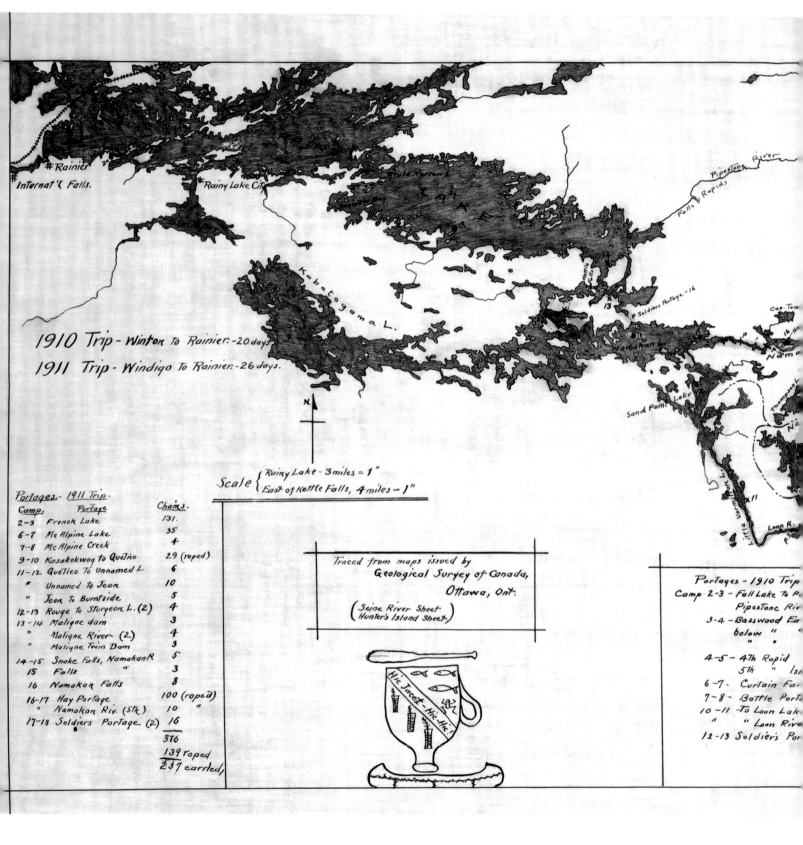

Rainier
Internat'l Falls.

Rainy Lake City

Brule Narrows

Kabetogama L.

Pipestone River

Falls & Rapids

Soldiers Portage - 16

Namakan L.

Sand Point Lake

1910 Trip - Winton to Rainier. - 20 days.

1911 Trip - Windigo To Rainier. - 26 days.

N

Scale {
Rainy Lake - 3 miles = 1"
East of Kettle Falls, 4 miles = 1"
}

Portages - 1911 Trip.

Camp:	Portage	Chains.
2-3	French Lake	131.
6-7	McAlpine Lake	35
7-8	McAlpine Creek	4
9-10	Kasakokwog to Quetico	29 (roped)
11-12	Quetico To Unnamed L.	6
"	Unnamed to Jean	10
"	Jean To Burntside	5
12-13	Rouge to Sturgeon L. (2)	4
13-14	Maligne dam	3
"	Maligne River (2)	4
"	Maligne Twin Dam	3
14-15	Snake Falls, Namakan R	5
15	Falls "	3
16	Namakan Falls	8
16-17	Hay Portage	100 (roped)
"	Namakan Riv. (5th)	10 "
17-18	Soldiers Portage (2)	16

376
139 roped
237 carried,

Traced from maps issued by
Geological Survey of Canada,
Ottawa, Ont.

(Seine River Sheet)
(Hunter's Island Sheet)

Hic Jacet - Hic Hic!

Portages - 1910 Trip

Camp 2-3 - Fall Lake To P
Pipestone Riv

3-4 - Basswood Ea
below "
"

4-5 - 4th Rapid
5th " Isl

6-7 - Curtain Fa

7-8 - Bottle Port

10-11 - To Loon Lake

" " Loon Rive

12-13 Soldier's Por

JOURNAL

1911

Here begins the story of the Gang in the year 1911 on their trip from Windigo, Ontario, to Rainier [Ranier], Minnesota.

Shortly after our return from our last trip, B.M. procured some excellent maps of Ontario, and these kept our spirits and were the occasion of several dinners during the winter. Various routes were laid out, abandoned, and projected again, until the selection was narrowed down to three routes,—

1.—To start from Winton, as in 1910, and follow the same course to Crooked Lake, then portage to Rebecca Falls (instead of Bottle Portage), and make the passage of the Namakan River.

2.—To start from Rainier and work into the Clear Water Lakes and return.

3.—To start from some point on the Canadian Northern Railway in the vicinity of Atikokan and work to Rainier.

The first plan was abandoned because the route would not be entirely new, and the second because we would have the current against us half the way. Doc's opposition to the second plan was especially strong, as he expected to have Clay for a partner.

Adopting plan 3, there were two ways of reaching our point of departure from the world,—one by boat from Duluth to Port Arthur, thence by Canadian Northern to Windigo; the other by rail to Fort Frances, and then by rail to our destination. The first route would take a day longer, and would bring us into camp at night, while the second required us to change cars

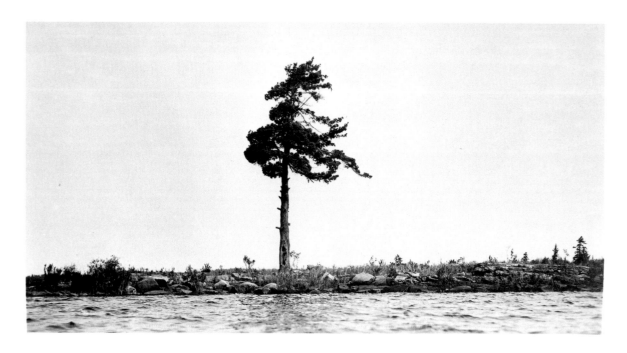

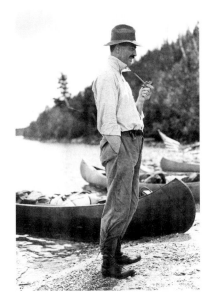

Bill Marr

about mid-night, but had the distinct advantage of bringing us into camp early in the morning.

The make-up of the gang was the most trying question. We would have liked to have added one or two but the necessity of traveling light warned us to reduce the party, or at least not to add new members. Heinie warned us in the early spring that he could not go and so we reduced to the number who could occupy one tent. Billy Mac chose to divert himself with a variety of ailments during the months of February, March, April, and May, and said he would have to attend to business for the rest of the year; so we counted five,—Doc, Dad, Bill, How, and Carl. Clay hesitated and finally said "Yes," so we were six. The seventh place we kept vacant in hopes that our prayers might be answered and another carbuncle be sent to Billy Mac—big enough to incapacitate him from business. When it failed to appear we gave "Di" a roving commission to fill the seventh place.

The month before our departure was marked off by a series of Gang Dinners at which lists were made up and revised. Dad and How attended to all details of camp equipment and grub; Carl, Doc, and Dad repainted four canoes on two terribly hot evenings; B.M. built sundry canoe yokes and things for our general convenience, and attended to various items of railway and customs information.

Through Mr. Pangborn of the Peninsular Box & Lumber Company we arranged for woodsmen and a cook. Fred Carr (our old reliable on the last two trips), Billy Warmbier (now a full fledged cook), and Billy Boucher were to go with us. Fred left Menominee Tuesday night, July 18, and was to spend Thursday, Friday, and Saturday getting our goods through customs at Fort Francis [Frances], and in buying flour, potatoes, etc. The other men were to leave Menominee on Friday night and meet us at Duluth the following morning.

In an appendix to this Journal will be found an almost complete list of our equipment and provisions with memoranda on customs information. It was the worst piece of preparation we ever had to do because of the necessity of shipping all stuff together and making lists and invoices for the Canadian and American Customs.

<div align="right">MILWAUKEE, JULY 21, 1911.</div>

As a peace offering Billy Mac invited us to a farewell dinner at the Gargoyle this evening at seven.[1] It was a well intended thought on Bill's part; but he gave us a cheap imitation of camp grub. He had ordered bean soup, corned beef hash, pancakes, and for the men two drinks apiece. We stood it all right until the pancakes came on. They were of the German style known as "Pfannekucken." When they appeared B.M. tried to brace up, but they looked so like the tub "Ivory"[2] that he had to give up, and to the others they were horribly suggestive of a foot bath or something intended for cleanliness. Let Billy Mac read, ponder, and know what we thought of him. He made good with the brutes with a present of books.

[1] The Gargoyle was a fashionable Milwaukee restaurant opened by Gustav Pabst, 1906–19.
[2] The Tub Ivory was Bill Marr's folding canoe from the Rainy Lake trip.

Mrs. Greene brought Di to the depot, and we said goodbye to her and Billy Mac. At 8:50 we had our belongings stowed away and were started on the first leg of our journey. Dad went to his bunk; the rest of the party sat up to help "change Diaper" at Rugby Junction. When Carl had performed this motherly duty he was spanked and kissed and put to bed—an operation attended with much noise and commotion.

At breakfast time we passed through Gordon, and saw the site of our first camp on the St. Croix River expedition of 1907. After breakfast Carl and B. M. looked through the train for our men and found them not. As we left the depot at Duluth, Dad recognized Billy Warmbier with a man whose face was familiar, but whose name he could not recall. It was Dave Paris, a brother of our fat cook of the Presque Isle trip. Billy Boucher was not well, and it had been arranged to have Dave take his place. We shall miss cheerful Billy but Dave looks all right.

The day at Duluth was spent in walking about buying odds and ends, and writing letters and getting our hair cut. We are to leave on the Duluth, Mesabe & Northern at 7 P.M. The only incident of the day at Duluth was the receipt of a telegram to Dad:—

"Will tent at Gargoyle tonight. No mosquitos. No portage.

"No fun.

Billy Mac."

Poor Billy Mac. Lonesome, no doubt.

We left Duluth at 7:10 P.M., checked our trunk containing our good clothes to Ranier, and sent the check to our last year's friend, Theodore Barker who keeps the Rainier House. The whiskey supply in five bottles was distributed a bottle each to B.M., Dad, Billy Warmbier, Doc and Dave. All of the bottles had been opened so as to pass the Canadian Customs Officials as personal effects. During the evening one of the boys went through the train and found Billy and Dave putting the contents of a bottle where no customs inspector would find it. This morning Dave reported that Billy lost his nerve at the appearance of the inspector at Fort Francis, and hid the bottle under the seat, where he left it.

On the train we met Mr. Osborne Scott, Asst. Passenger Agent of the Canadian Northern, whose business on the train, in part at least, was to look after our welfare. We took to our berths early. At Fort Francis our hand baggage was passed after a most cursory examination by the inspector, who had a most dignified and impressive manner. Ask B.M. or Carl. We then changed to an east-bound C.N. train. Fred Carr met us at the depot, and all our baggage, canoes, grub, were put on the baggage car. Fred paid $103.00 duty, of which $86.00 is to be refunded when we come out. None of our freight shipments were even opened for examination.

LAKE WINDIGOOSTIGWAN, JULY 23.

At seven this morning we reached Windigo which consists of a water tank and pumping station, and a section house inhabited by some Finn section hands.[3] It was raining when we arrived, and the woods were wet,— everything was wet. We sheltered some of our stuff under a porch at the section house, expecting to wait until the rain stopped. But Dad was possessed of an unreasonable and civilized fever for work, and shamed us into taking the stuff out into the rain and unpacking it. North of the track is a little lake, while to the south is Lake Windigoostigwan; but the latter is not accessible by trail from the station. While the equipment was being unpacked Fred and Bill went down the

[3] A section house was a building alongside a railroad track used to house workers and equipment needed to maintain the section of the railroad line.

Water tank and pumping station at Windigo

track exploring. This was one of the advantages of being official Guides. We launched our canoes and loaded them full, and paddled to the east end of the little lake where we worked out a trail about seven hundred feet long to Lake Windy—etc. and portaged our stuff. It was nine when we left the station and it was half past eleven when we left the landing on Lake Windi-go-on headed for a sandy beach a mile away. We passed a good camping ground where Indians had wintered, and had left behind them their tepee poles and a stench. All the morning it rained, and we were wet through. We had no breakfast—only a little pilot bread, berries we picked as we worked, and some candy Clay brought with him. At two-thirty we had our first meal of stereo soup, bacon, coffee, and pilot bread; and then the rain stopped for a while, and we were able to dry out some of the baggage and arrange it camp-wise, the latter operation occupying the entire afternoon.

Just after we reached our camp Doc caught three pickerel from his canoe right in front of the camp.

Near our camp is a little creek and along its bank is a well cut out trapper's trail where we found some old traps. The country is full of game. Doc saw a moose this morning and he found some partridges on the portage. There are moose tracks on the trapper's trail.

We had a beautiful dinner—venison, stewed rice with flies, and biscuit. Then we went to bed. It was broad daylight at half past eight—so much for getting in the far north.

SLEEPING ORDER

Di						
#?(*)						Di
o#?					——	
D	H		B	C	(D)	C
O	(—	I	A	(A))
C)		L	R	(D)	L
	O		L	L	(Di?))
	((_)	A
)	Di				(
	W					Y
Di						

_ Open
_ door
_ of tent

MONDAY, JULY 24, CAMP 1.

We awoke with a cold, keen wind blowing in the tent. The lake is too rough for us to get away from here, and here we shall have to stay—until the wind goes down. We wore all the clothes we had, borrowed some from the other fellow, and stood about the fire to eat our breakfast. During the morning everyone did sundry bits of work on the equipment. The tent had to come down because of the high wind; and later, as rain blew up, we pitched it again.

In looking over the cooks' outfit we found we had only a quarter-barrel sack of flour[4] which Fred had bought at Fort Frances; and according to our experience we ought to have over one hundred pounds to carry us for four weeks. We discussed the situation and decided to try to buy flour from the section men at Windigo, and if we could not get it there, to learn from them how far it would be to the nearest town and either pack some

[4] A quarter barrel of flour equaled 49 pounds.

in or Bill would spend a day going to Port Arthur, while most of the party went to the lower end of the lake. One man would be left behind and would accompany Bill to the next camp where the rest would have a portage commenced. Everyone wrote Billy Mac, and Clay wrote as many letters as we could furnish stamped envelopes.

Extract from Carl's letter to Billy Mac:—

> "Doc caught a pickerel yesterday that weighed eighty pounds. That is going some, eh? It took three of us to get him ashore. Fred took an axe to split his belly."

Right after dinner Fred, Doc, How, Clay, Bill, and Dad started out in the war-canoe with a wind so strong that we could not turn until we were in the shelter of the granite bluffs on the further shore, when we turned to where we made our portage yesterday. The woman at the section house could spare only forty pounds of

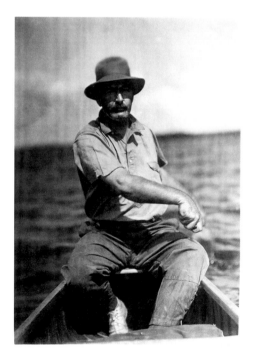

flour, and we decided to take that and see whether we could get more from a supply car which she said would come that afternoon. She asked three dollars for the forty pounds, we claimed that was what it cost. When the 49 pound sack was produced we found it was a 98 pound sack and we had fully 90 pounds for our three dollars. Doc and the brutes picked raspberries, and on our return gave them to the cook who promptly stewed them so we could have them for supper. We left our letters at Windigo to be mailed. The return to camp was easy for the wind had subsided.

Everyone worked over equipment, getting ready for our final start tomorrow. Bill patched a canoe broken in transit, Dad sewed up rips in his hand bag, Clay rigged a sail, and Carl made a pipe for the Doc. We had an early supper and went to bed at half past eight.

CAMPS NOS. 1 AND 2.
TUESDAY, JULY 25.

We had a cold and rainy night, and were not out until seven. There is a west wind but not so strong but that we can load the launch. We had a breakfast of scrambled eggs, pancakes, fish, and coffee, and then began the packing up. This is the way we travel:—

Doc and Clay . . . Doc's canoe
How . . . Clay's canoe
Bill and Carl . . . Bill's canoe
Fred and Dad . . . 18 ft. canoe
Dave and Billy . . . 20 ft. war canoe

The first boats left at 8:30, and the last at 8:50, which was very good time for our first start. The canoes carry our outfit easily.

Our course was west to the opposite shore to avoid the heavy waves and again westerly until 9:50 when we stopped to rest and compare notes. We then went on a southerly course exploring islands and bays for the

narrow part of the lake; and finally we located it and had our noon lunch, about three miles from our camp No. 1. This was at twelve o'clock.

At our noon camp there was a greatly disturbed hawk who probably had a nest in the vicinity. Clay and Di tried to find the nest while Billy was cooking lunch. We had two kinds of potted meats, sardines, corned beef, and coffee, with pilot bread, and then we took up our way.

We passed one narrows, and at the lower end saw a stump with a forked stick, evidently to mark the way. Looking for the next narrows we were pocketed in a bay, and had to retrace a part of our course. At the second narrows we found a guide mark, evidently Indian, a stick standing about four feet above the water, to which was tied with white cloth, a cross stick about ten inches long pointing down stream.

At the second narrows Fred and Dad were in the lead, and coming through quietly. Fred saw a big cow moose feeding at the water's edge about two hundred

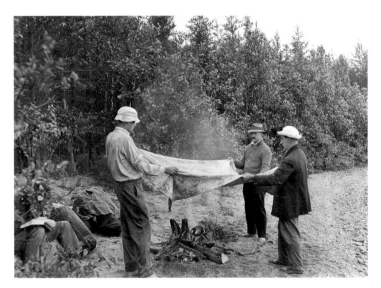

Drying blankets

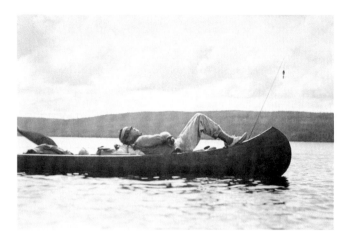

stream with some swift water and many rocks; not enough water for comfort. We travelled on about a mile to an old dam (now in ruins) which was a part of the Dawson Trail improvement. The bed of the river had been cleared of boulders to a great extent, by rolling them to one side so as to make a boat channel.

How, Clay, and the Doc explored the dam, and found hornets in plenty. Di also ran.

We have a good camping site on the hill near the dam. Mosquitoes and "no-see-ems" are here in plenty, but the night will probably be cool.

At the dam there is a lot of debris including the remains of an old steamer about 50 feet long, with an engine shaft, and wheel tire. The dam evidently flooded way back, as there are trees broken off 6 or 8 feet above the roots.

We have travelled about 20 miles by canoe.

yards away. Some water reeds partly concealed them, and they lay to until the rest of the party had come up, and watched the moose. Dad then quietly mounted his Gatling camera with a 11 inch lens,[5] and sneaking out had a fair distance view. As a second plate was about to be tried, the animal decided that the strange thing was dangerous, and trotted off.

At another narrows a long sand spit runs out and nearly closes the lake. In exploring the sandy beach Dad found a pair of cast-off moose horns in perfect state of preservation. These will add to the burdens at future portages. Carl amused himself here playing tag with a large frolicsome pickerel.

At about half past five we struck the French River, a narrow, crooked

[5] The Gatling camera was an undetermined type of camera, as named by Dad.

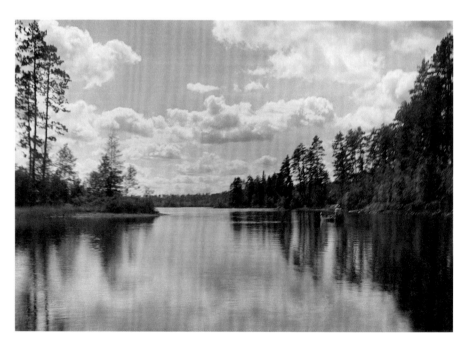

Lake Windigoostigwan

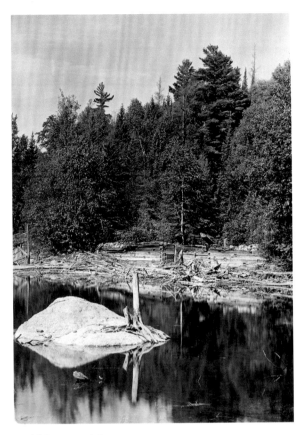

Old dam, French River

Portage trail, old wagon road

Tomorrow we portage.

In the morning Dad pictured the camp and the dam, while the rest of the party made one trip over the trail.

The portage is one and two-thirds miles long. It was originally a well cut out wagon road, ditched and filled, and with low places in corduroy; but of this only a foot path remains.

From end to end it is well shaded, and but for its length and the weight of our stuff, would be altogether pleasant. We planned to take all day to portage our camp equipment and to move the canoes tomorrow morning.

Fred and Davie made three trips, and the others, two trips. Billy baked bread and cooked our dinner. At four o'clock three of the canoes—all of our equipment, and part of the cook outfit were over. Doc, Dad, and the Brutes have knocked off and are waiting for a swim.

Di killed a wood chuck on the trail in the afternoon.

Di has thoroughly enjoyed the day, running up and down the trail meeting us. She was quite warm today with her fur coat and pants.

French Lake is very pretty. There is more standing timber in sight than on Lake Windigoostigwan. In front of our camp is a wooded island.

Moose tracks are plenty. A deer was down near our canoes last night, and stamped up the ground within a few feet of the trail.

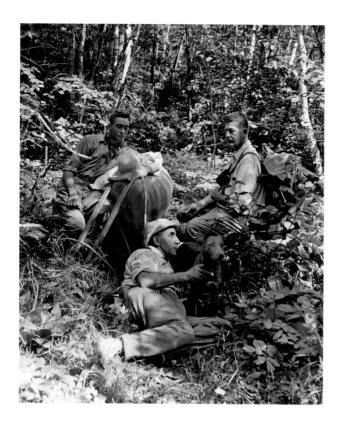

There are two fearless flocks of partridges on the trail, and they probably will not all be there tomorrow.

Doc and Clay saw a cow moose and calf at short range this afternoon.

We made bivouac camp. All rolled in at nine o'clock.

In front of our camp are the remains of an old dock of the Dawson Trail days.

CAMP NO. 3—FRENCH LAKE.
CAMP NO. 4—ISLAND IN PICKEREL LAKE.
THURSDAY, JULY 27.

We spent the entire morning at camp No. 3. Fred, Cope, Dad, and Clay brought over the last canoes and supplies. Dad and Clay went after fish. They saw a moose, and located both the French River and the one leading out of French Lake. Dad changed plates, and all about camp was a general activity of getting ready. We lunched at eleven, and at twelve Doc and Clay returned to eat what

Bivouac camp

· 204 ·

they could find. In the early morning and at noon we heard blasting, which we supposed was at Hematite or on the rail-road. At 12:50 we were ready to start, and in forty minutes we reached the river entrance. Here Dad mounted his Gatling camera for moose, and took the lead, the rest following at some distance. Dad saw one moose and had a snap shot at about two hundred foot range without a chance to sight the camera.

At the entrance to Pickerel Lake we stopped for a smoke, and then pushed on against a stiff wind until about five o'clock, when we camped on the north-west end of an island. We are on the site of an old Indian camp, and we cleared the space for our tents by throwing down their old tepee frame. The island is virgin timber, and the ground is heavily covered with moss.

Opposite us is a little rock island on which B.M. discovered blue berries in plenty, and a very perfect Indian cache. This cache is of birch bark weighted with

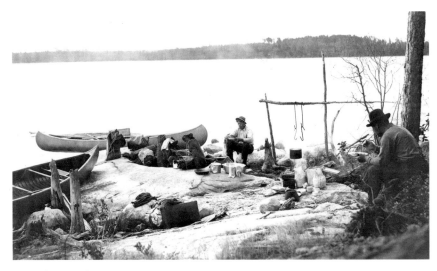

Lunch at French Lake

Indian cache

stones. The holes in the bark are neatly patched. Under the law of the woods we may look and wonder but not uncover. At one end we could peek underneath, and saw rolls of birch bark, a very small trunk; and above the trunk were evidently tin boxes. Cache Island we call it.

The boys gathered a lot of blue berries, and we expect a pie tomorrow.

Our grub pile is the best ever, and this is no reflection on the art of Martin Fogarty. Peace be to his soul wherever he or it may be.

The bread baked yesterday (12 loaves) is more than half gone; and such hash, such pancakes, and such quantities!

There is a general look and appearance of rain, and our tent has been put up. Carl caught two pike today, and several pickerel.

Pickerel Lake is well wooded. The shore in one place shows a recent forest fire, but not an extensive one. The lake opens up in attractive vistas of islands. At the end of the lake we shall have to choose between two

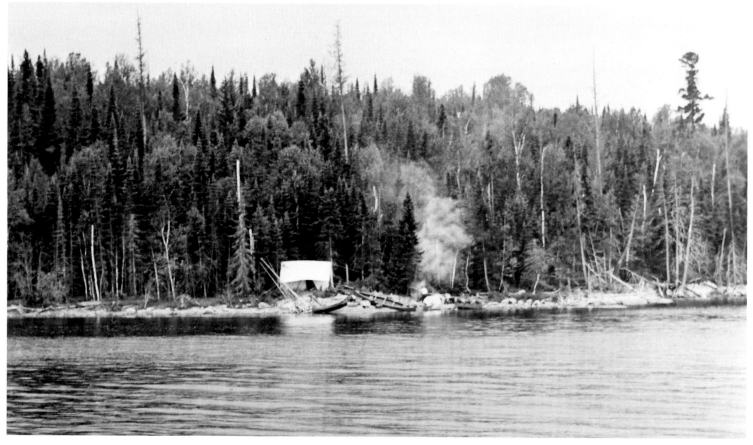

Camp Four, Pickerel Lake

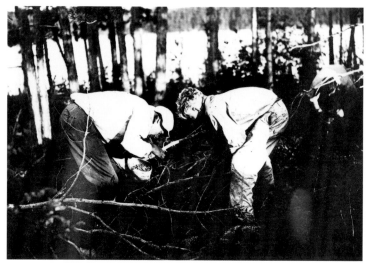

Gathering blueberries

courses,—one by Lake Dore and the Maligne River, and the other by Quetico Lake, and Quetico River. This Journal shows later than we combined both routes and lengthened our trip.

Bedding aired and dried this morning. Sun very hot, breeze nice. How studying shrubs with Clay. Bill made a sail for his boat tonight.

We went to bed and the tent was suffocating. We stood it for awhile, and then went out on the rocks clad in darkness and pajamas. Doc and Bill smoked and Carl raised daffydills. The row brought out Dad and his bed. We watched the play of lightning in the west. One by one we went back, leaving Dad curled up in a hollow in the rocks. He got the rain and the others got the mosquitoes.

CAMP NO. 4—ISLAND IN PICKEREL LAKE.
CAMP NO. 5—ISLAND IN PICKEREL LAKE.
FRIDAY, JULY 28.

The morning broke cloudy, and so windy that we could not move out; in a word, we were windbound. The island is beautiful, heavily timbered and carpeted with moss. The shore is rocky and so strewn with dead timber as to make it difficult to walk about. We spent the morning doing the hundred and one small things that always require attention when we are not traveling,—mending and washing clothes, shaving, repairing canoes and equipment. We had lunch at eleven and did more resting and repairs. At three we had tea, bread, and corned beef lunch and packed our canoes; and at about four took advantage of the subsiding wind and started along the southerly side of Pickerel Lake. After an hour's paddling we stopped in the lee of a point of land, and Bill appeared as Master of the Lunch, and gave us chocolate and pilot bread. At about half past five we stopped at an island to rest—for the sea had been heavy—and the boys went ashore to look for blue berries. In some ways this is better than the "blueberry camp" of the St. Croix trip. The berries are larger and sweeter, but the berry patch is smaller. We ate all we could and carried away a big basket of them for future pies.

On this island we found some pine trees, many dwarfed and twisted by exposure to prevailing cold winds. We paddled along watching a gorgeous sunset until dusk, when we made a bivouac camp in a grove of Norway on a small island west of Emerald Island.

In less than half an hour after landing we had supper. Everyone was somewhat wet from waves breaking over our canoes. Someone asked Carl if he got wet, and he replied, "I got two waves in my shoes, and I sat on the others."

The sun sets far into the north up here, and at quarter of nine it was light enough to read. Just after sunset we were treated to a gorgeous aurora in yellows and greens with long streamers and an arch reaching to the south. We tried to photograph the new moon and evening star by fading daylight, and succeeded in capturing the moon.

CAMP NO. 6—END OF PICKEREL LAKE.
SATURDAY, JULY 29.

We were up early and everyone but lazy Dad had a swim. We breakfasted at six, and at seven were on our way. About nine o'clock we came to the Dawson Trail portage at the end of Pine Lake. There is a short well cut out portage to Dore Lake. We found an old steamer and boiler and engines sunken and gone to pieces at this end of the trail; also saw bits of small saw mill outfit. The trail has recently been cleared out, and some of the trees show twenty years growth.

Sunken steamer at Dore Lake

Of the Hudson Bay Co.'s Post there is nothing to be seen. Not even the site can be found. We are in the right location for here is the Dawson Trail marked by the solitary pine.

Fred carried one canoe over the trail, and brought word of two forest Rangers who asked if we had come through the Game Reserve without a license. One was raising these questions, and the other, who was the more experienced man was inclined to be more quiet. Fred replied to their questions by saying he did not know anything about licenses and guides. Carl started over the trail to see them, and brought back word that one of them knew MacDonald and Campbell, whom we met last year, and that we had met him at Basswood Falls. Just after lunch, the Rangers came in, and we had a long talk with them and gave them one of our maps. One of them was Hampshire, whose life we saved with some tobacco last year when he passed us on his way to Winton for supplies. Nothing was said about licenses. They are going to an island in Quetico Lake where they will meet two other parties of Rangers. They will move their camp to this end of the portage, and will take dinner with us.

We decided this morning that we would follow the route through Quetico Lake. We shall be here all day, and tomorrow, too, if the fishing is good. Dore Lake is reputed to contain land-locked salmon, and Billy Mac had given to Doc and Bill a mysterious and wonderful collection of flies to assist in their capture.

This afternoon Doc, Bill, and Carl went to Dore Lake for some of those salmon, and after six o'clock they came back empty handed. Our Ranger friends took dinner with us, silent and talkative by turns, as is the way of men who live much alone in the woods.

In the evening Bill and Cope again tried the fishing, and brought back one pickerel which our Ranger companion thought was not fit to eat. "Snake," he called it.

We had a nice cool night.

CAMP NO. 6—END OF PICKEREL LAKE.
CAMP NO. 7—MCALPINE LAKE.
SUNDAY, JULY 30.

At six we were called, and had a breakfast of Pettijohns, stewed blue berries, coffee and pancakes. We packed in a leisurely way, and left camp No. 6 at quarter after eight, led by our Rangers, and headed for Pickerel Lake. There we turned at the first point, and said goodbye to

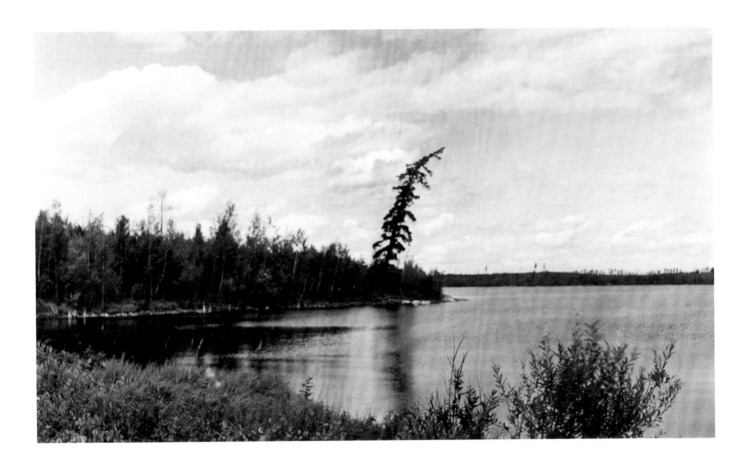

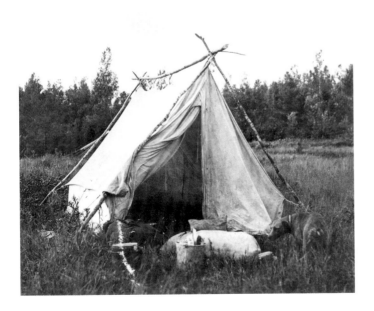

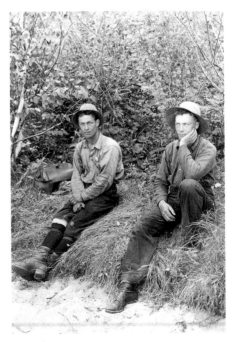

Canadian rangers

Emerald Isle, and headed westerly on the long arm of Pickerel Lake.

From now on we leave the Dawson Route, and follow the ways of the trapper, Indian, and Ranger.

From the west end of Pickerel Lake there are two courses to Quetico Lake,—one by Jesse and Fir Lakes, and the other by Batchewaung and Kasakokwog Lakes. Hampshire tells us to take the latter (northerly) course, as it is the better and more interesting. The former course is scant of water.

Just before reaching the narrows at the west arm of Pickerel Lake we stopped for our chocolate lunch: then Fred and Dad took the lead with the Gatling camera set for moose. They saw a cow and calf, but the distance was too great for a satisfactory picture. Some of the shores are rocky and well wooded.

About noon a thunder shower blew up, and we stopped for lunch. During the latter part of the morning and afternoon we had a good wind behind us, and

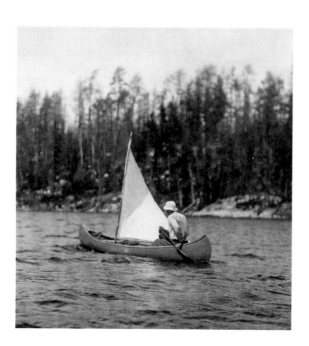

the three canoes rigged with sails spread their canvas and made good time, especially in the end of the lake where wind and water condensed into one narrow channel. Dad and Fred here had a discussion about the tactics to be observed in turning a canoe in a heavy sea.

The opening into Batchewaung Lake is narrow but easily passed. This lake is not very attractive, as a fire passed through here last year. At the west end it narrows, and all hands had to get out to lift the boats through.

The Rangers were a little ahead of us, and we found the portage but no camping site, so we were up against a rough portage of 35 chains to McAlpine Lake. The trail is rough and leads over a water-shed so steep that if it were much steeper a rope or a ladder would be desirable. Part of it is swampy, and the Rangers have laid down some trees. It was four when we came to the end of Batchewaung Lake, and each trip across and back took half an hour, so it was six before our supplies were over. Then the rain began to fall.

The evening was warm, so Doc and Dad put their bedding in a canoe and moored to an old tree in the lake. Another rain came on when they were well asleep, and back they came to camp. Doc was in an uncommon peevish frame of mind. He gave Howie his cigarette to hold while making his bed, and Howie smoked it up. Then Doc wanted canvas to sleep on; he wanted to borrow some blankets; he put Howie's shirt in Howie's shoes; he generally mixed up belongings and woke people up and kept the whole tent disturbed.

There was a heavy fall of rain during the night. This is our camp No. 7. At supper Hampshire came over and asked the names and residences of our party. He wanted only the names of the men—not the boys or the woodsmen. He advised hiding our guns if we had any. He said his orders were strict to turn back tourist parties unaccompanied by a licensed guide; but as they and we were going in the same direction, he interpreted

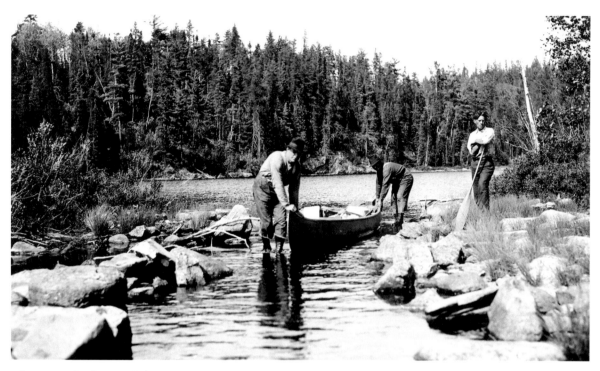

Passage into Batchewaung Lake

his instructions to see us off the Reserve in the way convenient to us and himself. He would have to report to his chief on Eden Island in Quetico Lake, who is a nice fellow and would probably make no disturbance, but let us go through to the Namakon [Namakan] as the shortest way out. A young loon near our camp was laughing and calling and the brutes mimicked his calls and entertained him a long time.

CAMP NO. 7—MCALPINE LAKE
CAMP NO. 8—KASAKOKWOG ISLAND.
JULY 31ST

Everything was soggy and wet when Billy called us to breakfast at six o'clock. The morning was spent in odd jobs, and loafing and reading. The Rangers came over for a call. Lunch time came before we expected it, and

then Dad changed plates. Carl has not been feeling well, but met with a fair measure of success this afternoon.

At about three o'clock, the sky being still cloudy, we left camp and went down McAlpine Lake with a fair wind behind us, and paddled about three miles to the outlet. We passed the Rangers' camp on our way, and they said they would stay there until next day. Before we were out of sight of their camp they were on our heels, pleasant, polite, tactful, but everlastingly watchful.

The last camp (No. 7) is to be known as Dad's camp on account of his supposed predilection for camps in burned timber.

"Uncle Charlie, oh you kid."

Mc Alpine Creek, as the Rangers call it, is a slow, murky stream, very shallow, muddy and full of sticks; and we were in and out of our boats a good deal to drag

our canoes over shoal places. There is one narrow where we portaged 225 feet. Moose tracks are plenty, but we saw no more, as our boats made too much noise.

The Rangers call Anna Lake what on our map appears as Kasakokwog Lake, none of us can frame to pronounce it right, the boys call it "the Kook Lake." We went half the length of the lake easily when How over-

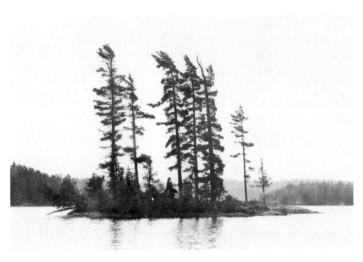

Island, Kasakokwog Lake

took Dad and Fred, who were in the lead, and reported that the rest wanted to camp. Before the party came up it was six o'clock, and looking over all promising points in the vicinity Doc decided upon a little island opposite the portage to Long Lake. The place has been used by Indians, and is overgrown with blue berries, the bushes being enough to make a good bed. There was hardly room to pitch a tent, so guessed that the night would be clear, and made up a bivouac camp. The night was cold, windy, and somewhat cloudy when we went to bed.

CAMP NO. 8—KASAKOKWOG ISLAND.
CAMP NO. 9—KASAKOKWOG LAKE.
TUESDAY, AUGUST 1ST.

Sometime during the night rain began to fall, the roots of a fallen white pine tree began to blaze from the kitchen fire, and Fred had to get out three times to keep the fire from spreading over the island. The rain fell heavily, and by morning we were well soaked, and still the rain was falling. The nice soft beds of the night before sank under our weight, and each hollow slowly but quite surely filled up with cold rain water. It came in faster than we could warm it up with the heat of our bodies.

We had breakfast and stood around getting wet and wetter all morning. The fire merely made us steam. The boys furnished some diversion which culminated in Doc dropping seat first into the fire. After lunch we packed up and started down the lake looking for a new camping place where we could pitch a tent and dry out. We paddled about a mile, passed our Ranger friends, and found a high, rocky point where we made a camp, stretched our lariat lines, and dried out between showers until late in the afternoon, when the wind shifted and blew up cold. The Rangers SAY they are going on tomorrow. We shall stay here two nights to dry out, repack, and bake bread.

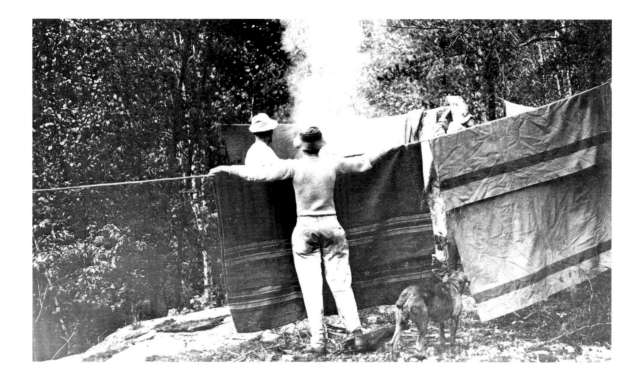

This lake is very attractive. The shores are heavily wooded and burned only here and there. We had a cold night, and a long night, for everyone was tired.

CAMP NO. 9—KASAKOKWOG LAKE.
WEDNESDAY, AUGUST 2D.

Drying out commenced in earnest as soon as we were out of our blankets. Everything was distributed over the rocks to sun-dry. Bill was again elected K.O., and he immediately directed that everyone wash clothes. The men shaved. We decided that Clay's whiskers will be red and advised moustache and goatee. The camp divided into three parties:—

Sockless,

Sox,

Insurgent, —Clay.

Our Ranger friends left their camp this morning, and we shall see them again at Eden Island in Quetico Lake.

Doc and Bill went fishing in the afternoon and caught six fish of which only three were of eating size. They did not return until after grub time.

The evening was still. Carl took Dad out for an evening paddle on the lake. Those who were in camp discovered an echo that answered from across the lake in four seconds. Di was much excited, and was very peeved at hearing another dog bark at her from the end of the lake.

How, Dad, and Doc slept out of doors to avoid the mosquitoes.

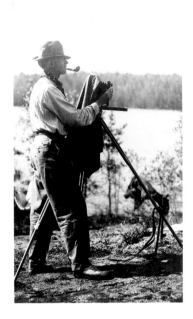
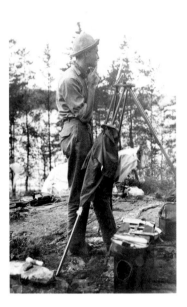
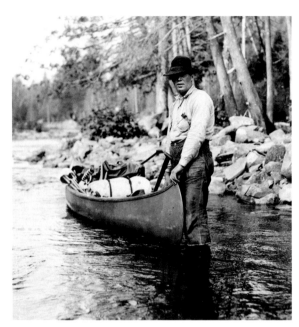

We left our camp at about eight o'clock and had an easy run across the lake to the river. There are three dams on the river, and by working our way down avoided a portage which appears upon the map as 29 chains. We had quite a bit of work with the first two dams, and the last one had been washed away. It was very like the Presque Isle in parts.

On reaching Quetico Lake we ran to an island where we had a chocolate lunch and pushed on until noontime, when we had our regular lunch in mossy woods.

The light was good and portraits were made of some of the gang.

We paddled along until four o'clock when, in turning the southeast of Eden Island we encountered a head wind, and promptly went into the place we chose Indians had once camped, and there were two canoes which had gone to pieces. Someone had started a little log hut, and stopped when the logs were only four logs up.

There is a beautiful growth of Norway and some young trees here. Doc asked Dad to photograph the latter; then Doc and Clay tried to spoil the subject by roughhousing all over the scenery.

This part of Ontario is not surveyed into townships and sections, as it is in the States, but here and there lines have been run. From these "Limit Lines," as the Rangers call them, there have been laid out "Timber Belts," and each belt has been estimated. At the corner of Eden Island, where we are camped, there is what we would call a "Government Tree" which bears this notation:—

<div align="center">

LS
L A LIMIT

</div>

Tacked to the tree is a little wooden arrow showing the direction of the Rangers' Headquarters Camp, a mile to the east.

There are some little red squirrels hereabouts which chatter and scold to Di's great annoyance. At odd moments she is worrying at a hole under a large rock on the lake shore, and trying to tell us what she thinks is in there.

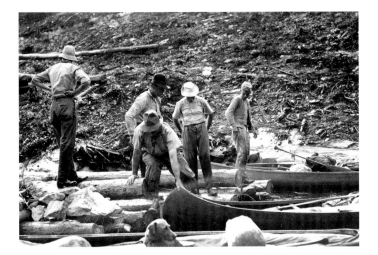

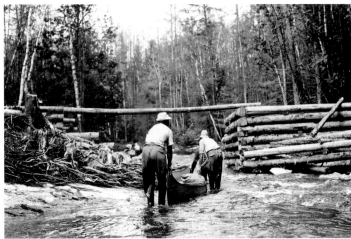

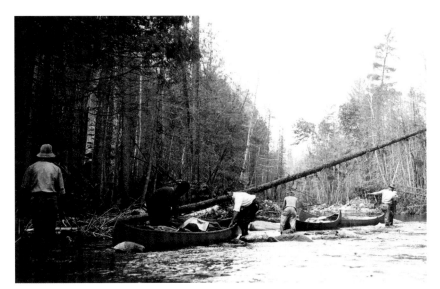

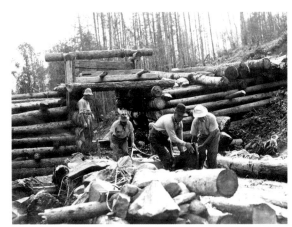

Portaging dams, Quetico River

The day broke cloudy, threatening rain, which looked bad for a start. It was decided that Dad and Bill should go to the Rangers' Camp to call on R.E. Readman, the chief, and see what he had to say about our being on the Reserve. Carl joined the visiting party.

We bucked a head wind for more than a mile, and found the camp easily. There were three tents and a cache shack. We met Cox and after a little chat with him, he asked us to see "the other lads," whom we found seated about a little fire heating water to wash their dishes. A few of them smoke and all chew. From them we learned that Mr. Readman will not be there for a day or two, and when he came he would bring a "big gun"

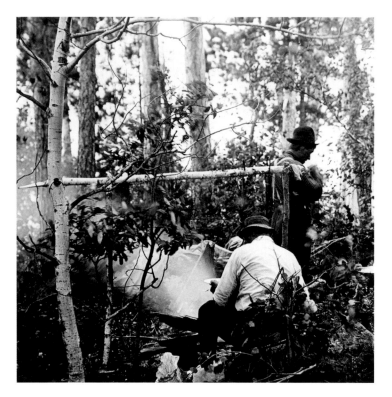

from Toronto. They tell us that the entrance to Quetico River, which is in front of our camp, has been dammed, and that the logs in the boom above the dam block the passage for a mile. The river is so low that they were obliged to open the dam to get water enough to bring their supplies up for the lumbermen. Eden Island is being cut over (estimated to contain three million feet), and the lake east of the island is boomed off and full of logs. The lumber camp is on the eastern end of the island, and is conspicuous because of a large white marquee tent.

The Rangers advise us to go out by way of Sturgeon Lake and the Maligne River. This takes us through the long eastern arm of Quetico Lake, then by a short portage into a little unnamed lake, and by another short portage to Jean Lake; then to Burnside [Burntside] Lake and to Rouge Lake, the latter not on our map. Hampshire and Cox are going out in that way and said they would start in the afternoon.

The names of the Rangers are:—

WELLINGTON MUSSELMAN,
 known as "Wallie," of Stratton, Ont.
FRED HAMPSHIRE, of Stratton, Ont.
ROBERT JOHNSON, of Stratton, Ont.
STANLEY WALL, (at one time lieutenant
 in the Royal Canadian Regiment),
 of La Valle, Ont.
ADDISON COX, of Elmo, Ont.
GEORGE WALL, of La Valle, Ont.,
 brother of Stanley Wall.

Not a word was said about fishing licenses, licensed guides, or any regulations. On our return to camp we told them how we had paid a license of five dollars each for Bill and Doc for fishing permits, which were to be mailed us from Fort Francis, and the Doc felt he had been severely imposed upon.

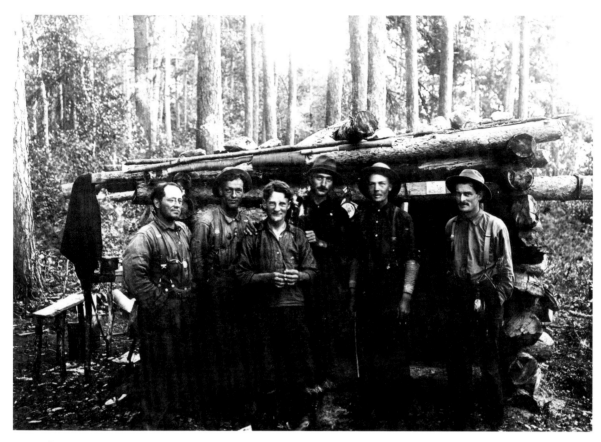

Canadian rangers camp

Upon our return we all helped Clay decide upon a profession.

After lunch, the sky being clear, we started on our journey along the south shore of Eden Island, and up the east arm of Quetico Lake. Doc, How, and Clay went directly up the lake, while Bill, Carl, Dad, and our three men made a farewell call at the Rangers' camp. We found Johnson cobbling and Stanley Wall doing some very necessary tailoring.

A picture was made of the group of Rangers about their little cache hut. We took shelter with them in a tent during a shower. Musselman gave Carl a lot of little wooden charms he had taken from a tree above an Indian grave. He says he has seen them twice—once in Eastern Ontario and once in these parts.

While traveling this afternoon we stopped to look at an abandoned camp where Indians had been making canoes. We found a lot of good birch bark and split cedar. The large tepee is about 20 feet in diameter. There was a small sledge for winter use.

We did not go to the extreme east end of Quetico Lake, but turned into a south bay about a mile and a half from the end, and made camp, setting up the tents, about six-thirty, on a low point. The passage up lake was very pleasant. The wind shifted, and the

three canoes equipped with canvas spread the sails and made good time.

Just after supper Di had an amusing encounter with a circular air pillow which fell in the water. She was afraid to tackle the monster, but from a safe distance barked and snapped at it.

A passing shower drove us to bed early. The mosquitoes were active and Doc snored so loudly that Bill and Dad got up to smoke and quiet their disturbed souls. While standing in the open in clear star light of these northern skies, brightened by aurora light, they heard the amorous call of a bull moose. Quetico Lake is the most beautifully timbered lake we have seen.

SATURDAY, AUGUST 5TH.
CAMP NO. 11—QUETICO LAKE.
CAMP NO. 12—ROUGE LAKE.

Doc was up early trying to get a fish. He had that fish license on his mind. In spite of dull skies and driving mist we started early and entered a little bay at the end of which we made a portage of six chains over a wet and

slippery trail to an unnamed lake. We crossed this and made a portage of ten chains to Jean Lake. Trappers have worked over this last portage. This is a water shed. By this time it was raining hard, and we had a strong west wind and a heavy sea. The passage through Jean Lake was sufficiently exhilarating to those who used only paddles, while those who spread sails bounded along at an exciting speed. Carl took charge of sheet and helm in his canoe, Bill playing "crew."

At noon we had rounded the point to the big bay on the south side of Jean Lake and stopped for lunch. There were tepees here, and the Indians have been fishing, for we found their floats and sinkers. They have also killed moose, for we found bones and hair.

There is an upturned tree with roots extending the height of two men. Carl posed in front of the roots on Bill's shoulders in the attitude of ascending to Heaven.

After crossing the bay of Jean Lake we had some difficulty in locating the portage to Burntside Lake, as the woods were burned through here last year. We found a little creek leading into a reedy lake and from this pond

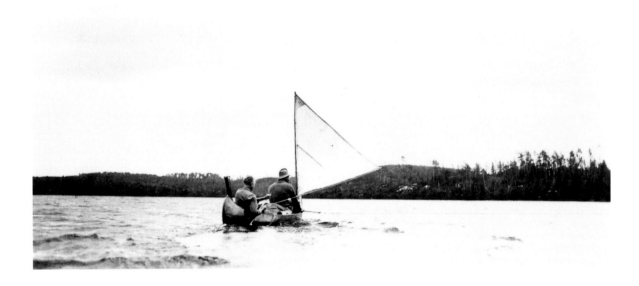

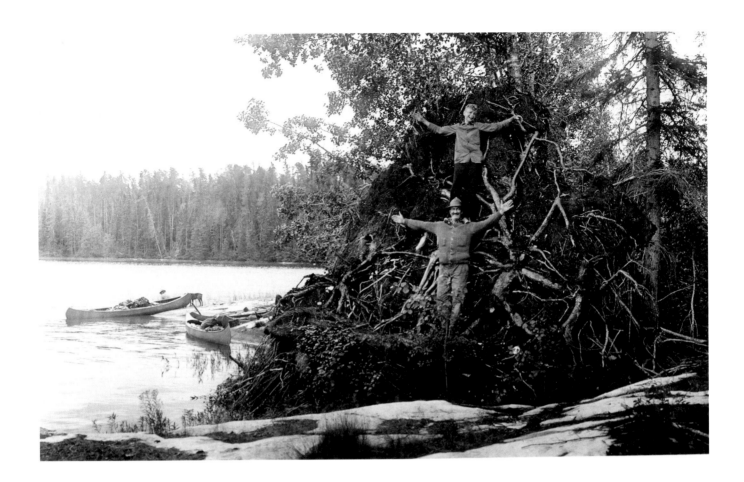

we made a portage into Burntside Lake. While crossing the pond we disturbed a family of ducks, which promptly dived and swam under the water to escape. Their sense of direction was not in working order, for when they came to the surface they found themselves in the center of the canoe squad. Then what a scramble and scatteration!

This was not quite in accordance with our maps, but we believed we were then in the west arm of Burntside Lake, and made a run for where the map showed a channel to the main part of the lake. We soon found ourselves pocketed and laid up on an island and looked over an abandoned Indian camp, while Bill and Carl explored. They were gone a long time and we moved over to another corner of the same island where the long boats lay to, and examined the refuse left by Indians who had smoked moose and fish. We found two leaden slugs, possibly musket balls or shot gun slugs, beaten with a hammer. Bill and Carl now returned and reported many things not on the map, and we decided to return to the place we started, and to explore the bay. There we found the open channel and had clear paddling through the lake, then through a channel to Rouge Lake.

At the end of Rouge Lake we stopped short looking for a channel or a portage. We found an old trail, but it was dis-used and swampy. Bill and Carl left to locate a waterfall we had heard near the entrance to the lake, and in the meantime Davie returned saying there must be another trail, part of which he had seen, which was

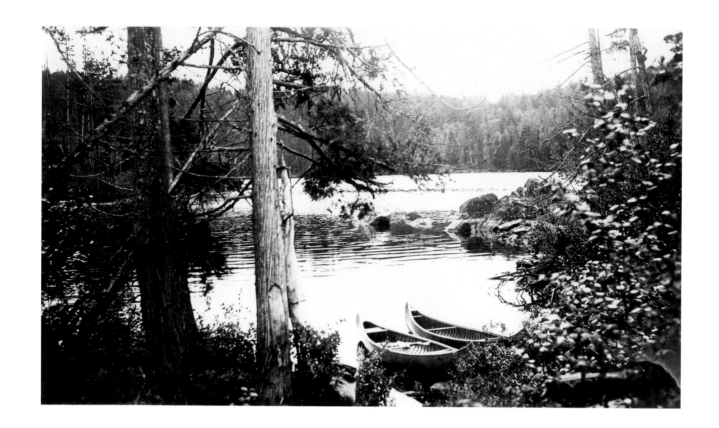

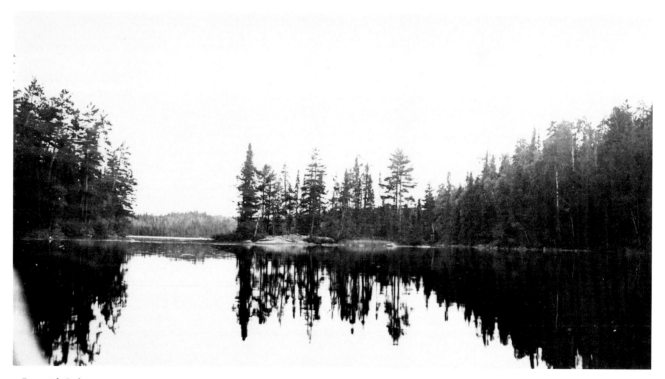

Burntside Lake

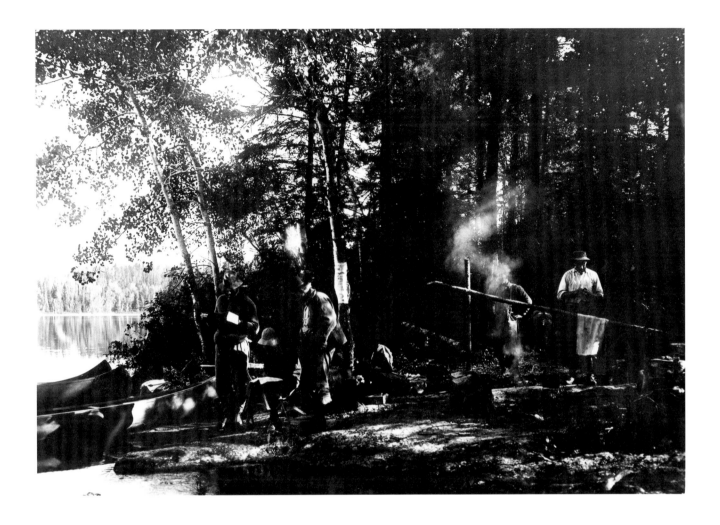

well worn, to the west of the one we had given up. Dad and Fred started to work this trail out, and found a sluggish stream, at the end a trail about half a mile long to Sturgeon Lake. The grub boat had followed them, and for a time the party was divided and hungry. They finally re-united at the waterfall, where there was a well worn trail and the usual Ranger's Fire Notice nailed to a tree. We had supper. The men bivouaced at the fall; the rest of the party crossed to a high rocky point where they bivouaced about nine o'clock with mosquito accompaniment.

Everywhere we have been today moose signs abound, but we have seen no moose. This part of the country is not mapped with accuracy, and the maps do not show all the water courses that actually exist. So if the beaten trail is lost one is apt to have difficulty working out. This may be seen by reference to the map, which shows a blank space north of the Maligne River.

SUNDAY, AUGUST 6TH.
CAMP NO. 12—ROUGE LAKE.
CAMP NO. 13—STURGEON LAKE.

As soon as breakfast was over, Cope and How started over the trail with an empty canoe, and worked their way to Sturgeon Lake, returning by the trail which Dad and Fred found yesterday. They reported the former, or falls trail, the easiest. The brook is rapid and stoney with rapids where we camped.

We started immediately. There is a short portage to a pond, and another short one to the stream where we loaded our canoes and worked them down stream, clearing our way as we went, digging channels and building wing dams so we could float our canoes. Just before entering Sturgeon Lake we crossed a wild rice swamp where we found some young ducks. We landed on a nice sandy beach, took a swim, and had lunch. Howie found a cedar "shake" on the beach bearing a pencil inscription in Indian. [See transcription at end of this journal.]

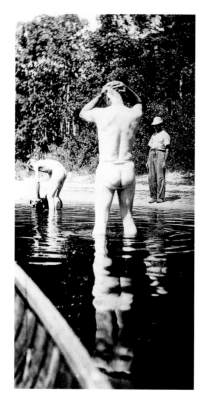

Here the party divided, Bill and Dad to look for an abandoned Hudson Bay Post on an island up lake, the others to go into camp as near the Maligne River outlet as possible.

MAC LAREN'S HUDSON BAY POST.

We knew, for Billy had told us, that one of his relatives had once run a H.B. Co. trading post, and we wanted to discover if we could, whether the Mac Laren who ran this post on Sturgeon Lake was one of the Billy Mac Laren Mac Laren's or not.

From the Rangers on Eden Island we heard that Mac Laren was now at Port Arthur; that he had a half breed son who, although comfortably kept and supported, made a practice of tapping the till until the old man fixed him by getting the son to marry a squaw who disciplined him ever after.

The Rangers told us that the Post was on the west end of the long island in the center of the lake.

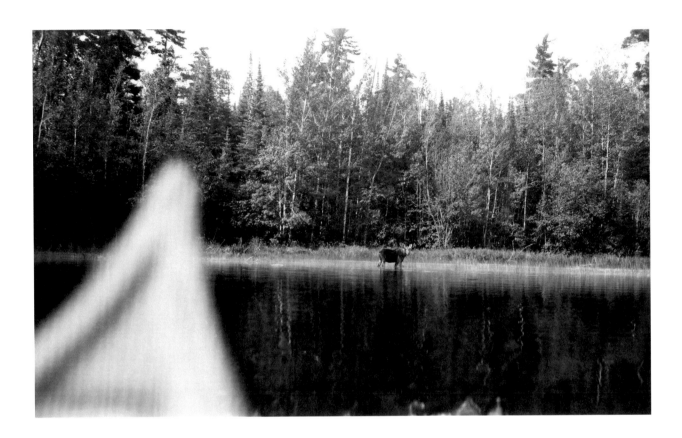

We left our party at noon. The lake was almost without a ripple, and the reflection of the rocks and trees in the water gave us the sensation of being suspended in mid air. We paddled along about six miles stopping occasionally to investigate old tepees, or to smoke, or to "just stop for awhile." At one tepee we found an old sled which we carried with us. At another place we found a spider web stretched along the shore from bush to rock to bush, one hundred and ten feet long, measured by paddle.

We traveled from point to point on the north side of the lake, and with our maps readily located the island indicated by the Rangers. Some timber cutting had been done long ago, and the place was covered with a dense undergrowth through which we struggled looking for some sign of habitation. We could find nothing, and so we paddled slowly along the southerly shore of the island, turning into all the bays looking for some break in the wilderness. It was in this way we met

BILL MEESE.

Turning a point to a little bay Dad saw a big bull moose standing in the water and quietly feeding. Dad's bristles stood up and he made Indian signs to Bill, who then had a noiseless fit in the rear of the canoe. Dad pulled out his hand camera and Bill paddled softly ahead while Bill Meese had his head under water, stopping pad-

dling when the head was raised. One shot was taken and still Bill Meese stood still and put his head down to feed. Again Bill moved the canoe forward and again the camera snapped. We were breathless; the camera seemed to make as much noise as a coffee mill when the film was wound up, and still the canoe glided forward. When we were about a hundred feet away Bill Meese became fully aware of our presence. He took a step forward, turned his big head, sniffed the air, lowered his head and turned for a good look—"Looking over his spectacles." The camera clicked; his attitude said he wasn't afraid of us, but did not like our picture, so he turned and quietly walked into the woods, beginning to trot just as he disappeared. He was a royal big fellow. We set up the Gattling camera, and cautiously turned all the other corners on that island, but saw no more moose.

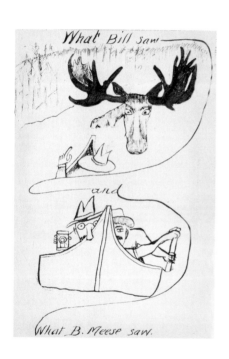

We circumnavigated the island and examined our maps. West of the big island, across a channel two hundred feet wide, lay another small island; it occurred to Dad that at some stages of water this channel might disappear and the two islands become one; and we decided to explore this westerly island. We pushed along the south shore. We checked up to take a picture of some wild rice, and as we paused Bill saw through the trees the old house we had sought so long.

MAC LAREN'S STORE HOUSE.

The trail led directly from the sandy shore where the wild rice grew to the old store, which is rapidly falling into decay. We moved fast, because the light was failing, and we wanted to photograph our finds. The interior of the store still contains the old counter, now much chewed by porcupines, and the old shelves and the scales are still there. Bill found a small axe and a saw, which with a scale weight, will be taken home to Billy Mac as Mac Laren family heirlooms. So much would indicate merely a Mac Laren as a shopkeeper, but nothing to indicate the real, true, and only Mac Laren family. In front of the counter two short length boards had been loosely laid as a part of the floor, and underneath those boards a little private cellar had been dug, and in the cellar was a jug. At last we had located the beginnings of a branch of the real family, for by their drink shall they be known.

We followed an old well worn path from the store until it was lost in a tangled growth of wild rose and raspberries. We worked through to a bare rock near the point, and then we saw another house,—this was Mac Laren's dwelling. About it we found tame mint running wild, and in the house was a nursing bottle. Evidently the children were brought up on mint julep in season. The house has a storm house built of cedar shakes. From the point of land at the house we had a magnificent sunset view down the lake.

About the Post were a lot of old square tin cans in which tobacco, tea, and probably oil had been transported.

Several old birch-bark canoes were disintegrating on the sandy beach, a reminder of the days when the Indians traded here.

The Rangers had told us that there were some Indian graves and we found them without difficulty. One

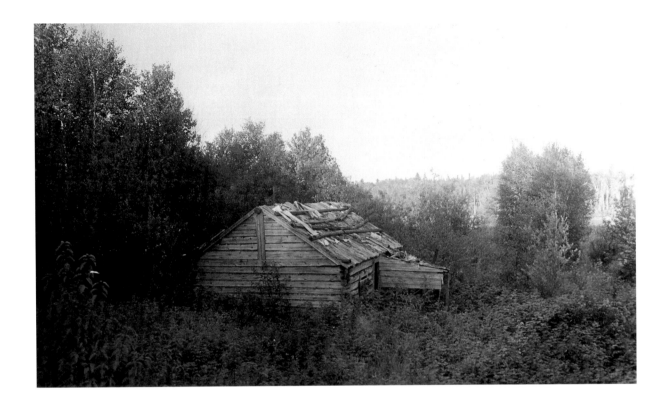

evidently contained the mortal remains of a squaw.[6] There were two old graves and a more recent one, covered by a well made kennel now falling into decay. Through a hole we could see that it contained a birch-bark casket neatly sewn, supported on a frame of small logs. We carefully raised the house, and found that birch bark was really a cover to a well made box, which at one time had been covered with canvas. It was a narrow box not wide enough to contain an adult's body, and from the lavish attention shown and the Indian fashion

[6] Along with the use of derogatory terms common to the time such as *squaw* and *half-breed*, the group examined Native sites at times in a disrespectful fashion.

We awoke in a drizzly rain which, with an east wind, looks badly for our getting an early start down the Maligne River. We had planned to stay here today to let Billy bake bread; but these rains will stop the baking and oblige us to be here part of tomorrow.

After breakfast Carl and Dad went up to the lake to get the canoe used in the Mac Laren expedition of yesterday. At the end of the lake the Dawson Trail appears in the form of a sunken steamer with boiler and engines complete except for the brasswork. The trail runs across a neck of land, and then probably entirely around the rapids.

There is an extensive dam at our camp. It is of logs in usual construction, but all fastened together with two inch square wooden pins. It is nearly in ruins now.

At one point on the trail there are three frames made of saplings, like we saw on the St. Croix, and which we

of burial, we conjecture it might have contained the remains of Mac Laren's half breed children.

It was now seven o'clock—the light was failing and we could not look for Mac Laren signs, so we packed our photographic outfit and started for camp.

It was a long way back. Before leaving the main party we arranged for them to build a beacon fire near their camp. We paddled steadily seeing nothing but the stars in sky and water and the black bulk of shore on our left. We kept our direction by compass and stars until the moon came up. About two miles from camp we heard the roar of the rapids and about a mile away from camp we saw the beacon fire which had been lighted for us.

Fred and Carl met us at the fire on the river shore, and gave us a new and peculiar sensation by putting us in the bottom of their big canoe and shooting down the river through rapids unknown to us, to camp. We then climbed and climbed and slipped and climbed to an aerial camp which everyone blamed on Doc.

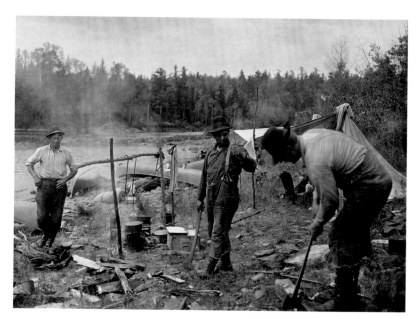

Baking bread

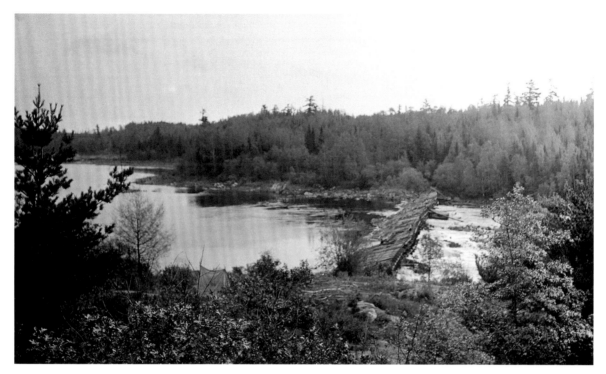

Bridge and dam, Old Dawson Trail

then thought to be graves. We do not know what they really are,—possibly for drying fish or berries.

The day was idly spent. Doc created a diversion early in the morning with an operatic effort intended to wake the sleeping gang. The effort was primitive but successful. It was too cold to be out of doors without stirring about, and everything is so wet that a walk is worse than a bath.

Carl undertook to play poker with the Doc and show the old gentleman how things were done in Asheville. Doc taught him a new game, won everything, and left Carl with a feeling that he had been done. Carl said: "I believe all he does nights is to sit up and play cards with Old Side Whiskers at the Club."[7]

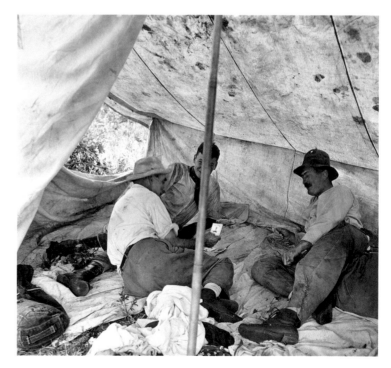

[7] Doc Copeland, a bachelor, lived in rooms at the University Club in Milwaukee, a common arrangement for wealthy unmarried or widowed men at that time. There were a number of other men living there, "Old Side Whiskers" probably being one.

Dad wrote up journal from notes made while we travelled. Doc caught three pickerel. The brutes were a disturbing element all day except when Doc had them analyzing flowers. The men moved the cook tent and boats below the dam.

Bill read geology of the region. Bill has studied rocks and gives them hard names. We find that the formation has changed, and where we formerly rolled over boulders and smooth granite, the rock is now of a greenish brown color. It breaks into thin layers generally turned on edge and worn sharp; where not turned upright, it slants at such an angle as to cut your boots both coming and going; where it is broken out and lies flat the pieces are always out of balance and tip. The only real variation is an occasional boulder covered with lichens, which today are slippery.

TUESDAY, AUGUST 8TH.
CAMP NO. 13—STURGEON LAKE.
CAMP NO. 14—MALIGNE RIVER.

Today is bright and will be warm. We had a very comfortable night and slept well. After breakfast Doc, Bill, and Dad shaved. Doc started it. He is sprucing up to meet the squaws at the settlements on the Indian Reservation at the end of the river. Billy is baking, and we shall be here until after lunch.

Our flour is running low and How reminds us that white sugar is going faster than brown.

Doc, Bill, and How played solitaire this morning to kill time.

Cope rigged a fish net for Carl who has been seining for minnows and such.

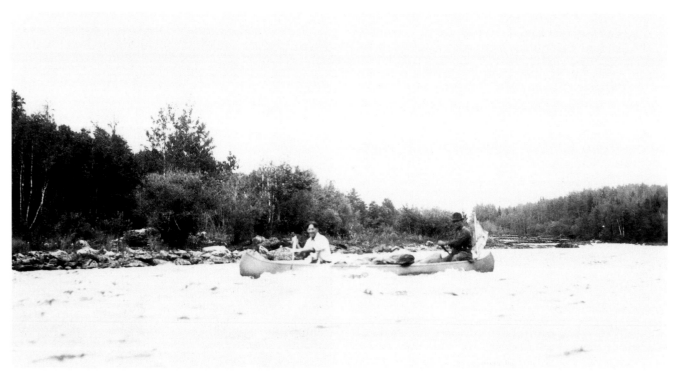

Canoeing at Tanner Lake

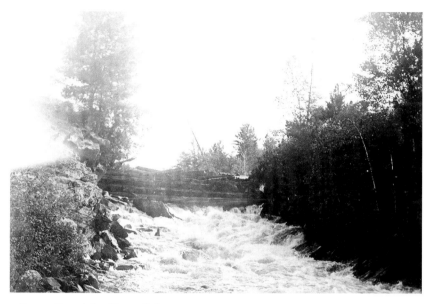
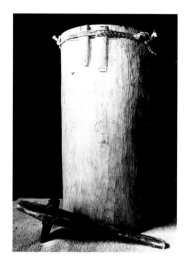

Dawson Dam, below Tanner Lake

After dinner we waited for Billy to finish baking and then started.

In the first rapid, which is less than a quarter of a mile from camp, Fred snapped his paddle, but another was right at hand so the canoe went through all right. Doc partly filled with water and had to stop and dump. The river is good for canoes. The rapids are small. Two portages we made over an island,—just lifts of a few feet. Here Di gave us some excitement by running the rapids on her own account in trying to get from the mainland to the island.

The river widens and is called Tanner Lake. We were threatened with thunderstorms, but they passed to the north and west of us, though for two hours we could hear the thunder, and we lost no time for we wanted to get supper and in camp before the rain commenced.

Below Tanner Lake there is a little current, and then we entered dead water above an old Dawson Dam. We made camp at the dam at seven o'clock, and at seven-thirty supper was cooked. At eight the rain began to fall.

We are on a little island. The water course on each side is dammed, but the dam, being old and rotten, the water runs through, making two beautiful cascades.

Doc prospected around and found a cedar tom tom frame which some Indian had made and hidden for future use. It is now traveling with us.[8]

Mosquitoes are in evidence. They are not singers; they merely bite and come again.

We saw leaves turning on Jean Lake, and every day since have seen colored branches. At Sturgeon Lake Cope brought in a maple all red.

"If Judson is blue, can Carl Greene?"

[8] An example of the Gang no longer just looking at, or not disturbing, Indian artifacts as they had in prior trips. During the Dawson Trail trip something regrettably shifted in their comfort level with Indian artifacts.

WEDNESDAY, AUGUST 9TH.

CAMP NO. 14—MALIGNE RIVER.

CAMP NO. 15—AT SECOND PORTAGE
ON NAMAKON RIVER.

After the shower we had a nice cold night. Carl caught three pickerel, and as soon as the sun was high enough to light the gorges, pictures were made of the two cascades.

We made good progress down the Maligne River, and at nine o'clock we had come to Lac LaCroix. We stopped to rest and check up. Carl and Clay started an interesting game of one locating the other with a cleaning rod, the fellow standing for the slashing defending himself with a paddle.

On the river there has been quite a camp of Indians, this being the eastern end of "Reserve D;"[9] but the tepees are all deserted. We found an old birch canoe under which had been cached a lot of birch bark in rolls for covering tepees. Bill and Carl investigated one deserted camp; they found an old axe, some fish hung up to dry and then abandoned, when they were arrested by a very uncanny groan from the bushes. As the rest of the canoes had gone ahead out of sight, Bill and Carl annexed the axe and departed. They did not want any Indian Ghost groans for their collection.

At half past eleven we made the point of the big bay which the Maligne River enters, and at twelve made lunch camp on a point a mile along the lake. The wind is fairly strong, and we may be obliged to work along

from point to point or even to wait until late afternoon, because the waves are piling up from the full expanse of open lake.

After lunch we started on a directly west course with the noses of our canoes poked straight into the wind and waves, and before we realized we had travelled so far we came to the point where we made bivouac in a Norway grove on an island last year. We went up on the bluff and recalled the incidents of our last visit; how Heine had left the Doc's reel at our noon camp and had bribed his brother brutes to go back and get it; of the drink Billy Mac had mixed, and of the picture of the five brutes in "Love is a Little Flower."

"NO, BUT A TOMATO CAN."

After leaving our old camp we paddled rapidly to the Indian Village at the entrance to the Namakan, which we visited last year. As we came up to the beach we saw some children, and finally we found an old squaw making fish nets, and with her, three little children.[10] As we approached, she made signs to us to go away. We asked for John Otter and she told us in the same way that he was gone. Then we handed her one of the photographs made at the village last year, and she had a long crooning talk with the youngsters; their voices are very soft and pleasing. She stretched her hand out for another picture, and then another and another, and she stopped her work from time to time to stir the smoldering fire.

When she came to the picture of John Otter and his family, she pointed to the young squaw (John's

[9] "Reserve D" could apply to a part of the Quetico Forest Reserve, established in 1909, or to a reserve of the Lac La Croix First Nation. The creation of the Quetico Forest Reserve created a conflict with the Lac La Croix First Nation, who had a reserve located within the park. In 1915, the province canceled the band's right to the reserve and relocated the people on the reserve.

[10] In this entry, the group returned to the same village where they had met John Otter in 1910. During this stay, they shared photos of their previous trip to the village. In the journal describing their interactions, terms such *squaw* and *buck* were used.

daughter-in-law), and said, "Gowan is see," crossing her arms across her breast and rocking to and fro as she sat upon the ground. To make her meaning clearer she pointed to a fresh grave near by and beating her hand on the ground, repeating, "Gowan is see". Minowa's grave is adorned with usual feather, beads and firewood and fresh feathers.

We felt we had made our way, and that the camera might now be produced; but at sight of the instrument there was trouble in plenty. She ran to a cabin gathering the children and made signs that we must go away. Carl tempted her with a half dollar, and she emerged to scold. Bill and Dad went a short distance from the cabin to reassure her. Carl peeked around the cabin corner to see if the squaw was coming out, and the squaw peeked in Carl's face trying to see if we had gone.

Dad offered some tobacco through ambassador Carl, and the old story of Eden was confirmed. The squaw came out and accepted the tobacco, and went to her net to look for her pipe. In the meantime we had taken pictures of the drying berries and of a wigwam about which was stored a quantity of birch bark and some untanned moose skins; the camera was left aimed at the place where she had been sitting at her work of net making. As she got her matches and pipe, the camera clicked, and there was a scene. She took a stick to Dad, who retreated with his camera while she and her brood sought refuge on the lake shore, evidently intending to cross the river in a canoe. We reassured them and ostentatiously retreated to our canoes and started off, leaving them returning to their cabin. As we went down the river the children exchanged good-bye signals with us.

While we were at the village we asked for bead work, but the squaw had none. The Rangers told Carl that some Duluth people had been there and bought everything, and had paid eighty dollars for a caribou robe.

THE NAMAKAN RIVER.
—(Extract from Ontario Geological Report.)

"This river is very rapid and turbulent. It is unsafe for the traveler without a guide who is thoroughly conversant with its many treacherous rapids and falls; and it is extremely laborious to force a canoe against its strong current."

Last year MacDonald advised us not to take the river because we were too heavily loaded. John Otter gave us the same advice after a glance at the tub. Our Ranger friends this year told us that we could go through all right, and that we could even save the long Hay Portage at the present low stage of water by roping through.

These were our letters introductory to the Namakan River.

Just after we left the Indian Village we ran a little riffle, and a little later a small rapid; and hearing a larger rapid ahead of us, we ran to the right bank and made a short portage. There is a small fall here too great to venture in canoes.

The river divides, and we took the Right Branch—the longer course—and after about six miles of paddling we came to a fall with a well marked portage to the left. We portaged our stuff and made a bivouac camp. On the way down we passed two Indians in a canoe. We said "B'jou" once, by way of greeting. The front Indian gave us a lesson in Indian etiquette by saying "B'jou" twice for two of us. We later passed an Indian and a squaw in a canoe and said "B'jou" twice by way of greeting. The Indian replied saying "B'jou" once; the squaw evidently was not entitled to a greeting when "Buck" was along.

Doc and Bill had a little sport catching wall eyed pike below the falls. Dave crossed a branch of the river in a canoe for some firewood, just before supper time. He cut up a dead pine and laid a chunk a foot thick and ten feet long on the canoe thwarts and stepped in the canoe. The canoe wobbled in surprise at this unusual

top heavy load and then quickly rolled over, dumping Dave and the log in three feet of water. Carl was on the shore within ten feet of Dave, laughing so hard he could not move to help him.

We decided to travel more leisurely from now on because we have time. Our only reason for moving is that we are getting a little short of flour. We have enough left for a small baking, and we can undoubtedly buy more at Kettle Falls.

THURSDAY, AUGUST 10TH.
CAMP NO. 15—SECOND NAMAKAN PORTAGE.
CAMP NO. 16—THIRD NAMAKAN PORTAGE.

We had a beautiful night. There were a few mosquitoes, and they did not sing, but attended strictly to business.

We idled about and made pictures. Then we started on our way leisurely down stream. At the point where the outlet from Wolseley Lake comes in and the bayou towards Lake La Croix opens, we steered by compass and kept the course all right. At a sand bar where we stopped to look about, Dad saw some gigantic deer tracks, and estimated the size of the beast which made them. That estimate was "some deer." Then we discovered that Doc had made the tracks with the grip of his

paddle. Bill found some old caches in the woods containing birch bark with inscriptions, and an old sled on the beach. We made a picture of a big Norway that had fallen and was propped up by another pine it had partly crushed in the fall.

During intervals the brutes threw mud at each other with their paddles to avoid ennui.

Where we stopped for lunch on a little island Bill found a cache, evidently forgotten by its owner, for it was in a neglected and weather-beaten condition. The owner was undoubtedly a Medicine Man. There were several bags containing powders and slips of paper bearing Indian inscriptions in English script, evidently directions for using the contents of the bag.

A green velvet skull cap with wildcat-fur band.
An instrument for scraping hair from hide.
A little wooden duck.
Two bone charms.
Two horse hair braids.
Two china dish covers.

How found an Indian basket in the woods.

At four o'clock we came to some magnificent falls. An island divides these falls; the portage is easy, and we are making our bivouac camp at the lower end on a big flat rock.

These falls are very beautiful, and it is well worth a long trip to see them.

We are now about two-thirds of the way down the Namakan, and we are still looking for the dangers described in the Geological Report.

Our kitchen is located under a rocky cliff. Just above the kitchen is a good sized white pine tree. A semi-circular cut has been made in the bark, and at the lower end is a spout and an old tin can for gathering the pitch.

Di has evidently been deprived of her share of grub by the other brutes, for she devoured an old moccasin she found on top of the cliff. She is now looking rather sorry she ate it.

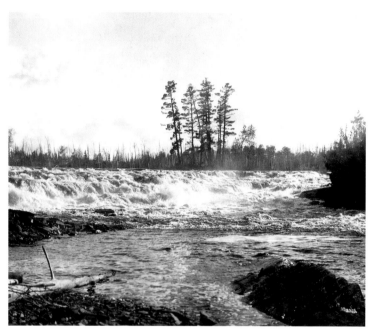

Namakan River

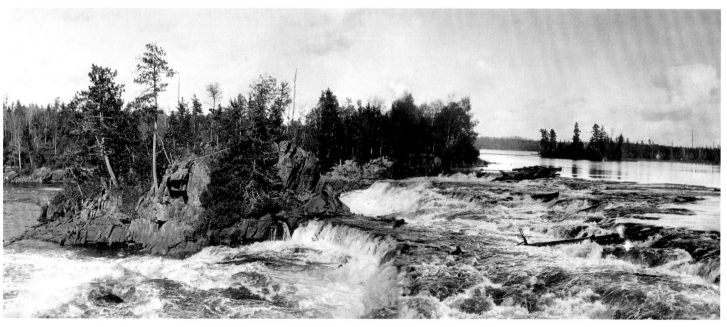

Namakan River

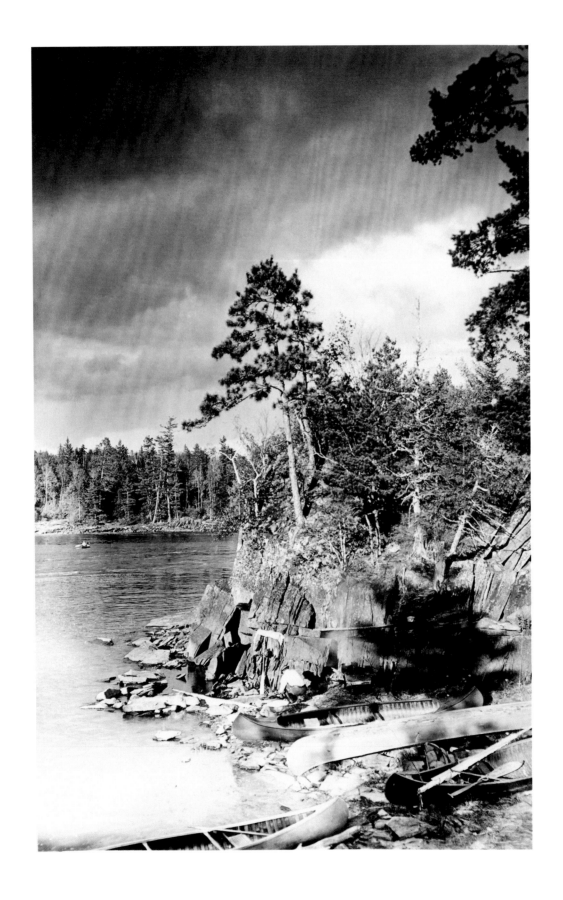

FRIDAY, AUGUST 11TH.

CAMP NO. 16—3D NAMAKAN PORTAGE.

CAMP NO. 17—ISLAND, NAMAKAN LAKE.

We had a beautiful clear, cold night. Two incidents marked the opening of the day, after we lazily lay in our blankets and watched some birds which Doc and Clay were trying to identify.

INCIDENT No. 1.—(This is really an event.) DAD WAS FIRST MAN UP.

INCIDENT No. 2.—Bill, in the interest of the whole camp, broke his bottle of punkey dope over his bed roll.

We all dried out our bedding on the big rock in the sunshine. It has been damp for several days, which has been the cause of several intimations made at bed time that someone was pretty smelly.

Today Dad traveled with B.M. with the Gatling camera set for moose. Bill paddled quietly into all out-of-the-way bays and inlets; once they heard a crashing but saw no moose.

At about eleven o'clock we came to the rapids at Hay Portage.

Dad and Bill went over the trail. The first part, the upper end, is good walking; the lower end passes through marshy land that in high water is overflowed and must be bad traveling under a heavy load. They returned to camp by walking along the river bank and studying the river. They saw they could easily run or lead through all the rapids. The first one is the only one where there is enough fall to be picturesque; and its perfect apron of smooth water is somewhat unusual.

We had a chocolate lunch a little after eleven; then worked through the rapids without mishap and ran on to the last portage where we stopped for lunch. On the north bank there is a house and barn, evidently a Indian's habitation; and we can see the frame work of what appears to be a council house.

This portage looks harmless enough, and Fred, after going along the north bank, tells us that except at one point we can run it all right.

We followed his directions and made our run close to shore, and everyone took in water so freely we had to stop to bail out. Doc in particular arrived with Clay carefully centered in the canoe holding his breath to be buoyant, Di looking as if Doc had swatted her with his paddle, and all three sitting deep in water and hoping they could get to shore before the canoe sank.

As soon as we reached smooth water Bill, Dad, and the camera again took the lead looking for Bill Meese. They made a picture of duck leaving the water just ahead of the canoe. Too far ahead for results, the picture showed.

Drying bedding at camp

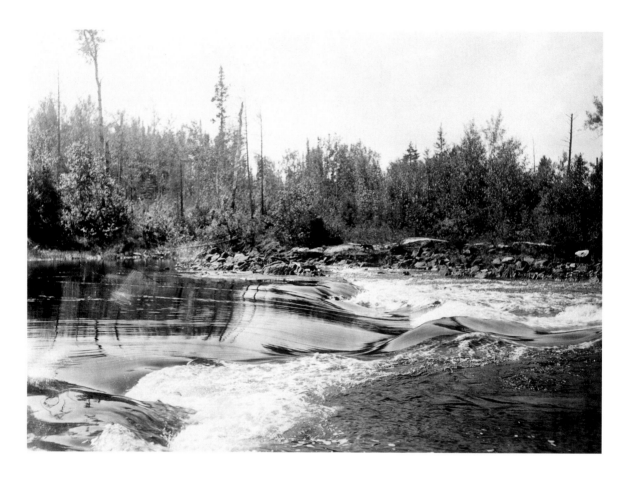

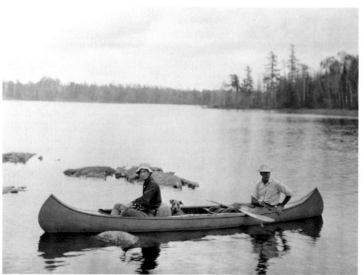

Clay, Di, and Doc

This ends the passage of the terrible Namakan. In our six years' experience we have never found a place as bad as it was pictured to us by the natives who knew it all. Even the Presque Isle River was handed out to us as impassable, and the one man who had seen it and knew it said it was an ideal place for a vacation trip.

At the outlet of the river into Namakan Lake we found a large cleared space and some old tepees, so Bill and Dad stopped to investigate; and soon How came up. Here we found the frame of an old dance hall or council house fifty feet long and fifteen feet wide. It was built in Wickiup form. At one end and in the middle are high poles, apparently for flags. Inside at each end and about three feet from the doorways, which are at

the ends, is a stake about two feet high. Although the place had not been used for fully two years, the pathway around the interior was not grown up.

Beside one of the tepees Bill found a mound of earth, about four feet in diameter and a foot and a half high. Investigating this, he found a rim of hard baked clay, which proved to be bowl shaped and full of charcoal and partly burned wood. Below the bowl was the natural earth, and the whole thing was grown over with turf.

We were looking for graves, and when How came he found two near where he pulled up his canoe. There is a fence which encloses an old grave which bears the decoration of an empty whiskey bottle. The other is newer and better made. The kennel is covered with oilcloth neatly cleated on with small cedar strips. The ends of the kennel are of birch bark, and at one end the usual hole. Over the kennel is a frame covered with birch bark from an old canoe. On this shelter was an old fashioned smooth-bore and an axe. Some recent visitor left a spray of brightly colored sumac leaves. Each grave was marked with a pole in the end of which was set a long feather. The pole at the newer grave was decorated with pink ribbons now much faded. Peeking through the hole in the kennel of the newer grave How saw some bones like Bill found in the medicine man's cache; and when Bill came up he hooked a string of bones with a stick, thereby disclosing more bones which Dad hooked out. This was a string of bones. Bill lighted up the inside with a match and pulled out two rings, a cloth partridge totem, two brass bracelets, and a copper disc cut like a cross cut saw at the edge. We burned matches and peeked, but could find nothing more. The rings were stamped inside with the initials.[11]

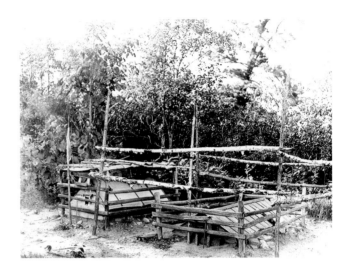

[11] Here again we see an unfortunate shift in how the group at times interacted with Native culture—in this instance, their willingness to disturb and remove items from a grave site.

The rest of the party now came up and we paddled out of the bay into the main lake, and made a bivouac camp in a grove of white pine on an island of distinctive mica schist. Another island, only about a hundred yards away, is of pure quartzite granite. The boys had a swim with Ivory before supper.

SATURDAY, AUGUST 12TH.
CAMP NO. 17—NAMAKAN LAKE.
CAMP NO. 18—SOLDIERS' PORTAGE.

We had a beautiful clear cold night with a full moon. After breakfast we packed our stuff. Dad wrote Journal and darned his socks which, with his boot, had been cut by a sharp rock in the rapids yesterday. The day started in without a breeze, but at seven a hard south wind had sprung up which, for a time, threatened to hold us on the little island.

At ten o'clock we started and ran together to the point of another island where B.M. and Dad left the party to make some explorations of their own.

Then ran to the north shore where they had seen a log house, and found a good sized house built right on the shore, in fact projecting into the lake without a floor, so there was about a foot of water where the floor ought to be. It had two opposite doors, one on the lake side and one on the shore side. The roof had fallen in. Near the house was the remains of some baled hay, and all around was timothy and tame grasses. They followed an old work road a mile back into the woods and found where moose had cropped at the grass and had made their beds. They ran across some partridges who were less surprised than they. The house on the shore was probably a camp where men and teams spent the night when lumbering. On the work road was seen an old "travois."

At one o'clock the party came to a rendezvous a few miles further along the north shore, where they had lunch. The boys had picked a lot of choke berries which Billy stewed up, and they were very good.

The wind was strong and had full sweep across the lake. We were windbound, and did many things and nothing, to pass the time. Bill, Dad, and Clay deciphered the legend on the cedar strip picked up last Sunday.

Clay thinks he is suffering from knee skinnitis complicated with housemaid's inertia, developed at French Creek where he was chased by hornets and fell off the dam; Doc made a careful examination today.

Doc and How put on swimming clothes and sailed out to try to tip over in the big waves. Di located them by scent when they were a mile off shore. How blames Doc, and Doc says it merely shows that the dog has a keen scent.

We lay windbound until nearly five o'clock; then the waves lengthened out into big swells that our canoes could climb without shipping water; and the wind swung into the southwest so we could quarter into it on our way westward. Doc had the lowest canoe, and when he said he could travel we all started. We expected to move on to the next point for a better camping site, but that did not look good and we went on to the next point, and on, and on. And as the wind abated we kept on our course until we made camp at seven-thirty on an island opposite Soldiers Portage to Rainy Lake.

Bill, Dad, and the Brutes went swimming off the rocks. Our bivouac camp is on a level bit of ground in a bit of Norway pine. The entire island has been burned over recently.

We stopped at a little island near here and found an abundance of choke cherries.

After the swim Clay put all his clothes on hind side before for convenience in darning the hole in the seat of his pants. In some ways he found the change inconvenient.

> Oh where, oh where, are my sho-o-oes gone?
> Oh where, oh where, can they be?
> With their tongues cut short and their laces gone,
> Oh where ____ * ____?
> ouch—
> DON'T throw the other one.
> (Carl's song.)

AUGUST 13TH.
CAMP NO. 18—NEAR SOLDIERS PORTAGE.
CAMP NO. 19—RAINY LAKE, ON BASS ISLAND.

We had a warm night but reasonably clear from mosquitoes. In the morning Fred told Dad that Billy would have to bake some corn bread, and for that reason the starting hour was put over and the time utilized by the Doc in botanizing; by Dad in changing plates. As it turned out the flour was all gone and we shall have to depend on what we can buy at Kettle Falls. We left our camp at nine o'clock and at half past had finished the first one of the two portages at Soldiers Portage. At the second portage the camera was set up and pictures were made of everyone as they passed with their packs. At the lower end of the second portage we met an Indian buck and squaw who came up the lake.[12]

[12] On earlier trips the Gang had been more responsive to Native Americans' wishes but failed to be so here. They also continued to use terms such as *squaw* and *buck*.

They would not allow us to make pictures of them, though surreptitiously some snap shots were made with a hand camera. Carl presented them with an old pipe of Bill's which greatly delighted the buck, and thereafter they were less shy of us.

As Carl and Cope came over the trail and found the Indians, Carl asked, "Doc, have you got a biscuit?"

After reaching Rainy Lake we stopped at the site of our Camp No. 13, of 1910, and crossed the channel to see whether some caches of canoe material were still there. We found the tepee back of our old camp, and the tepees and caches on the other side were practically intact. It almost seems as if these people went to a large amount of work in getting material and then forgot about it. We reached Kettle Falls at about noon time and were surprised to find that the town had been increased by the addition of a rough board shack which is being run by G. Swenson. Here we bought

<div align="center">

3 cans condensed milk.

1 ham.

5 lbs. flour.

10 loaves bread.

1 peck potatoes.

Fresh sturgeon.

Fresh fruit.

</div>

While we were there an old Indian and boy brought in a lot of blue berries. The Indian, whom they called "Old Bill," is said to be seventy-nine years of age. He has a strong and interesting face. They told us here that they paid for fish as follows:—

<div align="center">

Sturgeon, 13 cts.

Whitefish, 3 cts.

Pickerel, 1¾ cts.

</div>

Dad made some pictures of Old Indian Bill, which were made more interesting by the efforts of the hotel

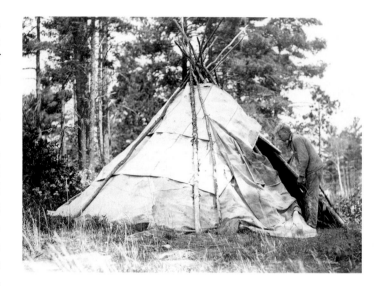

keeper, Ed. Douglas, to have his picture taken with Bill, and Dad's maneuvers to keep him out.

As soon as our supplies were purchased we started the men down the lake, telling them to stop at the site of our last year's Camp No. 14, and prepare dinner for us.

At Kettle Falls we saw a folding canvas "Tub," like Bill's "Ivory;" evidently abandoned by some poor fellow who worked his way in it this far, and no farther.

We reached the place about half after two and found that the Indians had moved their sturgeon pen from the main shore to the landing at old Camp No. 14.

The cache that we found on this island last year has been entirely removed.

The wind has been from the west all day and a whole village of Indians have taken advantage of the opportunity to come down the lake from Fort Frances. There were fifteen canoes in all, and there were probably between fifty and sixty persons altogether who stopped at the opposite point for lunch. We never heard Indians so talkative. They seemed to take great pleasure in sousing

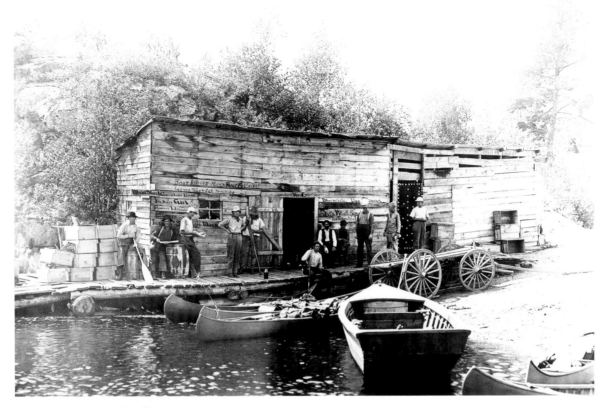

G. Swenson's store, Kettle Falls

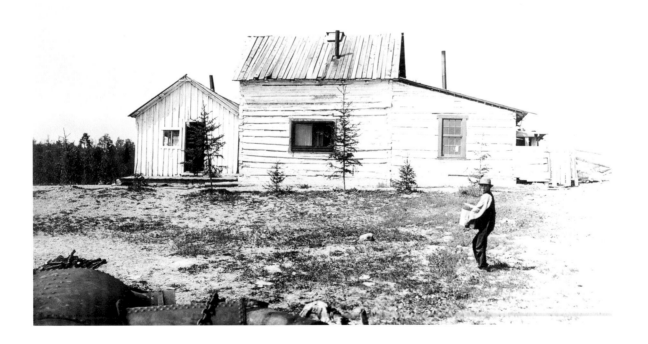

their dogs in water, and it was not until they left that we understood why this was done. Their canoes were so crowded that they left the dogs ashore and let them follow on. The dogs came in tired and exhausted, and were thrown into the water to refresh them.

We left camp at half past four and paddled along steadily holding a course outside of the islands until six o'clock, when we stopped for a smoke and a rest, and then we paddled slowly along until about eight, when we ran to the same point of the same Island where we had our Camp No. 15 last year. For hours a thunder storm had been slowly coming up from the north. We stopped for supper, set up our tent and made ourselves as comfortable as we could on the rocky ground.

In the middle of the night the storm struck us, and the lightning was so severe we all felt relieved when it was over. Rainy Lake is well named, and sometimes two or three separate storms may be seen playing on different parts of the lake.

AUGUST 14TH.
CAMP NO. 19—BASS ISLAND, RAINY LAKE.

All hands were up at five o'clock, and at six we had had breakfast and were under way. We had to cross Saginaw Bay to reach Brule's Narrows, and it must be done before the wind came up or we would be swamped on this big lake. We laid out a compass course to some trees which stuck up above the horizon to the northwest, and started out. The lake was smooth as could be for an hour, when a light wind from the east sprang up which increased as we approached the Narrows; so it required all our skill to keep our canoes on their course in the quartering sea. We reached the Narrows at eight and stopped half an hour for chocolate lunch. At half past nine we had passed the Narrows and about ten o'clock we stopped to rest and cook our first lunch, for we were terribly hungry after our early breakfast and the heavy work we had done in paddling this morning.

At eleven we again started and at half past twelve

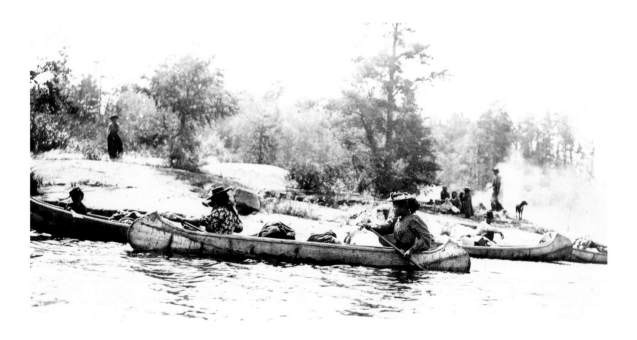

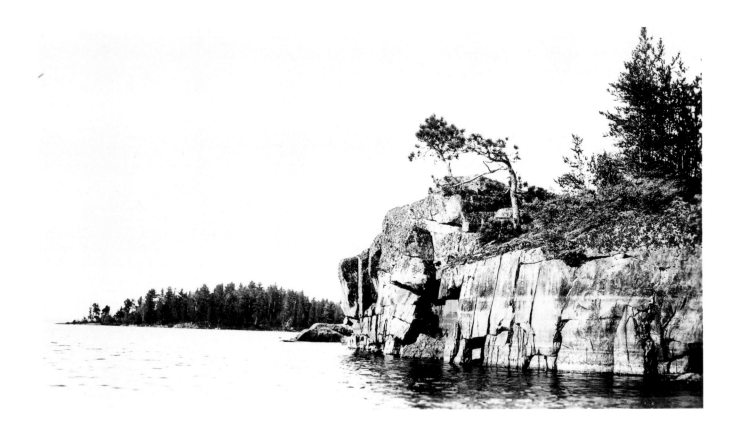

we were passing our old camp No. 16 on Lyle Island. At half past one we stopped for a short rest on an island which had recently been devastated by a wind storm, and again at three o'clock we stopped at the old gold mill to let Bill investigate the rock.

At four o'clock we reached a nice ledge of rock where we decided to spend at least an hour. Doc, Bill, Dad, and CLAY shaved. Everybody took a swim and eased up a bit.

Our blankets were wet from last night's storm, so we spread out our bed rolls in the sunshine.

From this stopping point we ran along about six or seven miles to the place where we had lunched on our last day last year. Here we made a bivouac camp at seven in the evening, and while supper was being cooked we made a Grand Army Cocktail, which took the last of our tangle-foot and two cans of cherries. We toasted Billy Mac, as always on these pleasant occasions, and then had supper.

The night was one of our worst for heat and mosquitoes. Finally Dad and Bill got up and into a canoe in their pajamas, and floated out into the moonlight to talk it over. From the west came a robust voice singing "Heil Dir im Siegeskranz" in German.[13] This roused Di, who barked at the voice. This roused Carl, who slid

[13] "Hail to Thee in Victor's Crown" was a German anthem popular from 1871 to 1918.

into a canoe and went out to meet the voice. All three canoes drifted together through the light and shadows, exchanged talk, matches, and tobacco, and the two trappers went on their way eastward with their songs and their bottle of inspiration.

"SHIPS THAT PASS IN THE NIGHT."

We are now about four or five miles from Rainier, and unless we run into very heavy water we are practically sure of making our destination early tomorrow morning. The Rangers say they can make the trip across this lake in a full day when the wind is with them. We shall have made the trip in less than one and a half days, and for only a part of the time we had a favoring wind. This is really better work than the Rangers do because we have larger canoes and are more heavily loaded.

.AUGUST 15TH.

CAMP NO. 20—RAINY LAKE NEAR FORT FRANCIS.

We did not try to make a very early start, and as soon as we got into the open part of the lake we struck quite a heavy sea with the wind against us. It was nearly ten o'clock when we made Rainier, where we received our first mail and started immediately for Fort Frances, to collect the refund duty on our canoes and outfit. It was after twelve o'clock before we had finished these formalities of the Canadian Custom House and we then made our way through a jam of logs to International Falls where Mr. Haller, who seems to be in charge of customs, told us that he had mislaid our manifest, and advised us to return to Rainier and make our legal entry at that point. It was then one o'clock. The other canoes made their way out. Dad and Bill were left behind to buy lunch, and they purchased a lot of things which we had not had for the last three weeks. We reached Rain-

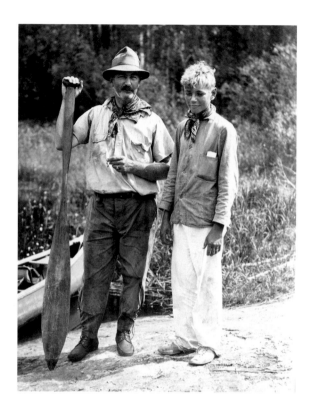

ier about three o'clock. The Customs Officer made a very casual inspection and allowed us to pass. Our baggage was all packed and delivered at the depot before dark and before supper Dad and Bill had a big farewell swim and general cleanup.

Bill traded his faithful Wanigan, the patriarch canoe, for sundry samples of Indian bead work.

We left Rainier at two o'clock Wednesday morning and reached Duluth in six hours. The morning passed very quickly, for everyone had to go to the barber. In the afternoon we had a box at the Orpheum, and we left on the 6:45 on the Soo Line for Milwaukee. Fred and the other men were on the same train as far as Ladysmith.

INSCRIPTION WRITTEN ON A
CEDAR SPLINT (6 FT. × 3 IN.)
WRITTEN IN PENCIL IN ENGLISH SCRIPT.

TRANSCRIBED BY DAD, BILL, AND CLAY.

Anish enakamikay cahi caianimag otani ____) () ()
 otanisican
() () () () katago iswa ()
 nikinag

igamikedav aga jawa aw tash wekin-wab wiwan enialeg ()
igo miketab agagiwat awatash wekinaiwab ginaug minoaia

() niwab () .
 niwah

Anish kishi buki—g katukish ig nikibimase omanshimig
 anawikagun
 bukishg kabikishig nikibimase omanobinaig anawikagwe

wabaminan wikatash nitanaginisgar iw otang ka-in-taph awia ki
wabamman wikatash nitanaginitgat iw btang

abi si iw gata kanaminima waten aw nito athi giwaian miiw
kiabiji iwgata kanawenina waten aw nito behi giwaion miiw

anakiateh atoneona.
anakioteh atoneom

Itawatash kio-bin wemi c-igotik waani thawanen mia itawa ()
Itawatash kiohkin wemi c-igoteki waani shawanen oma itoma
 kitanagna

kiket () ki-la o ahibiake omakioshi biskaian magisha
kiket tamini ki-ta o shibi-ika om-kioshi biikian magisha

nigabasla oum nigakag - natonomin kantash miaetanaknishe oma
nigabisha om - nigahig - natonomin kautash niwianakaniiki oma

kanameki-ca-ki tinama niwa oana mii teh cishaian oma bi a ta
kanamekak kitinama niwaniigana miia kekibishaian oma bi o ta

wa camag-aw abiht nikwinawiata wakenin wikago na waht nika
wa camag aw otter nikwinawiata wakenin wikago nawaht nika

di mi ki weni.
bi mi ki wenin.

REVERSE.
Misamnig eni na-og nitaming eni na nog cikwa shani shu
mahelog bikwa shonishu na belog () pa-jomath elato
 jonin ismalk
 jo nim elato

The upper lines were read by B.M. and the lower ones by Clay as a check.

CAMP OUTFIT FOR 1911.

TENTAGE—

1 New Amazon Tent.
1 Old Amazon Tent, small,
 for men.
1 Old A Tent for storage.
4 Ground Cloths—5 ft. 6 in. × 8 ft.

BOATS—

1 20 ft. Guide Canoe, to be
 shipped from Milwaukee.
1 18 ft. Guide Canoe, to be
 shipped from Milwaukee.
Clay's Boat, to be shipped from
 Milwaukee.
Doc's Boat, to be shipped from
 Milwaukee.
Bill's Old Wangan Boat, to be
 shipped from Racine.
Assortment of bow, stern, and
 river paddles so that each boat
 carries an extra paddle.

GENERAL EQUIPMENT—

8 Pack Straps.
2 Canvas Pails.
1 Lariat.
General Ditty Bag for sewing
 outfit, pins, etc., etc.
1 Ball Marlin.
1 Qt. Orange Shellac in can.
½ doz. Rolls Toilet Paper.
Writing Paper for journal, etc.
Repair Outfit—Tools, wire, nails,
 cloth, screws, tacks, etc.

1 Lb. White Lead
1 Lunch Bag.
2 Cans Viscol, 25c size.
2 Canoe Carrying Yokes.
Doctor Shop.
Flags for Canoes.
Shaving Outfit.
3 in 1 Oil, 25c size.
1 "Game Getter" and
 Ammunition.
1 Rifle 30-30, and ammunition.
Lantern.
Axes, as selected by men.
Extra Rope for each canoe.
Sponge for each canoe.
1 Coarse Whetstone.
Small Waterproof Provision Bags.
Large Waterproof Provision Bags.
Grub Carrying Sacks.

COOKING OUTFIT—

2 Bake Ovens.
2 Bake Oven Pans.
1 Broiler.
1 Coffee Pot.
3 Butcher Knives.
1 Butcher Knife Case of leather.
4 Nested Kettles.
2 Large Frying Pans.
1 Small Frying Pan.
1 Dish Pan and Bread Mixing Pan.
1 Wash Basin.
Friction Tins for Coffee, tea, etc.
1 Iron Ring Pot Cleaner.

1 Long Spoon.
1 Long Fork.
1 Pancake Turner.
Camp Grates and Supports.
S Hooks.
1 Can Opener.
Dish Towels.
Potato Knife.
Cork Screw.
6 Tin Pie Plates.

MESS OUTFIT:

1 doz. Plates.
1 1-3 doz. Cups.
1 doz. Knives.
1 doz. Forks.
1½ doz. Spoons.
Bags for Knives, Forks and Spoons.
1 Salt Box.

COMMISSARY—

2 Cans Powdered Milk.
2 Cans Powdered Egg.
1 Tin Blazer Matches.
1 Tin Matches.
Matches for general use are bought
 at last town.
1 Case Carnation Milk.
1 Can 100 Stereo Tablets.
1 Peck Bermuda Onions.
6 Lbs. Erbswurst, ½ lbs.
30 Lbs. Bacon.
1 Case Pilot Bread.
2 Boxes Chocolate.

Case 50 Lbs. Oleomargerine.

5 Lbs. Salt Pork.

1 doz. Laundry Soap.

½ doz. Sapolio.

2 Pieces Sommerwurst.

WILLIAM STEINMEYER & CO.—

3 Lb. Cans Sumaba Coffee-
Ground.

4 Lb. Extra Choice Eng. Breakfast
Tea.

3 Lb. Royal Baking Powder
(¼ Lb.).

3 Lbs. Dried Apples.

25 Lbs. Best California Prunes.

5 Lbs. Figs.

5 Lbs. Seedless Raisins.

3 Lbs. Currants.

3 Cans DeHydro Onions.

3 Cans DeHydro Peas.

2 doz. 2-lb. Cans Libby's Corned
Beef.

1 doz. Underwood's Devilled Ham
(½ lbs.).

1 doz. Potted Ham (½ lb.).

1 doz. Underwood's Devilled
Tongue (½ lb.).

1 doz. Sardines, ½ Rose Boucher
at 26c.

½ doz. Salmon.

2 Bags Salt.

4 5-lb. Pails Lard.

3 Brickstein Cheese.

5 lbs. Rice.

5 Lbs. Rice.

1 doz. Pettijohn's Breakfast Food,
2 lb. packages.

30 Lbs. Yellow Cornmeal.

1 doz. Large Ivory Soap.

1 doz. Royal Pancake Flour.

1½ Lbs. Lantern Candles.

30 Lbs. Brown Sugar.

20 Lbs. Granulated Sugar.

¼ Lb. Can Pepper.

¼ Lb. Can Cinnamon.

1 Bottle Vanilla Extract.

5 Lbs. Maple Sugar.

2 Packages Yeast Foam.

10 Lbs. Navy Beans.

1 doz. Laundry Soap.

1 qt. Chow Chow.

1 doz. Canned Peaches, Red Seal.

½ doz. Canned White Cherries,
Red Seal.

½ doz. Canned Pears.

½ doz. Canned Tomatoes,
Red Seal.

C pieces Clothes Line.

10 lbs. Lump Sugar.

2 qts. Pickled Onions.

THE GANG AND
THE PIGEON OUTFIT

1914

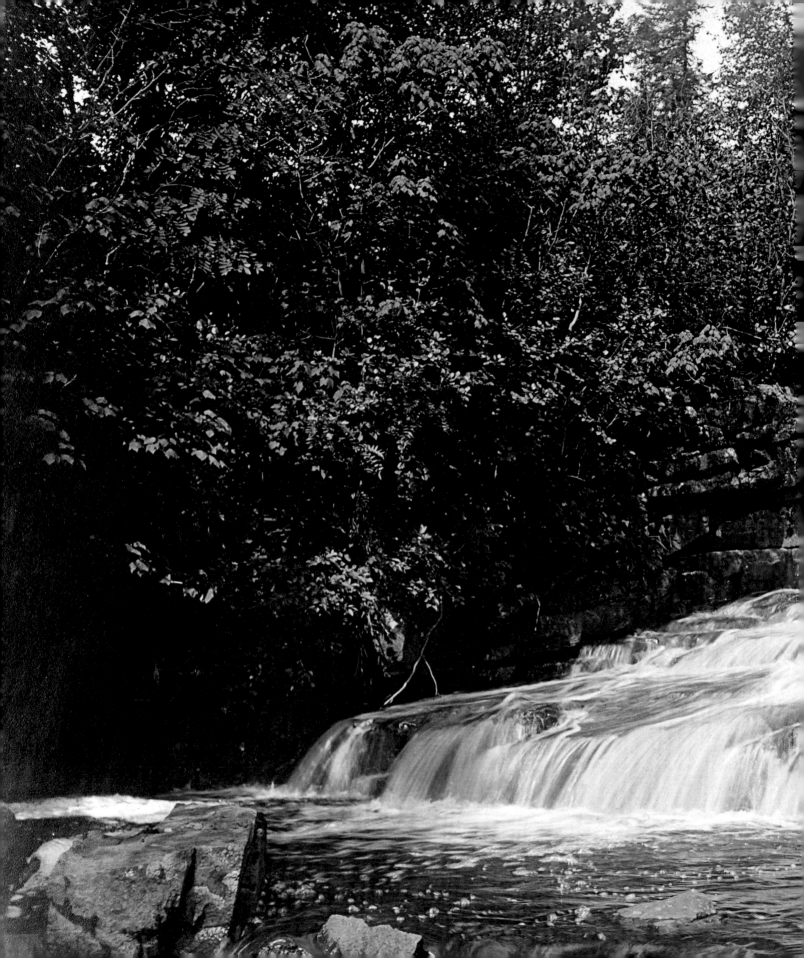

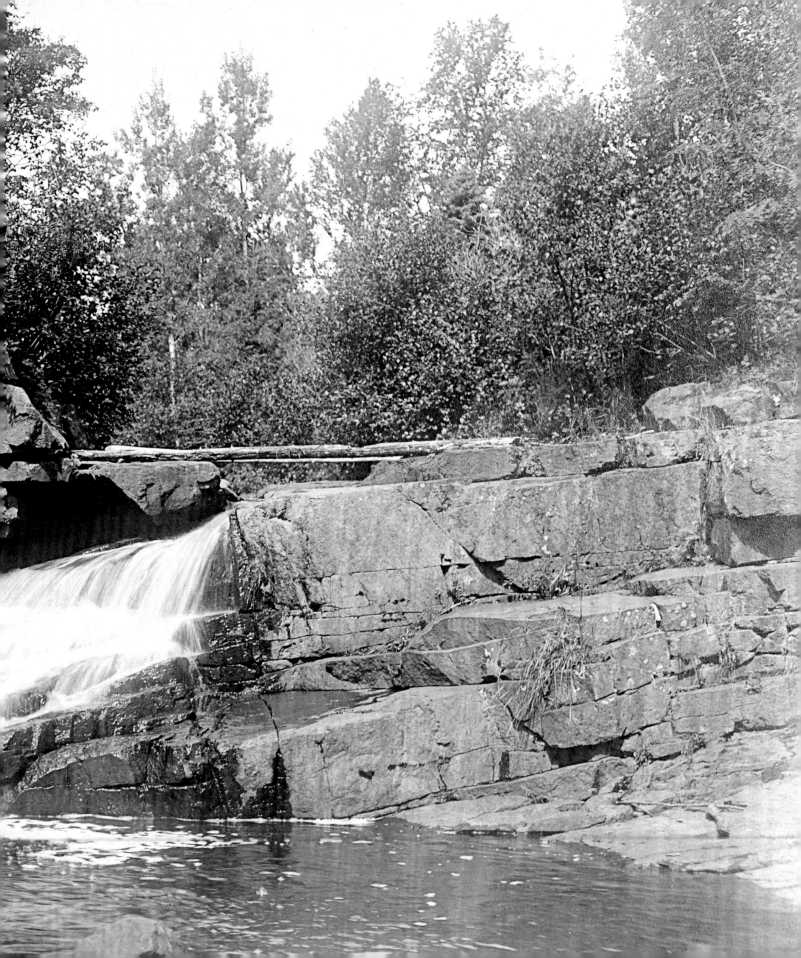

The 1910 Rainy Lake and 1911 Dawson Trail trips were huge ones for the Gang; after those two years, it seemed that they could muster neither the men nor the time for another major excursion. In 1912 some of the Gang made a short fishing sortie to Caldron Falls, near Peshtigo, Wisconsin. For unknown reasons they were not "in camp" at all in 1913.

By 1914 Doc and Dad were restless for another trip, and Dad went to Duluth to explore possibilities. They decided to do a trip to McFarland Lake, over the Sawtooth Mountains from Lake Superior's Chicago Bay (Hovland).[1]

Dad's Duluth friend Eddie Whalen arranged for the Gang to use the summer-idled Pigeon River Lumber Company camp on McFarland Lake as a base for exploring the area, which was reported to be mostly wooded and unspoiled by lumbering or settlement. The company's teams would meet them in Chicago Bay to take them to McFarland Lake. From their tents alongside the Pigeon River Lumber Company camp, they made day paddles to various other lakes and rivers, returning "home" to their bedrolls and tents at night.

They began their trip on a train to Duluth, followed by travel on the steamer *Easton* along the North Shore, past the newly built Split Rock Lighthouse, and onwards to Chicago Bay.[2] Soon after the *Easton* landed the Gang at Chicago Bay's pier, they found lodging at a Chicago Bay boardinghouse and, the next morning, began to prepare for their long trip inland by team and wagon furnished by the Pigeon River Lumber Company. As soon as they met Mr. Corcoran, the "walking boss" of the Pigeon River Lumber Company, they learned of a troublesome man named Frank Kugler, who lived near the Pigeon River camp and was creating problems for the lumber company over a passage between Pine and McFarland Lakes.

Meanwhile, the Gang had come to McFarland Lake as guests of the lumber company and intended to enjoy a week or two of being away from civilization exploring beautiful untamed country. Given those circumstances, they could not have anticipated that they would find Kugler to be a very interesting person and would spend a substantial amount of their time at McFarland Lake with him, ultimately becoming sympathetic friends with him during their sojourn in the woods.

The Pigeon River journal is filled with moose and fish stories, Frank Kugler, and the new use of gasoline motor launches for some of the Gang's forays. They still made rough overland passage on freight wagons pulled by teams and paddled canoes every day, but the new "automobile road" was being constructed parallel to the Superior shore, and this trip ended with Eddie Whalen taking the men out for an "automobile tour" of Duluth before they caught the train home to Milwaukee.

The Gang
and
The Pigeon Outfit

Although the Gang was probably unaware of Kugler's life after the 1914 trip, Kugler reappeared in one of Calvin Rutstrum's books.[3] Later, Kugler moved from the lake to the shore of Lake Superior, east of Hovland, and became a county commissioner. At one point in his life he was charged with murder but was reportedly cleared of that charge by a court in Duluth.[4] What would the Gang have thought of Kugler's colorful experiences after their stay on McFarland Lake, and did he remember the Gang's 1914 stay at the Pigeon River camp?

[M.G.P.]

NOTES

1 Although Hovland was incorporated in the late 1880s, and the post office established in 1889, Dad used the name Chicago Bay for the town as well as the bay on Lake Superior.

2 The *Easton* was the sister ship to the *America*, and both steamers were part of the U.S. and Dominion Transportation Company lines.

3 Calvin Rutstrum, *Challenge of the Wilderness* (Minneapolis: T. S. Denison, 1970).

4 A local Hovland historian, Bruce Updyke, knew Frank Kugler and has studied his life. Bruce was helpful in sharing information about Kugler with me.

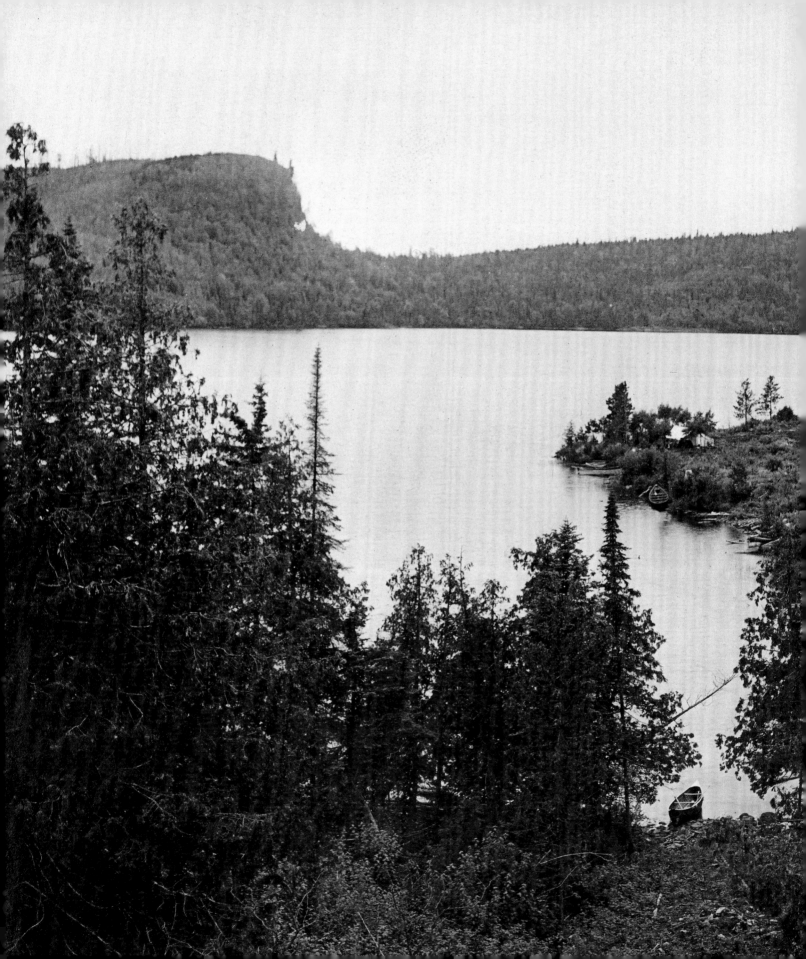

THE GANG AND
THE PIGEON OUTFIT
1914

This edition is limited to six numbered copies owned by

———————

Ernest Copeland Clay Judson

Howard Greene Carl Greene

Mackey Wells Jack Greene

———————

CAMPING TRIP SCHEDULE.

August 12, Carl will leave for Duluth to buy supplies.

August 13, 7.45 P.M. C.N.W.Ry. Depot. Leave for Duluth. Jack will join here or at Wales.

August 14, 9.25 A.M. Arrive at Duluth. We could be reached by wire C/O Steamer "Easton" or U.S. & Dominion Transportation Co. until

10. A.M. Steamer "Easton" to Chicago Bay where we are due at 9.30 P.M. Spend the night at Chicago Bay House.

August 15, Early in morning take teams for McFarland Lake where there is no settlement. In case of necessity, a message in care of the Transportation Co. could be forwarded by steamer on Sunday, Monday, Wednesday, or Friday to Chicago Bay; and the hotel man could get some one to find the party.

August 26, Steamer from Chicago Bay (America) to Port Arthur and Duluth, or August 27th taking the same steamer on return trip, and

August 28, 8.00 A.M. Arrive at Duluth. Address there in care of the Spaulding Hotel.

5.40 P.M. C.N.W.Ry. for Wales and Milwaukee.

August 29, Arrive Wales about 6.45 A.M.

Arrive Milwaukee 7.45 A.M.

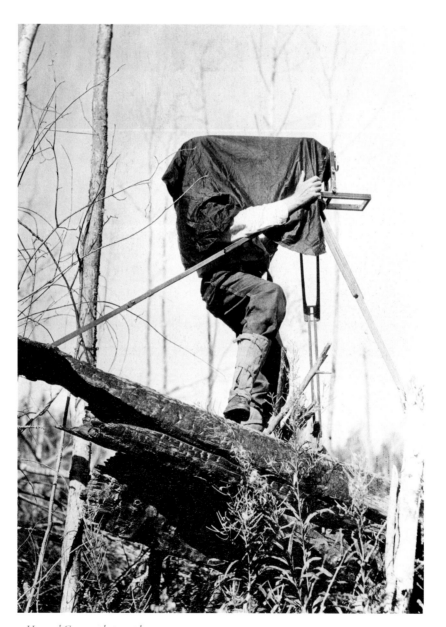

Howard Greene, photographer

Since our last canoe trip in Canada in 1911, the Gang has given occasional dinners to itself, but has not assembled under canvas. In 1912 some of the old crowd,—B.M., Heine, Carl, and Dad, with Jack Greene as a prospective new member, camped for a week at Caldron Falls on the Peshtigo River in Marinette County, Wisconsin. In the following year none of the Gang were in camp. A year more of inaction, and we might be reduced to telling the same stories at dinner which would be fatal to any future expedition.

Late in July Doc and Dad talked of a short vacation in the woods, and Dad went to Duluth to investigate the possibilities of an expedition by gasoline launch and small boats along the North Shore of Lake Superior, making camps at attractive points along shore. At Duluth Dad met his old friend "Eddie" Whalen who told him wondrous tales of a lake—McFarland Lake—which could be reached by team from Chicago Bay and which was so far inland that lumbermen had not destroyed the natural beauty, and where game abounded; for there were no settlers to harry it out of the country. Eddie had been there, and he knew. Eddie wrote to his friend W. J. Corcoran, the "Walking Boss" of the Pigeon River Lumber Company, who replied that we might use the Company's camp buildings at McFarland Lake, and that he would arrange to have the Company teams meet us at Chicago Bay, and take us in.

The next question was as to the personnel of the party,—who could go? Bill Marr had given notice early in the season that he must be left out on any plans for this year. He even refused to go and quit before the rest. Billy Mac said business was so dull that he could

not leave. He promised to forward the accumulated war news to us at Duluth. Heine had not sufficiently recovered from a serious illness of last winter to make it safe for him to endure the exposure incident to camp life. Howard was busy at Brook Hill Farm where he was making changes in his working organization, and he could not be away at this time. Doc and Dad then were the moving spirits in getting the old crowd together. Clay, who was studying industrial conditions in a railroad shop in New England, was reached by wire, and he promptly signified his acceptance. A letter written to Carl, who was studying at the University, put him in a reminiscent mood, and he replied,

"About this time in the year I remember eating a late supper of bacon, cherries, and good coffee; then taking a smoke two hundred feet to the lee of camp, and with prudence under one arm and anticipation under the other finally rolling in

"Under the wide and starry sky
And seeing the northern lights o'erhead
And thanking the Lord for a good dry bed
And having Di-sy kiss you good night
(My God, but aint her breath a fright?)
Then snores from Docie's end of the tent—
Knowing that Doc to sleep has went—"

The temporary loss of old members of the Gang gave us an opportunity to recruit up to a tentful by adding Mackey Wells, who had successfully eaten several dinners with us, and Jack, who has had the promise of a trial trip which, if satisfactory, would be followed by full initiation. Here follow the journal and photographs.

MILWAUKEE, WIS.

WEDNESDAY, AUGUST 12, 1914.

THE ASSEMBLING AND FAREWELL OF THE GANG.

Dad gave a farewell dinner at the Milwaukee Club, and around the table were seated Doc, Dad, Clay, Billy Mac, Carl, and Howard. Howard and Billy Mac went to the Depot to see us off, and Billy presented us with an American flag to fly over our permanent camp. Jack had been ill with a cold for a day or two, and it had been arranged that he was to meet us at Wales. When the train stopped we found Jack on the platform with his pack-sack on his back, and accompanied by his friend, Hunter Goodrich, Heine, Mrs. Greene, and Elizabeth, all of whom had come over to see him off. Accompanying Jack was a considerable sized package of various medicines to cure his cold, which was carefully put away and was brought home intact. Jack coughed once or twice as he went to bed, and after that was in absolutely perfect condition throughout the trip. It was late enough for Jack to go to bed, and the rest of the Gang crowded in for what B.M. used to call a "good-night smoke."

FRIDAY, AUGUST 14, 1914.

Some of us were up early enough to look out of the windows as we passed Gordon and see the old camping ground we occupied in starting on our trip down the St. Croix River in 1907. We reached Duluth at 9.05, and a minute later Carl appeared at the Depot with an express wagon to take our packs and belongings to the Steamboat Dock. We had nearly an hour to spare, and everyone scattered to do some last errands. We all agreed to meet at Whalens' on our way to the boat.

We met McGrew, a spectacled college student-looking sort of chap whom Carl had engaged as our cook. He immediately made himself useful looking after our baggage with an intelligence and willingness to do other work that is not usually found in a cook.

Just as the boat was about to start Carl discovered that various bags and boxes, comprising our first shipment from Wales of tentage, blankets, and camp equipment had not been transferred to the Dock. These goods were at the Northwestern Depot yesterday morning, and the Railway people had promised to have them transferred to the Booth Line by that afternoon. Hurried telephoning brought us only the information that the goods were not then at the Northwestern Depot. The boat was casting off just as Dad and Carl scrambled aboard to break the news that we were starting for an unknown place without equipment.

We had good weather with the wind off shore, and we sat on the starboard side of the hurricane deck enjoying the voyage. Some pears that Doc bought at Duluth served to maintain until dinnertime that gentle pressure against the belt which comfort requires. The meals on the boat are best forgotten, and fortunately the Lake was so smooth that they did not return to vex us.

From Duluth to Two Harbors the railroad follows the shore, and presumably serves the people of that sparsely settled country. East of Two Harbors the people depend upon the boats for their supplies in summer, and during the winter what mail and supplies reach them come by team from Two Harbors. We passed Split Rock Lighthouse,—a beautiful picture from the Boat with neat government buildings topping a precipitous rocky cliff, and beyond them a bold rockbound cape.[1] We stopped at Beaver Bay, which is typical of the

[1] The Split Rock Lighthouse had been built quite recently, and there had been substantial publicity about it and its anticipated help in navigation.

smaller fishing settlements, where the boat put off passengers and supplies.

Usually the landing is made by small boats which come out to meet the steamer, and only occasionally is there a settlement which boasts a pier where the steamer can discharge freight.

The shores are all rocky; the water is deep, close to shore, and very clear. Occasionally rocky islands form breeding grounds for the sea gulls. We passed through two showers blown from off shore, and were rewarded with really wonderful rainbows.

After supper, as we approached Grand Marais, we held a council, and decided to wake up the Duluth Freight Transfer people, if that were possible; and we sent a wireless from Grand Marais to Eddie Whalen and asked him to chase up our missing baggage. We gave another message to the steward to be sent by telegram from Port Arthur to the Booth Line office, asking them to expedite

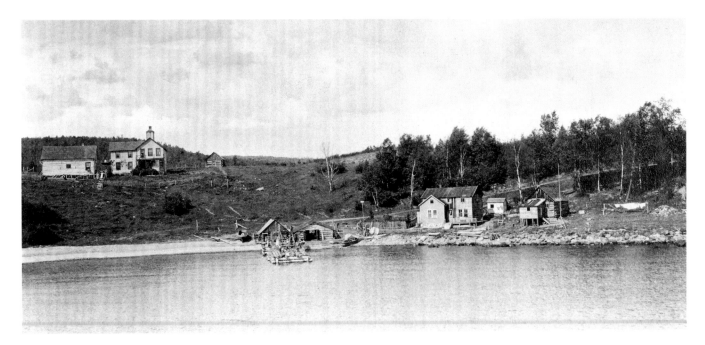

Beaver Bay

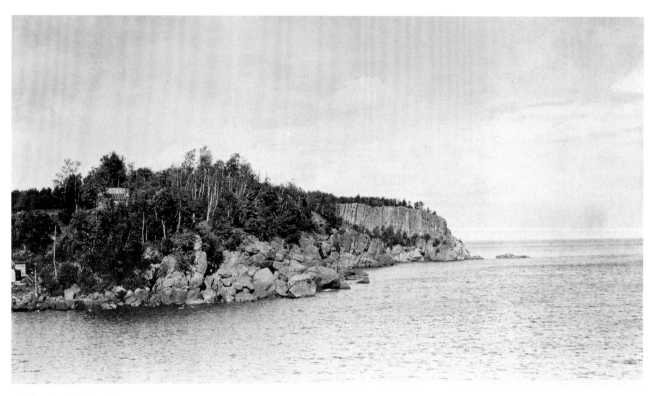

Palisades, Lake Superior

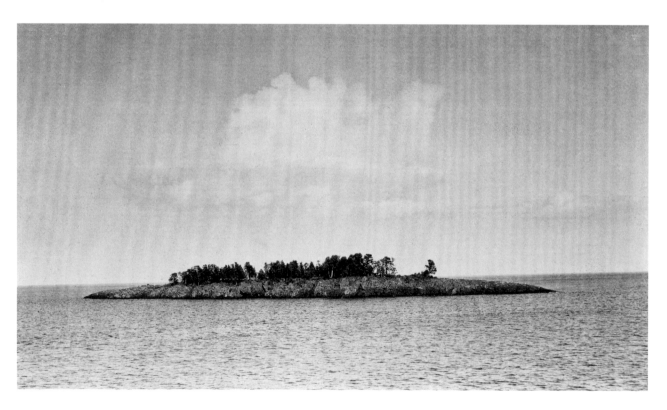

the transfer and send our goods by next boat. Before leaving home Carl had bought a sailor's canvas overshirt which he put on that evening. To heighten the effect he had the arms stagged, and for oddity of dress he was certainly the sensation of the cabin.

None of the settlements we have passed, with the exception of Grand Marais, boast of a hotel; but Chicago Bay appears upon the list as having a hotel with a rate of $2.00 a day. It is said to be nothing more than a clean boarding-house, and not very good at that. We hoped to get accommodations, but did not feel particularly hopeful. We reached Chicago Bay at 9:30 P.M., and, as we stumbled ashore over a roughly-built pier, we saw lights in a small house ahead of us. A small boy told us to turn to the right and follow the road until we came to the boarding-house which we could easily see because it was lighted up. The road led through a bit of woods that gave us the first smell of wet forest, and if we only had our tentage we would have been sure of a comfortable night. The hotel is a scant quarter of a mile from the pier, and we were glad to see lights as we approached. It looks like an old-time lumber company boarding-house with the exterior finished off in corrugated galvanized iron. In the main room, which serves as an office and wash room, we found two slouchy men, one of whom admitted that this was a hotel, and told us that if we were the people that Corcoran spoke of, there were rooms ready for us. A steep stair led to the second floor where we found good comfortable rooms, and we paired off in this way:

Cope and Clay
Mackey and Carl
Jack and Dad

while McGrew had a room to himself. We were soon asleep, for the night was cold, and we were tired from being out of doors all day.

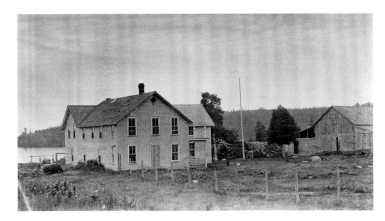

Chicago Bay boarding house

SATURDAY, AUGUST 15, 1914.

After a good breakfast we looked over our surroundings. We have with us our hand baggage and the supplies which Carl bought at Duluth. The hotel is clean, and the meals are as good as could be expected in a place of its kind. The Pigeon River Lumber Company's team was here yesterday, and it is said that they will return this afternoon. The country is attractive. The Bay lies between two rocky points, the one on the east being a rather high wooded cliff. Just beyond the hotel a trout stream empties into the Lake, and there is a possibility of getting some fish in this or other streams in the neighborhood. A Mr. Burness, a lawyer from St. Paul, and his wife are here, and are going up to Reservation River with camp equipment this morning. They have been here before, and tell us that there is good fishing in the neighborhood. Our camp equipment ought to come in on Sunday night's boat, and we have decided to remain here until Monday morning, this being the best and perhaps the only way to be comfortable. We spent the morning overhauling our baggage and belongings, and trying the neighboring trout stream. In the afternoon everyone turned out to see the "Easton" which touched here on her return trip.

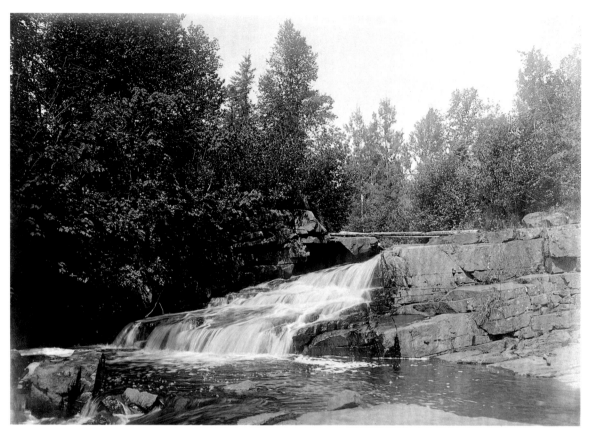

Flute Reed River

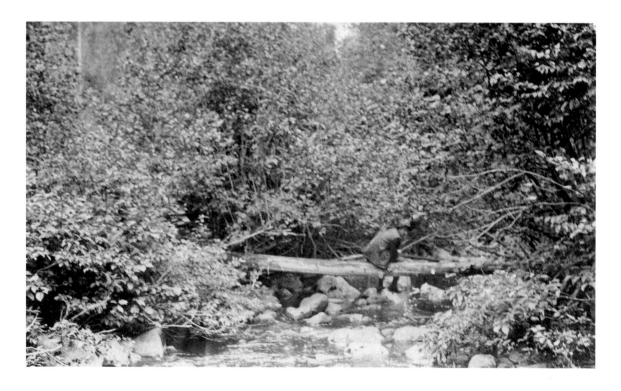

At about half past one a "Pigeon " team came in, and during the afternoon we met Mr. Corcoran, the "Walking Boss," who is camping and fishing at Reservation River with a party of friends. He came down from Reservation River this afternoon in a Ford machine which is quite a novelty in this part of the country.[2] We met Mullen, his camp foreman,—a bright-eyed chap who shows by his face and manner that he is accustomed to dealing with men in the rough, and we also met McLoughlin, his camp clerk. Mullen tells us that the trip to McFarland Lake will take us all day. He has a four-horse team and wagon for our supplies. His clerk is going up on Monday with a light wagon, and three of us can ride with him, alternating with the others in walking. It is a rough hard road through the mountains.

These people tell us queer stories of one Kugler, a squaw-man[3] who lives near their camp. It seems that he is always engaged in a quarrel with "the Company" and its employees or their friends. He owns a little piece of land at the end of McFarland Lake, and he owns both sides of a waterway connecting that lake with Pine Lake. This waterway he has improved, and he exacts a toll from all who pass. He is trying to breed foxes at his place. He is a trapper and hunter, and knows the whereabouts of game.

The Burness family came back from Pigeon River this afternoon. They found that their old camping ground had been burned over and that other people were camping in the vicinity. They decided to set up their tent back of the hotel, and we helped transfer their dunnage to their new camp-site. Mackey refers to Mr. Burness as "Talkative Tommy," and as such we shall remember him.

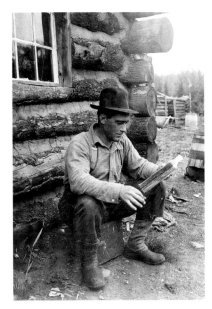

Dan Mullen, lumber camp foreman

One of the celebrities of this place is a Mrs. Stevens, who, with her husband, owns a considerable tract of land. She describes herself as being "the progressive woman" of the town, and she is very anxious to have us come up and make a picture of her truck garden. She is doing a good deal of home canning. She has waylaid each one of us separately to tell us of her progressiveness. Her conversational abilities are so great that none of us want to meet her again.

Doc fished faithfully all day with his usual luck. Mackey got a lake trout on a trolling line. For supper we had beef of the toughest type that any of us have ever seen. "Pit it out if it won't chew," says Clay.

SUNDAY, AUGUST 16, 1914.

We were called at seven, and after breakfast we did some heavy sitting around in our mackinaws, for it was cold and a heavy dew had fallen. Doc went fishing, of course. Jack and McGrew had become good friends and went out in the Burness light boat to explore the west point and beyond. Mackey and Dad went fishing with Mackey as fisherman. Clay also went fishing, and still we have no fish.

[2] The Walking Boss must have possessed enough confidence or status to enable him to own and use an automobile in such an undeveloped area. As indicated later in the journal, the new automobile road along the North Shore was just being constructed. Many roads in the area were simply wagon or tote roads.

[3] "Squaw-man" was a derogatory term for a white man who lived with or married an Indian.

At dinner Jack asked to be excused from table so he could eat his watermelon comfortably.

The afternoon was spent most leisurely. Carl is nursing a cold which is probably the result of exposure in his middy-shirt. This is his usual camp cold, and he is waiting for something to happen to relieve him. Jack and Clay went fishing for brook trout together, and later the Doc followed. Dad re-packed an overcrowded grip, read a lot of newspapers, and late in the afternoon Jack and Cope came back with two trout that Jack had caught. They were about eight inches long. Jack showed Cope a place in the road where someone had spilled some water, and told Cope that it was water that had dripped off from his fish as he brought them to the hotel.

Late in the evening our missing camp equipment came in by the "America," and we are due for an early start to-morrow morning.

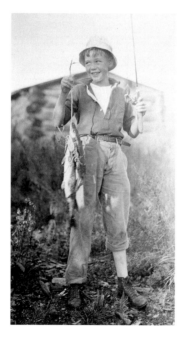

MONDAY, AUGUST 17, 1914.

CHICAGO BAY TO CAMP NO. 1.

We were ready to start at 7.00 A.M., and left our hand baggage by the roadside for the team to pick up. Some of us started out ahead of the teams.

Mullen and his team of four grays pulled out of Chicago Bay at 7.15 A.M. with most of the party riding high on top of the load. He carried some hay and oats for the Company, and was loaded to the limit of his wagon. Jack McLoughlin left half an hour later with Jack, Dad, and McGrew. He had a light wagon with one seat, and two of us rode on the floor of the wagon. The road leads past the Post Office, past a lonely graveyard on top of the hill, and for a mile follows what they call "The New Automobile Road" which is now under construction between Duluth and Port Arthur. From this road we turned off onto what is called the "Tote Road" which follows a winding course over the mountains. Jack McGrew with the light wagon was soon in the lead, and alternating in walking and riding we passed over the first range of mountains; and at 10.15 pulled into what is called the "Half-way Camp" on Tom Lake, a distance of ten miles from Chicago Bay. We had crossed the first range of mountains, and had travelled over the worst part of the road. In two places the descent is so steep that the wheels of the freight wagon were chained.[4] The low places are swampy. The road is blocked by outcropping of large rock, stumps, and rolling stones. Where the road is made up of corduroy the logs are pretty well gone to pieces, and it is really surprising that the teams got through as well as they did.

[4] Horse-drawn freight wagons were not always equipped with brakes, but even a sturdy four-horse team cannot hold back a heavy load downhill. Two wheels are chained to the wagon frame to become stationary and skid, slowing the wagon's momentum.

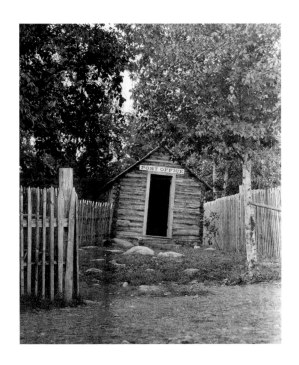

At 12.30 Dan Mullen pulled in with his big freight team. Mackey was riding with him. Dad had a bottle of whiskey with him when he started, and Mackey tried to be a good fellow for a while but gave it up. Mullen was able to handle his team but he was pretty badly shot. Fortunately the whiskey was gone and he had all the afternoon to get his eyes in line.

The Half Way Camp consists of two buildings: one for teams and the other a small bunk house with cooking outfit. It is used only as a stopping place for teamsters. There is a good spring, and, except for the general dirt and filth of the camp, it looks like an attractive place to stay. We had to break up Dan's load a good deal to find the necessary things, and McGrew made us a good lunch of bacon, bread (which we brought from the hotel), boiled potatoes, and coffee. It was a really good meal,—the best we have had since our breakfast on the dining car on our way to Duluth. It was two o'clock when we pulled out of the Half Way Camp, for our horses are soft and have been sweating hard.

Now McLoughlin took the lead. Everyone walked.

Jack held to the trail for about four miles, when we persuaded him to get in with McLoughlin, for the whole trip would be too hard on him. For the first three or four miles the road, as Eddie Whalen says, "skirtles the shore of Lake Tom," giving occasional views of the Lake; and then leads over a second range. On one of the high points in this range the Pigeon River Lumber Company have their Camp One. The distance is about eight miles.

Camp One is an outfit of old buildings, and is temporarily in charge of a few men who are acting as camp watch, and are looking after about thirty head of horses which are summering here, and incidentally they are doing some work on the road. There is a beautiful view to the north across a broad valley to a range of mountains.[5] There are two passes which can be plainly seen. We are to go through one to-morrow to McFarland Lake, and the other is on the border line between Minnesota and Canada.

[5] This view can still be seen from a short detour off the tote road going from modern Hovland to McFarland Lake.

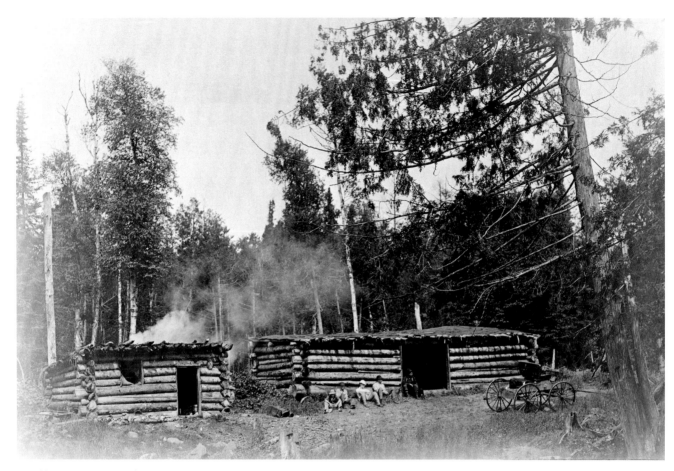

Half Way Camp, Tom Lake

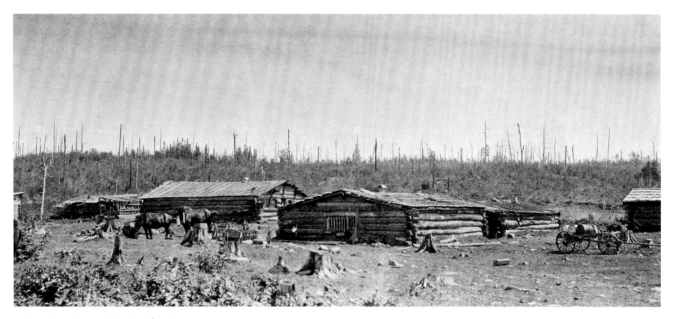

Camp One, Pigeon River Lumber Company

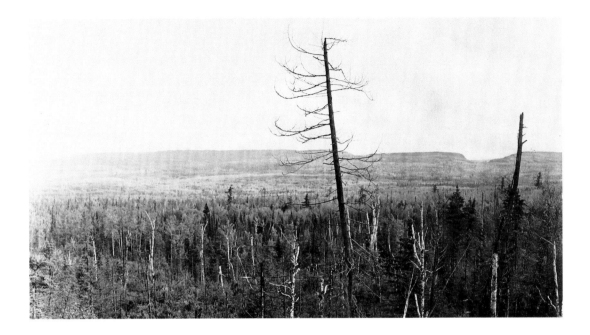

We knew that it would be impossible to push through to McFarland Lake this afternoon, so we arranged to have McGrew cook for us. We had a partridge bouillon which was excellent. We had seen partridge along the road at various times during the day. At seven o'clock Mullen came in with his big freight wagon. We had picked out a sight for our camp and set about locating our stuff, putting up our tent, and sorting out our blankets. It took a long time, for the tent poles did not fit easily, and the blankets were not packed as we pack them in camp,—so they roll out into a bed. Clay fixed our sleeping order in this way:

D	C	M	J	D	C
o	a	a	a	a	l
c	r	c	c	d	a
	l	k	k		y
		e			
		y			

During the night the horses came around to investigate the tent. Clay tried his elocutionary powers upon them with no result; finally, to the surprise and edification of the tent, he spoke in vulgate, slightly disturbing the horses. The camp was not quiet until Doc drove the horses off with a hiss.

TUESDAY, AUGUST 18, 1914.

We were up for an early breakfast. In looking over our baggage we found that we were short a pot, coffee pot, and the "Doctor Shop," all of which the Doc remembered having carefully wired to Mullen's load at the Half Way Camp yesterday. A horse was saddled, and Clay rode back to look for the missing articles. It was a long tedious ride, the horse could not move faster than walk over the rough roads, and the articles were finally found within a few rods of where the Doc had wired them on.

One of the men at this camp, Jim Cyr, has a pet sow, "Biddy" by name, who comes when called and kneels before her lord and master. Biddy has been troubled

Jack and "Biddy"

with vermin, and Jim gave her a coating of grease and pine tar. Jack, clad in reasonably clean khaki pants, sat on Biddy to pet her.

After lunch McLoughlin hitched up; and with Jack, Cope, and Carl started for McFarland Lake. At 1.30 Clay came in with our missing pots; and at two o'clock Dan Mullen pulled out with his big four-horse team with McGrew astride of the load, and the rest of us following afoot.

The road is rough, but better than yesterday. For the first mile or two it runs through the broad valley, and then slowly ascends and crosses the mountain range. At one point, four and a half miles from Camp One, the road runs along half way up a mountain, and suddenly we looked down upon McFarland Lake with the Pigeon River Camp buildings in the foreground. The camp is

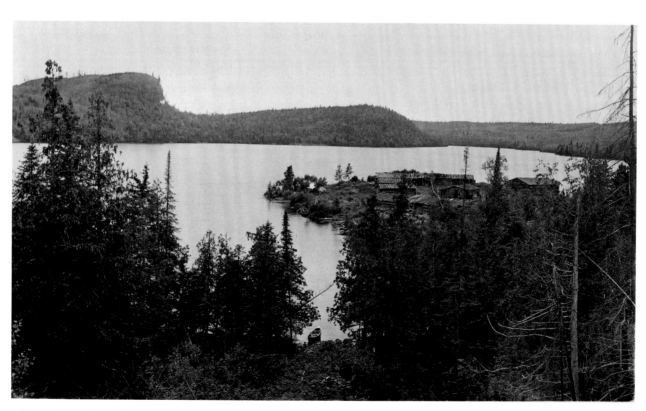

Camp at McFarland Lake

an old one in charge of a disabled old man as camp watch. Old Dan has been lumbering all his life, and has been in the hospital on account of a broken leg. This evening a harness-maker walked up from Chicago Bay. He is to work for the Pigeon outfit for a month overhauling its harnesses for the winter.[6] These two men with Mullen, McLoughlin, and ourselves are the only people here. We have located our camp on a point of land beyond the lumber camps, and made ourselves comfortable. We are flying Billy Mac's flag at the end of a pike pole.

There is a big skiff here with an Evinrude motor in which McLoughlin and Carl went down the Lake to find a big canoe and bring it up to the camp. At some far distant time it was a good Peterborough canoe; but it got banged up and leaked, and was finally covered with a coat of tar and canvas, so that it is now as heavy as an ordinary rowboat. It will, however, do us good service.

There is a good kitchen connected with the camp with a good steel range and our outfit of cooking utensils. McGrew has cleaned it up, and has cleared one end of a table in the mess house. There is a prospect of our having good cooking and rather elaborate meals for our camp.

Camp kitchen, Pigeon River Lumber Company

Jack learned to do camp laundry work. Carl and Clay went swimming off the rocks beside our camp. Jack observed and called them, "September Morn."

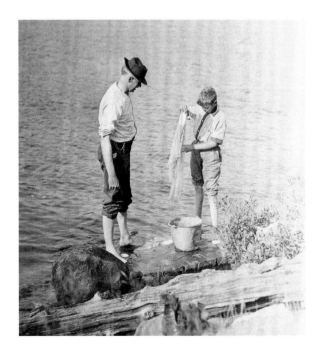

[6] Presumably, the lumber Camp One had all the needed tools and supplies for harness repair so that the harness maker had to walk all the way to the Pigeon River camp carrying only personal effects sufficient for a month-long stay. The seasonal nature of a logging camp is apparent here; a camp had to be completely ready for the winter's work so that employing a harness maker for a month, full-time, was a necessary investment. It would be interesting to know how many teams were used in this camp over a winter, and how many harnesses had to be maintained in good working order.

WEDNESDAY, AUGUST 19, 1914.

This morning Cope, Mackey, and Jack went exploring in the motor boat. They went to the further end of the Lake, and made the acquaintance of the squaw man, Kugler. Carl says he is a decent enough fellow, but at outs with the Pigeon outfit because they have their own ways which are not his ways.

The party brought back some pickerel (Great Northern Pike) which our people call snakes, but which are good fish, coming from this cold water. Clay explored the mountains opposite our camp; Dad straightened up baggage, blankets, changed plates, took a bath, and shaved.

In the afternoon Carl took Dad in the motor boat to visit the Squaw Man. We met him half down the Lake. He is a young fellow between thirty-two and thirty-five years old, clean shaven, with a clear blue eye. He came into our launch and let us tow his boat back.

He asked me about the European war and said that all the great wars were brought about in some way or other by the Catholic Church; and that in this instance the Church had found its members discontented, and had contrived to bring about the war to keep its domination over them. He is a Ty-

rolese Austrian. He says his people are German and have less in common with Catholic Austria than they have with Protestant Germany. His parents died before he was of age, and under the direction of the Priest his Mother made a will, giving all of her property to the Church. From what he said it appeared that he was doing army service at the time, and was discharged in

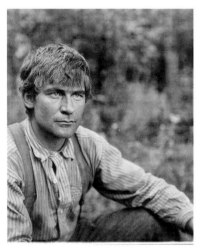

Frank Kugler

order to look after the family; that through his efforts a guardian was appointed for himself and the minor children, and the will was set aside. He says that the influence of the Church is very strong over there; and that if a man is in disfavor with the Church and gets a job, a priest will go to his employer and tell him to discharge his man. "I know what it is, for I have been there," he said. He tells us that his only religion is his belief in a free country.

As to his relations with the Company, Kugler had little to say except incidental to the general conversation. He had a forty between Pine and McFarland Lakes. The survey shows no connection between the Lakes; and once, while he was away from home, the Company dynamited a channel, and the scattering rocks spoiled his garden and damaged his house. He has a good root cellar located near the shore, and the Company had damaged one of the outlets to the Lake, flooding his cellar and freezing his winter supply of potatoes. He does not appear to be particularly resentful.

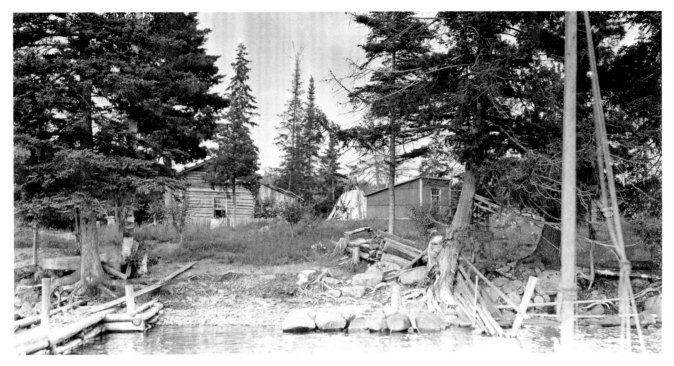

Kugler homestead

It is easy to imagine that there would be friction between a man who sought freedom in the woods and who was so outspoken against the Church of his fathers; and lumbermen who rule in the interest of the Company, and bear such names as McLoughlin, Mullen, and Corcoran.

Kugler is industrious. He has a nice house built of squared logs, a flower garden with pansies and Dahlias, and a nice truck garden.

He has two clinker-built boats, one rigged with a sail; and has well-built piers extending into both lakes. He showed us his foxes which are in a wire enclosure not far from his house. He is now planning to build a five-room farm house, and is at work digging the cellar. When it is done, he will tear down the old house. He and his squaw wife are cutting all the lumber by hand, and in the cool days of the Spring and Fall he tells me that they cut two hundred feet board measure a day. The siding he said would take him too much time to cut, and he is going to buy this item and have it hauled up by team.

I asked him how much of the country he covered in his trapping. He says he does not know, but in the winter he covers the best part of six towns. He has two dogs with which he can make the trip to Chicago Bay in three hours,—this is following a direct line by way of the road. He asked us to come into his house, and we found his squaw seated in a chair. She speaks only Indian, and when addressing her his voice falls into the soft murmur of these people. As we came in he told her to give one of us her chair. Dad moved as if to sit on the bed and hesitated. "It's all right," he said, "we're not lousy here." He showed us some pictures someone had made of them, and he pointed out a young girl of about sixteen whom he spoke of as "our girl." In reply to a question as to whether he had only one child, he looked a little confused, and replied, "The girl is hers," indicating the squaw. The girl is now

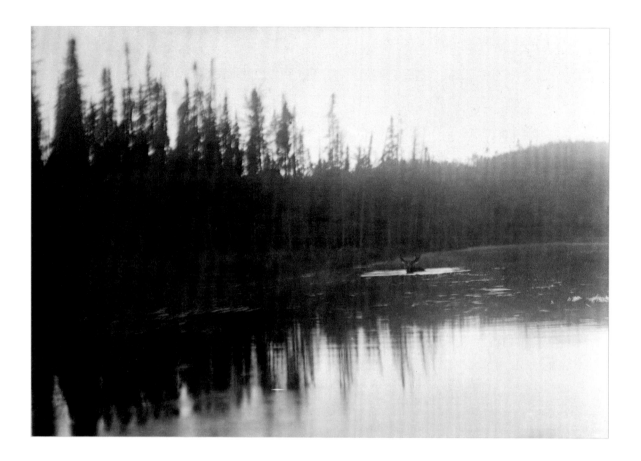

gathering berries on the Canadian border. She is with his brother-in-law.

As we sat there, the woman opened the oven and took out her baking nine loaves of nice well-made bread, and it all looked good. She has a sewing machine. In the root cellar Kugler showed us more than one hundred jars of preserves that they put up during the summer for their winter use.

As to moose, Kugler knows where they are abundant at a little lake not far from the further end of Pine Lake; and he said that he would take us down so that Dad could make some pictures. The present arrangement is to go down to-morrow (Thursday afternoon) and spend Friday there. This will give an evening and morning to get moose pictures beside what we may be able to get during the day. We are to furnish the grub and are

to sleep at a little shack he has at the end of the Lake. After supper Mullen took Dad up to the other arm of McFarland Lake looking for moose. They travelled in the canoe. They easily passed the first rapids to Mud Lake where they saw two cow moose standing on the further bank of the Lake. The moose watched the canoe and did not like the looks of it as it moved slowly down upon them. Presently there was a noise in the woods; and they were joined by a yearling bull who took a survey of the situation, and then came down into the water to feed. The cows nosed along the bank, but did not feed much. Dad exposed several plates in the failing light, and finally got so close to the bull that it seemed impossible to make a further change of plates; and Dad broke the silence by telling the bull that his portrait was made, and that he could go on. We had to yell before

the bull was frightened sufficiently to trot away. Had we realized how fearless he was we might have gone on taking pictures of him. The moose hears nothing when his head is under water, and when his head is raised above water his nose and ears seem to be so dull that he cannot smell or hear distinctly.

This was the night of the aurora. It started faintly. Cope and Mackey brought out their blankets so they could lie and watch it. After a time pale yellow and green streamers came up. Dad pulled Jack out of his blankets to see. Clay followed, and we saw a magnificent display. After everyone was finally in bed and asleep Mackey again called us to see a streamer which came up at the horizon in the East, crossed the heavens south of the zenith, and ended in the West. It was a strong band of yellow and green light, and there seemed to be a constant movement of nebulous light starting in the East and crossing the heavens to the West. It was a most unusual sight; none of us have seen anything like it.

THURSDAY, AUGUST 20, 1914.

The morning was cold, and there was a cold wind blowing. A fire was lighted outside of the tent which added to everyone's comfort. Mackey and Clay were reading Clay's book on Modern European History, and the discussion of European politics took up most of the morning. The sky was overcast, and the prospect for picture-making was discouraging.

In the afternoon the sun came out, making a good illumination over the mountains opposite our camp. Mackey and Dad made some pictures from the hill back of the camp. Later in the afternoon Clay, Cope, Carl, and Dad went to see Kugler to tell him that the light was so poor that they would not make the expedition they had planned for moose pictures. While they were out of camp Jack, Mullen, McGrew, and Mackey went fishing. Jack was fishing all of the time, and had a string

of eleven pickerel when he came in. This was the record catch to date, and it was really a picture.

In the evening Mullen took Jack, Dad, and Mackey down the Lake to look for moose, but they had no luck. McLoughlin, who had been out of camp for a day or two, came back this afternoon.

FRIDAY, AUGUST 21, 1914.

In the morning Clay and Doc took a walk over the mountain across the Lake west of our camp. They saw a great many birds and saw where the moose had been browsing all through the valleys. Carl and McLoughlin went over land to North Fowl Lake to put the large gasoline launch in shape to use. They took their lunch with them. The program was for Carl to swim out to the boat, raise the anchor, and bring the boat ashore to be pumped out, and equipped with new batteries.

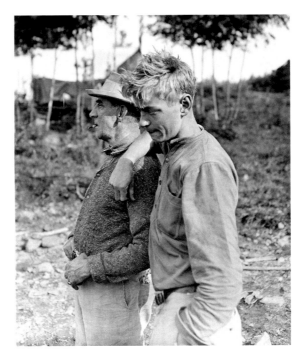

Doc and Clay

About 3.00 P.M. Clay, Jack, and Dad took the gasoline boat for the "Dutchman's," as they call Kugler here, to spend the night and a day looking for moose. Kugler met us at his dock with the information that it was too late for starting, but he said we might as well try it anyway. He got an anchor and walked out into the Lake with it to get it firmly planted on the bottom, and then passed the line to us so that we could pull our boat up the little stream and rapids connecting McFarland Lake with Pine Lake. It seems to make no difference to Kugler whether his clothes are wet or dry. He makes no attempt to stay out of the water, and walks into the Lake with the same equanimity with which an ordinary man will move from one room to another in his house.

After our boat was on Pine Lake, Kugler got a birch canoe over, and we towed it for the length of Pine Lake,—nine miles. There was quite a sea as we left Kugler's, and as we approached the end of the lake we gradually worked out of it. At the very west end of the Lake Kugler has a little shack with stove, blankets, and a few supplies. The house is carefully locked and the key is placed in a crevice between the logs where the state forest rangers and government service people can find it.

From the provisions we had taken with us we had a hasty lunch, then portaged the camera outfit and birch-bark canoe for a quarter of a mile to another lake which Kugler tells us has no name. The birchbark canoe (Wigwash Chemung) was very crowded. Dad with his camera outfit in the bow took up most of the space. Jack and Clay were thrust in the middle, and Kugler, at the stern, did the paddling. Silence was commanded by Kugler, and we stiffened in our positions, while Kugler paddled us slowly around the Lake. It is clearly a lake frequented by moose who come to feed, for along the shore the waves had carried up quite a bit of the loose hair they shed at this season of the year. We were just about to give up search for moose for the night when we saw one

standing in the water feeding. He finally swam out into the Lake, and then we started in pursuit. It was a young bull moose. Kugler could not see over the heads of the party and so he had to guide the canoe by general sense of direction and by sound. The moose was driven out into the Lake and finally brought up on shore with the canoe only a few feet behind him. We had a splendid opportunity to look at him, but the light had failed beyond the point where a picture could be made.

Kugler's walking in the woods is more noiseless than anyone's we have ever known. He wears only a shirt made of striped mattress ticking, khaki trousers, and moose skin moccasins. His feet are so tough that he goes barefoot over these rocky trails. The greater part of his time is given to observing and trailing wild animals, and his hearing and sight are wonderfully keen.

We returned to the shack at dark. Kugler cooked up some coffee for himself, drank four or five cups of it, smoked, and went to bed. In one corner of the shack there is a little hay covered with some very dirty blankets. In another corner is a pile of steel traps. On entering the shack, Kugler observed that someone had taken one of the blankets he left there. He took a blanket to a corner for himself, and told us to make our beds on the hay. We spread our blanket roll to cover the space to be occupied by the three of us, and made ourselves comfortable for the night.

The shack was so small that our feet and Kugler's met as we lay down to sleep. Jack enlivened the night with a nightmare and later woke up to remark, "Dad, I'm cold." Jack crowded into Dad's blankets, and slept happily the rest of the night. When we went to sleep Kugler wanted to close his door, but was persuaded to leave it open. Even with the door partly open the air was stuffy and close and stinky—there is nothing else to express it.

Kugler tells us that in the winter time he builds up

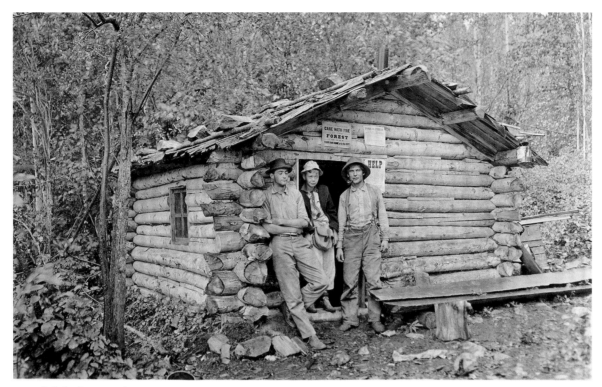

Kugler's shack, Pine Lake

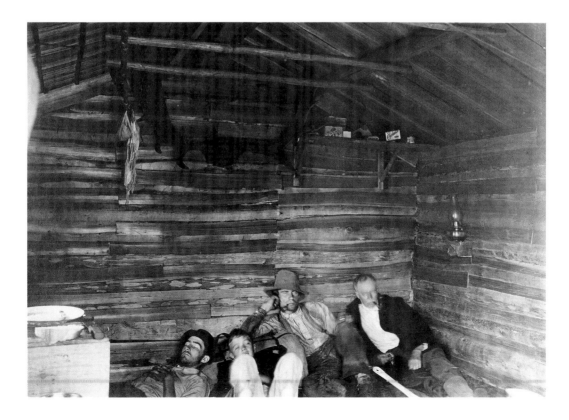

a big fire and shuts up the shack as tight as he can. How he survives it we can't guess. He says he is going to keep the rangers from using his shack, for he thinks some of them are lousy, and he tells us that when he gets his new house built he is not going to let any lumbering people inside of it, for he wants to keep the place clean.

SATURDAY, AUGUST 22, 1914.

We were up early, and after a bite at the cold grub left from the evening before we were on the trail at 5.30. We paddled around the Lake in the morning fog, and neither saw nor heard anything of moose. We returned to the shack, started a fire, and cooked our bacon, while Kugler prepared his usual prodigious pot of coffee, ate a little of our bacon, and consumed all our bacon grease that was left over by soaking it up in bread. He criticized our way of frying bacon because we cooked all the grease out of it. He says he ate it because he did not want it wasted, and the little he could not eat he drew off into a kettle for future use. He told us he did not eat much fat in summer, but "in the winter I pray for lard." After breakfast we returned to the Lake and lay on the shore most of the morning watching and listening for moose that never came.

Kugler told us that beavers had built a house in the next lake, which he called Caribou Lake, so we picked up our outfit and went over to the west end of the unnamed lake from where we portaged to Caribou Lake, and visited the beaver house that was then in the making. Along shore we found trees which had been cut down by beaver. In passing the beaver house I tried to get a good picture of it, but the woods were not well illuminated.

Returning to the portage we returned to the unnamed lake; and, after watching and waiting for moose, we went back to Kugler's shack to finish our cold grub. For his lunch Kugler took some of our bacon which he

ate raw, and washed down that and some dry bread with a marathon of warmed-over coffee.

Rain had begun to fall, and we waited, expecting it would cease. While we were killing time at the shack, Dad made some pictures of the exterior and interior. The latter was a slow exposure in dull light, and it was hard for Jack to sit still so long. At 2.30 we decided that weather conditions would not improve, and we started for Kugler's house in the launch.

We had the full benefit of a head wind and of a downpour of rain. Fortunately Dad had taken ponchos which partially covered all of us except Kugler who took his wetting with absolute unconcern. As the wind

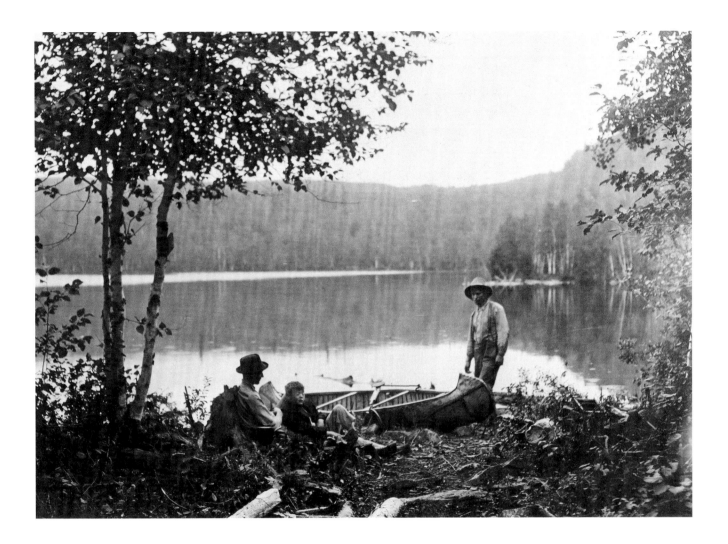

grew colder, he put on a wet mackinaw. We feared that our supply of gasoline would not be sufficient to carry us through Pine Lake, and we ran along shore where, if need be, we could use our oars to better advantage; but we came through to Kugler's house without running short of fuel. Kugler invited us to warm up at his house, and while we were there Dad arranged through Kugler as interpreter for his squaw wife to make a pair of moccasins for Jack and bring them down to our camp on Monday night. Kugler got out his Edison machine and played two records. He would like to have had us stay longer, but we were wet and we had to face more storm and wind before we reached our own camp. He took our boat through the rapids between the Lakes, and he cautioned us to tell the people at our camp that of the two dollars we have paid him for services, a dollar and seventy-five cents was his pay and twenty-five cents was toll for passing through his channel.

Our gasoline held out, and we reached our own camp at about 6.00 P.M. On the shore there was a big pickerel which Mackey had caught in the second narrows. We had a camp fire for drying out and went to bed speculating on the weight of Mackey's fish. In the discussion the weight was estimated from twelve to

thirty pounds according as it pleased our mood to tease or flatter the fortunate fisherman.

During our trip with Kugler he gave us several Indian names:—

Wigwash,	Birchbark
Wigwam,	Birchbark House
Chemung,	Canoe
Wigwash Chemung,	Birchbark Canoe
Animus,	Dog

Animus is the only real term of approbrium that the Indian knows. His language is deficient in cuss words.

During our trip down the Lake Clay and Dad were speculating on the height of the mountains and were figuring out some way of taking their height by angles from a lease line. It was a little startling to have Kugler enter into the conversation by telling us that it could be worked out by geometry. To try him a little the discussion was carried into the solution of the problem by trigonometry and Kugler again chipped into the conversation on hearing the words sines and tangents to remark that he once knew about them but that he had forgotten it. He admitted that he had a pretty good education. He said that after that he worked at the carpenter's trade for seven years. Kugler was very much interested in the European War. He said he supposed it would do him no good and that he still had a little money coming to him from his people.

Kugler was very shy about answering any questions in regard to his trapping. He says that he gets some mink, fisher, and wild cat. In reply to a direct question from Dad he said that he did not want to tell what he made, because people would repeat it, and then others would come in and he did not want them. He said it would do no harm to tell us, but that we might tell someone who would tell someone else. He finally said that he made $1,000.00 on his first year's work, and that

it took less work to make that $1,000.00 than it has to make $600.00 which he has made in recent years. His family expenses for three amount to $150.00 a year. He buys his tobacco in twenty-five pound lots, for both he and "the old woman" smoke. Occasionally he visits Duluth and once in a long while he has gone to St. Paul; but the noise of the large cities is very distressing to him, and he usually goes home as fast as he can.

SUNDAY, AUGUST 23, 1914.

The morning opened cold, and we lighted a fire next to the tent. After breakfast Dad was called upon to make pictures of Mackey and his pickerel. In order to weigh the pickerel a scale was devised. A stick was hung so as to balance on a wire. On one end was hung an empty pail while on the other was hung a stick of wood at such distance as to exactly balance it. The pickerel was then hung opposite to the pail and equally distant from the center. The pail was then carefully filled with water by the cupful until 19½ pint cups exactly balanced the pickerel. This would give a net weight of 19½ pounds after the pickerel had been out of water for twenty-four hours.

We estimate that the shrinkage would have been not less than three pounds during that time. From an examination of the fish it was evident that he had had a good sized fish for his dinner so everyone went over to watch the autopsy. In his belly he had a sucker weighing about two pounds. The cleaning of the fish was about all that Jack's stomach could stand.

McGrew took a little more than half the fish and baked it for dinner. There was enough for all of us including Mullen, old Dan (the harnessmaker) and McGrew; and then we had enough left for a second meal. Jack did not eat any fish, for he could not forget the sucker that he had seen taken out at the autopsy in the morning.

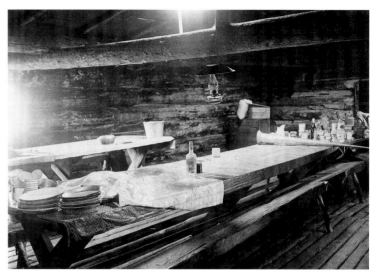

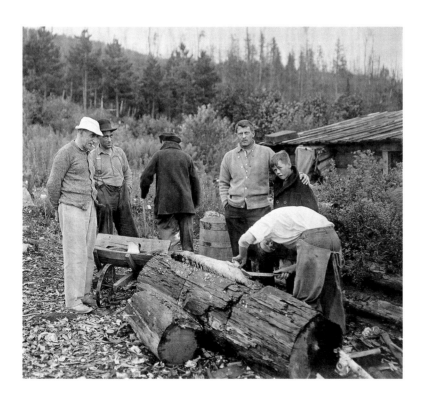

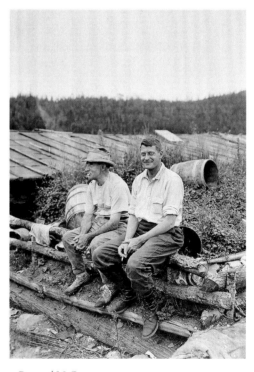

Doc and McGrew

Roy Lake

In the afternoon Carl, Mackey, Jack, and Dad set out with Mullen in the gasoline launch, towing the canoe—all bound for Royal Lake. On the way through the first narrows Mackey spied a porcupine in a small poplar tree, and we went ashore to poke him out of the tree so Jack might see him. At the dam between the end of Mud Lake and John Lake, Mullen led the canoe through. Carl left us to walk home through the woods. The view through the valley is very beautiful.

After picture-making we took the canoe and dropped down quietly to Roy Lake looking for moose. We had good light for picture-making, but no moose. We rested quietly in a cove until about six o'clock, and then went down, passing a beaver house, to an old beaver dam, where we pulled up the boat and walked over to an abandoned drive camp at the end of South Fowl Lake.

Our return was against the current, and Mullen had to take the oars to work up stream.

Roy Lake in itself is not interesting, for it is shallow and weedy almost to the center; but it is surrounded almost entirely by high mountains which were beautiful in the light of the setting sun. Just as the sun was about to set, Dad saw a moose feeding in the middle of the stream. By paddling hard when the moose had his head down we were able to work up to within very

short range of him; and, although Dad tried to make a plate, the light was not strong enough. It was a young bull moose, and he had little fear of us until he was well on shore and had opportunity to consider the incident. The last that we saw of him he was going as fast as he could through an opening in the woods. It was surprising to see how much noise we could make when his head was under water and how intent he was on feeding.

In the dark it was very hard to work our way through the narrows, for the water had been lowered by an opening in the dam. At camp we learned that when Carl left us he started for camp following a work road where a porcy disputed possession. The road ran out to a moose trail and then ended. Carl would not back-track and wait for us, so he took his course by compass and sun. He heard some strange noises in the woods, and finally turned to the West to find our Lake. He came to the Lake about a half mile north

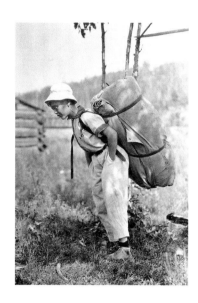

of our camp, and was separated from the camp by a bay and a boggy marsh which he could not cross. Rather than go back to the highland and work his way out again, he made a raft of a saw log and an old tree trunk, which he fastened together with the nails from an old box cover which he found on the shore; and with a stick he paddled his way across the bay to camp. "Twelve strokes to eight feet" was his speed. Cope and Clay saw him from a distance, and they say it was one of the funniest sights they had ever seen. Carl was wet through when he reached camp. We had a late supper and went to bed. The night was very cold.

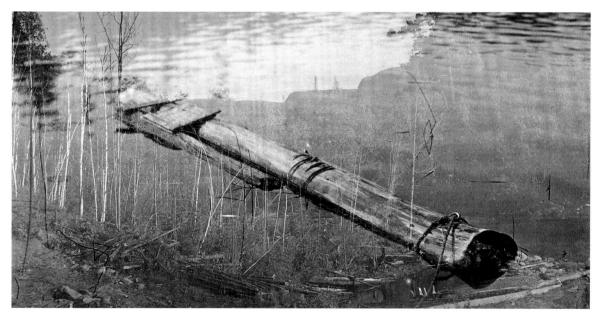

Carl's raft

Another cold morning. Jack ate a most prodigious amount of raspberries and Pettijohns for breakfast, and pronounced himself feeling fine. Dad went to the almost daily duty of changing plates, and made a picture of Carl with the Doc, a picture of McGrew (which was spoiled), and of the bay Carl crossed and of the raft itself.

McLoughlin had been away and came into camp this morning. He, Mullen, and Carl had planned a trip to North Fowl Lake to set nets for whitefish, and as they were about to start. Cope and Mackey decided to

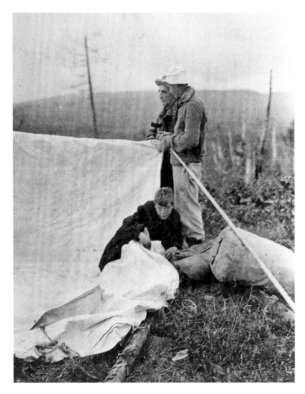

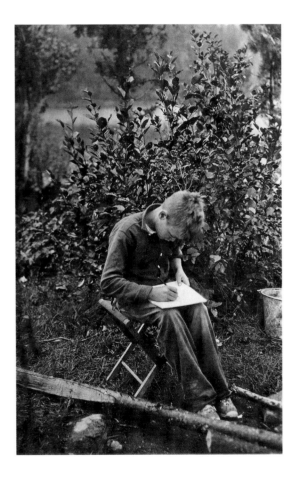

start for Kugler's where they could get Kugler to row them, and they would spend the day fishing in Pine Lake. Carl took them up in the gasoline launch. Dad, Clay, and Jack were left in camp. Dad sketched up a map from the only plate Mullen had and wrote journal. Jack and McGrew climbed mountain, and hailed us from the mountain top. The 22 rifle was brought out, and Jack shot at tin cans.

Everybody occupied himself well around camp, gathering up fire wood, straightening out bedding, and getting the camp equipment ready for packing for the return to civilization.

In the evening Mullen, Mackey, Jack, and Dad went for moose to Mud Lake, but saw nothing. It was very slow work.

TUESDAY, AUGUST 25, 1914.

It was raining during the morning. Mullen left for Camp One to get the teams, and planned to return in time for a trip after moose.

About 10.30 Jack, Carl, Dad, and McLoughlin took the launch through the three lakes, portaged the trail to Vinette River, and so on down through Roy Lake to the beaver dam; and then walked over to South Fowl Lake. This trip was to be a photographic trip, and was intended for getting pictures of moose; but it rained or drizzled steadily almost all day long.

As we approached South Fowl Lake, a skunk stood in the trail ready to dispute possession, but finally changed his mind and went off quietly into the brush. The Lake is low because the dams are open. As we approached we saw a moose feeding in some down timber near the shore. Dad was carrying the large camera over his arm, and he used it for snapshot work; but without good result. The moose that was feeding was very much disturbed, but had to make its way out of the morass very slowly.

We made a trip around North and South Fowl

South Fowl Lake

Lakes, seeing a good many duck; and we had a long chase after some which were too young to fly but could swim fast enough to keep just ahead of the launch. At a drive camp[7] at the end of North Fowl Lake we had our cold lunch in the rain; then we took the launch over to the dam and let Jack go ashore so as to enjoy the sensation of walking into Canada. Had the light been good we should have had some beautiful pictures of this trip. What pictures we had were taken in a failing light.

On our way back we found a moose feeding close to the shore, and we were able to run up very close to him, and we ought to have had a picture; but there was so much motion in the launch that we could not catch him quickly enough. This was really the best chance at a moose picture we have had. It was nearly dark when we reached the landing on South Fowl Lake. We concluded to follow the trail on the right hand bank of the river clear through to John Lake instead of trying to work through Roy Lake and Vinette River in the dark with the canoe. Carl left us for a few minutes to pick up something we had left in the canoe, while McLoughlin, Jack, and Dad worked ahead on the trail.

Carl followed, and not finding us returned to where he left the trail for the canoe, intending to light a fire and stay there until he could locate us or we him. We had heard Carl's call and answered it, but he did not hear us. We dropped our stuff in the woods and went back

[7] A "drive camp" was a camp established for the logging drive.

to find Carl, and by that time the woods were pretty nearly dark and the trail could not be easily seen. Jack stumbled and fell twice, and then began to see spooks. Jack's own account of it is better than ours:

———✺———

"The night was cold and dreary:
The sky looked dark and qeery:"

That certainly was a good description of that night.

We had decided to leave the canoe where it was, and followed the tote road or trail to the dam.

Hardly had we gotten half way there, Carl started down the path that led to the canoe to get Dads tripod for his camera. We kept on. We had gone a little way when we heard Carl shout, it was so near that we kept on going. Trudge, Trudge, Trudge, about fifteen minutes elapsed and no Carl. Dad became anxious, we slung down our packs and left them where they lay and proceeded to back track. Dad shouted. No answer except the death-like silence of the woods. Again still deeper in the forest trudge, trudge, trudge again Dad shouted the echo resounded at last in desperation Dad called "Coming I am" Voice came back. He had, in fear of losing the trail, gone back to the deserted driving camp, that last time was the only shout he had heard. We followed the trail back to the paraphernalia picked it up and began wending our weary way toward the waterfall. Something told me that there were things behind me. I looked—we had just turned a corner in the tote road and saw a white thing just slipping into view, from the bushes. I turned back again; a stronger impulse than before made me turn my head—two black objects had joined the white, spooks! and ghosts! A little more to the boat and we would be safe, for ghosts and spooks dare not cross water. I called Dads attention to the fact that the ghost and the spooks were behind

us. He said he could not see them which shows how much imagination he has. I tripped and fell on a root of a tree planted there by the ghost and spooks for me so they could catch me but I got up to soon for them that taught me a lesson that lesson was that I had to keep eye on those ghost and spooks or they would catch me for they can't gain on a fellow when he is looking for they are cowards. The boat is hove in sight, aboard, cast off, safe, safe, at last.

———✺———

It was raining throughout the morning. Everybody took a bath and decorated the trees and bushes about the camp with cast-off underclothing. Jack had been forewarned that this was the morning for initiation; and at the first break of daylight he was up, dressed, and beat a retreat into the bushes where he stayed until his clothes were soaked through. Later in the morning he was allowed to take off his clothes, and Cope pulled him out into the Lake and threw him overboard, so that he might thereafter be known to all as a real member of the Gang.

Late in the morning the bedding was made up into rolls, and fires were made inside the tent to dry it out as thoroughly as possible. We did not finally break camp until just before the teams were ready, which was at 2.00 o'clock. Everybody walked to Camp One, where we arrived at 4.10; and pitched our tent on the edge of the bluff overlooking the big valley and the mountain ranges beyond. It was rainy from start to finish. John Cyr came into camp to make inquiries about the pictures we had made of his pig Biddy. There was a long discussion on whether Nature is always beautiful, which ended where it began. In the evening we sat around the camp fire drying out our clothes which were more or less wet.

At daybreak the weather was clear. The sunrise so disturbed Cope that he woke up the party. Everybody made some remark about it. Mackey finally said it was Titian, after which everyone went back to sleep. By breakfast-time some clouds had blown up. We had an early breakfast, and at 7.50 we started. Dad and Cope were ahead of the rest of the party looking for partridge in the hopes of making a picture in the roadway where we expected to find them drying off the rain of the night before. A few miles from Camp One Jack McLoughlin and his team caught up with us, and then broke an axle. The

wagon had to be stacked up in an opening in the woods beside the road, and we said good-bye to Jack who started for Camp One. After that all the party walked except that occasionally young Jack was loaded into the wagon, for the trail ahead of us was too much for his short legs to undertake. On the road we found frequent track of bear, some wolf tracks, and an occasional fox track. Moose tracks were abundant. We saw an osprey in a tree, and in some places the woods were thick with warblers. We saw deer track in one or two places.

At 10.45 we came to the Half Way Camp, and at 11.45 Dan Mullen pulled in with his big team. Here

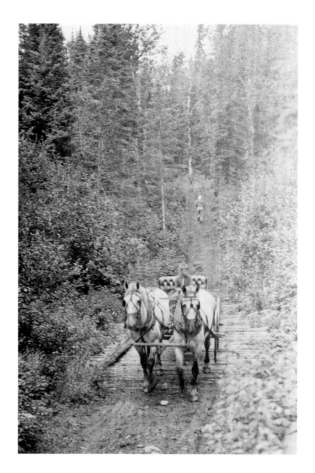

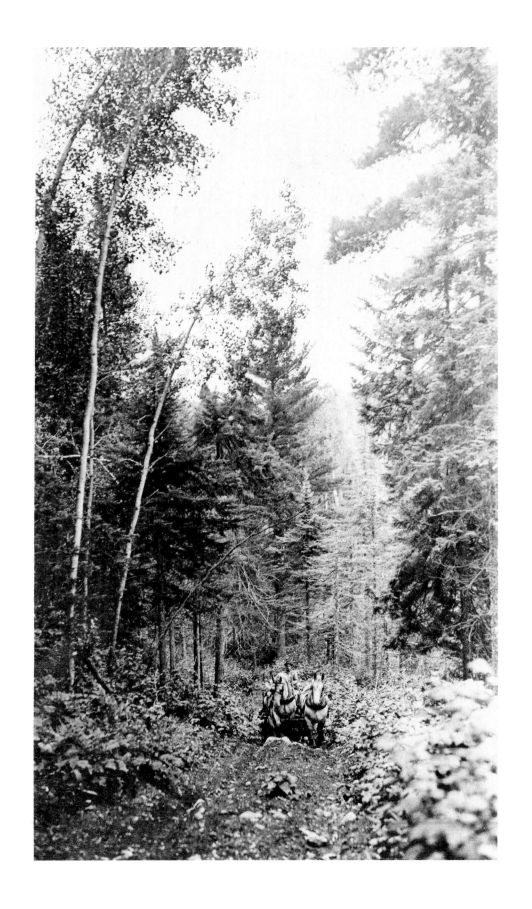

Carl made a sketch of the Camp, and Dad made a picture of some lichens on a tree.

We found a clearing across the road from the Half Way Camp in which someone had at one time a good permanent camp with boughs of trees for bed, and a fire-place.

At one o'clock we said farewell to the Half Way Camp. The road is very steep. The woods are thick and untouched almost to Chicago Bay which we reached at 4.30, and there were letters waiting for some of us. Cope and Dad took a foot bath in the Lake before changing their clothes. The afternoon and evening were spent in fixing up our baggage and getting it ready for shipment. We arranged with John Eliason to air out and dry our tentage, and ship it to us by the next boat.

At 9.30 the steamer "America" came in, and the steward said that he had no accommodations for us, nor had any reservations been made. A generous tip convinced him that there were some staterooms for our party. We were all comfortably quartered for the night.

We reached Duluth a little after eight, having had breakfast on the boat. The weather has been perfect. McGrew listed up all of our hand baggage, and saw that it was properly transferred and checked at the Depot. The morning was spent in getting reservations for the sleeper and giving the barbers a chance to better our appearance.

By pre-arrangement we met at Whalen's at noon, and then went over to the Spalding with McGrew as our guest for lunch. After lunch Cope entertained the Gang with a long automobile ride through Duluth and up over the new Boulevard Drive on the heights above the city. We had a wonderfully beautiful view of Duluth, Superior, and the big harbor.

At 5.45 we left for home. McGrew was at the station to see us off. Clay had engaged reservations and is to go by steamer to Menominee and thence to Wequitonsing [Wequetonsing], Michigan, where his family are spending the summer. Carl and Jack were dropped off at

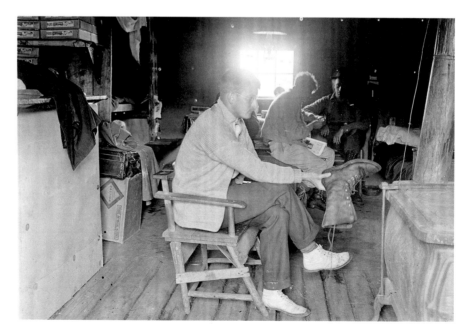

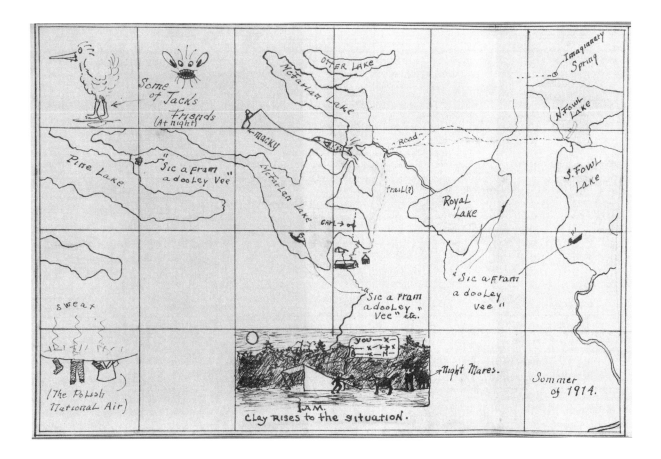

Wales early the next morning, and Cope, Mackey, and Dad were the only ones to go through to Milwaukee.

Here ends the Journal.

— ON PICTURES —

To the members of the Gang, who are always patient with me and my picture-taking, I feel that there is a word of apology or explanation, for some of the pictures that we would have most liked to have had do not appear in this book. For some unknown reason several plates in each of the three first boxes of plates were absolutely blank, and without a sign of a picture upon them. I feel satisfied that I exercised the usual care in handling my plates, but they are as badly lightstruck as if someone had opened the box to peek in. The moose pictures were almost all failures either from the motion of the boat or because the light was too dim for quick photography. I know now that in photographing moose it would be better to work by the coming light of early morning than by the fading light of evening. I am sorry that there is no picture of McGrew. I made one plate of him, but it is too thin to print. I intended to photograph the genial McLoughlin at the Half Way Camp on our return, but the breakdown of his wagon removed him from the party. Possibly I ought to bear in mind that I have hardly touched a camera during the two years' interval since our last trip, and I ought to be satisfied with the results obtained.

Dad.

PACK AND PADDLE
FROM TOWER TO RANIER

1915

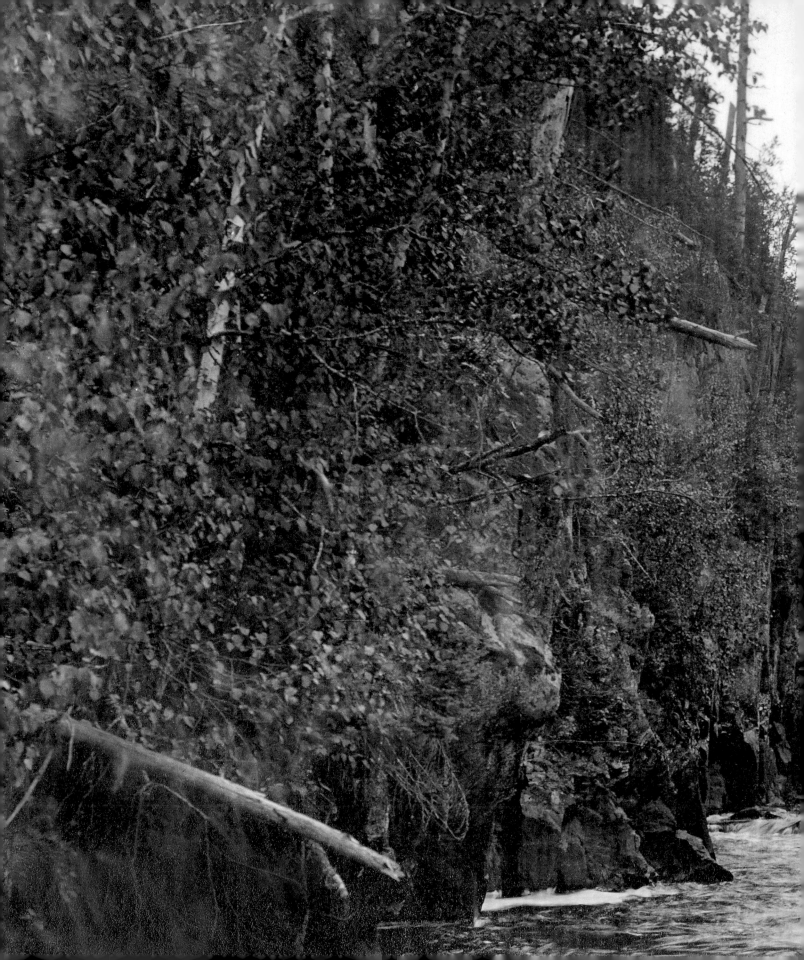

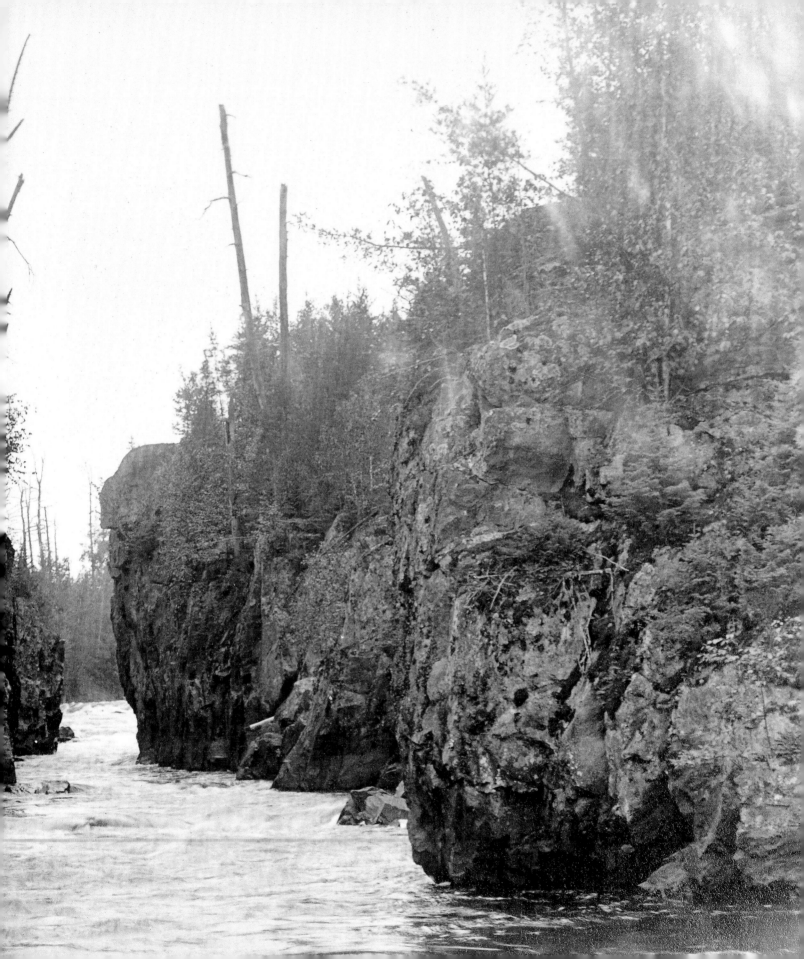

Pack and Paddle
from
Tower to Ranier

Dad's introduction to the "Pack and Paddle from Tower to Ranier" journal began with a description of 1915 as "an off year for the old Gang." In the summer of 1915, Clay—who was then twenty-three and had graduated from Harvard—was invited via his father's Army Engineers relationships to Panama, to see the construction of the canal there. Howard T., age twenty-two, had graduated from the University of Wisconsin and was already immersed in managing the Greene family's dairy, Brook Hill Farm at Genesee Depot. Carl, at nineteen, was in art school. The men in the Gang—Doc, Bill Marr, and Billy Mac—all had other obligations or couldn't get away. They had to say "No" to a trip that summer.

Of his sons and their friends, only Jack, age thirteen, was available for a canoe trip. "B," or William Norris, a slightly younger schoolmate of Carl Greene, was interested in joining the trip. Dave Parris, from the Peninsula Box and Lumber Company, came along as a handyman, as did Dave Mullen, from the Pigeon River trip. Eddie Whalen, Dad's friend in Duluth, found a cook, Earl. The small group was ready to go. Their trip got off to a choppy start, with personnel and equipment changes following soon after their launch.

Canoeing and camping were still rugged; Dad still carried photography "plates" for making pictures. Although he often used other cameras, glass plates made some of his best images.

Once under way, Dad found the region a little different from his earlier experiences. During the earlier travels, the Gang had sometimes struggled to find portages, and maps were challenging to obtain. On this trip they found some campsites marked and portage locations (with estimated distances) noted on signs made by the new Minnesota Forest Service. There were more resorts, logging railroads, settlements, and even a post office at a hotel. They were able to visit Indian villages as they had in the past, and Dad continued to take many photographs of the people and their way of life.

By the time they arrived at Kettle Falls, making the third stop there within a five-year period, not only was there a good hotel (built in 1910) but also a new and large dam to hold back water for power at International Falls. Water levels had risen on Rainy and other lakes west of the dam, changing the landscape dramatically. Gasoline launches were being used for fishing and trade. It was all becoming "too civilized" for their tastes. Dad and the Gang had canoed these border lakes at a pivotal time in the area's development. He was now a witness to changes he had, perhaps, foreseen but had not imagined happening so quickly.

Although Dad and the Gang appeared to be ready for more adventures in the coming years, one cannot help but wonder if the beginnings of war in Europe put those plans into doubt. Canoes were sold or traded at the end of the trip—not sent back to Milwaukee as in other years. Did they foresee bigger changes than they acknowledged? [M.G.P.]

SECTIONAL MAP
ST. LOUIS COUNTY, MINN.

SCALE 2½ MILES TO ONE INCH.

1911

PACK AND PADDLE
FROM TOWER TO RANIER
1915

This Journal is issued in three numbered copies to the Gang on this trip.

———————

1 - Howard Greene

2 - John M. Greene

3 - William A. Norris

———————

FOREWORD

The year 1915 was an off year for the old Gang. Everyone wanted to go camping but only Jack and Dad Greene could spare the time. Doc, when consulted, thought a moment and replied that he could not leave. Billy Mac, whose over-flowing Santa Claus pack will always be remembered, said something about "the new store" and then he said "no" definitely. B.M. gave us a geological report and told about some recent canoeing in the Rocky Mountains and some vacation fishing trips which had taken all his leave for this year. Clay was game and ready to go anywhere until an invitation to see Panama with General Goethals allured him to the tropics. Howard was too busy bossing Brook Hill to consider a trip and then, too, he felt that his leave had been exhausted in a visit to Williams College in May. Carl was too busy working up a color temperament to be enticed away by pack and paddle. Mackey Wells had his vacation else-where and thus the old Gang seemed hopeless unless recruited up to traveling strength.

About this time, Dad Greene and William A. Norris, who will here-after appear under his schoolboy name of "B," talked of vacation trips and it was soon brought about that a party was made up of Dad, B and Jack. The trip planned was from Tower, Minnesota, through the Vermillion [Vermilion] Lake and Vermillion [Vermilion] River to Crane Lake and then through the chain of lakes, Sand Point, Namakan and Rainy Lake to Ranier, with a possible digression to Kabetogama Lake, which none of us had ever seen. It was arranged that we would get Dave Paris of the P. B. & L. Company crew to go with us as handy-man, and our friend, Eddie Whalen, promised to get us a cook at Duluth.

Then came several preliminary dinners. The Journal will now tell the rest of the story.

THE JOURNAL

The Gang always eats before it moves. This time grub pile was sounded at the Milwaukee Club for Doc, Billy Mac, Heine, Carl, Jim Crittenden and the three departing members, — Jack, B Norris and myself.

We had been told that the Duluth Sleeper left Milwaukee at 7:45 P.M., and when we checked our hand-baggage at the depot, we were told that the time had been changed to 8:00 P.M. As we were about to board the train, the news was broken to us that the Duluth Sleeper was now attached to a train leaving at 6:10 P.M. and that the best we could do was go to Madison and wait there until 1:50 A.M. and then take a train which would reach Duluth at noon. We, therefore, had about three and a half hours to kill at Madison. B and I made some pleasant walking excursions from the depot to which we returned from time to time to find Jack dozing and snoring the time away.

The train was to arrive at Duluth at 1:20 P.M. To save time, we had arranged for luncheon to be served on the diner before reaching our destination and we had just enough time to do the absolutely necessary errands before taking the 3:15 train for Tower. At E. J. Whalen's, we met Dave Mullen, who appears in last year's Journal with the "Pigeon Outfit."

At 7:00 P.M. we reached Tower, where we found the stolid Dave Paris waiting for us. He had brought both canoes to a dock about a block from the Depot and we had to paddle about a mile to where our Camp One was located. The tents had been set up and our boxes opened, so that we could get our blankets quickly and make up our beds. The men built up a big fire and we sat and talked until nearly ten o'clock. Our cook is Earl Kraus, a large, pleasant-looking fellow. A little away from our camp there is a shack where a squaw man lives and he came over to spend the evening with us at our camp-fire.[1]

This morning was spent in repacking our grub in bags and arranging our camp equipment. Late in the morning, everyone except the cook went to Tower to buy our last supplies and mail letters and postals. On our way back to camp we were drenched by repeated thunderstorms. After dinner, we hung about waiting for the weather to clear. We sent Dave to Tower to buy some more bread and get some nails which could be used in patching our guide canoe which seemed to be leaking. After the storm cleared, there was a strong wind and it would have been better to have remained in this camp over night, but we wanted to be as far away as possible from Tower on Sunday, so at half past five we pulled out. The beach was rocky and we could only load one canoe at a time and our baggage piled in quickly, made our canoes top-heavy. We traveled—B, Jack and I in one canoe and the two men followed us in the other.

There is a Government Indian School near Tower, which we passed.[2] The buildings are substantial. The

[1] The derogatory *squaw man* was at the time a common term for a white man in a relationship with a Native woman.
[2] The Vermilion Lake Indian School at Tower, Minnesota, was featured in the Winter 2002–3 issue of *Minnesota History* 58: 224–40. About a hundred students attended the school in 1915.

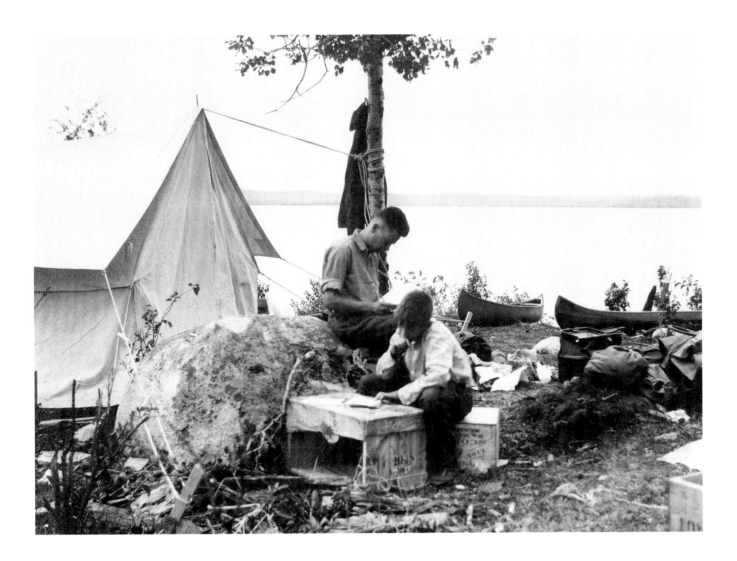

people in Tower, with whom we talked, tell us that the Indians become learned in white man's ways only to revert to their own customs as soon as they leave civilization.

Our first camp was on Hoodoo Point.

For the first two miles, our course was directly across the bay, so as to avoid rough water. We then ran under the lee shore to the end of the bay where we stopped and decided to land on an island about a mile down the Lake. The sea was too heavy and we shipped water over our bows so fast that we had to change our course to

another island, which was farther off. When we landed, we had six inches of water in the stern. The other canoe came up in bad condition and both of the men were considerably shaken up, for neither of them could swim. We had been in a somewhat dangerous position, but we could have beaten for some distance further or we could have run for the mainland. The island at which we landed we found to be swampy and with a rocky shore. A larger island lay a little farther on and we soon reached a rocky headland where we decided to camp. It was then about half past seven. Dave found a

good place for our tent and at the same time found a hornet's nest in which discovery he was assisted by B and Earl but no one was very badly stung. We made a short shift for supper and soon went to bed.

<div align="center">

CAMP TWO TO CAMP THREE

SUNDAY-AUGUST 15-1915.

</div>

Our experience in rough water had shown us that we had too much baggage for two canoes, and that we would be in that condition until some of our food supplies were used. We decided to buy another canoe at Tower. This morning, B and Dave went down and came back this afternoon with a birch canoe which had been made at the Indian School and for which they had paid eight dollars. It was a fair looking canoe. While they were gone, we packed up all of our stuff and made ready to start. We wanted to cross the long bay to Birch Point while the lake was smooth and camp there over night. This is the largest single stretch of open water we shall have to cross. It is about two and a half miles long.

We were just about to load when Dave came to me to ask,

"Will I have time to go to Tower?"

I asked him what he had forgotten and he said that he wanted to get another man. He then told me that he had lost his nerve and wanted to go home and thought that he had been suffering from the effects of the sun. The short and long of the story was that he had completely lost his nerve and showed the same yellow streak that his brother, Joe Paris, exhibited on the Presque Isle River trip. There was only one thing to do and that was to take him to Tower and send him home. With Jack for company and Dave for bow paddle, I took him to Tower. Dave paddled very slowly and was evidently afraid of the canoe although the water was very smooth. It took

an hour and a half to go to town, a distance of four and a half miles. Dave told me that there were a number of men who had asked him for a job, and I told him to find some of them and bring them down to the landing for me to look over. I cautioned him to tell the men that he was sick and was going home on that account. After about an hour he came back with two men.—One was a dirty looking Canuck, shifty-eyed and a hard drinker, with a sore on his face that had very much the appearance of a cancer.[3] This man said that he was an experienced packer. The other was a young man and inexperienced. His front teeth were gone and his face was in the process of changing into a funnel. I did not want either of them but I told them to wait. Just then I saw a muscular, square-shouldered man of about thirty years of age, wheeling a baby carriage. He looked capable so I spoke to him and told him of our situation. He said he knew just the man for us, if the man would go, and he was sure that if this man, Merrill, could not go, Merrill would know some-one equally good. Together we went up town where we found two men building a fence. I was introduced to Fred Merrill, a clean-cut, nervous man about fifty years old, who had been a cruiser. He didn't know whether he could go or not. When did I want to start? There was some further hesitation and an evident unwillingness to take a chance on the situation. The bargaining was interrupted by three puppies who came bounding out to see us. Small as they were, I saw they were Airedales, and asked him some questions about them. Fred was instantly alert and called the mother, a fair looking dog, and so we talked "dog" for a while. I again approached the subject of his going with

[3] Like many other common slang words of the turn of the century, *Canuck* is either a general descriptor or a derogatory one and refers to a Canadian, more specifically a French Canadian.

<div align="center">

</div>

us, and after a little hesitation, he looked squarely at me and asked,

"Are you a tender-foot or not?"

I replied that I didn't know but that I had been in the woods somewhat and that he might consider me a tenderfoot but that I thought I could take care of myself under ordinary circumstances.

"Have you been in these woods before?"

I told him I had gone from Ely to Ranier and of our trip from Windigoostigwan, Ontario, to Ranier. There was a little further hesitation and he said that he would go but that he wanted four dollars a day for the portages were long and hard on the Vermillion River. It was a good price to pay a man, but it was better to take a competent man than the kind that were waiting for me at the dock, so I engaged him. He dropped his job of fence-building and told me he would meet me in half an hour at the canoe. True to his promise, he was on hand in his woods clothes and with a pack on his back. We soon discovered the distance back to our camp. He looked over our outfit while we ate our supper and he began loading the canoes at once. I saw that he knew his business and left him alone.

We had had three piece of bad luck,—missing our train at Milwaukee, the drenching rain storm yesterday and Dave's yellow streak. I now feel that our luck ought to change.

The evening was absolutely calm with a smoky-blue haze over the water as the sun set. There was a beautiful pale blue light on low shores in the distance. The moonlight and long northern twilight lasted until we had passed Birch Point, and about a mile beyond that we made camp at a point indicated by a "Please Camp Here" sign of the Minnesota Forest Service.[4] There is

[4] The Minnesota Forest Service, founded in 1911, had made significant inroads here; these were the first campsite signs the Gang had experienced.

a sandy beach here, the only one I have seen, so that our landing in the dark was easy. We built a big fire and spread our blankets for a bivouac camp.

CAMP THREE TO CAMP FOUR
MONDAY-AUGUST 16-1915.

The clear night ended with rain at day-break. We tried to sleep but there was too much rain and it began getting inside of our blankets. We crawled out of our beds, set up one tent and took shelter. The rain did not last long and we were soon loaded and away. As we were packing, I noticed the cook had a bottle of "red eye," which accounted for some of his actions in the last day or two.

The distance from here to the Vermillion River is twelve miles. Jack and B travelled with me, Earl had the guide canoe, and Merrill was in the birchbark. We met some wind but not enough to make it difficult to handle a canoe. At one place we found a pier and a settler's cabin. This is evidently a resort if empty bottles and kegs can be considered evidence. About a mile from the Vermillion River, we stopped on the right-hand bank at one o'clock and had a lunch of hard-tack and coffee. As we had had our breakfast at six o'clock that morning, we were all very hungry. At the Vermillion River we met a steamer bound for Tower, by which we sent postals home.

At the outlet of Vermillion Lake there is a fisherman's hotel and a dock where the steamers land. The County road—a good road—passes here. We unloaded all of our stuff at the steamer pier where some of the loafer class of steamer people were hanging on and making comments, intending to discourage us.

"An awful lot of baggage to carry over twenty-three portages!" (The actual number of portages as shown on the map is thirteen.)

"Fred will have something to do here if he does

anything." A remark evidently intended to question Fred Merrill's willingness as a worker.

Then there were more comments on our baggage; the long portages and the rough trails but when these comforters found they were not noticed, they moved away in evident disgust.

The first portage commences right at the outlet of the Lake. Fred told us they have blasted in some rock to raise the water in Vermillion Lake and for this reason, they refer to the point as "The Dam." A man living there told me that the trails and portages are all marked by the Minnesota Forest Service, and that the total length of each portage is marked on the signs. This trail commences back of the hotel and is fifty-nine yards long.

As a matter of fact, it is about fourteen hundred feet from where we landed at the pier to the end of the trail. The trail is brushed out but is very stony, the footing is poor and the path runs up and down hill and is hard traveling. It was four o'clock in the afternoon before we finished this portage and we started on our way down River.

We paddled about a quarter of a mile to the next rapids, a portage of sixty rods. The footing here is a little better than at the first portage but there is no good place for a camp. Two or three hundred feet from the lower end of the portage, I found a place where we could pitch our tents on a hill-top, so we brought up what stuff was necessary for supper and continued our portaging until

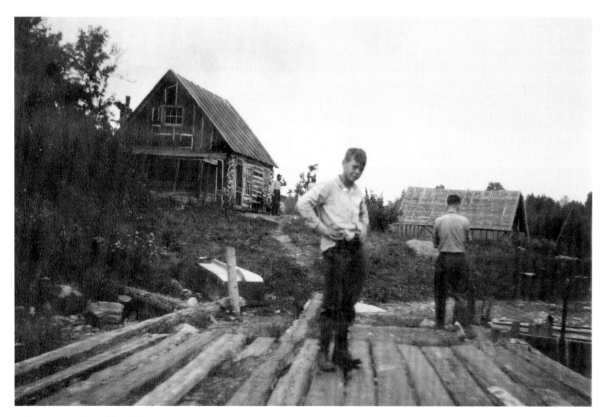

Steamer pier, Vermillion Lake

night-fall. In this way we got everything over except the canoes and a few odds and ends of baggage.

For supper we had an enormous corn-beef hash with potatoes and hot buns. We lighted smudge fires in our tents and outside of them. The mosquitoes bothered a good deal but we had somewhat the best of it because we were high up where there was a little wind and our smudge fires kept them away.

The site of our camp is well chosen, in fact, it was the only possible one on this trail, but our beds were rough and stony. Our backs and legs are lame from portaging, and we realize that it will be several days before we can carry our loads with any degree of comfort.

CAMP FOUR TO CAMP FIVE
TUESDAY-AUGUST 17-1915

We have discovered that Earl wants to make late starts in the morning, and that Fred, although he is fifty-one years old, is the more active of the two. He starts the fire and does a lot of camp work before our lubberly cook can pull his twenty-two years out of his blankets.

We had a good breakfast of prunes, Pettijohns with syrup, "Carnation" cow and brown sugar and coffee—an excellent filling to start a day's work.

Our camp gives good views up and down the trail.

Some fat fishermen, who were guests at the Hotel, crossed the trail and took a boat down River. We soon overtook them at a little portage over which they dragged their skiff. There is a fall here of about five feet. Half a mile or so we came to the fourth portage of about fifty rods. The trail here is good and we had some pretty views of the rapids. We lunched at the downstream end of the portage where the fishermen were busy with rod and line. We saw them take in a good-sized pickerel and Jack got out his rod and line and caught a small pickerel. The rapid was not difficult but it was hardly safe to run it with the canoes. I took Fred and B and showed

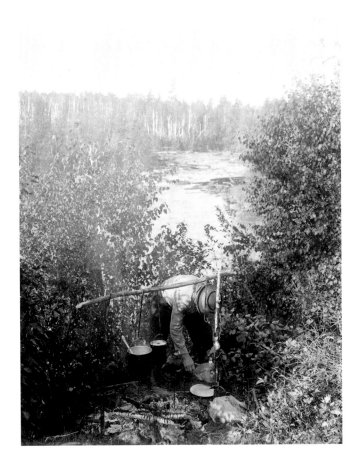

Fred how to rope a canoe through swift water. It was a new experience for him and he was excited. B and I kept fairly dry until the last canoe was over when B's foot slipped and in he went up to his neck. Fred got pretty wet because he was afraid to trust to the rope until he had seen a canoe worked through.[5]

[5] The men Dad hired were experienced cooks and woodsmen but were not experienced with canoes, nor were they trained guides. In many instances both the Gang and the woodsmen were learning skills from each other, be it cooking, roping a canoe, orienting, or log rolling.

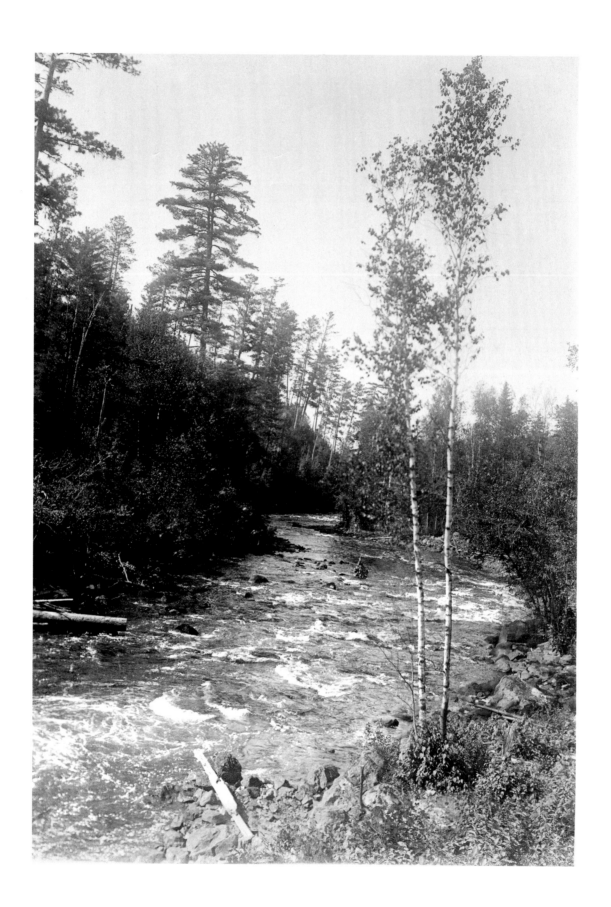

We were now in still water and had a long stretch of it before us. B and I shot ahead, hoping to see moose or some game. It was a long, hot paddle for several miles. The stream runs through rice beds, weeds and pond lilies and we saw fifty or more duck. Once a heron flew close to us and was just about to alight when she decided that she would be more comfortable in other surroundings. We passed a boat with three or four towhead youngsters in it, who were probably the children of some Finn settler in the vicinity.[6]

It was six o'clock when we came to the fifth rapid, a long portage of four hundred rods. We landed and were immediately welcomed and taken possession of by mosquitoes, flies and gnats. They were not only singers and biters but were so venomous that smudge fires gave us little relief. We explored and found an open trail, a bridge (somewhat broken) across the stream and a camping ground which was well up a hillside and a little exposed to the wind. We lighted camp fires and smudge fires and were comparatively free from mosquitoes. We pitched our tents and established our kitchen. The men set up their tent on lower land, where plenty of mosquitoes sang and bit all night long. This was our Camp Five. For supper we had the fish Jack caught during the day. It was after supper before we could get off our water-soaked clothes, for no one in his right senses would undress before so many mosquitoes. Darkness brought the evening chill and some protection from their inquisitive manners.

The view up the River and across was very good, especially the sunset and just before sunrise.

The hot day was followed by a cold night. B and I sat by the fire and talked of politics, history and education until after ten o'clock. The men got their blankets wet at Camp Three and had not taken time to dry them out. They are using our tent fly for additional bedding and they have most of the sod cloths at their quarters.

CAMP FIVE
WEDNESDAY-AUGUST 18-1915.

Earl was true to the reputation he has established in this Journal and he did not appear until after we were up at eight o'clock. We had a long sleep. We were "slept out" as Fred expressed it, but we were still stiff from portaging, paddling and camp work. During the morning, Fred explored the trail, taking Earl with him. They returned in the early afternoon and reported that the trail was "the worst ever." The "Company" has been logging here and has skidded logs across the trail so as not only to obliterate the path but it is so cut up that footing under a pack load is well-nigh impossible. Mosquitoes infest the entire trail. Below this portage, the "Company" has

[6] Areas of northeastern Minnesota, northern Wisconsin, and the western end of the Upper Peninsula of Michigan were heavily settled by Finnish immigrants. Finns made up over half of the population at the time of this trip and still make up about half of the population in some regions of the Upper Peninsula.

a camp and is building new camps. Fred talked with the people at the Camp about getting one of their teams to carry some of our stuff over, but the boss was not there and he could get no definite answer. He proposed that we cross the River at the bridge and see if we could not follow the work road to the County road, which leads to "Decaineys," five miles below. At "Decaineys" he thought he could get a team to carry most of our stuff over and we could then work the boats through or portage them, as seemed best. The heat and location of the camp, and the idea of spending at least two days in this portage, made his proposal seem reasonable, so Fred started out for "Decaineys." He will spend the night there and hopes to be back with a team before half-past seven tomorrow. In the meantime, we can do what work seems necessary and get packed and ready for tomorrow morning.

While working in the rapids today, I nearly ripped off the sole from one of my high boots. Unfortunately, I left my sewing awl at home and I had to improvise repairs with a piece of malleable iron wire.

Today Earl came to me and said that it had been distinctly understood when he started out that he should do no packing and he wanted to quit. I told him to be a sport and not talk of leaving when we were in the woods and could get no one in his place. After I had talked him into shape and given him a chance to think it over, I made him a proposition to make his pay two dollars and a half a day, which he accepted.

The River near our camp has one or two cascades that are much better than can be shown by a photograph, for a camera will take in only a small part of the River.

I have been carrying my photograph plates in a large

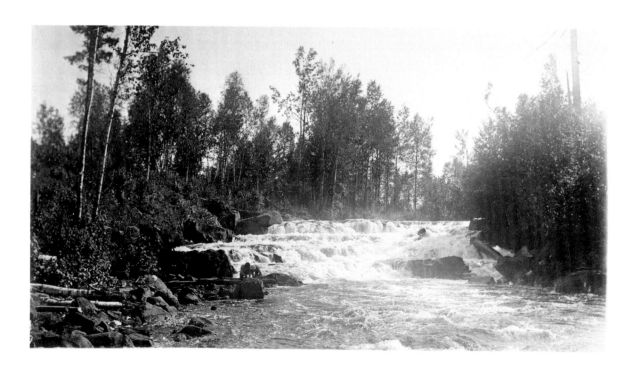

leather satchel, which was a back-breaking load for it could not be packed and it was so heavy that it swung from side to side and would not carry easily. From an old box, I made a smaller box that will pack comfortably. These jobs,—repairing clothes, oiling boots, etc., occupied the entire day.

Earl put up our fly for a dining room and we were very comfortable in its shade during the afternoon. We had a lot of chipmunks around camp and we had to watch our plates when we set them down so as not to have our food stolen.

We had a cool night and slept well.

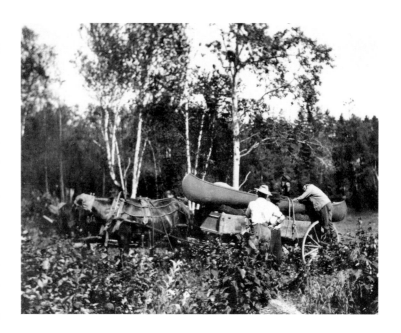

CAMP FIVE-"DECAINEYS"-
CAMP SIX
THURSDAY-AUGUST 19, 1915.

We were up early and commenced packing our stuff into the canoes to carry across the River. A little after eight, Fred appeared with a light work team of mares, one of which was followed by a filly. We took two canoe loads of baggage across the River to be portaged by the team. Fred wanted to load the canoe first and pack the baggage around it and on top, but I persuaded him to load the baggage first and let the canoe ride free on top. When the wagon was finally loaded, it carried all of our stuff. The work road leading to the County road is short and rough. The horses were nearly frantic with flies. They would not pull together and one of them balked. Just as we reached the main road, one of the "Company's" teams came along with an empty wagon and they loaded in our two other boats.

We were glad to leave Camp Five. It was hot, dirty and infested with all kinds of stinging varmints.

It cost us a dollar to get our two boats to the "Company's" camp where Fred picked up a lunch for us, and he, Earl, Jack, B and I started down the River with the photographic outfit. We ran a short rapid and then had our lunch on a grassy bank and made an easy portage of the baggage.

The next rapid was partly run and partly roped.

"Decainey's" is twelve miles by road from Vermillion Dam. Decainey owns a broad piece of meadow land from which he gets a good crop of hay and he also owns a store and a hotel. There is a church near the settlement. He charged us four dollars and a quarter for hauling the stuff from our Camp Five, including Fred's board and bed for last night. Our supplies are not low but there were a number of small purchases to be made at the store. There is a post office here and this is our second unexpected opportunity of writing home since we started. Among our purchases were two bottles of tar oil,[7] which the boys are going to use. Already their faces are nearly the color of Indians. Below "Decainey's"

[7] Tar oil was commonly used for sun protection in the early 1900s and remains an ingredient in some modern sunscreens.

Decainey's resort

we found some Indians in camp, and from time to time we saw nice, neat farmsteads of Finn settlers. In one place a woman was washing outdoors, singing as if she really enjoyed it. One Farm, which Earl thought especially nice, he told us about as "the place where the lady was feeding her pigs." As we went down the River, Jack fished intermittently but his line was constantly snagging in weeds and he finally gave it up.

We traveled about ten miles until we came to the tenth rapid, at five o'clock. There is not much of a camping place here but we found a place for our tent near a hill top, while the men made camp below. Except for our necessary things, the baggage was left at the bottom of the hill. The mosquitoes were in evidence but were not as bad as in our last camp and smudge fires made us fairly comfortable. For supper we had a corn-beef hash, followed by a talk. B repeated one of Alfred Noyes' poems, "The Barrel Organ," which Jack paraphrased into, "It's Milking Time at Genesee" and improvised

verses derogatory to some of our neighbor's farms. He thought he ought to be able to sell his production to Howard for advertising purposes. The boys said that I snored loudly all night. This is not true.

CAMP SIX TO CAMP SEVEN
FRIDAY-AUGUST 20-1915.

There was a delay of more than two hours in starting, all owing to the cook, who would not roll out. In the meantime we portaged most of our stuff over the trail, all of which is high and the footing is good. I made a picture of our camp in the early morning, looking up the stream, and also a picture of wild sunflowers that were growing around the camp.

Fred let the canoes down by rope, for he is quite proud of his new accomplishment, and we left the lower end of the portage at ten o'clock. Just as we left, three canoe loads of Indians came up; bucks, squaws, children, papooses, dogs and dirt. I gave Jack some tobacco for

them and he was cordially received.[8] Below this point, the River is not interesting. The banks are low and wooded and the stream flows through long stretches of wild rice in a winding, twisting course. Again Jack tried to fish but the weeds snagged his line. The Virginia and Rainy Lake Railroad, which is only a logging road, crosses the River twice, and at the second crossing, there is a large hoist, which Fred tells me is capable of loading seventy cars of logs a day. A little below this last crossing, we stopped for lunch and then paddled on through more rice fields, seeing plenty of duck and herons but nothing else. At noon, Fred told us of two camping places which we might make. B and Jack and I were in the lead, and when we came to the first, we didn't like it, and so we paddled on to where an old shack had been built by someone whose business it was to bring settlers into the country.[9]

Here we found a clear space for our tents, and there were good, rocky banks. After we

had camp made, I paddled out in the stream to take a swim. Jack came up to ask questions, and with his assistance I got my clothes spattered with mud and lost one suit of underwear. The splashing of his paddles wet my clean clothes, so I doubt whether I was any more comfortable than when I was thoroughly dirty. Below this point, are the larger rice fields, which Fred tells me is a great moose country.

CAMP SEVEN
SATURDAY-AUGUST 21-1915.

Early in the morning, Fred took B and me out to look for moose with the camera. We saw no moose but paddled into a great flock of mallards, who were asleep in the rice fields and because of the morning mist, we could not see them until we were right upon them. There was also a great flock of red-winged black-birds in the rice, the largest gathering I have yet seen. I tried to photograph both mallards and blackbirds, but with no results.

[8] While offering tobacco as a way of greeting, language that we now understand to be derogatory was used, such as *buck*, *squaw*, and *papoose*.

[9] During the late nineteenth and early twentieth century, a significant and often quite profitable industry revolved around attracting new immigrants to an area, supported by state government and agriculture departments. Advertising from that time included highly exaggerated claims of productive farmland available in the north woods.

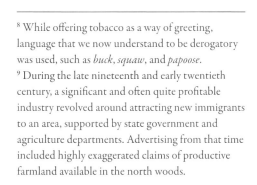

Here is where I had my best opportunity to picture a sunrise in the fog.

On our return to camp, we found Jack fishing. Jack came down to welcome us, and as he dropped his rod, Earl picked it up and in a minute he caught a lively twelve-pound pickerel. Jack was mightily disgusted.

We should have been out and under way early but owing to the cook's delay, it was after nine when we started. The run to the eleventh rapid was short and the portage was easy. We ran part of our baggage through and portaged the rest. We had lunch at the end of the trail. This was one of the prettiest portages we had made, and as we were finishing in the late afternoon, I was able to get some very good pictures with the sunlight striking through the woods.

The twelfth portage is in a curve in the River, where the banks are high or in cliff formation. It was impossible to either run or rope and we carried everything about thirty rods. There were some good views to be had up river and across. Just below this portage, we found a large buck dead in the River. The animal had probably been killed by someone who wanted a little meat and left the carcass where it would annoy the game warden. The game wardens in this country are thoroughly disliked and game is slaughtered and left to make trouble for them.

We had hoped to reduce the last (the thirteenth) portage by roping our boats, for it is scheduled as five hundred and sixty rods and we hoped we might make a part of it today, but it was too late in the afternoon.

Smoke on the bank brought us to an Indian's fire. There was a single Indian there who was eating his solitary evening meal. Fred talked with him and learned that he was going up-stream and that his canoe was at the other end of the trail. We, therefore, took his camping place but we were so tired we would have taken it anyway. The view up River is uninteresting, a continuation of the wild rice country we have been passing through. At our camp, the River turns at a right angle and there is a rapid at camp which can be roped and another below camp which could also be roped, and then follows a bit of clear water and beyond can be seen the upper part of a fall.—What is beyond that, we can only guess. Mosquitoes and gnats were with us all night.

CAMP EIGHT
SUNDAY-AUGUST 22-1915.

The day broke warm and at the end of the trail it was hot. I got up, called the men, shaved, changed photographic plates and then had breakfast. In the meantime, Fred had explored the trail and he came back saying that the lower end of the rapid ran through a "draw" a gorge with rocky walls on either side which could neither be run or roped. He told us that the trail led straight up a high hill and after that the portage was on a rocky ridge until it dropped off on the other side.

The length of the portage, as it appears upon the map, is five hundred and sixty rods, and in reality, it is very nearly a mile long. We commenced portaging

· 311 ·

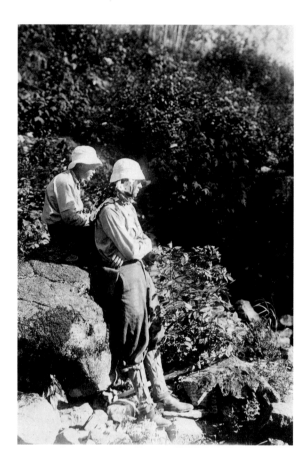

been killed by a hunter who had cut off the feet so as to reduce the bulk to what he could easily carry.

By two o'clock we were well on our way down the River. The banks are high and well timbered. We soon came to Crane Lake and made our way half way across the Lake to what seemed to be a good camping ground. It was on a point of land and had been used before by both Indians and whites. As we landed, Jack found some fungus on aquatic plant stems. They were as large as cocoanuts and from the exterior looked spongy. The inside was almost a clear white, gelatinous mass.

B, Jack and I washed our clothes and had a swim before supper. While we were at supper, a launch with three men came across the Lake from Harding. Fred knew one of the men. Harding is nothing more than one or two houses and an Indian store kept by a man named King, and he is located at the end of the Railway. There is no post office. Every few days someone goes to "Decainey's" where letters are mailed. We sent two postals home.

While we were at our noon lunch, at Camp Eight, we saw a cow moose walk into the river a little way above

at eight o'clock and by three in the afternoon we had had our lunch and finished the portage and we were on the River once more. The day was hot and the climb up the steep hill was killing. We were worn out when our work was over. The portaging was too long to make light loads and with heavy packs we had to rest. As the men were making the last trip, B and I ran up River and made a photograph of the rapids in the gorge. Fred said he had heard of it but had never seen it before this trip. The gorge is well off the trail, and through tangled timber and rough stones.

We left Jack at the end of the portage but he thought he heard a bear or wolves and tried to follow us along the bank. On our return from the photographic excursion, we found the feet of a deer, which had recently

the Camp. After a few moments, she swam down River toward the Camp and it seemed as if she were about to land at our Camp, when she either saw us or smelled us, for she turned and in a few seconds was caught in the current of the stream. We saw her struggling in the rapids, saw her go over the rapids and with some difficulty climb out on the bank and walk off through the woods. Unfortunately, every bit of our photographic outfit was at the other end of the trail. Fred told the story of the moose to the men who visited our camp this evening, and it was touched up so that it was a bull moose with horns of six feet spread. On the trail we were working today, a moose had recently been killed and most of the carcass had been left to decay. We saw little animal life. One porcupine met us on the trail and disputed possession. The rocky road over which we traveled was used for a sunbath by partridges in the early morning.

CAMP NINE
MONDAY-AUGUST 23, 1915.

I was up at half past five, called Fred and had a swim. It was nearly an hour later when Earl came out in answer to our several calls. We packed up and were off at half past eight. All of us were glad to be out of the River and back on lakes again. The shores of Crane Lake are low and the place is somewhat rocky. A dam has been built at Kettle Falls so that Crane Lake, Sand Point, Namakan and Kabetogama are all part of a general storage reservoir for the water power at International Falls on Rainy Lake. As nearly as I can judge, the water is two or three feet higher than normal. Fortunately, we had a following breeze and we had no difficulty in finding the channel to Sand Point Lake. Big storm clouds rolled up and the varying cloud and light effects made our passage through the channel very attractive.

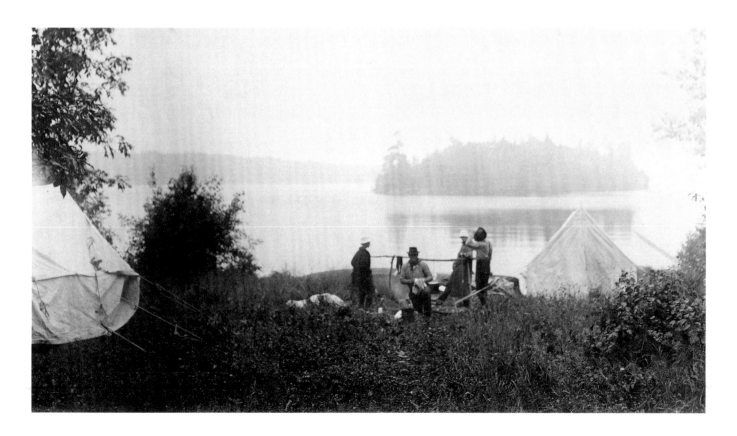

At the narrows on Sandy Point, we found some fishermen on the Canadian side and we set Jack ashore so that he could say he had been in Canada. Jack saw the International Boundary mark and enjoyed the novel sensation of being partly in one country and partly in another.

We had our lunch just above the narrows, and in looking about, I saw a peculiar slashing on a nearby point. Investigation showed that a random and corrected line had been run, and from a point I could begin to pick up other points where the survey had been run for the International Boundary. Here and there we still see the "Dawson" pine tree guides to travelers. Today was the first time that I had occasion to use a compass and I found that my compass was entirely unreliable. Fortunately I have another with me which is correct. We found the channel to Namakan Lake without very much difficulty and at about four o'clock we camped on the Canadian side, halfway down the channel, and made short work of pitching our tents, for the rain was beginning to fall.

As the evening came on, the rain ceased, a northwest wind blew strong and we had a cold night but we

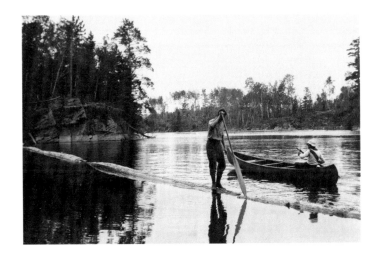

were entirely free from mosquitoes. We decided that we would not move tomorrow, preparatory to a very early start, which is necessary in crossing windy Namakan. This morning, Fred told us he thought we would have three days of cold, mist and rain. Jack asked me about it and I suggested that they were trying to "throw a scare into us," so Jack went back to the cook to whom he confided that Dad was prepared to cross Namakan Lake rain or no rain, wind or no wind, and then he reported to us that the men did not like my program.

CAMP NINE
TUESDAY-AUGUST 24-1915.

We spent eleven hours last night in our blankets. The weather was very cold, so cold that Jack, towards morning, crawled in to my blankets to share them with me. It rained a little during the night and it rained a little as we rolled out of bed. B and I made plans for various repair jobs and other things we wanted to do, and I made some pictures about the camp.

I also made a little study of moss and wintergreen, using a tilting head on a light tripod. These are studies I have intended to make for several years.

Fred spent a good part of the morning at the fire that B built back of our tent, and had an hour's chat with me. He is a well-informed, intelligent man, who has seen something of the world.

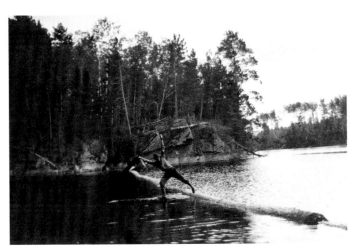

Jack walking a boom

· 315 ·

At about half past two, the sun shone a little, so Jack and Fred went fishing. B went to look at Namakan. He was in a light canoe and the first swell from the Lake tipped him over. He came back to camp in this moist condition and tried to walk a boom at our camp. Of course, he went in and later he and Jack went swimming; and then came a contest at rifle shooting followed by a general picking up about camp. The sun set clear and the outlook is good for a fair day tomorrow. B made a fire at our tent in the evening, and the full moon came up through the pine trees and made the night very bright. We left the tent open the cold wind blew over us all night. I have marked this camp with a blaze indicated by a red rag and our initials—this is for Mr. Norris.

CAMP NINE TO CAMP TEN
WEDNESDAY-AUGUST 25-1915.

I called the men at five o'clock and we made preparations to get away early. I had told Earl what we wanted for breakfast and that he must get up early and have the things ready for us. Earl did not roll out of his blankets until the tent was coming down. In reply to his question as to whether we wanted to leave at once, I said that we would get on the way as soon as possible, and a few minutes later I saw him paddling away in his canoe. He was trying to make us leave without breakfast because the hour for breakfast did not suit him. Fred called him back to "boil the pot" and while he worked he was as sour and disagreeable as could be.

By this time, the night wind had increased and was blowing hard from the northwest, shifting to north. We knew that we could not buck our way across Lake Namakan with the birchbark and so stayed at camp, Indian fashion, sleeping and waiting for the wind to go down. At half past ten the wind subsided a little, so we piled in the last of our camp stuff and started for the Lake,

which was about a half mile away. Here we faced white-capped waves and strong wind, and we were obliged to lay to under a point on the Canada side.

We had a dinner of fish, corned-beef hash, dehydro corn and tea.

While we waited for the wind to die down, Jack and Fred shot a mark, B fell sound asleep in the sunshine and I wrote up the Journal.

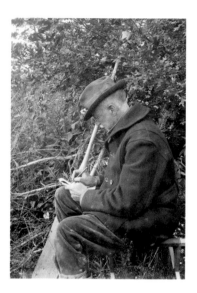

It was about six o'clock when we finally started out. While the men went on, I stopped on an island at the end of the channel to make some pictures of the rocky island at the outlet. The sun was near the west and the temptation to work the camera into the sunlight was very great.

The first half-mile or so was not in very heavy sea, and as the wind subsided with the setting of the sun, we had quieter water and more northwesterly wind blowing from the mainland. Our plan had been to see the south shore but we expected a north wind tomorrow; and as the Lake was open, we wanted to be on the leeward side.

The islands and shore in Namakan Lake are all rocky and the effect is much bolder than on Sand Point Lake where the rocky promontories are higher but are bare. The light of the setting sun and the cloud-coloring was gorgeous, and in the east the clouds were a smoky purple. The two sun-sets we have seen on Vermillion and Namakan Lakes have shown the most beautiful range of coloring I have ever seen in this region. At twilight

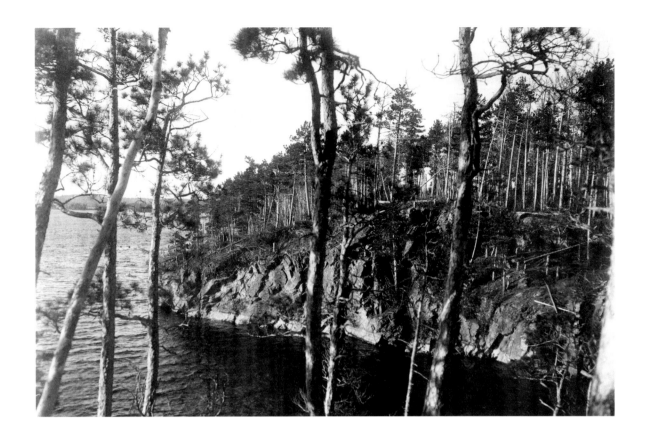

we began investigating places for our camp and at a second rocky point we stopped. We found a beautiful spot—there were places for sleeping between balsams and young pine trees. The men pitched the tent for themselves and closed it up tightly while the rest of us spread our tent for a bivouac camp, taking precaution to leave a part of the tent for an extra covering if the night was cold.

It was half past nine when supper finished, we went to bed. We spread our beds facing to the south so as to see the full moon; but an aurora display appearing in the north made us get up and turn our beds around, so that we could watch the play of the northern lights. They were the best northern lights we have seen on this trip. They were a brilliant greenish-white, mostly nebulous. At times there were long streamers of greenish-yellow, but only once we had a brilliant red streamer.

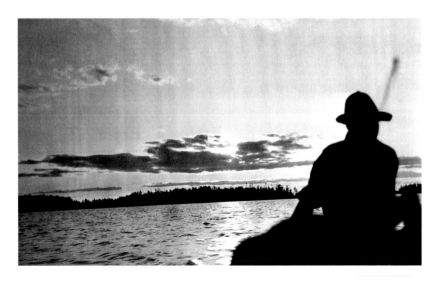

Last night was one of the two nights that I can recall when I went to sleep in spite of an effort to stay awake. The brilliancy of the northern lights, the quiet, and the clear, cold air were something to remember.

For breakfast we had bacon, Pettijohns with cockroaches and coffee. The Lake was smooth and there was no breeze, so we took our time about starting. As we left, a birchbark canoe with an Indian, his squaw and baby came up and watched our departure. As we took our course up the lake, we met two other canoes, and of one I got a good picture, which didn't please the Indians.[10]

Our course across lay generally toward the southwest end of the Lake. We stopped once to look at an old Indian tepee where Jack found a snake for a playmate.

At ten o'clock we saw a forest fire to the west and came close enough to see the flames. It did not amount to much for it was only burning the moss and dry undergrowth.

We had a pleasant site for a lunch camp, where we talked things over. Fred had been running a course for the south shore, which was all right; and he was looking for the channel to go to Kettle Falls where I planned to run in tomorrow to mail letters and buy a few supplies. After lunch, Fred turned south into a bay and I then saw that he really didn't know the course. He had been on the Moose River at the southwest end of Namakan Lake and had traveled in a boat from there to Kettle Falls. He was, therefore, paddling in a southwesterly direction, looking for the Moose River, and,

of course, all of this was carrying us away from Kettle Falls, which lies considerably to the north. I realized that Fred was working his way in a blundering fashion, so I had him come up and I took the lead myself. With compass and map, I guessed our position, and after a very little paddling, I had made the main channel lead-

[10] Here the gang took greater liberties in their interactions and willingness to snap photographs without asking first for permission, as they had in most of their trips.

ing to Kettle Falls. Fred is unquestionably a good man in the woods but he knows the least possible of finding his way by map and compass on open water. The result of this change from the course was that we arrived at Kettle Falls and made camp a little above the Falls at five o'clock. B and I went down to Kettle Falls and saw the rapids which have been dammed. When I looked for the old settlement at Kettle Falls, I was entirely lost, for it had been completely obliterated by fire and has not been rebuilt. Back of the old settlement, across a marshy space, there has been built a sort of boarding-house or hotel, which seems to be a stopping place for lumbermen and cruisers. There is no store, but we were able to buy a little stuff at the hotel and mail some letters. We bought bread, rice and flour, etc. At the hotel we met a young man from Winnepeg [Winnipeg], a very sociable fellow, who said he had been down through the Canadian waters with one of the park commissioners. He told us of the beauty and wildness of some of the Canadian lakes. His tale makes that part of the country look more inviting to us than the exploration of the eastern part of the Dawson route, which we had so often talked about.

We returned to camp and carried our stuff out to a rocky promontory where we found a good soft bed of moss. We pitched a tent although we slept in bivouac camp. Neither Fred nor Earl will sleep out of doors since that night on Vermillion Lake when we got a little wet from the rain. We were entirely free from mosquitoes and there was no necessity of closing the tent, but they tied it up tight and lost all the benefit of the cold night air. As we were going to sleep, a big owl came near the camp and let out several hoots. We had been tell-

ing wolf stories and the owl's hoot did not add to Jack's pleasure in the least. He was very willing to lie close to me and soon went to sleep. The owl came nearer and hooted over our beds but did not wake Jack.

CAMP ELEVEN TO CAMP TWELVE
FRIDAY-AUGUST 27-1915.

We tried to make an early start, but, as usual, the cook would not rise and it was after nine before we left the camp and then we had to buck the wind all the morning. Our course for several miles was the same as the one that we followed up the night before, then we bore more to the west to get to the west end of Namakan Lake. As we came over the Lake today, the weather was clear and we had good drinking water even close to shore. This morning the water was not clear at our camp and I had everybody drink "Postum," tea or coffee because the water had an unpleasant smell. As we went

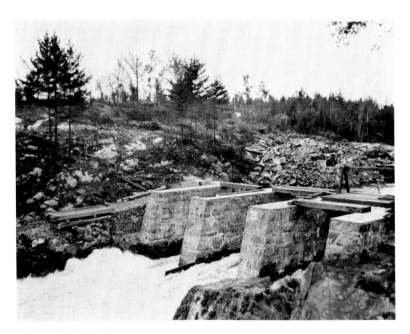

Dam at Kettle Falls

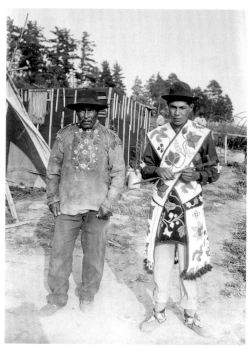
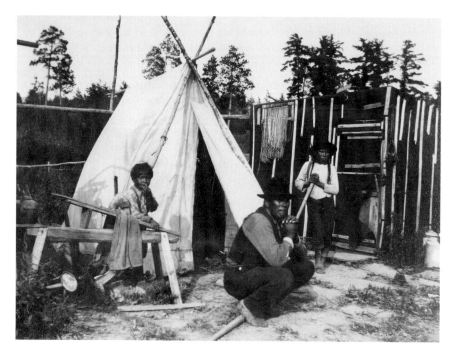
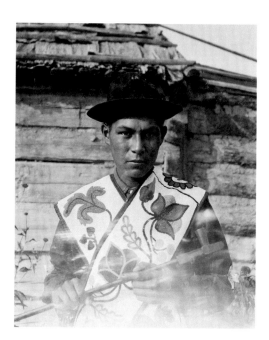

up the Lake, the water was green. Earl said it looked as if somebody had mixed Paris-Green with it. The water, which was clear yesterday, was full of green stuff, mile after mile. Whether it was a fungus growth or not, I do not know. To make matters worse, it gave the water a disagreeable taste.

At noon we made a lunch camp, and the day being hot, we spread out on the rocks and slept for an hour after lunch.

At the west end of Namakan Lake we found an Indian settlement at Moose River. Fred talked with them and for fifty cents consideration, two bucks dressed up in their best togs for their pictures.[11] After that it was twenty-five cents to one and half a dollar to another, and so I continued the picture-making. Fred said that they were "doing" me and that I must not pay them any more money. Then they became sulky and Jack thought it was time to leave. One of the young Indians was a clean-cut young fellow who gave his name as Roy. He talked very good English. He said he would write me if I would send him a picture. Except for his general appearance of neatness, I didn't notice him, but they told me that he was consumptive and was spitting blood and coughing.[12]

This is the way with the Indians.—They get consumption and go very rapidly. Fred gives this band a very hard reputation.

We pushed down through the narrows into Kabetogama Lake and as it was getting late, we looked for a camping place. The banks are high and rocky and we had hard work to find any place that was suitable. The night was cold and it looked a little like rain, so we had

our tent set up and then slept outside. There were very few mosquitoes, not enough to annoy us. Our camp was in a grove of Norway pines with a beautiful view of the lake.

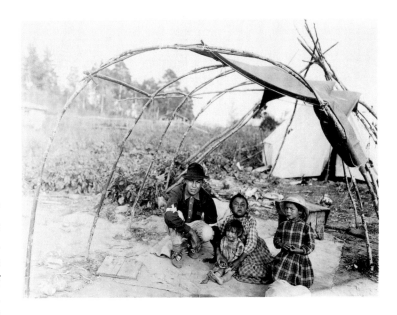

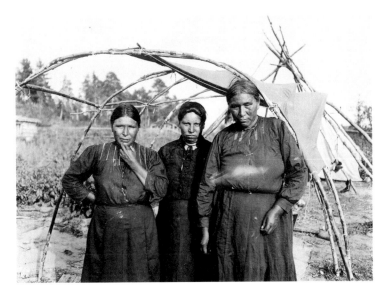

[11] In this short interaction, where the group exchanged money for a few photographs of two men, the common term *buck*, now understood as derogatory, was used.

[12] *Consumption* is a term for tuberculosis.

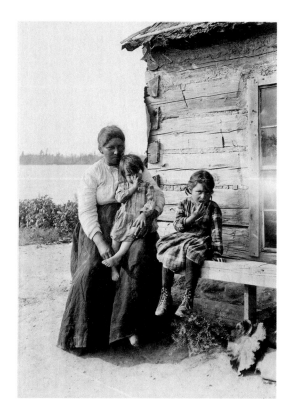

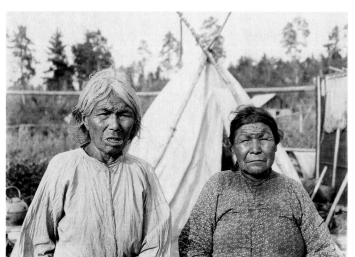

I told Earl to get bacon and pan-cakes for supper. In a few minutes he called us and I found that he had opened a lot of canned goods and had done nothing he had been told to do. He claimed that he was short of bacon and that he had forgotten to tell me about it when we were at Kettle Falls.

Toward morning it rained, but not enough to make us take our beds into the tents

CAMP TWELVE TO CAMP THIRTEEN
SATURDAY-AUGUST 28-1915.

Our plan was to get Earl to cook in camp while Fred, B, Jack and I explored Kabetogama Lake. Earl was surly and said he could not bake or cook in the wind and could not make the stakes for his fire-place stand up because there was no ground. I was disgusted with him and left him to get over it.

I had an opportunity this morning to make some photographic studies of mosses.

A huge square block of rock is covered with ferns and looks like a bit of green-house planting.

I made a study of some blue-bells and wild grasses. I hope this last one will be a successful picture because I have always wanted one. The blue-bells are so light that the slightest breeze keeps them moving and I think they will be hard to picture.

As we were getting ready to start, Fred came to me with the suggestion that we had better all move to a better camping place, make a good set up against threatening rain and leave Earl there to cook. This was a good suggestion. Earl, of course, could cook where he was, but the camping place itself was not good.

Half a mile down the south side of the channel we made our Camp Thirteen. There is a thick growth of young timber, and halfway up a hill,

Fred found a little clearing which was large enough

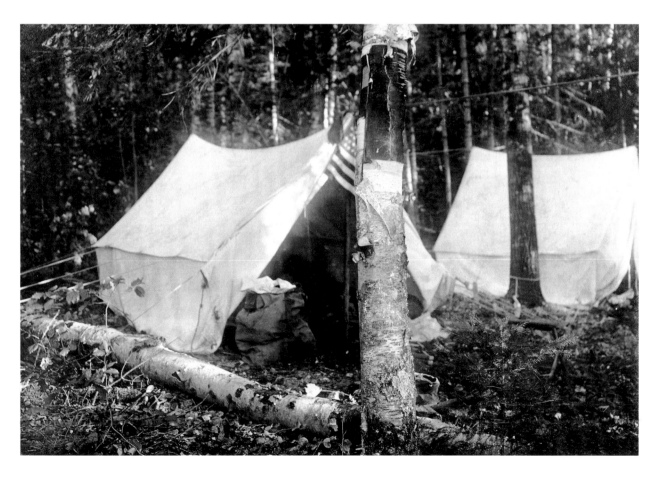

for two tents. It took quite a little work to make a path to our boats on one side and another to the cook's place on the other side. By the time we had finished making camp, dinner was ready and then the rain began to fall. During the afternoon, Jack, B, Fred and I made a trip to Lake Kabetogama, but it was so rainy that we did not go far. The timber has been cut at a good many places and the country has been burned over. It is really not as attractive as Rainy Lake. During the day, gasoline launches used for fishing and trade passed and re-passed our camp. This country is getting far too civilized for any comfort. During the afternoon we did a little rifle shooting and then we built a drying fire in our tents, had supper and went to bed. We did not have much stuff to dry out but the fire added greatly to our comfort. Jack has daubed his face with balsam pitch—will it ever come off?

CAMP THIRTEEN TO CAMP FOURTEEN
SUNDAY-AUGUST 29-1915.

For us, we made a fairly early start in spite of the cook's usual delay. Once started, we paddled straight along to Kettle Falls where we stopped near our old camp site for lunch and to pick up our birchbark canoe, which we had left there. I hoped to trade this off on somebody, for it is a poor canoe made by the Indians at the Indian School at Tower to sell to strangers, and instead of pitching the seams, they had used rosin. The bark is not well attached to the gunwale and had begun to drop away.

We made an easy portage at Kettle Falls, where I met a stranger who was curious about our boats. I tried to sell him the canoe for five dollars, but failed, so Fred traded it off at the Hotel for five pounds of bacon, four loaves of bread and two bottles of beer.

We left Kettle Falls at quarter after three, and paddled to our old "Camp Fourteen" site of our trip 1910. It is no longer an attractive spot as it has been used as a camping place by a large party, apparently engineers, for they have left broken stadia rods and such stuff lying around. The whole place is littered up and dirty. The old bath-rubs we used to have at the western end of the island, are flooded, for the level of Rainy Lake has been raised by the dam at International Falls.

We looked at our old friend, the "Jap pine" tree, and I made a farewell picture of it with the Graflex.

We left at four o'clock and paddled from point to point. As the wind subsided, we made straight for the last one of the Pine islands, where we found a suitable place for a camp in a group of Norway pines. The views of the sunset from these island were some of the best we have had on the trip.

Fearing rain, we set up our tents and then made our beds outside. We were soon obliged to retreat to the shelter of the tent, and hardly were we settled before our camp fire blazed up and threatened to burn up the whole island. In making his fire, our fool cook had built up a fire-place with two piles of stones, and for a back log he had chosen the upturned root of a cedar tree. I noticed it but said nothing about it for I had "jumped" the cook so much that I was getting tired. Then, too, I thought it was Fred's job to look after the cook. Earl said that he had put eight buckets of water on the fire before he went to bed, but I believe he lied, for I saw a little blaze when I went to bed. We were all out at midnight in the rain, trying to carry water over piles of rock to put out the fire which had spread over the resinous

groups of cedar and through the dry undergrowth. I think the cook really felt hurt at some of our observations. Of course, when we returned to our tents, everybody's clothes were wet and we were thoroughly dirty from handling the burned and charred wood.

CAMP FOURTEEN TO CAMP FIFTEEN
MONDAY, AUGUST 30-1915.

I wanted to get away from this camp early in the morning, and I had so warned the men. As a result of our being up during the night, I did not awaken and when I did, it was so dark and rainy that I thought it was early. B got up, looked out and told me that the woods were afire again. I called the men and this time we had more than an hour's job, for we had to work into the woods and carry out every bit of fallen timber we saw afire and get out fallen trees, and then thoroughly soak the mold with water to keep the fire from spreading. During breakfast, there were some pointed remarks addressed to the cook but he was a little bit more timid today

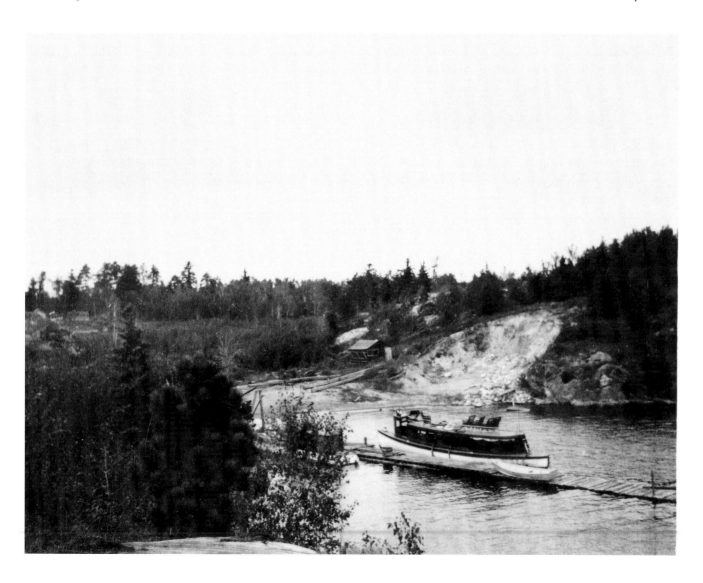

than he was yesterday. There was a white pine tree here that grew like a shrub, dwarfed from exposure to bleak winds.

It was late in the morning when we left our Camp Fourteen, and almost immediately we encountered a head wind. Fred was very anxious to get to the lee shore under all conditions and I let him lead, for there was nothing else to do. After lunch, we started out and as we ran to the point, I saw that the sea was going to be too heavy and we returned to the lee shore again where we "lay to" for several hours. We continued on the course of my choosing (working across Saginaw Bay) and finally, after dark, made camp on an island which was about a mile and a half from the narrows. We were all pretty well tired out from paddling. Had we made our get-away from Camp Fourteen early in the morning, we would probably have made our way across Saginaw Bay before a wind came up to impede our progress and then we could have beaten along the shore so that we could have passed through the narrows long before sunset.

Our camping place for tonight is among big Norway pines, and it is really very attractive.

CAMP FIFTEEN TO RANIER
TUESDAY-AUGUST 31-1915.

This morning we made a reasonably early start for Fred saw the necessity for making the Narrows early. As we passed through the Narrows, Fred saw an Indian grave, but I had my eyes somewhere else. I am sorry I passed it, for I wanted the boys to see it.

The old Dawson pine which served as a guide mark in the channel, has been killed by the rising water and now stands desolate and alone.

We held our course pretty well by the south shore and I paddled pretty steadily to an island where we had lunch. There was some moss which I pictured, while Jack and Fred fished. We did not have to buck rough water very much today. On Dayweed Island there were forest fires, but nothing serious.

We passed Rainy Lake City and saw the shaft of the old gold mine and then picked up our course through the Islands for Ranier, which we reached at half past six in the evening. Our trip across Rainy Lake was, in some ways, the best trip I have made across the lake. Today we were so near the shores that we saw a good deal of the rocky shores and twisted pine growth, growing in the crevices of rock, the carpeting of heavy moss and wild flowers.

At Ranier, we landed on a pier and sought the hospitality of a shed to change to our best camping clothes, which were none too dry or clean, but were not anything like as bad as what we wore. The Ericson Brothers, the store-keepers whom we had known before, came around to see us and I sold them the Thompson canoe for fifteen dollars. I gave Fred the guide canoe, for he was very much taken with it. I also gave Fred enough food stuff so that he was a substantial winner beside his pay. To Earl, the cook, I gave his just and full pay, his railroad fare to Tower and I told him he could pay his own fare back. There were no kind words coming to him from any of us.

Our old friend, Barker, who formerly ran the hotel, has gone out of business and it is now more bar-room than hotel. A sign is prominently displayed in the office, "Sleeping in the office forbidden—Beds 50 ¢," so we followed the rule and engaged beds. Fred did not engage his bed soon enough, so he had to wait until I left my bed at two o'clock in the morning before he could get a place to roll in. Our train came along at two o'clock and we got accommodations on it for Duluth. We left Fred behind to pack up and ship our stuff home to us.

We reached Duluth at 9:20 and after engaging sleeping reservations for Milwaukee, we went to the hotel and proceeded to clean up. It was nearly one o'clock before we were clean enough to appear in the dining room. During the day, I saw Eddie Whalen and Neville P. Mowatt, who heard that I was in town, and came down to see me. With Mowatt for company, we took an auto ride in the afternoon and left for Milwaukee at 5:55.

Mr. Norris met us at the depot on our arrival and invited us to the Milwaukee Club for a farewell breakfast.

Here the Journal ends, but I feel that there is still a word to be said as to the pictures. I thought all of my photographic outfit was in perfect order, but, alas, I trusted too much to a black bag in which I change my plates and it leaked light. There are a number of plates which except for this accident were good and would have added greatly to the interest of the Journal. I particularly regret losing portraits of B and Jack.

I hope there will be a next trip and that some of the old gang will be with us and that the picture-making will be more successful.

———

DATA

The following table of elevations is from the Minnesota Geological Report.—

Lake Superior	-	601.56
Vermillion Lake	-	1357. (13.60)
Sand Point Lake	-	1121.
Namakan	-	1121.
Kabetogama	-	1121.
Rainy Lake	-	1111.

The total distance traveled by canoe must have been nearly three hundred miles.

THE CHIPPEWA RIVER TRIP

1916

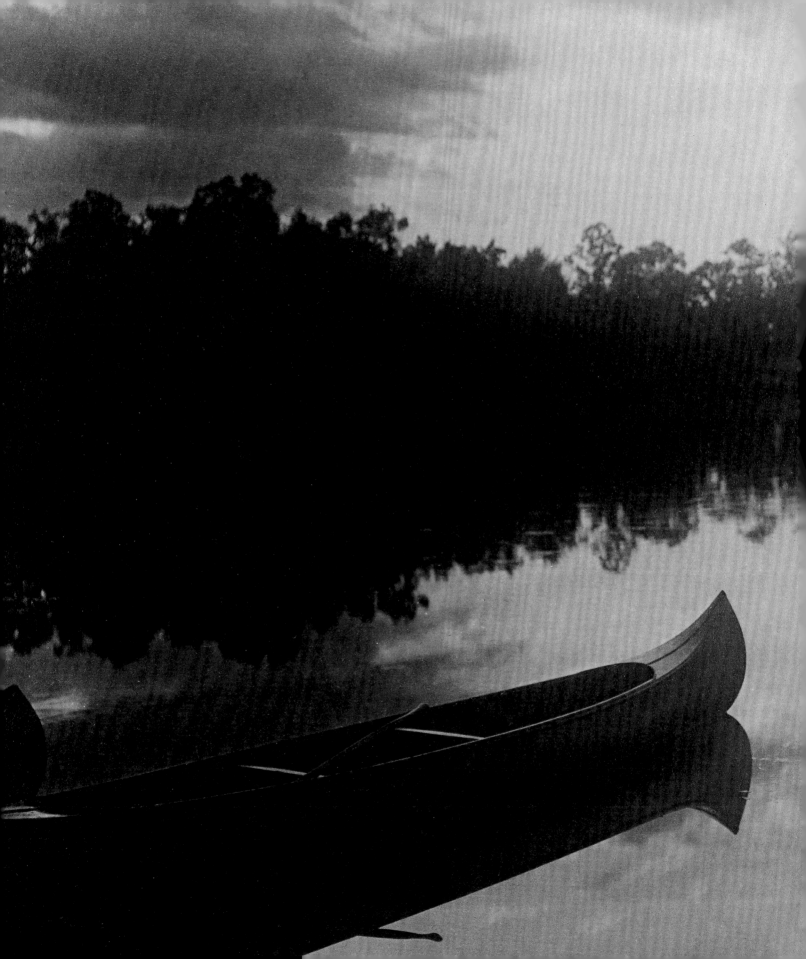

THE CHIPPEWA RIVER TRIP
AUGUST - 1916

The 1916 Chippewa River trip forms with the Wisconsin River trip of 1906 a pair of bookends for the other six trips the Gang made between 1906 and 1916. The route echoes their first trip made on the Wisconsin; the Chippewa was a more settled river, within one state, and didn't require making their own maps or having such extensive outfits. They would be near towns, railroad lines, and settlers' farms. Nevertheless, it was a canoe trip and fulfilled some of Dad's and Doc's needs to get away in the outdoors and travel by canoe.

This journal is slightly abridged. Passages have been selected to reflect the spirit of the trip and capture many of the highlights.

Doc and Dad were the only men available from the old Gang. Dad's youngest son, Jack, and Russell Greene, a cousin visiting from the East, made up the rest of the camping party. Joe Paris, a cook from the Presque Isle trip, came along to help, adding one more familiar face. The party was overall a much quieter and less camp-experienced version of the former Gang.

The terrain, the population, and land use made the Chippewa River seem pastoral in contrast to the rugged landscape of the Canadian border rivers. This area had been developed earlier than the lakes farther north, so that logging was mostly a matter of history in the Chippewa valley, and some of the cutover land was already reforested. In contrast to the Wisconsin, the Chippewa was smaller and was not the same kind of working river. Few dams existed, and very few more were ever to follow the summer of their voyage. The Chippewa was a good choice for two slightly older men traveling with two inexperienced campers and introducing them to the ways of the wild.

Dad's photographs no longer focused on wild cascades and rocky islands. Instead he made several botanical studies as they slowly wended their way downstream.

While in camp, Dad and Doc read from a book on socialized Germany; the war in Europe was just beyond the horizon. In April of the next year, the United States would enter the Great War. Everything changed.

The Chippewa River was a fitting, if not foreseen, end of the Gang's trips. [M.G.P.]

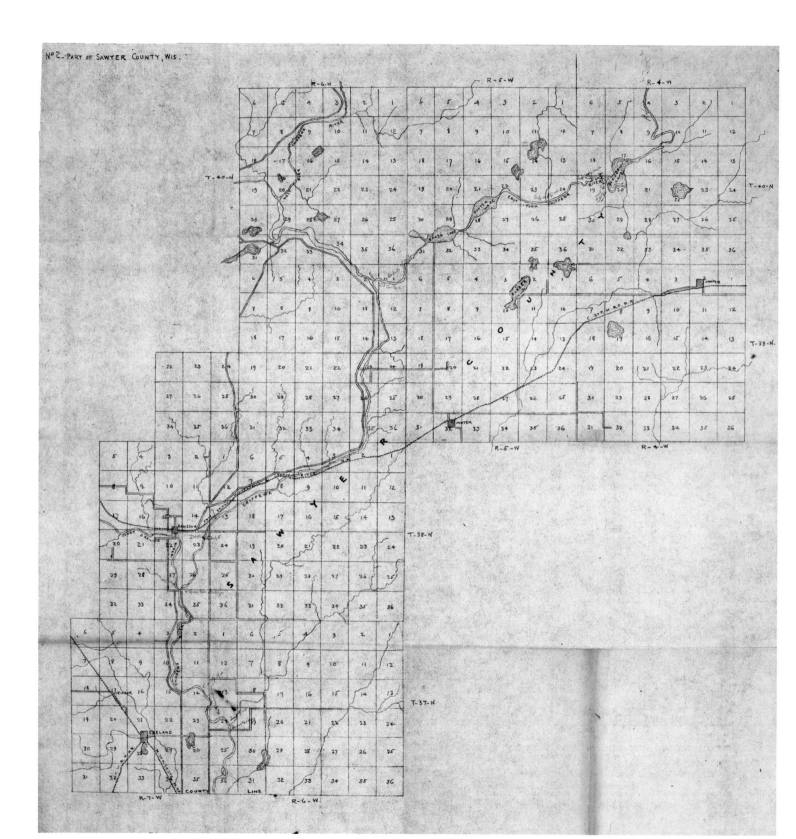

THE CHIPPEWA RIVER TRIP

AUGUST 1916

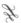

BEFORE LEAVING

. . . On Friday, the Fourth Day of August, 1916, both Doc and Dad decided that they could retire from civilization on or about the middle of that month for a short trip . . . The maps of the still untraveled part of the North indicated that a canoe trip on the Chippewa River gave promises of satisfying all conditions.

Of the old Gang, neither B.M., Billy Mac, Howard T. or Carl were available. Clay was reached by telegram at Wequetonsing, Michigan, and wired in reply:

"Can't go. Want to more than anything. Aint it hell?" This reply suggested the night he talked to mosquito bitten horses on our way to McFarlane Lake in 1915. Billy Norris had made other plans which could not be changed and so the make-up of the party was Doc, Dad, Jack and Dad's cousin, Russell H. Greene of Barrington, R.I. who was visiting in the West.

The next Sunday was spent in over-hauling the camp equipment and preparing lists of supplies. By the next Wednesday, everything had been shipped to Glidden and Mr. Haslanger of the "P.B. & L. Co." had agreed to furnish two men,—Merrill Gould, a brother of P.B. Gould, the woods superintendent of the P.B. & L. Co." as woodsman and Joe Paris, who was with the Gang on the Presque Isle River, as cook. All were to meet at Glidden on the morning of the sixteenth of August.

There was no opportunity for Gang dinners for the making, unmaking and revision of plans, but Billy Mac summoned to the Milwaukee Club on Tuesday, August 15th, for a farewell dinner:

Jack

John Crittenden Billy Mac

Billy Marr Howard

Doc Dad

The envious stay-at-homes made many sarcastic or pointless comments on our trip as being through a country interspersed with summer colony settlements. Their spirit of jealousy was embodied in a map and guide-book prepared for the occasion by B.M. and Billy Mac and appear as expurgated plates in Dad's original copy of the Journal.[1] Otherwise the dinner passed off very pleasantly. We left the obsolete members of the Gang and boarded the Soo Line train at eight o'clock.

Doc offered a professional miscalculation as an excuse for not being with us to help in making camp but agreed to join on Friday at Glidden.

[1] This mock map and guide book appear to have been lost as they are not a part of this journal.

THE JOURNAL

The advance party left at 8:15 by Soo Line for Glidden.

Dad found the men in one of the forward cars. They had boarded the train at Oshkosh. Both were sober, which is a good omen. Mel does not drink or smoke.

On stepping on the platform at Glidden, at 6:23 A.M., we were assailed by teamsters who insisted on hauling us and our equipment to Shanagolden, a summer resort three and a half miles away which they said was the proper point of departure for by leaving from there we would avoid twenty-five miles of "bad—very bad" river travel. They were aided and abetted by a man who insisted on our breakfasting at the Layton House, a downcast hotel near the depot. Glidden, even at that corner of the town, seemed to give promise of a better place and we soon found a fair hotel where we breakfasted and then began to look about for a place to make camp, arrange our equipment and await the arrival of Doc.

At the edge of the town and on the River Bank we found an open field with a bit of underbrush for shelter. Beyond it lay an open hayfield, somewhat wet and uninviting. It was this or falling right into the hands of the teamsters who were still trying to way-lay and mislead us. We piled our boxes into canoes and paddled downstream to a camping place, which was beside a very little dam built to make a pond for a mill above which is cutting lath and ties.

We had the usual line of advice from citizens of the hanger-on type on the foolishness of starting from any point except Shanagolden, on the dangers of rapids and windfalls, dams and bad run of the River we were to travel.

All our supplies are here except the oleomargarine. This always fails us for at least a day. There are good stores where we could get butter, eggs and bread for the days of luxury-feeds until we commence to travel. The weather is more than hot. It took all day to unpack our stores and establish camp. At noon we had bread, bacon and eggs, and at night we had a real dinner of corn-beef hash. From a local butcher we bought some chunks of very old cow for bouillon tomorrow.

Glidden is in a condition of wild excitement. A street carnival is planned for tonight and there is a special car of merry-go-rounds and other paraphernalia and a car of performers. During the evening, the boys went up and took it all in. From our camp we could hear the "barkers" and could almost smell the crowds.

The country has been cut over and is uninteresting.

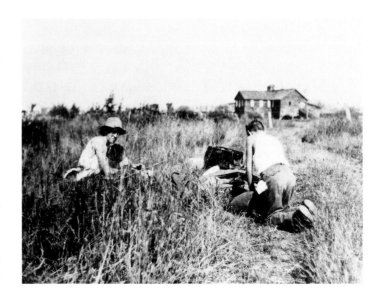

Treeless hills and houses bare of anything attractive quiver in the sun while switching engines pull cars and cars of ties and hard-wood bolts.[2]

While the boys were up-town, a native human drifted into camp and sat down to smoke with me. He is time-keeper in charge of a crew rebuilding a disused veneer mill into a broom-handle factory. He has fished and trapped a good deal and is longing for his work to be finished so he can go out and be alone again. I walked half-way back to the factory with him. He has the rare faculty of taciturn companionship in a pipe. The boys and I watched the moon rise over the treeless hills opposite our camp before we went to our blankets.

[2] Cutting hardwood was the second round of logging in this area. The primary source, white pine, had been gone from this part of the state for several years. The logging companies turned to hardwood for a new source of income.

We were free from mosquitos, that is, comparatively free and we had a comfortable night though Jack found his bed hard. We are commencing to live for we had a really "Gang" breakfast of pettijohns with flies, pancakes, hash and coffee.

Knowing I would have a day to kill, I had brought up some left-over work from the office and by early afternoon, I had launched a job back to the office. What a reception for Miss Fichtner when she returns from her vacation!

Joe baked bread and at noon gave us a most delectable stew of the meat of an old cow. His bouillon was really a work of art when backed by lyonnaise potatoes and bread.

The boys explored the River a little below camp and they found a tree blown across the channel and behind

it a mass of driftwood. I looked over the situation in the afternoon with Mel and we decided to portage from camp to a point beyond the bend where it is obstructive. We will begin our work tomorrow after the Doc comes.

The day has been cool with some sunshine and occasional passing showers. Tonight the carnival again holds forth. There is an abandoned saw-mill near camp and the boys explored it, finding belting and saws left just as when the work ended. During the evening, Mel and the boys went to town; Joe fished and after lighting a mosquito smudge in front of the tent, I stretched out for a rest. I fell asleep and awoke startled by some noise in camp. Joe was just coming in from fishing and as I raised my head, some good-sized animal which had been prowling in our kitchen, went past me with a rush. It was probably a coon or a wild-cat. During the night, we had thunder, lightning and rain. Our cups—straight sided cups—showed more than an inch of water. There was probably an inch and a half of rain-fall. Both of the boys got their bedding wet and some things they left outside were well soaked. I had spoken to them several times and had decided to let them learn something by experience.

<div style="text-align:right">

FRIDAY

AUGUST 18

CAMP 1 TO CAMP TWO

</div>

The boys were up early to go for the Doc and a little before seven they brought him into camp but without his dunnage bag which the train man had not thrown off. During the morning the boys dried bedding. Russell made his first portage, carrying his bed-roll to a point to which Mel and I had been carrying some of our baggage. This is below the windfall which obstructs the river channel.

Joe made a fine bouillon for dinner and by half-past

twelve, we were ready to leave our bare, hot Camp One. We are only awaiting the return of Doc and the boys who have gone to the town for the Doc's bag which ought to come by the noon-way freight. The Doc's bag did not come so he bought a blanket and made a kick to the Soo Line. Mel and I had made one trip to the drift jamb on the River in the canoe laden with baggage. We portaged this on the open side and then dumped our stuff on the bank. After dinner, we started downstream in two canoes, portaging as Mel and I had in the morning. The stream is very tortuous and we travel easily two or three times the distance indicated on the map. The banks are grown with alder and occasionally we find a considerable growth of pine and on the higher land, hard wood. Their farms are usually well taken care of and they have good dairy cattle, probably the influence of the creamery at Glidden. Twice we ran into driftwood jambs which we portaged and twice we were able to work through but not without some of us—Mel and I—getting into the drink.

At six we found a nice clearing in a settler's pasture. Here the River makes an ox-bow bend. The farmer's house is on the other shore and he has a big bridge across the stream. The night was hot and sultry. We tried a bivouac but it was too hot to sleep. Cope and I got up to smoke and finally we fell asleep for a little while. The mosquitos were not bad but the boys were annoyed and finally they retreated to the tent.

<div style="text-align:right">

SATURDAY

AUGUST 19

CAMP TWO TO CAMP THREE

</div>

We were out early. Cope and I took a walk after breakfast along a work road leading along a hardwood ridge through dense virginal growth—mostly maples. The river is still tortuous but from our general course we know we have passed the big bend in Section 34. We

worked our way through several jambs of driftwood and through occasional bits of rapid water.

At noon, we reached Shanagolden, the summer resort we have heard of, and found it a well-nigh deserted saw-mill town with a saw-mill and dam in dilapidation. We had lunch at an old log landing. In approaching the mill, Mel and Jo ran their canoe onto a spike and we laid up two hours while Doc repaired her bottom.

After passing this dam, we came to a succession of small rapids and finally I stopped, seeing one ahead that was too long to venture and I did not want the others to follow. I started in and a moment later was in the water leading the canoe; the Doc and Mel worked their canoe by line while Jack and Joe kept dry. Russell was willing to do but he is unaccustomed to this sort of thing. We passed these rapids after about an hour's work and at about four o'clock we found a fair camping place but decided to run until we found another. On and on we went. My canoe struck a sunken rough rock and staved a rib. It was six when we caught

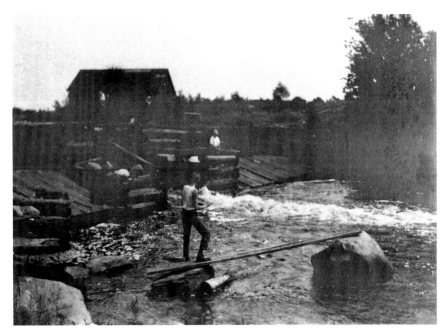

Shanagolden sawmill and dam

up with the Doc at the head of Pelican Lake where he had located an indifferent camp site in the hard wood. It was apparently Hobson's choice[3] and a thunder storm was threatening. We made camp and filled up with bacon, boiled potatoes, bread and a can of cherries. I was very tired and so Doc and I took his canoe out to be in the cold night air and listen. We heard coons and the splashing of large fish. When we came back, we had very definite but not spectacular northern lights.

Pelican Lake is a broadening out of the Chippewa River. The shores are ready and give promise of good fishing.

<div align="right">

SUNDAY

AUGUST 20TH

CAMP THREE TO FOUR

</div>

This day Joe had set aside for baking and he made many loaves and some biscuits. Doc fished and caught one fish.

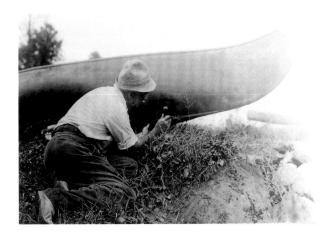

[3] Hobson's choice: a choice in which only one viable or actual option is offered.

The boys fished and Russell caught one fish.

I did sundry odd jobs and made some pictures. The Doc, in the course of his canoe explorations, found a bed of purple water flowers which he believes are lotus flowers. He brought me a specimen to photograph and later I am to try picturing them on the bed where they grow.

There are some good mosses and lichens about here.

About twelve o'clock we left Camp 3 and moved across the Lake to Camp 4, which is on a hill-top where the wind will reach us. The Camp is in a grove of young Norway and the view down the Lake is very pretty. . . .

In the evening we built a fire at our tent door and went to our blankets where we watched the fire until we went to sleep. I made pictures of the men and a group picture of Russell and Jack.

Both Doc and I were tired from working our canoes through the rapids yesterday. I had a heavier load and was leg-weary all day.

We slept late and it was nine o'clock before we were fairly under way. We were soon in the rapids again but I was only out of the canoe three or four times during the morning. At a point at about 23-41-3 W, a new branch of the logging railroad crosses the river and a crew of peelers have been stripping hemlock logs. Here we met two men who were apparently cruisers but they had a good canoe and were just starting in. They did not know the location. We saw four porcupine. The River is falling. At noon we came to Bear Lake and camped on a sand beach for our lunch. There are some wild grasses here which I photographed. I also made a picture of a patch of Lycopodium and a picture in the hardwood forest back of our noon camp.

Just as we finished lunch, one of the two men we met at the railroad crossing came into camp to show us

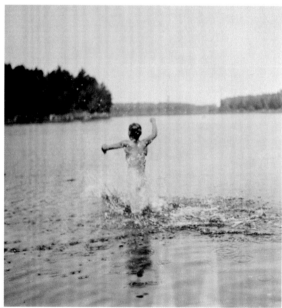

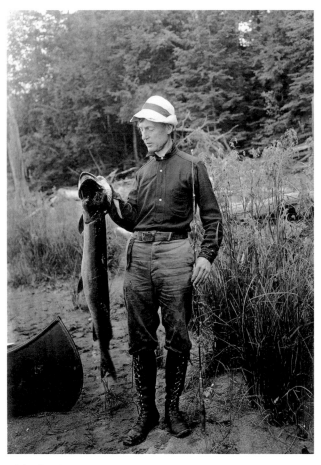

Theodore Brazeau

a big muskalonge he caught this morning. His name is Brazeau, an ex-senator from Grand Rapids, Wisconsin, and I made pictures of him and his big fish.

Right after lunch, all left for the dam at the lower end of Bear Lake except Russell and I. I paddled around the Lake while Russell trolled but caught nothing. We had a little difficulty in finding the outlet for the overflow has obliterated the natural lay of the land.

The party had made camp at the dam when we arrived. The dam had gone out but it still holds back some water. The camp is on the wing wall of the dam—a high and breezy spot—and below is a small rapid.

Doc caught a pike and bass for supper.

Early in the evening, two deer—a buck and doe—crossed the river about 300 yards below our camp. The night was cool and broken by showers. We were in our blankets by eight o'clock and I do not know how late we slept but it was well after daylight when we were ready for breakfast. . . .

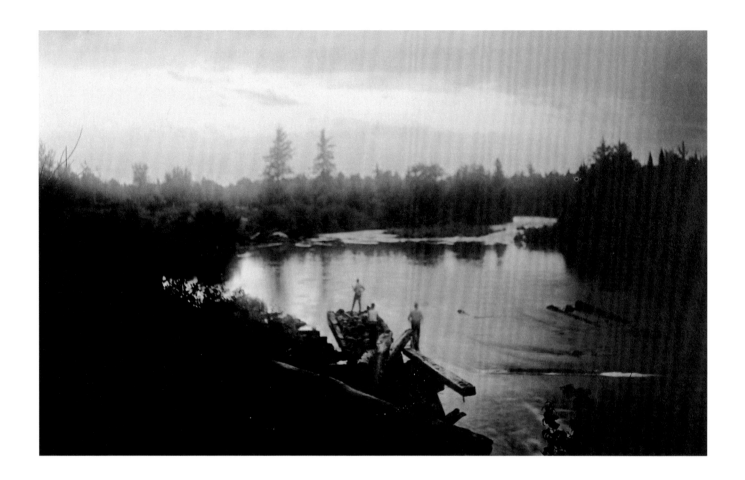

Rain threating, we decided to remain in our camp until the weather cleared. I made pictures up and down stream and I tried to make some Graflex pictures of flowers—milkweed and sunflowers—which grow about the camp.

The boys played and fished. Joe patched his clothes and Doc fished and picked berries.

I am tired. I can work in the canoe or about camp all right but when work is over and my bed roll is looked after, I am willing to read or to do nothing. During the morning, I read a little and wrote Journal. Incidentally, I had visits from Joe and Mel.

After lunch we started. In view of everyone, Doc, attempting to steady his canoe, fell into the drink and was jeered as he emerged. A rapid was just below camp and this we ran easily. Then came more and more rapids of the race-horse variety. We ran a good many and my boat got severely bumped. Finally I feared to risk it anymore and my judgment was good for the rapid was as rocky as it looked and we are well loaded. Mel, Doc and I were in the water continually and at times I had Russell get out to lighten up the bow. Finally we came to Blaisdell Lake, a reedy widening of the river, about two miles long. We found a clean camping place toward the further end of the Lake and brought our battered canoes ashore. My canoe has received the worst treatment due in no small part to the material used. It is built of crooked grain

cedar, very dry and brittle. Doc came through best and our old guide canoe bought in 1909 for our first trip into Canada is on its last trip. I only hope it will hold together until this trip is finished. There are a good many fish here. We see big fellows jumping every day but the water is so high they won't bite. Occasionally we met people fishing, usually two men in a skiff, who tell us they are having no luck. Who these people are I have no idea for there are no settlers here. —Probably people who spend their summers in the woods, living on fish, deer and berries and in the winter either work in the camps or trap. . . . We had a wonderfully beautiful sunset tonight.

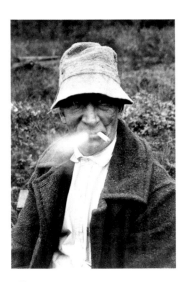

Doc

Below our camp is the camp of a lumber or construction outfit. We had berries for supper picked right about our camp. . . . The night was clear and when darkness fell, there was not a cloud in sight. Our tent was up but we made a bivouac camp. The night was really cold and we slept all of ten hours.

WEDNESDAY
AUGUST 23D
CAMP 6 TO CAMP 7

Russell reminded us that it was just a week ago that we arrived at Glidden and became unpopular with the persistent hotel-keeper and still more aggressive teamsters. The one place where we were popular was the drug store where the boys spent all their money on ice cream.

We had berries, ham and eggs and coffee for break-

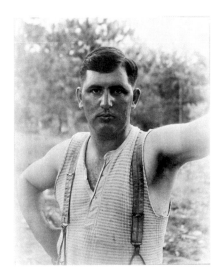

Joe Paris

fast. The berries are very good. . . . Joe reminisces a good deal on the Presque Isle River trip and some of it looks very funny in retrospect.

We shall have to spend the morning in camp repairing canoes. Doc has constituted himself repair man and he is doing good work, if it only holds. This year, I cut our repair outfit down to reasonable proportions, below what the Doc advised, but it should have been larger. Another year, I'll take a tin box of tools and repair equipment that will be lighter than our old roll and I'll look to the tools more carefully. This year everything was done in too much of a hurry.

During the morning, we aired our blankets. They were getting damp and, of course, very smelly.

Joe baked some corn-bread for lunch and told me how tired he got of corn bread on the Presque Isle trip when our commissary supply was reduced to corn-meal and very little flour and corned beef, a diminishing supply of coffee and dried potatoes. He says he learned on that trip not to waste.

Mel and the boys went to the camp and found it is

a small lumbering crew. He got some tar for our boats and a few odds and ends. He tells us that below Blaisdell Lake there is a mile and a half of rapids. We are now about eleven miles from the Junction of the West Fork of the Chippewa River.

The boys tried fishing with no result. They brought in berries for lunch.

Lunch finished, we started down-stream at one o'clock, passing under a logging and railroad bridge at the end of the Lake. There were a few little rapids and then we struck a succession of rapids a mile and a half long. We ran these fairly successfully but we were all obliged to take to the water at times from ankle depth to full depth. I was especially careful because of the frail condition of my Kennebec canoe.

Hunter Lake looked fairly good but we preferred to keep going, expecting to camp between Hunter and Baker Lakes where we could fish in both waters. The passage is narrow between the two lakes, the banks are high and there are small rapids. Baker Lake offered at least one fair camping spot but we passed that to look

for a better. It was a sure case of "next point" for we went on and on through rapids, where we ran by guess, for the sun on the water was so blinding we could not see and took our course by the draw of the water and the looks of the river banks. There is a bad rapid at the lower end of the East Fork, nearly a half mile long. At half-past six we came to the place where the East Fork and West Fork of the Chippewa River join and we made camp. Everyone had to change clothes for we were all soaked in working our canoes through the rapids. The night was clear and free from chill. Russell and the Doc took to the tent while Jack and I made a bivouac camp until after midnight when a shower drove us to shelter.

By a compass course and according to the map, we have travelled eleven miles, but taking into account the windings and twistings of the stream, we have covered fully fifteen miles this afternoon.

The stream below must naturally be larger and we are told that it will be comparatively free from rapids.

We bought fresh potatoes at the camp near our Camp Six.

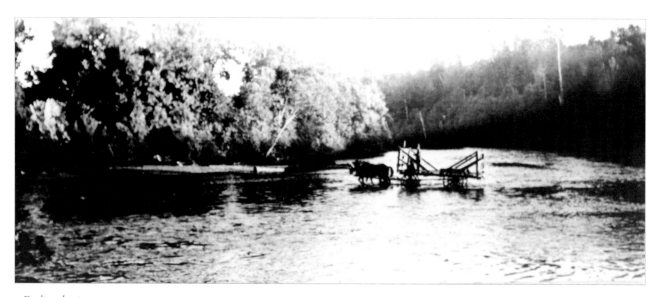

Fording the river

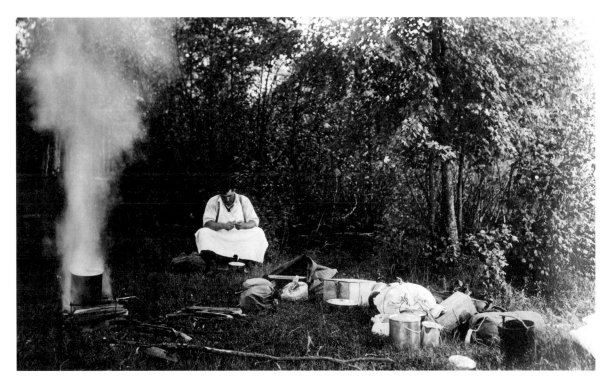

Joe making "drop cakes"

We have made good time and we have probably covered the most interesting part of the River and all our canoes need some over-hauling. The river looks as if it might contain some trout and so we decided that it would be well to camp here for a day before going on.

The mosquitos drove us out of our tent early. The men had rolled out early, built a fire and gone fishing so we waited until seven o'clock for our breakfast. In the meantime, I made some early morning studies of stream and flowers. While at breakfast, a passing shower drove us to the shelter of our tents. In exploring back of our camp, I came across a potato patch evidently belonging to the lumber camp across the stream. I also found a profusion of wild morning glories and sun-flowers and the bees were working them for honey.

Before lunch, everybody shaved except the boys.

In the afternoon, Joe made "drop cakes." Doc patched canoes. The men tarred the old guide canoe inside and outside. Tar cannot hurt it for it is on its last trip. I read "Socialized Germany" for a great part of the afternoon and at intervals went out to talk with the Doc about the book.

The night was cold and everyone brought his blankets out for a bivouac sleep and so we were awake reasonably early on the morning of

The morning was showery. Doc patched at the canoes and then he and I crossed the river (the West Fork) and worked out to a main road. It is a good road,

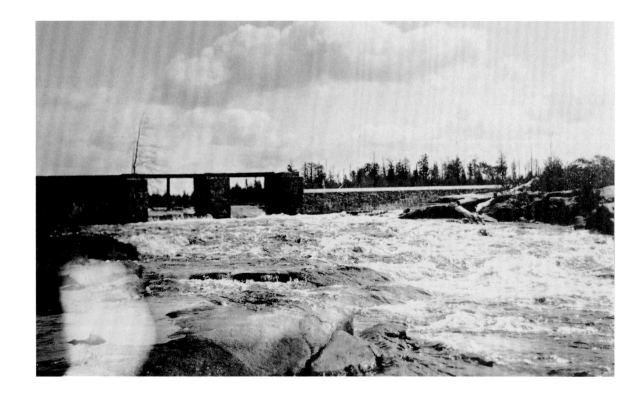

good enough for auto travel. There is a beautiful bit of nature—a hardwood forest—here and we found large bunches of northern elderberry along the road-side. There are plenty of berries to be gathered here and on our return to Camp, Russell took a cup and went across for some.

We left our camp about 11:30 and worked steadily downstream until five o'clock when we made a camp at the dam below Radisson. The camp is in an old over-grown borrow pit made when the original dam was constructed. The old dam has gone out and is now partially replaced by a masonry and concrete structure.

During the afternoon, we paddled about 15 miles, running various rapids and going through without having to get out of our canoes. This was our first dry-foot day. The camp being established, Cope and I took a canoe to inspect the dam and look for the easy way to portage. The dam is not high and will not hold much of a head of water. The pondage is very moderate. The spillways are vertical on the down-stream side. There are various openings for Tainter gates but the gates have never been installed.[4] Wooden flashboards take their place. On the east bank of the river a large canal has been excavated and it was clearly the intention to build a power house about a half a mile below and thus take advantage of a considerable fall below the dam. The work has been abandoned and two old machines for excavating are left beside the canal. A portage could clearly be worked out on this side but it would be a long carry.

At the west end of the dam, we found we could make a short carry with our canoes and stuff and then start out through the rapids either roping or running them.

There we had supper, a beautiful sunset, and the sky threatening rain, we all went into the tent to sleep with a big, roaring fire in front of the tent. During the evening,

[4] A Tainter gate is a curved gate operated on a radial arm, used for flood control.

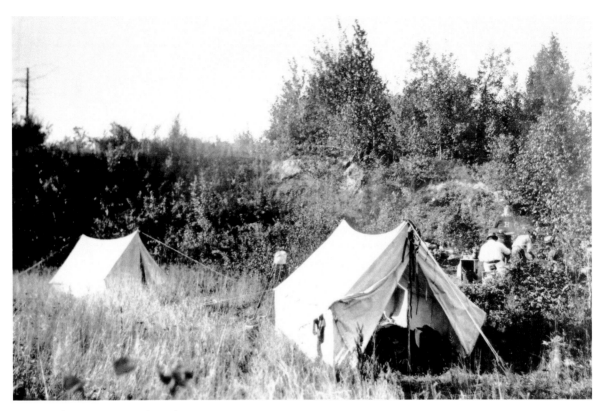

Camp in barrow pit near Radisson dam

the men with the boys went to the town and found it consisted of a bar, a store where bellyache candy was sold and a post office which was closed. I sent postals to Carl, Mrs. Greene, Miss Fichtner and Mr. Strong.

SATURDAY
AUGUST 26TH
CAMP 8 TO CAMP 9

We were all out fairly early. The boys went to town; Doc and I idled about camp and then stretched out on a pile of mess bags and blanket bags and went to sleep in the sunshine. Joe baked bread. At half-past two we were ready to start and we took our canoes across the dam and loaded up. No one knew the course of the rapid but we could see that the draw of the river crossed and re-crossed repeatedly. Russell and I were in the first boat and soon were on the rocks and out of our boat up to our waists in the water. The worst end of this rapid is at the lower end and when we reached it, we found Mel and Joe on the rocks at the right bank. They had profited by our misfortune and had passed us and now we ran by them and into a heavy horse-race rapid where we struck with water coming in over our bows. Cope followed with a similar experience. We both had to stop to bail out and then we ran several lesser rapids before we came to still water and found a place for our lunch camp. The Doc, Mel and Russell changed their clothes. I was wet but not quite to the belt so I thought it best to dry out as I could during the afternoon and be ready to take to the water. Our lunch

Russell Greene

camp was in a pretty place and after drying out my load as well as I could, we started down-stream.

This country is well settled and where crossed by bridges, they are made of iron. At one place, Mel bought some eggs of a farmer. Most of the farmers, although in the process of clearing, look prosperous. Where we had noon camp, there was a good field of corn.

At about four o'clock we found a place on a high bank edged with Norway pine which was apparently on no man's farm and we decided to camp. The river views are very good. There should be good fishing here but it was not until after supper that Doc caught a small pickerel and a good-sized bass. Jack and I arranged our blankets for a bivouac. Cope took to the tent and Russell, after trying to make the best choice and method, decided to bivouac. We were hardly in our blankets before a brilliant display of northern lights commenced. The aurora covered nearly the northern part of the heavens and was a series of flashes of greenish light with occasional flashes of red. Once I awoke during the night and the aurora was then flashing from the horizon upward.

The camp site is covered with blue-berries growing on low bushes. Cope started the boys picking with promise of a pie. The night was very cold and water standing in pails froze over the top. Cope fared worst of all for he is short blankets,—he had only one light pair which he bought in Glidden and one of my pair of army blankets.

SUNDAY
AUGUST 27TH
CAMP 9 TO CAMP 10

Canoe patching is an every-day matter with us; my Kennebec canoe is the regular offender and Cope always does the patching. This morning, while he patched, I read to him from "Socialized Germany."

After our cold night, the day was hot—too hot for comfort in the sunshine unless we were at some wind-

swept spot. At this camp we found a poplar tree about 5 inches in diameter which had been felled by beaver and another of the same size which was nearly cut off. The workings were a month or so old.—Cope thought they were much older but I found a smaller poplar tree felled which still bore this year's faded leaves.

The view from our camp up and down the river made it a very attractive place. Some farmers who live across the River came down for a morning's visit and fished all the morning without catching anything. We had lunch in camp—among other things a blue-berry pie from berries the boys picked yesterday. After lunch, we made a short run to Camp 10, a little below the Soo Line Bridge on the Duluth Division.

There is a high bluff upstream from our camp and Jack helped me to get some pictures.

The western sun glared almost too strong for our pictures but we ventured it, shading the camera with one hand. No good.

Dinner was a gorging success. The boys started a big fire at our tent and were helped by Cope and Mel. I laid out my bed-roll for a bivouac and Jack stretched his beside mine. The others slept in the tent. The night was cold—not as cold as last night—and there was a dense fog over the River.

<div align="right">

MONDAY
AUGUST 28TH
CAMP 10 TO CAMP 11

</div>

We have been so lazy in the mornings that we decided to make a fairly early start at getting ready whether we went anywhere or not.

Doc was first man up and brought my canoe to the fire to dry her bottom preparatory to the morning patching and mending. Jack did not bestir himself and so he was carefully roped in by Cope as a bear trap and when "grub pile" sounded at seven, he was firmly entangled.

Last night, Mel had walked up-stream and crossing the Soo Line Bridge, came to Murry, which is a small

store and a box car station. He told me that I could get a good view from the bridge. Before breakfast, I made some pictures in the mist, one of which is the best one made on this trip.

I found a good picture along an old road through the birch woods.

I made one picture looking from the top of the bluff towards our camp.

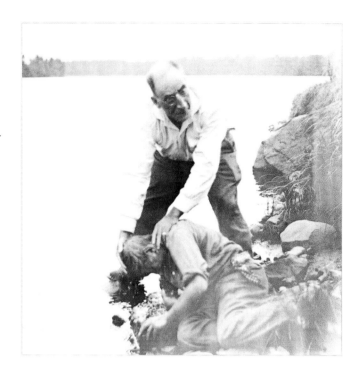

We left camp about nine o'clock. We passed the mouth of Weirgon Creek on the west. This did not look attractive for fishing. We were in rapid water most of the morning and generally speaking, the country is settled—that is, one is seldom out of sight of a farm for any length of time.

We made a short stop at noon for a lunch camp where Doc took a bath and commenced to complain because the rest of us smelled bad. Jack cleaned his

face with tooth-paste and the Doc finished the job. Just after we started down-stream, Cope complained of being sleepy and so he and Jack landed to let Cope take a nap. They happened to land in a blueberry patch and as the rest of us came up, we were all pressed into service as blueberry pickers. We have enough for four pies. Our general plan was to run to the mouth of the Thornapple River where we proposed to camp and let the boys have a chance to buy candy and stuff at the neighboring town of Bruce. The mouth of that river is fenced across and the Soo Line Bridge below (main line to St. Paul) affords no camping site so we paddled on and on looking for a camping place. The banks of the river are generally low with occasional higher land. The

After dinner, Jack took me out paddling and we had quite a talk. While we were gone, the men lighted a big camp fire near our tents. Clouds threatened rain and so we all slept in the tent.

Cope found a strange flower which I photographed before he pressed it. There were some beautiful sunset clouds which I pictured but I could get no view of the camp itself.

TUESDAY
AUGUST 29TH
CAMP 11 TO CAMP 12

We breakfasted at seven. As usual, Doc was the first up. I got up, took some clean clothes and went in for a bath before breakfast. Except for the wettings I had in the rapids, it was my first bath for more than a week. After breakfast, I captured Jack and at Cope's suggestion I took him across the River for a swim. We both washed clothes. Russell swam across.

We left at about ten, telling the men to go ahead for two hours and then to make a lunch camp and wait for us The river is broad and the current is swift on falling water. Once we stopped at a farm-house and Jack was sent in to negotiate for three dozen sweet corn. . . .

At noon we camped in a hot place but we found a white pine tree that gave us shelter from the sun. We had roast corn and the boys picked a big pail of blackberries. We traveled during the morning about seven miles.

The afternoon trip was varied by reaching the Flambeau at about half-past four. Cope lead us upstream, looking for a camp and it was hard paddling against the current. We were unanimously opposed to the first camping place so we examined our maps and

rapids have disappeared and we find sandbars forming across the channel which oblige us to cross and recross the stream as we go down. It was nearly five o'clock before we found a fair place to make camp. This is on the west bank with a little ridge on which to pitch our tents. The kitchen is below.

went down the Flambeau to the mouth and followed through the little village of Flambeau down the Chippewa River. We camped at a steep hill-side with our tents in the young birches above.

The evening brought a beautiful sunset. The sky clouded up but finally the clouds blew away enough to make it reasonably safe to sleep out-of-doors. Jack and I spread our blanket-rolls outside and were not disturbed by rain. Some animals occasionally stirred near us and in the morning I found their burrows but I do not know what they are. During the night, we had occasional flashes of aurora.

WEDNESDAY
AUGUST 30TH
CAMP 12 TO CAMP 13

We made a late start because we were lazy. It was half-past nine when we got under way. The country at first was interesting as we passed well-tilled, prosperous farms. Then we ran into low country and later into country that had been overflowed by a dam. It was half-past eleven when we reached the dam, an old timber structure, and we pulled in on the west side of the stream to look over the situation. The river makes a sudden turn and below the dam are great rapids.

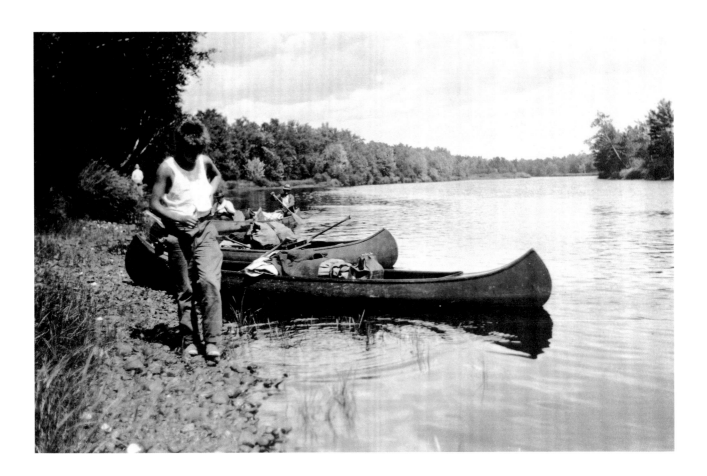

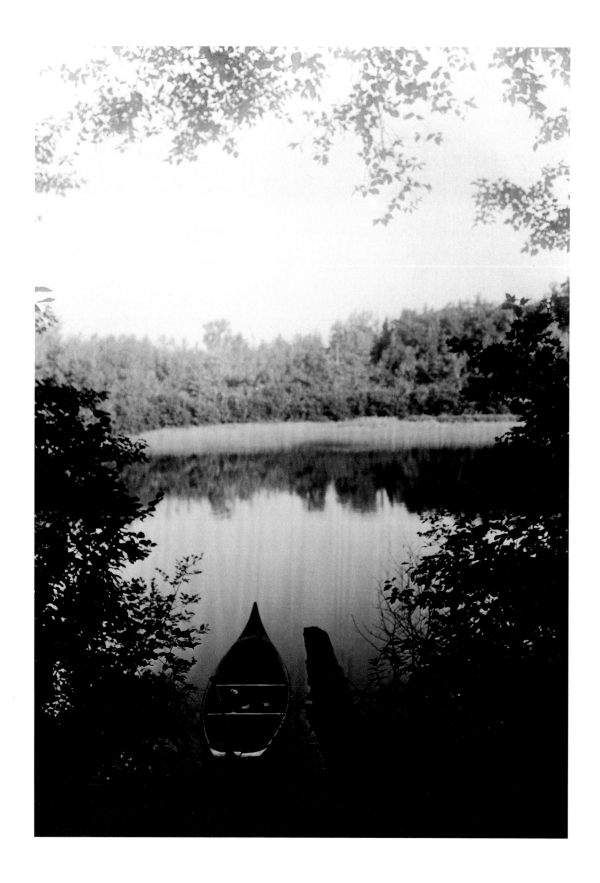

Holcombe lies a little beyond camp and Mel went down for mail. We lunched at our landing and will try to make the portage by team. Before lunch, the boys had a swim and Jack fed "au naturel." This will give us all day Thursday to loaf in camp, shave, fish and make pictures.

After lunch, Mel got a team and he paid the man a dollar for hauling all of our canoes and stuff around the dam and rapids. This was the easiest way of getting over. It would have been difficult to work through the rapids although some could have been run easily. We found a good, clean, open camping spot and the river looks as if there might be good fishing.

This is our Camp 13 and is a little below the footbridge leading to Holcombe. Our plan is to stay here tomorrow, take pictures and do some fishing and then to travel on to the next town, which is Cornell and either go out there or at Chippewa Falls, where there is another dam. This afternoon, I took up two bags of plates and sent them home by express and sent some mail out at the same time. Holcombe is a "has-been" town and there was once a large saw-mill here but this disappeared years ago. It is said that the Wisconsin & Minnesota Power Company is going to build a dam just above our camping site, which will flood the entire country over and above the old dam.

THURSDAY
AUGUST 31
CAMP THIRTEEN

I woke up fairly early and as the light seemed to be good, I left camp immediately with my camera to make some pictures of the rapids of the rock formation and of the rapids before the sun was too bright to interfere with my work. It was about half-past six when I reached the bridge and sometime later I heard Jack shouting "grub-pile" at me and he came across the River. It was then eight o'clock and I had just finished my picture making. I made some rather interesting pictures of flowers that grow around there.

The day was hot and at times the men went fishing. Russell lost his fish rod in the stream and it could not be

recovered by dragging for it. It was a day given to airing blankets and over-hauling stuff.

Cope and I had a conference today and we decided that in view of the threatened railroad strike and Carver's desire to have Russell go home for a visit before College begins, that it would be rather better to break camp here tomorrow. We do not know what kind of a place Cornell will be and we certainly can get boxes for packing our stuff here. I told Mel and Jo about our plans that night and both expressed their satisfaction. Really, the trip had gone far enough and it was time to end it. We had a good deal of discussion about the weather. Joe held that it was to be clear but about supper-time a thunder storm came up and another and another and the result was that we had to spend the night in our tents. It rained at intervals during the entire night. The tent leaked a little until it was thoroughly wet and after that we had a good dry tent.

The sky was over-cast and some rain was falling as we got up and we had to have our breakfast in the shelter of the men's tent. After breakfast, I started packing all of my best blankets in the dunnage-bag and getting it ready to check home. Mel arrived for a one-horse wagon to haul or stuff over to the depot, the consideration being our old guide canoe, which is tarred inside and out and leaks badly but is good enough for such use as a settler could make of it. I told him that I was going to leave my Kennebec canoe and Mel said he would pay the freight on it if he could have it for use on the pond at Crivitz. Later he succeeded in selling it to a local barber for $5. I made one grand junk pile of all of our cast-off clothing, quilts, etc. which were to be given to the boys who hauled our stuff. Because of the threatened

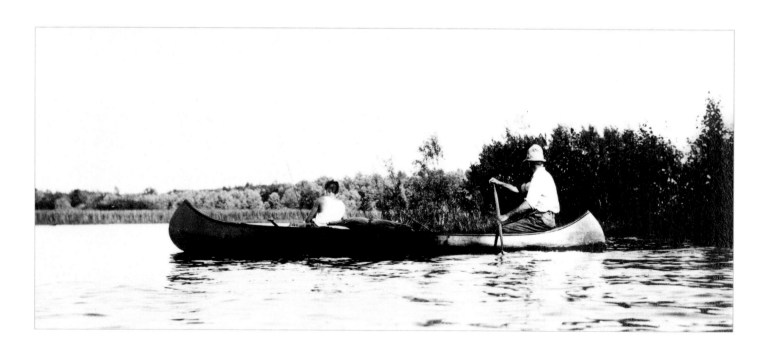

railroad strike, the local railroad agent had instructions not to receive freight which would arrive at its destination later than Monday morning and we, therefore, had the choice of shipping our stuff by express, abandoning it or trying to arrange with someone to hold it and ship it for us later. We reduced bulk as much as possible and decided to ship the balance by express.

When the sun came out, we opened Cope's "carryall" and took out our city clothes, stretched them and aired them preparatory to starting. Cope made clotheshangers of branches of trees to take the creases out of the coats. First I had a bath—then the boys went across the river for a bath and on their return, Cope shoved their canoe out in the stream, followed them out and then tipped it. This was all in honor of Russell that he might be initiated as a camper. We had lunch.

At half-past two, we were all of us dressed up and thoroughly uncomfortable and unhappy waiting for the train.

The boys went downtown to lap up a farewell icecream soda while Cope and I sat in a little grove near the camp and talked about the trip we had just finished.

The distance from Holcombe to Chippewa Falls is about 25 miles. The train is a combination freight, mail and passenger and it takes an hour and a half to reach Chippewa Falls and a little longer to reach Eau

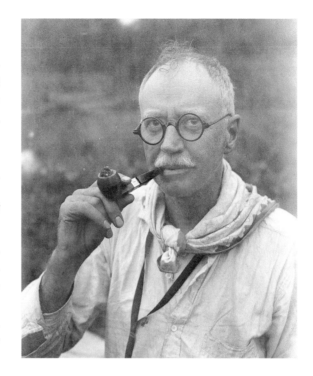

Claire. At Eau Claire we went to the hotel, had supper and then with difficulty killed time until eleven o'clock when the train carrying the Milwaukee sleeper came in. We boarded this train, which runs via Wyeville, and reached Milwaukee about seven o'clock.

Another camping trip was ended.

CODA

The following passage is directly quoted from Dad's
last camping journal from a trip to Montana in 1926.

A RETROSPECT.

In other years when others besides 'The Doc', Howard, Clay, Carl and I constituted 'The Gang', I wrote journals for the boys telling of our preliminary gatherings to discuss untraveled routes, of dinners at which it was understood no final decision was to be reached, and of other gatherings to which past and possible new members were invited and there all matters previously informally decided upon became res gestae and the departure date was fixed. Then followed a week or two of overhauling canoes, tentage, bedrolls and camp utensils; of buying groceries and camp stores and having these sent a week or more in advance to some almost unknown waystation where we came, looked our last upon civilization and by latitude and departure worked out upon maps, we explorers set out for a point lying somewhere across the wilderness. Those days are now only fond recollections for with the unwinding years the boys have grown to man's estate. The War took some to other camps and, after the War, the 'Gang' was but a memory—and an occasional reunion dinner.

AND NOW

Experience in fields, camps, and sundry places, has taught me that the best form of recuperation for a tired mind and body is to break loose from the usual manner of life and to go away with men who live outdoors in the great open places where the postman does not come nor the A.D.T. boy bear brief and importune messages.[1] I admit that in the years since our last camps on Lake Superior I had grown weary, I wanted to go to places not clearly marked between night rests, the distance and a day's travel by horse and pack train.

HOWARD GREENE

[1] An A.D.T. boy was a telegraph delivery boy.

EPILOGUE

The Chippewa River trip marked the end of a decade of canoe-camping trips for Dad and the Gang, and the end of an era. One year later, the United States had entered the Great War; it was a watershed event, and life changed greatly and forever.

What happened to Dad and the Gang after 1916? For most of the Gang, life went on for many more years, while for some life was cut much shorter. Following you will find sketches of the Gang's lives up through the early 1930s, extending beyond into midcentury where appropriate.

Dad went to France as part of the Army Engineers during World War I, then returned home to Milwaukee and his work and family. He went on two more camping trips, without the Gang, writing journals for each. One, in 1925, was designed around his daughter's insistence on having an experience similar to what her brothers had enjoyed so often; Dad took Elizabeth and one of her college friends along the Lake Superior shore north of Michigan for a short camping trip. In 1926 he and a younger friend went on a long horse-packing trip in Montana.[1] The Milwaukee Drug Company continued to flourish through the mid-1920s and survived the Depression. Dad endured significant personal losses over the next several years: the death of his very close friend Doc, in 1929; his wife's death in February 1932; the tragic accident that killed his daughter, Elizabeth, in November 1932; and the death of his only sister in 1935.

Carl went to World War I, first in the French ambulance corps of the Red Cross and later serving in the American Expeditionary Services, Air Service. Carl, the free-spirited artistic boy in the Gang, was not to survive the traumas of war intact. He returned home with shell shock and never fully recovered, spending the rest of his life in and out of mental health care. Carl's story, after getting to know him through the journals, seems incredibly sad; how Dad and the family survived Carl's fall into lifelong mental illness is hard to imagine.

Dad's oldest son, Howard T., graduated from the University of Wisconsin and became the general manager of Brook Hill Farm, the family-owned dairy farm at Genesee Depot, Wisconsin, which was widely known for its innovative and scientific approach to dairy farming. He married Else Goetz and had four children. Active in politics, he ran for governor of Wisconsin in 1934. A loyal alumnus of the University of Wisconsin, Howard T. was chair of the University of Wisconsin Alumni Association and a founder of the Wisconsin Alumni Foundation. Howard and Else were very interested in conservation, ultimately giving an environmentally significant tract of their land in Genesee Depot for conservation and an outdoor classroom managed by Carroll College.

Jack Greene became a commercial artist. He lived in Genesee Depot and worked in Waukesha and Milwaukee. He married Louise Sederholm and had two children.[2] Jack was more inclined to the arts and less drawn to the rustic or outdoor life than his brothers had been.

Billy Mac, manager of the Gimbels Department Store, was a member of the Board of Regents of Marquette University and on the public library board. Billy was a well-liked and respected community leader. His love of the outdoors continued until his unexpected death in 1917.[3] His obituaries do not report a specific cause of death.

Doc continued to be a community leader in the arts: an art critic and collector, he helped found the Layton Gallery and bequeathed dozens of paintings to the gallery at his death. He was an active member of the Milwaukee Academy of Medicine, the county medical society, and other medical organizations. An obstetrician, he delivered many of the Greene grandchildren. He bought land adjacent to the Greenes' farm in Genesee Depot and was an intrinsic part of Dad's and Howard T.'s family life.[4] Doc, always an interesting character, remained true to form through life and until his death in 1929.[5]

Bill Marr continued to live and work in Racine, Wisconsin. Far less is known about him than the other men, and it was hard to trace him beyond the early 1940s.[6]

Clay Judson maintained friendships with Dad and Howard T. over the years, even though he lived and practiced law in Chicago. He became a highly respected attorney and philanthropist, marrying and raising his family in Lake Forest, Illinois. He was a naturalist and an animal lover, and he was active in support of the Lincoln Park and Brookfield Zoos in Chicago.[7] When I began writing this book, I was able to locate and contact Clay's grandchildren, who needed no explanation, none whatsoever, about these canoe-camping journals. Their grandfather had often talked about the days of the Gang and had kept his copies of all of the journals.[8]

Piffy (Charles Ilsley) and Heinie (Fred Hanson) went on to become community and business leaders in Milwaukee. Piffy was part of the family banking business, the Marshall and Ilsley Bank, in Milwaukee.[9] Heinie remained in Milwaukee and was an executive of a Milwaukee electrical firm. Both of these young men had many contacts and positive interactions with Dad and the Greenes over the years, but those relationships appear to have been less active than Doc's and Clay's. More information on the Ilsley and Hanson families is readily available elsewhere and need not be told here.

Returning to Dad's life, a little more history is, perhaps, necessary to round out his long and interesting life. A few years after his wife's death in 1932, he met a nurse who had been hired to care for his sister, Kitty Upham, in her final days. They fell in love, married, and had a family of three children. We three younger children grew up in a large extended family, including

Howard T. and Jack and their families, and we enjoyed close relationships with Kitty Upham's children. It was often a bit tedious for us to explain to others our skewed generational lines, such as having half brothers so much older than we and having first cousins older than my mother. But my childhood was rich in Greene family relationships that have continued to this day.

Dad remained remarkably active, youthful, and involved with his family until his fairly sudden death in 1956 at age ninety-two. During his last decade he was able to return his attention to an unfinished manuscript begun thirty years earlier. *The Journals of Welcome Arnold Greene: The Voyages of the Brigantine* Perseverance, *1817–1820* was published by the Wisconsin Historical Society in 1956.

•

Following World War I, conservation and recreation burgeoned. In spite of conservation's upswing, industry and development continued to impact the rivers the Gang had so freely traveled, though probably at a reduced rate and severity. The events and policies that created the area we know as the Boundary Waters Canoe Area Wilderness and Quetico Provincial Park made the region more open to recreational use and better protected from industrial exploitation but also changed those areas in ways Dad and the Gang would not recognize. The petroglyphs, for which one can purchase a detailed guidebook, are still there, as are many of their old landmarks, but the signposted campsites, permit system, and well-maintained and marked portages would be baffling to the Gang. I suspect they would say it is now too civilized to qualify for one of their trips.

The Gang sought uncivilized areas. They wanted days and weeks in poorly mapped wilderness areas where they were constantly discovering places they would know very little about in advance and had to learn how to make their way through. This required minds open to observation and skills in reading the land. Because of their choices of destination, the Gang's literacy in natural history, and Dad's low-key and candid style in reporting the daily details, we get to "discover" along with the Gang. In the process, we get to be a part of their heightened sense of place in the North Woods.

Many people have asked if I were going to re-create these journeys as part of the process of writing this book, and I have consistently answered "No." It is simply not possible, for me or anyone, to re-create the trips. We know some things about the richness of what Dad saw, and we have seen it through his eyes. Now the region is a designated "wilderness," with campsites and portages set aside and guidebooks readily available; I cannot paddle the same stream he did. It is unlikely that I could ever experience the landscape and terrain as he did. How would I rid my mind of all the knowledge we now have of the Boundary Waters or of a National Scenic Riverway?

That said, I have had surprising moments of profound identity with Dad and the Gang as I traveled to see some of the places they went. When I stood in the "borrow pit" adjacent to the Radisson Dam on the Chippewa River, basically the same as one hundred years ago, I recognized I was standing in the exact place they had camped, likely on the spot where one of their old canvas tents had stood. On another occasion, I was driving on a gravel road toward McFarland Lake from Hovland, tracking alongside the route of the old tote road over the Sawtooth Mountains. Pulling aside at an overlook to take pictures, it suddenly became crystal clear that I was standing and taking pictures exactly where Dad had, making the same images that he had so many years earlier. While in Voyageurs National Park, it was exciting to see the petroglyphs the Gang had canoed past and to experience how one could get wind

locked on the shore of Namakan, but neither of those experiences in Voyageurs spoke to me quite so deeply as taking a hike to an inland lake there, with no sign of anyone around, and swimming in that very secluded lake—just cold water, a bowl of blue sky, rocky shores, pine trees, and a little sense of risk. Maybe that is how the Gang felt on their trips?

NOTES

1 The journals of these trips are interesting but entirely different in nature from the 1906–16 ones with the Gang, and they were not germane to this book.

2 Jack Greene's wife, Louise Sederholm, was a half sister of Alfred Lunt, the actor. Jack and Louise lived in Genesee Depot near Alfred and Lynn Fontanne's "Ten Chimneys" home. Louise died in 1959.

3 From Billy Mac's obituary in the *Milwaukee Daily News,* December 6, 1917: "Mr. MacLaren was fond of outdoors sports and each year spent what time he could spare in the hunting regions about Genesee Lake and in the Gogebic Range. His hunting and fishing companions generally were Dr. Ernest Copeland, J. H. Crittendon, Howard Greene, Howard Russell, and John W. Foster."

4 Howard T. Greene's older son was named Howard Copeland Greene, to honor Doc.

5 Doc outlined his detailed design for his funeral in his will, which was carried out explicitly. The *Milwaukee Sentinel* reported on September 12, 1929, that "Simple Rites are held for Dr. Copeland . . . the coffin rested on a rostrum at Forest Home Chapel . . . and two hundred professional and fraternal associates and personal friends filled the pews. . . . A Chicago string orchestra, half-hidden by the palms in the conservatory adjoining the chapel began to play. . . . For fifteen minutes they played classical compositions. The music stopped and the crowd silently filed out. That was all."

6 I found a letter from Bill that had been slipped inside a book's pages, congratulating my parents on my arrival in the world. That is the last trace of correspondence between Dad and him that I could find. Of course, no one of his generation survives to tell us any more about him now.

7 From a small memoir of Clay Judson, "Clay Judson—My Father," written by his daughter Alice Judson Ryerson for his funeral service: "The other day we found a piece of paper listing important things he remembered. Almost one third of the list consists of names of birds and where they were seen. Some were birds he had seen as a boy on canoe trips in the north woods and those particular warblers and kinglets were still vivid in his mind fifty years later, and outranked memories of Harvard and Law School in importance."

8 Clay Judson's personal papers can be seen at the Newberry Library in Chicago. Among his papers are correspondence with Dad and other remembrances from this earlier part of his life, as well as his daughter's memoir, quoted in note 7.

9 One of Piffy's grandsons had a copy of the Rainy Lake journal, which passed through other hands and was ultimately given to the Oberholtzer Foundation in Rainy Lake, Minnesota, for placement in its Mallard Island Library.

GLOSSARY

AIR LINE Used to describe distance "as the crow flies."

AMAZON TENT A substantial cotton canvas rectangular tent with an eight- to nine-foot center and four-foot walls, a roof sloping toward the rear, and an awning in front over the door.

APPOLINARIS A German mineral water called the "Queen of Table Waters" popular from 1895 on through the early twentieth century.

ARMY COCKTAIL A popular cocktail from 1869 to 1920 composed of gin, vermouth, and grenadine. The juice from bottled maraschino cherries could be substituted for grenadine.

BAGGAGE CAR; BAGGAGE BREAKER Passenger trains included baggage cars, which carried larger objects, such as trunks and crates or, for the Gang, canoes. The baggage breaker was the handler and manager of the baggage car.

BATEAU (BATEAUX, PLURAL) A large, flat-bottom boat with planked sides, made from rough-sawn lumber and pointed at both ends; originally used in the fur trade, later used on log drives. Bateaux ranged widely in size, commonly from twenty-four feet and up to fifty feet in length.

BIVOUAC CAMP Improvised camping without cover or tent; sleeping under the stars.

BLAZER MATCHES This name is probably the colloquial name for Torch or Flare safety matches, which would burn when wet and could not be blown out; sold in tins of one hundred.

BOLT A block of timber to be sawed or cut, or a short round section of a log.

BOOM A pen or enclosure of cut logs, chained end to end and attached to the shore, holding logs for later release. Booms were used to hold logs collected

downstream at a sawmill, or at the mouth of a river awaiting transport by a tug to a mill farther away on a lakeshore.

BOUILLON At the turn of the twentieth century, bouillon meant any clear soup or broth, plain or with meats and vegetables added. Bouillon is not thickened as chowders and cream soups are.

BREAKING CENTERS AND WINGS As logs ran downstream on a full head, or river flood, some would jam up along the edges of the river or catch in the river's center. To get things opened and moving again, specialized crews worked to separate logs, using pike poles, working from bateaux or by standing on the jams. The work was extremely dangerous and resulted in frequent injuries and deaths.

CHAIN A measure in surveying; a chain equals sixty-six feet in length.

CHANGING PLATES Refers to changing film (in film holders) or glass-plate negatives.

CNW (CHICAGO AND NORTH WESTERN RAILWAY) A passenger route primarily serving the Chicago to St. Paul route.

CONDUCTOR The train conductor supervises the train, acting as coordinator between the engineer and other railroad officials, such as station masters. The conductor signals stops and starts, meets passenger needs, and keeps the train running smoothly and safely.

CORDUROY ROAD A primitive road spanning boggy land that utilized trees or logs laid closely and crosswise on the trail.

CSTPM&O RAILWAY The Chicago, St Paul, Minneapolis and Omaha Railway served a route from Chicago, through the Twin Cities, and on to Omaha (often called the Omaha line).

CRUISER Another name for a timber walker.

DAVID A suitcase.

DOPE Mosquito dope or punky dope, used to discourage biting insects. This was the forerunner of modern insect repellents.

DRIVES Logs harvested during the winter were skidded and stockpiled along the banks of rivers and streams until ice-out, when the rivers were running full enough to float the logs to a sawmill or processing area. Sometimes dams were built to hold back enough water to float logs through a particular river section. A drive failed if the logs could not be made to move on downstream to a waiting sawmill.

DUFFLE Clothing and other personal gear carried by a camper.

DULUTH, SOUTH SHORE, AND ATLANTIC RAILROAD One of nine railroads that served Duluth around 1920, the DSS&A served a route from Duluth east through Michigan's Upper Peninsula to Lake Superior's South Shore. (Other railroads serving Duluth included the Northern Pacific; Great Northern; CStPM&O; Soo Line; Duluth, Winnipeg, & Pacific; Duluth, Missabe, and Northern; and the Duluth & Iron Range.)

DUNNAGE, DUNNAGE BAG Personal belongings or baggage.

DYNAMITE FISHING An illegal way for an individual to catch fish quickly by throwing a small dynamite charge into a stream or bay where fish have gathered for spawning. A wasteful practice, it was not used for commercial, subsistence, or sport fishing.

DYNAMITE SOUP Soup made from a sausage-shaped portion of compressed dry pea soup; *see also* Erbswurst.

ENSIGN A flag displayed on a boat or ship to identify nationality.

ERBSWURST A sausage-shaped portion of compressed dry pea soup, first used as a ration for the army in the Franco-Prussian War. It was in continuous use by European armies up to World War I and was popular with outdoorsmen. Erbswurst sold in the 1910 Abercrombie and Fitch catalog for thirty-two cents per pound. *See also* dynamite soup.

EXPRESS TRAIN A special train, often carrying freight, that traveled occasionally and had third priority to the tracks, after mail and passenger trains.

GRUB PILE Early-twentieth-century term for food, a meal, or provisions.

KENNEL An archaic term for a lodging.

LAUNCH Any large, open boat powered by steam or gasoline.

LINING A CANOE *See* roping a canoe.

MAIL TRAIN A specialized train, with first priority to track usage to allow timely delivery of mail. Mail was picked up in bags along the route, sorted in transit by staff in post office cars, and distributed to other railway stations before speeding on its way again. This remarkable service provided excellent mail communication through many of the Gang's trips. If Dad could get a letter to a settler's store or a logging train, it might be delivered in Milwaukee a day later.

MARLIN Jute twine for marine use.

MARQUEE TENT Large tent with open sides.

MOSQUITO BAR A netting, similar to more modern mosquito netting, sold by the yard. Mosquito netting was not a standard accessory on tents of the early twentieth century.

NORTHERN PACIFIC A transcontinental railway that joined the Great Lakes and Pacific in 1883.

OMAHA ROUTE *See* CStPM&O Railway.

OUTFIT Set of tools or equipment for a specialized purpose.

PASSENGER TRAIN A passenger train carried passengers, primarily, and could be made up of passenger cars, Pullman or sleeping cars, dining cars, baggage cars, and a mail car if the route was not served by a dedicated mail train.

PAULIN A cover; abbreviation for tarpaulin.

P.B.&L. COMPANY Peninsula Box and Lumber, of Menominee, Wisconsin, and Marinette, Michigan. Howard Greene was a board member, serving as president for several years. Redmond Pangborn was manager.

PEAVEY A peavey, or cant hook, is a tool used to raise or turn a log in the woods or at a mill.

PETTIJOHNS A popular whole-grain cooked breakfast cereal.

PIKE POLE A long pole with a sharp point and a small hook used by loggers in a drive or within a boom.

PILOT BREAD Another name for hardtack.

PLATFORM An area alongside tracks at stations and along sidings allowing passenger access to trains.

PORTER A term usually referring to a Pullman or sleeping car porter; a man assigned to an array of passenger services such as making up berths, handling hand baggage, shining shoes, delivering meals and beverages, and taking care of passengers' needs round the clock.

POSTING LETTERS BY STEAM Sending letters by steamboat.

PULLMAN CAR *See* sleeping car.

PUNKY, PUNKIE A biting midge or gnat.

PUNKY DOPE Something used to discourage punkies.

RAISING DAFFYDILS Vernacular for sleeping or snoring.

REDCAP A man employed at a depot or train station to handle baggage for the passengers, delivering it to the correct train car, or unloading at the passenger's destination.

RICE WITH FLIES, COCKROACHES Perhaps Dad was making a joke about having rice mixed with raisins or other dried fruits. (It was also a possible statement on having rice or cereal laden with weevils, more common at the turn of the century.)

RIGHT-OF-WAY (ROW) Each railroad held title to strips of land along both sides of a track, called the right-of-way. Around 1900 the usual ROW was one hundred feet.

RIVER PIG A lumberjack, or jack, who worked on a log drive, handling the logs as they went downstream to a mill.

ROPING A CANOE Allowing a canoe to float through rapids tethered by ropes or lines held by one or two canoeists on foot, who walk the bank or the edge of the river. Stern upstream, the canoe floats freely and safely through rapids too dangerous to paddle.

SAPOLIO A popular, all-purpose hand and household soap made from 1883 through the early 1900s.

SEPTEMBER MORN In 1911 the French artist Paul Émile Chabas completed a highly controversial painting of this title, featuring a nude girl standing in the shallow water of a lakeshore. It was considered indecent and shocking by many at that time, giving great notoriety to the work. This popular painting is often referenced in these camping journals.

SIDING A low-speed track, separate from higher-speed main lines, but connected to the main track at both ends. Sidings allowed trains to pass one another or provided storage for cars not in use.

SIGNAL PLATFORM A platform between depots with a hand-operated signal device to flag, or stop, a train for boarding.

SLEEPING CAR A car designed to have open seating during the day that converted into upper and lower berths at night, each curtained off for privacy from a central passageway. These were not private rooms but were luxurious compared to sitting up overnight on coach seats. Often called Pullman cars after their manufacturer, these cars were leased by individual railroads from the Pullman Company.

SLUMGULLION, SLUBGULLION A stew of meat, vegetables and potatoes.

SMUDGE, SMUDGING Smoking an area to drive away mosquitoes.

SNAKES An archaic slang term for pickerel, which were not considered edible by many fishermen in the early 1900s.

SOWBELLY Fat salt pork or bacon.

STEREO TABLETS Slang for Steero-brand beef bouillon tablets or cubes, used to make instant soups (sold by the Milwaukee Drug Company as late as 1926 in bottles of one hundred, for $1.27).

TEAMING A job description, c. 1900. Used when a man and his team of horses were hired on in a logging camp or other industry. It often connoted a seasonal, part-time, or contract job.

TENDERFOOT A somewhat desultory name for an inexperienced camper or outdoorsman.

TIMBER WALKER Someone who walked, or "cruised," forest land to determine its potential lumber yield.

TOTE ROAD A road for hauling supplies, especially to a lumber camp.

TUMP LINE A strap attached at both ends to a pack and worn around the forehead to help suspend a heavy load.

VISCOL A waterproof dressing for leather, which will keep it soft and flexible.

WANGAN, WANIGAN, WANNIGAN A logging term for a boat for carrying provisions, or a floating cookshack.

WILDERNESS Land, uncultivated or uninhabited; a pathless area of any kind. In the early twentieth century this definition was broad but was later supplanted by stricter definitions as in the code of the 1964 Wilderness Act.

WISCONSIN CENTRAL RAILROAD A freight line in central Wisconsin.

WOOD BUTCHER A camp helper. An older usage referred to a logger who clear-cut the forest.

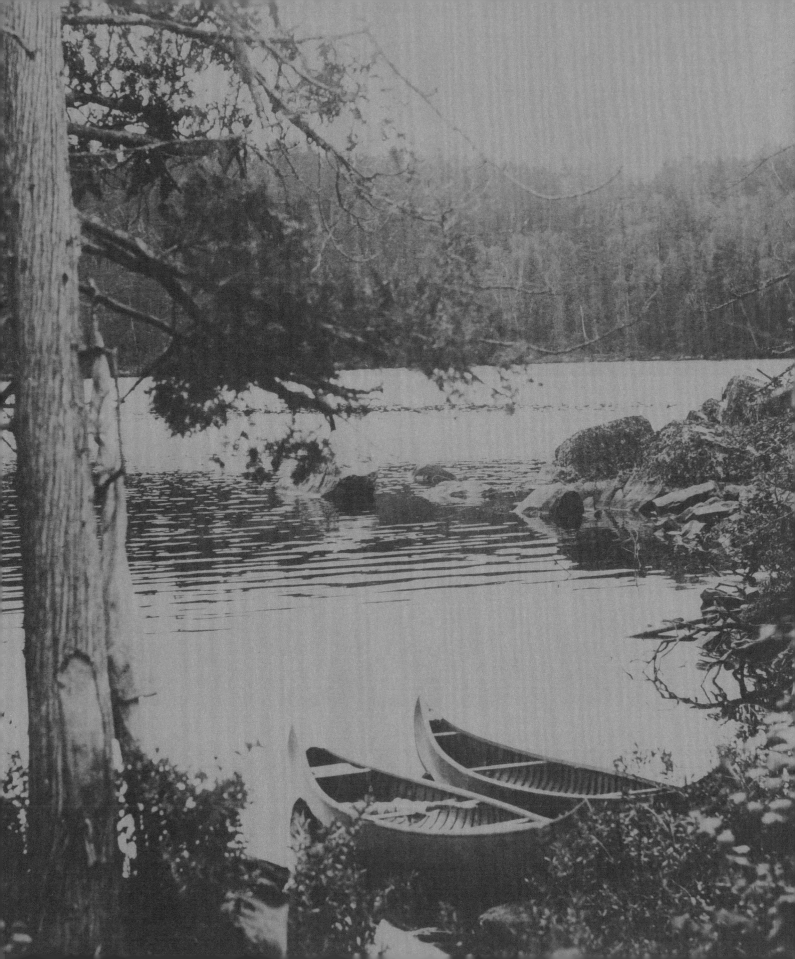

FOR FURTHER READING

Howard Greene's journals are positioned at an intersection between a late-nineteenth-century way of life in the North Woods and the rapid changes in conservation and recreation that followed World War I. These resources may be relevant to readers looking for additional information about this era and the wilderness areas in northern Minnesota, Wisconsin, and Canada.

·

These four privately published books about the North Woods were written about the time of Howard Greene's journals:

Alexander, Kirkland Barker. *The Log of the North Shore Club: Paddle and Portage on the Hundred Trout Rivers of Lake Superior.* New York: The Knickerbocker Press, G. P. Putnam's Sons, 1911.

Holcomb, Arthur Tenney. *From the Log of a Trout Fisherman.* Brule, Wis.: Miller Print Company, Winneboujou Club, 1949. This is a classic account of the development of early fishing camps on Wisconsin's Brule River in the 1880s.

Tenney, Horace Kent. *Vert and Venison.* Chicago: Lakeside Press, 1924. A hunting, fishing, and travel account written by a distant cousin of Howard Greene.

Tuttle, Liz. *Crab Lake Memories: A Collection of Crab Lake and Presque Isle Nostalgia.* Privately printed, 1990. Includes an account of the Forester canoe trip of 1910. Forester was a Milwaukee man, probably acquainted with Howard Greene.

·

These books focus on people and subjects contemporary to Howard Greene's time in the woods:

Abercrombie and Fitch Company. *Abercrombie and Fitch Company Catalog.* New York, 1910.

Black, George. *Casting a Spell: The Bamboo Fly Rod and the American Pursuit of Perfection*. New York: Random House, 2006.

Egan, Timothy. *The Big Burn: Teddy Roosevelt and the Fire That Saved America*. Boston and New York: Houghton Mifflin Mariner Books, 2010.

———. *Short Nights of the Shadow Catcher: The Epic Life and Immortal Photographs of Edward Curtis*. Boston and New York: Houghton Mifflin, 2012.

Henricksson, John, ed. *North Writers I: A Strong Woods Collection*. Minneapolis: University of Minnesota Press, 2000.

McPhee, John. *The Survival of the Bark Canoe*. New York: Farrar, Straus and Giroux, 1975.

Nash, Roderick Frazier. *Wilderness and the American Mind*. New Haven and London: Nota Bene Book, Yale University Press, 2001.

Nessmuk [also known as George W. Sears]. *Woodcraft and Camping*. New York: Forest and Stream Publishing, 1884.

Paddock, Joe. *Keeper of the Wild: The Life of Ernest Oberholtzer*. St. Paul: Minnesota Historical Society Press, 2001.

Peruniak, Shirley. *Quetico Provincial Park, an Illustrated History*. Atikokan, Ontario: Friends of Quetico Park, 2000.

Rath, Sara. *H. H. Bennett, Photographer: His American Landscapes*. Madison: Terrace Books, University of Wisconsin Press, 2010.

Vaux, C. Bowyer. *Canoe Handling: The Canoe, History, Uses, Limitations and Varieties, Practical Management and Care, and Relative Facts*. New York: Forest and Stream Publishing, 1886.

•

After World War I, when travel and recreation began to boom, writers started to describe canoe travel and wilderness experience in the newly set-aside preserves along the Canadian–United States border, known today as the Boundary Waters Canoe Area Wilderness and Quetico Provincial Park. Because of their experiences, style, expressiveness, and contributions to conservation, some of those writers have achieved nearly legendary status over the past fifty to seventy-five years. A few were quite prolific, and readers can certainly find an extensive selection of their books. These four authors come immediately to mind:

Francis Lee Jaques (1884–1969) and Florence Page Jaques (1890–1972). This artist-and-writer couple made beautiful books based on their experiences in northern Minnesota and Canada in the 1930s and 1940s.

Sigurd Olson (1899–1982). This prominent conservationist, professor, and writer lived in Ely, Minnesota, now a put-in town for the Boundary Waters Canoe Area Wilderness. His many books eloquently highlight the spiritual value of wilderness and canoeing.

Calvin Rutstrum (1895–1982). This writer lived most of his adult life in and around the Boundary Waters area and progressively farther into the wilderness. His fifteen popular books focus on this region and his experiences there.

•

Among the library collections that may be of interest to readers are Howard Greene's personal papers, held by the Wisconsin Historical Society in Madison and Milwaukee, Wisconsin; and Clay Judson's personal papers, in the collection of the Newberry Library in Chicago, Illinois.

HOWARD GREENE was born in Milwaukee, Wisconsin, in 1864. He attended the University of Wisconsin–Madison and served in the Wisconsin Infantry in the Spanish-American War. During the summer months between 1906 and 1916, he made canoe and camping trips throughout the North Woods with his friends and sons. Carrying a heavy Graflex camera, tripod, and glass plates, he documented these journeys in remarkable photographs and detailed writing accounts. During the 1920s and 1930s, he continued his father's pharmacy business, which became the Milwaukee Drug Company. His book *The Journals of Welcome Arnold Greene: The Voyages of the Brigantine* Perseverance, *1817–1820*, was published in 1956, the year of his death at age ninety-two.

MARTHA GREENE PHILLIPS, the daughter of Howard Greene, researched her father's canoe trips into the remote northern wilderness. After a career in social work, she is now a freelance writer and author of *The Floating Boathouses on the Upper Mississippi River*. She lives near Madison, Wisconsin.

·

PETER GEYE is the best-selling author of *Safe from the Sea*, *The Lighthouse Road*, and *Wintering*. He lives in Minneapolis.

Border Country

The Northwoods Canoe Journals
of Howard Greene
1906–1916

Published by the
University of Minnesota Press

Erik Anderson *Regional and Trade Editor*

Kristian Tvedten *Associate Editor*

Daniel Ochsner *Production and Design Manager*

Laura Westlund *Managing Editor*

Mary Keirstead *Copy editor*

Catherine Broberg *Proofreader*

PRODUCED BY WILSTED & TAYLOR PUBLISHING SERVICES

Project manager Christine Taylor

Production assistant LeRoy Wilsted

Designer and compositor Nancy Koerner

Printer's devil Lillian Marie Wilsted